Travel
& See

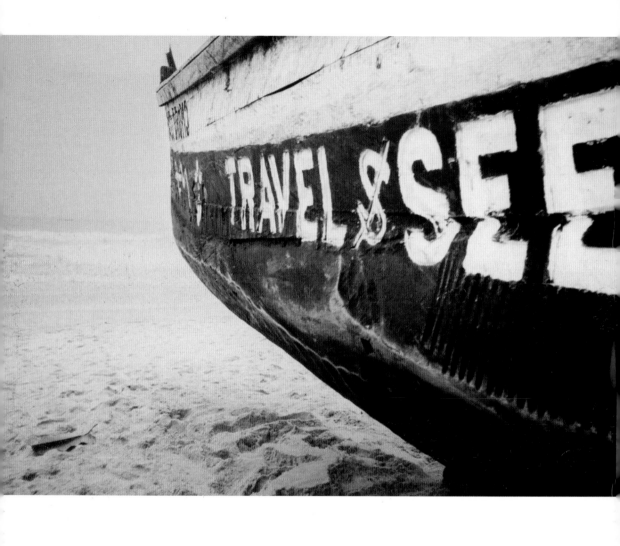

Travel
& See

BLACK DIASPORA ART PRACTICES SINCE THE 1980s

Kobena Mercer

DUKE UNIVERSITY PRESS

DURHAM AND LONDON

2016

Printed in China on acid-free paper ∞
Interior designed by Barbara Wiedemann
Typeset in Minion and Lato by Tseng Information Systems, Inc.

Library of Congress Cataloging-in-Publication Data
Mercer, Kobena, [date] author.
Travel & see : Black diaspora art practices since the 1980s /
Kobena Mercer.
pages cm
Includes bibliographical references and index.
ISBN 978-0-8223-6080-3 (hardcover : alk. paper)
ISBN 978-0-8223-6094-0 (pbk. : alk. paper)
ISBN 978-0-8223-7451-0 (e-book)
1. Art, Black—History and criticism. 2. Race in art. 3. Ethnicity in
art. 4. African diaspora in art. 5. Art and globalization. I. Title.
N8232.M48 2016
704.03'96—dc23 2015029323

Frontispiece: Proverb inscribed on boat, Kokrobite, Ghana, 1991.
Cover art: Isaac Julien, *Western Union Series No. 1 (Cast No Shadow)*,
2007. Duratrans in lightbox, 47.24 × 47.24 inches (120 × 120 cm).
Courtesy of the artist.

This book was published with the assistance of The Frederick W.
Hilles Publication Fund of Yale University.
Publication has also been made possible by the generous support
of the Department of the History of Art Publications Fund,
Yale University.

Dedicated to the memory of my father,
Krakue Kweku Mercer, 1925–1998

Contents

Illustrations

Acknowledgments

The writings in *Travel & See* document an adventure of "becoming" that would not have been possible without friends and colleagues on both sides of the Atlantic whose encouragement has sustained me with conversations that have been ongoing "since the 1980s." I would like to thank colleagues with whom I've worked at various institutions: Victor Burgin, while I was at the University of California, Santa Cruz, and Manthia Diawara at New York University, where I spent the late 1990s in the company of Clyde Taylor and a cohort of incredible graduate students. Former colleagues at Middlesex University, London, including Jon Bird, Adrian Rifkin, Lisa Tickner, and the late Paul Overy, always supported my work; I would especially like to thank Jean Fisher, Keith Piper, and Pam Simpson. Fellowships that provided time for research and reflection gave me enriching experiences for which I owe thanks to Maurice Berger and Sondra Farganis at the Vera List Center for Art and Politics at the New School University, New York; Dominick LaCapra and Timothy Murray at the Society for the Humanities, Cornell University; Michael Ann Holly at the Research and Academic Program of the Clark Art Institute, Williamstown, Massachusetts; and Valerie Smith, for my semester at the Center for African American Studies, Princeton University. I am immensely grateful to Gilane Tawadros, former director of the Institute of International Visual Arts, London, for the trust she placed in me to initiate the Annotating Art's Histories series and bring it to such a successful fruition.

I have experienced tremendous hospitality around the world which has broadened my outlook immeasurably, for which I thank Okwui Enwezor, Geeta Kapur, Partha Mitter, Keith Moxey, Marcel Obenbach, Marion von Osten, Nikos Papastergiadis, and Annie Paul. David Bindman, Henry Louis Gates Jr., and Griselda Pollock have warmly

supported my endeavors, as have colleagues at Yale University, especially Elizabeth Alexander, Hazel Carby, Alexander Nemerov, and Robert Farris Thompson. All of the artists in this book have my utmost gratitude, for their work which has transformed contemporary art on a global scale, and for their kind permission for me to feature their art so extensively in this book; I am also grateful to the galleries, museums, collections, and organizations that have granted permission for images to be reproduced. The illustrations throughout this book were made possible by a subvention from the Department of the History of Art at Yale University and a grant awarded by the Hilles Publication Fund at Yale University. Numerous editors in the United Kingdom and United States have helped shape my writing over the years; I thank all those who worked on the journals, books, and exhibition catalogues in which the texts within this book first appeared. Ken Wissoker has helped bring this book to completion with enthusiasm, and, as well as Jade Brooks and Bonnie Perkel at Duke University Press, I thank Heather Vermeulen for assisting with picture research.

Stuart Hall's generosity and friendship are something I will cherish forever as they influenced the course my life has taken; his presence in the world created the conditions that allowed me to become who I am. With the sorrow of his passing, I also know his life's work will continue to inspire people all over the world for many years to come. In the face of immense losses, I would like to express my heartfelt gratitude to my extended family, especially Thomas and Katherine Mercer, Effie Acquah-Harrison, Emmanuel Ato Mercer, James Mercer, Joe Bankole, and Jean and Julian Waites. Friends of my beloved sister, Araba Yacoba Mercer, have been hugely supportive, and I am so grateful to Madeleine Boulesteix, Carmelita Kadeena, and Pip Salvador-Jones. To my lifelong friends—John Akomfrah, Karen Alexander, Brian Freeman, Isaac Julien, Mark Sealy and Shona Illingworth, and Jerry Wright—I would like to say how much I treasure their presence, especially as I look forward to continuing our conversations as we journey into the future.

Travel
& See

INTRODUCTION

African American, black British, and Caribbean artists led the way in shaping the critical terrain on which contemporary art was redefined at the end of the twentieth century and the start of the twenty-first. Addressing cross-cultural entanglements among multiple identities as a feature of social life worldwide, their interventions brought renewed urgency to our understanding of art and society in an era of globalization when West-centered interpretations of modernism and modernity were thrown into crisis. Introducing vocabularies of hybridity, multiplicity, and transculturation, black visual arts practices in painting, sculpture, photography, film, performance, and installation all speak to the unpredictable potentials brought to life when heterogeneous cultures come into contact. It is this opening onto realms of future possibility, arising out of worldly histories shot through with the chance happenings of contingency, that is encapsulated in the idea of diaspora, whose far-reaching implications cut across the entire epistemic field in which the articulation of aesthetics and politics has been understood.

Covering the period circa 1992 to 2012, the writings gathered into this book trace the arc of my journey in following developments on both sides of the Atlantic. Putting eighteen texts between two covers, *Travel & See* brings into focus my endeavor to build a framework of analysis capable of doing justice to the astonishing aesthetic inventiveness set into motion by the critique of race and representation Black Atlantic artists and thinkers initiated in the 1980s. But any attempt to sum up this historic breakthrough in a narrative that simply transports black visual arts from invisibility to visibility, from margin to center, immediately reveals the dilemmas of ekphrasis that race and ethnicity bring to writing about art, notwithstanding the historical value of those key metaphors in black cultural criticism. Ekphrasis challenges us to match the visual and the verbal, calling for words adequate to the close attention that individual artworks demand; yet in much discourse on black visual arts we find a repeated emphasis on the artist's biographical identity or on problems of minority access to art institutions that tends to detract attention from the aesthetic intelligence embodied in actual works of art as objects

of experience in their own right. It is entirely fitting to find an upbeat response to the flourishing of black visual arts over the last thirty years. To observe how artists making an entrance in the years 1980–89 such as Sonia Boyce, Isaac Julien, or Lorna Simpson, for instance, were followed from 1990 to 1999 by artists such as Chris Ofili, Yinka Shonibare, and Kara Walker, to name but a few, and then by practitioners including Wangechi Mutu, the Otolith Group, or Kehinde Wiley in the 2000–2010 period, is to notice a chain of developments whose impact shows no sign of ending anytime soon. However, in the shallow celebrationism of so much of the writing surrounding this output, we tend to find a dehistoricized way of seeing that acknowledges the hard-won visibility black visual artists now enjoy in an international art world that has come to accept inclusion as a regulative norm, but which consistently fails to give an in-depth account of what is at stake in such practices, why such practices matter aesthetically as well as politically, and how they alter our understanding of what art actively *does* as it enters into the circulatory networks of public life.

The writing in *Travel & See* is animated by my dissatisfaction with the biographical and sociological reductionisms that pervade the literature on black visual arts, which ultimately leave intact opposing tendencies that write out race and ethnicity in the name of an outmoded formalist universalism. In monographs, exhibition catalogue essays, journal articles, conference papers, and reviews, my quest has been to assemble an interpretive model capable not only of encompassing the present but also of offering a historical account of the forces and pressures that put black diaspora arts into a condition of marginality and invisibility in the first place. For two decades plus, this has been the critical ambition driving my journeys of intellectual inquiry, albeit in a somewhat zigzag pattern. For even as the chapters of this book lay out a broadly chronological map of my various routes across the fields of art criticism and art history, drawing on methods from cultural studies, social theory, psychoanalysis, and political philosophy, it needs to be said that, in the decentering realm of diaspora, the pathways of such investigative voyaging were never going to be straightforwardly linear at all.

Stepping away from the now-ism that regards the contemporary as a terminal moment of resolution in which issues of race and ethnicity are magically brought to a close, my journey leads toward a critical alternative to such wishful thinking in the more rounded world picture that comes into view once the *longue durée* is taken into account. In the long-range perspective, from the ancient world to the present day, laid out in the five-volume study *The Image of the Black in Western Art* (Bindman and Gates, 2010–14), the late twentieth-century breakthrough of black diaspora artists reveals a rupture of epic proportions. Taking control of the black image, which for centuries had been

seen primarily through white eyes, the living presence of black artists in Western art institutions began to change the rules of the game. What was once a monologue about otherness became a dialogue about difference. Where the identity of "the West" itself was dependent upon visualizations of blackness as absolutely different, the time factor whereby it is only within the last thirty years that such deep-rooted entanglements have been drawn out of the shadows of the unconscious into the daylight of critical inquiry suggests that scholarship is only now beginning to uncover interdependencies buried at the foundations of the modern discourse of aesthetics which took disciplinary shape in late eighteenth-century Europe. Far from being a matter of those who were once marginal asking for inclusion so as to make good past omissions of race and ethnicity in art history's narrative of civilizational value, the questions erupting from the epistemological break of the 1980s call for a rethinking of the entire field in which the study of visual art upholds the humanistic vocation of critical self-knowledge. The central argument of *Travel & See* is that the contemporary reworlding of the diaspora concept allows us to do just that, for the interruptive agency of blackness in unsettling long-standing habits and traditions in the humanities opens our understanding of art to a broader range of interpretive pathways.

Diasporas define the spaces into which a population is forcibly scattered and dispersed as a result of involuntary migration. By default, the concept directs attention to social interactivity among asymmetrically positioned identities and thus counteracts the tendencies by which black artists are misperceived as a class apart whose work is confined to a separatist narrative. Where this book builds on my earlier work (Mercer, 1994), in which the diaspora theory put forward by Stuart Hall and Paul Gilroy was brought together with Mikhail Bakhtin's dialogical methods of textual analysis,[1] the underlying approach is culturally materialist in its emphasis on the volatile dynamics of structure and agency that have given rise to the visibility of race and ethnicity in the recent history of contemporary art as one of its distinctive features. Indeed, the very structure of the five parts of *Travel & See* speaks to the unforeseeable twists and turns such that black artists wielded the power to change perceptions of identity and difference in the culture at large, and yet momentous shifts in the ideological conditions of artistic production under globalization profoundly reshaped the institutional contexts in which artists decided on their individual choices.

The critique of race and representation launched in the 1980s did not just open debate on equal rights of black access to the resources of artistic and cultural production; it also began to unsettle the either/or logic of dichotomous reasoning which, for the most part of the past century, had locked down our ability to understand cross-cultural

interaction in the visual arts. In the five years between the 1984 exhibition *"Primitiv-ism" in 20th Century Art: Affinity of the Tribal and the Modern* (Rubin, 1984) and two 1989 exhibitions, *The Decade Show* in New York (L. Young, 1990) and *The Other Story* in London (Araeen, 1989), which were the first of their kind to survey black and other artists of color as a distinct presence in art, the discursive terrain that had secured the hegemony of monocultural interpretations of modernism was opened to a logic of de-centering. Once-rigid binary oppositions among the tribal and the modern, the origi-nal and the copy, the authentic and the imitative, the individual and the mass—which were all vertical hierarchies, never horizontal contrasts—were pulled apart by a new-found awareness of the intermixing that had always taken place beneath the categori-cal boundaries of modernist art criticism. Chapters in part I address the excavationary impulse to unearth all that lay buried beneath the dualistic codes which have domi-nated the construction of race as a social reality that is put into place by representa-tion. Whether questioning the authority of the museum as an institution claiming to represent national histories, as do the installations of Renée Green and Fred Wilson, or taking aim at the political technology of stereotypes that encode *black* and *white* as symbolic positions into which social actors are invited to identify in an imaginary rela-tionship of self and other, artists as diverse as Glenn Ligon, Mitra Tabrizian, and Carrie Mae Weems were intervening in the ideological points of closure whereby the visual typification of black life in commonplace representations comes to be socially accepted as natural, obvious, and unchangeable.

To say the constructionist outlook resulting from this postessentialist break-through has become today's orthodoxy is to say one must also insist on the underlying stakes. An art that is able to deconstruct oppressive relations of "othering" installed by discourses of racism has the capacity to open a critical space in which the reconstruc-tion of relations among selves and others along more equitable lines is brought within reach. In contrast to the mimetic model that saw representation in reflectionist terms as correspondence between an image and a pregiven reality, or else regarded the artist's authorial consciousness in intentionalist terms as the guarantor of meaning, the 1980s turning point was predicated on a semiotic model in which the production of meaning was understood to be inherently social. Where the signifying systems through which actors refer to reality are arbitrary and conventional in nature, the ability of material marks to generate ideational content depends on an underlying agreement or consen-sus that is achieved by way of shared codes and conventions. Art that intervenes to disrupt such embedded rules and norms within the symbolic order of culture has the potential to bring about a momentary crisis in our lived relation to reality, thereby cut-

ting an opening into the imaginative realm in which alternatives become thinkable. For artists such as Keith Piper, Isaac Julien, and Rotimi Fani-Kayode, examined in part II, the aim was not to create more faithful or more flattering depictions of given identities but to intervene in real-world perceptions of black male bodies, in this instance, by undoing the identificatory dynamics of "othering" sedimented in racializing codes of representation. The wager was that art's interruptions might thereby open a dialogical space in which subject positions among selves and others might be rebuilt more democratically.

Once representation was grasped, "not simply as a manifestation or expression of power, but as an integral part of social processes of differentiation, exclusion, incorporation, and rule," as Craig Owens stated (1992b, 91), the articulation of aesthetics and politics was no longer a matter of individual artists declaring their beliefs (as it was for modernists), nor of attempting to speak on behalf of the masses in the name of a future utopia (as it was for the historical avant-garde). Instead, while the ambition to transform reality remained, the way that black diaspora artists went about it was to solicit the viewer's active response by interrupting the signifying chains of race, sexuality, and gender encoded around the black body and then leaving them in an open-ended state of ambivalence and strategic irresolution. In this way, the dialogism set into motion among authors, texts, and readers did indeed alter social reality. It led to "the recognition of the immense diversity and differentiation of the historical and cultural experiences of black subjects" (Hall, 1988b, 28) by calling forth new possibilities of imagined community from the multicultural public sphere as part of a counterhegemonic pursuit of radical democracy. While artists discussed in monographic terms in part II are male, the role of black feminist artists in opening the way to an intersectional view of art's ability to reposition identities is a point I return to later in addressing how the dialogic model undercuts art history's routine dichotomy regarding the study of aesthetics that examines form "inside" the work of art and the question of its political impact, which is investigated in its social contexts on the "outside."

By the mid-1990s, however, even as arguments for inclusion were being won by cross-cultural practices that hybridized sources hitherto kept separate in fixed dichotomies, the ground was shifting as a result of the conflicting pressures of globalization. Along with the fatwa on Salman Rushdie, the first Gulf War, "ethnic cleansing" in post–Cold War Europe, and riots in Los Angeles following the Rodney King affair, one may observe that metropolitan art worlds came to terms with the cultural politics of difference in contradictory ways. Hostile reactions to the 1993 Whitney Biennial (Sussman et al., 1993) decried what was seen as partisan content and urged a formalist return to

"beauty," whereas the populist irreverence of *Sensation*, a 1997 exhibition of British artists in Charles Saatchi's collection (Adams and Rosenthal, 1997), took aim at multicultural self-seriousness not by opposing it but by subsuming diversity into a neoliberal attitude. The divergent paths taken in part III of *Travel & See* reflect the contested character of globalization as it gave rise to an antihybridity backlash in artistic and intellectual circles that saw the clash of cultures, and not creative renewal, as the predominant outcome of accelerating transcultural contact. The mid-1990s conjuncture in which the Clinton and Blair administrations signaled neoliberal rapprochement between multiculture and global markets for art also led to the historiographic shift in my writing and research that informs the texts placed in part IV.

Where African art entered global circulation as a result of the postprimitivist breakup of the tribal/modern dichotomy, the rediscovery of portraiture traditions in photography created by practitioners such as Seydou Keïta in Mali introduced archival depth to our understanding of modernity as a worldwide phenomenon. Alongside the photographer's stylized use of patterned fabric backdrops, the self-staging of identity among Keïta's Bamako sitters evidenced the agency of appropriation whereby Western imports, such as the camera, were creatively adapted to local tastes. Such portraits were nothing new. Following the *In/sight* exhibition (Bell et al., 1996), research leading to the *Anthology of African and Indian Ocean Photography* (Saint Léon and Fall, 1999) revealed a timeline in which photographic studios in Africa began to flourish from the 1890s onward, which is congruent with the simultaneous uptake of the new picture-making technology in Asia, Latin America, and the Middle East as well as in Europe.[2] In contrast to the world-system approach in which Western imperialism was a steamroller that had totally flattened indigenous cultures, postcolonial studies drew on the concept of appropriation to demonstrate that although the colonized were economically exploited and politically dominated, they nonetheless exerted cultural agency in what they adapted and what they resisted in the space of the colonial encounter. What arose from this analytical shift became known as the multiple modernities thesis. It showed that even as the material processes of modernization emanated from the West, the cross-cultural dynamics of selective appropriation meant that interdependence in the colonizer/colonized relationship was always far more messy, ambiguous, and leaky than any of the actors could readily admit. While the concept of postmodernism fell away once it had cleared the ground for the recognition of hybridity as a long-standing feature of globalization in pre-twentieth-century periods, it is crucial to note that concepts of appropriation had begun their intellectual journey in accounts of photo-text practices that contributed to the 1970s critique of institutional modernism. But once

we realize that it was only in the years 2000–2010 that art history gradually began to accept the existence of multiple modernisms, in the plural, then in addition to the need to clarify distinctions among the terms "modernism," "modernity," and "modernization," which I do in part IV, we also need to take account of ideological blockages in the selective perception of visual materials. Keïta's photographs from the 1940s to the 1960s had lain dormant and unseen in the archive because independence-era cultural nationalists wanted authentic images of Africanity uncontaminated by foreign influences, just as Western art collectors whose sightlines were shaped by primitivist discourse wanted Africa to remain the tribal "other" of modernity. Where competing interests converge in hegemonic formations of consensus whose framing of reality comes to be accepted as normative common sense, one faces a "regime of truth" in which alternative possibilities get blocked out. During the 1990s this is what took place in the process of multicultural normalization whereby inclusionism came to be installed as a global reality.

In the hyperironic, jokey nationalism of the Young British Artist (YBA) phenomenon, questions of race and ethnicity were pivotal to the populist diffusion of a seemingly transgressive aesthetics of "shock" that antagonized the multicultural "correctness" of art and culture institutions that had accepted the 1980s critique of race and representation. The self-parodying regression to quaint clichés of parochial Britishness is intelligible as a defensive response to global forces that created new centers of artistic production in China, Brazil, India, and elsewhere, such that the YBA acted as branding to ensure product differentiation under increasing competition. But the hypervisibility acquired by black images originating from African American vernacular culture, and disseminated in the global culture industries of music, film, television, and advertising, gave rise to the phenomenon of "hyperblackness" (Gray, 1995), which also shifted the terrain on which black diaspora artists made their choices. Whereas artists such as Yinka Shonibare and Chris Ofili in the United Kingdom introduced a playful tone into practices that explored the hybrid history of the Dutch wax print fabric in the case of the former, and employed elephant dung in the case of the latter to activate the subversive wit of carnivalesque laughter, the controversy surrounding Kara Walker in the United States when she received a prestigious MacArthur Foundation grant in 1997, and was attacked by senior African American artists who claimed she reproduced racist imagery which pandered to a white-majority art world, showed that instead of being resolved, struggles over the social relations of race and representation had merely undergone a reconfiguration.

In registering the limits of what was deemed permissible in "black representational space" (English, 2007), the backlash against Walker pointed to ongoing antagonisms in

which blackness was still the focus of political contestation. Similarly, the moral panic that was enacted when *Sensation* traveled to New York, and Mayor Rudolph Guiliani claimed Ofili's *Holy Virgin Mary* (1997) besmirched a religious icon with animal excrement and thus offended Catholics, showed that social anxieties which fueled the 1980s culture wars were far from exhausted. But in the art world hype surrounding such events, the heightened visibility of the artists arrived at the price of blocking any in-depth understanding of the historical continuities and transgenerational concerns that structure the distinctive "problem space" (Scott, 1997) which black diaspora artists have addressed throughout modernity. Indeed, in the trade-off whereby the advent of inclusion meant questions of difference no longer seemed urgent, and dissenting critique was henceforth toned down now that diversity was treated globally as an administrative norm, with many younger black artists often mute or evasive when it came to the politics of race within their practice, it may be said that a pervasive form of discursive closure was put into place by an ideology of multicultural presentism. Inclusionism expanded geographical coverage beyond the West and yet reproduced dehistoricized conceptions of difference that locked our understanding of cross-cultural interactivity solely within the "now." While winning consent among hitherto subaltern subjects who felt vindicated by their entry into globality, such celebratory now-ism insidiously meant that the West retained a symbolic monopoly over the temporal agency whereby art moves through time. Monocultural interpretations of modernism's "then," as it was narrated in the advance from postmodernism to contemporaneity, thus remained fully intact. Instead of the spatial margins to which they were once consigned in synchronic terms, black and other artists of color were diachronically confined to the present.

While the 2000–2010 years were marked by the moment when "post-black" enters circulation, as if to proclaim definitive endings, my research took me in a converse direction. In the pursuit of hermeneutic depth in understanding hybridity, syncretism, créolité, interculturation, and other translational concepts attempting to discern what is distinctive to diaspora aesthetics in twentieth-century art, my research led me to earlier periods when African American modernists such as Romare Bearden and Caribbean artists such as abstract painter Frank Bowling articulated cross-cultural dialogues with their European and American counterparts, even though their work went unseen and undervalued within the institutional canons of modern art museums (Mercer, 2002, 2003). Consequent to this historiographic turn, my editorial role in producing four volumes of art historical scholarship highlighted the ways in which methodological issues in the study of Black Atlantic practices gave shape and direction to a newly globalized account of modernism's cross-cultural genesis (Mercer, 2005a, 2006, 2007b,

2008). Insights arising from my Annotating Art's Histories series are summed up in the penultimate chapter of part IV. This is also to say that in returning to contemporary art, in part V, the historical depth brought to readings of Black Audio Film Collective, Kerry James Marshall, and Hew Locke suggests that, rather than the short-term polemic noise of "post-black," the contributions black diaspora artists have made to the global conditions of art today are better placed within the investigative frame of Afro-modernism as a distinctive variant within the long-range proliferation of multiple modernities.

Reflecting on theoretical sources I have drawn on in assembling an interpretive model that brings methods from cultural studies into art history, this introduction goes on to show why a dialogical approach offers the best fit for a culturally materialist ekphrasis of diaspora aesthetics. "Afro-modernism" is a term coined by Robert Farris Thompson, who also originated the idea of the Black Atlantic. In view of his skepticism about the finality implied by the "post" — "why use the word 'post-Modern' when it may also mean 'postblack'?" — I find it intriguing to note that when he urged "a retelling of Modernism to show how it . . . reveal[s] that 'the Other' is your neighbor — that black and Modernist cultures were inseparable long ago," he envisioned my research trajectory over the past twenty years. His future-oriented outlook also asked a question that resonates throughout all the chapters of *Travel & See*: "What happens when the more than 1½ million Africans and black Antilleans in Paris, the hundreds of thousands of black Caribbeans in London, the thousands of blacks, respectively from Central Africa and Suriname, in Lisbon and Amsterdam, and so on, are free to wander where they will across the old centers of colonial domination?" (Thompson, 1991, 91).

Aesthetics and Politics as Interruptive Practices

What gains our attention in art is often something visually arresting that eludes comprehension, thus giving us pause. Art invites us into a concentrated act of looking, thinking, and feeling that takes us out of the ordinary as we reflect on what we behold in the very moment of beholding it. Before we can say what art is about, our sensory engagement tells us that form comes first. The primacy of the aesthetic dimension, however, receives the least attention when it comes to black artists. Race is acknowledged at the level of content in social histories of art but is dismissed as irrelevant in the art for art's sake formalism that influenced institutional adherence to ideas of intrinsic "quality" as a category elevating aesthetics into a transcendental realm of timelessness. But in the philosophy of culture put forward by Bakhtin and other members of his circle in 1930s Russia, the understanding of language as a social phenomenon undercut

the seemingly obvious either/or between the formal properties found "inside" an art-work and the social world "outside," where artistic intention finds an audience as works of art travel out into the world.

Moving away from the verificationist view that read novels in terms of correspondence to given realities, Bakhtin's interest in the aesthetic autonomy whereby a literary artwork creates its own reality led him to examine the plurality of accents and inflections that clash and combine in the multivocal intertextuality by which a text differentiates the signifying elements it shares with previous contributions to an artistic genre. Pictures act differently to words, but to the extent that the building blocks of all signifying practice generate meaning on the basis of a relational process of differentiation, art's social dimension is never exterior to the moment of creation but is already inscribed in the multiaccentual character of semiotic resources that exist in a socially stratified condition of heteroglossia. If every signifier had an invariant relationship to a signified, formal innovation would be impossible. This is to say that when art takes us out of the ordinary by interrupting our horizon of expectations, what we are exposed to is a glimpse of the invisible rules that ordinarily work to fix the polysemic surplus which gives art the potential to introduce something different and new into the world. On this approach, we not only begin to grasp how black artists have always engaged modern art paradigms in dialogical modes of cross-cultural translation, but we also find a way out of biographical and sociological reductionisms that block our recognition of the necessary autonomy at work in black diaspora acts of aesthetic ingenuity.

Zarina Bhimji's large-scale Polaroid *Untitled* (1989) (fig. I.1), part of a suite of works that explore the Indian Collection in London's Victoria and Albert Museum, sets up an oscillation between two foreground figures in a chiaroscuro drama which creates something opaque in the image that resists instant legibility. The similar scale of the neoclassical caryatid at left and the crouching woman at right suggests both are artifacts built into their architectural surroundings, for the light on the woman's back and her pink sari are vital details distinguishing living flesh from inert marble. To say the work interferes with Orientalist pictorial codes, which depict South Asian bodies as exotically and erotically available objects to be consumed in the act of looking, is to say Bhimji's choices gain interruptive force by virtue of the way that the almost unreadable figure/ground relationship seduces our attention, inviting us to linger in the ambiguity of shadow, color, and light where the composition thwarts colonial fantasies of mastery over the visual field. To observe the backward-facing figure that appears in photo-text works by Lorna Simpson, such as *Waterbearer* (1986), *Guarded Conditions* (1989), and *Vantage Point* (1991) (fig. I.2), where it likewise performs interruptively to challenge the

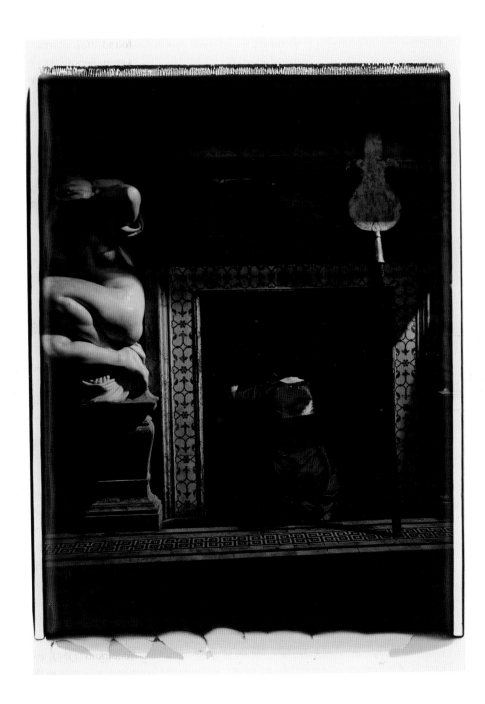

1.1 Zarina Bhimji, *Untitled*, 1989. Polaroid 600 mm × 500 mm. Courtesy of the artist.

presumption that looking is equivalent to knowing, and to witness a further return of the trope in Joy Gregory's *Autoportraits* (1990), where a black woman's face cannot be seen as a whole since her image is cut, cropped, and repeated in a photographic grid, is to notice a recursive pattern. But to isolate the backward-facing figure on purely formal grounds as an aesthetic feature carrying intrinsic subversive value would be as misleading as an identitarian stance that interprets biographical traits among black women artists as the basis on which an artwork's political value is to be secured.

Interrupting conventions of facingness that define the portrait genre, the formal measures of cropping, framing, and captioning that create an "antiportrait" strategy depart from the goals of individualist self-expression or protest against stereotypical distortions of black female bodies to enact instead a postconceptual practice that alters the very terrain on which identity is taken as a target of dialogic intervention.[3] Where Simpson's backward-facing figure reaccentuates the frontal and lateral depictions of subaltern subjects in photography's archive, from criminal mug shots to classificatory anthropometrics, and Bhimji transcodes repertoires of visual Orientalism, it is by working in and against predominant inflections among the signifying materials deposited in each historical genre that the two artists produce insights into the formative role of the gaze in constructing identities that are racialized and gendered by the subject/object polarity of looking and being looked at. Using the verb "to dissolve" to describe what art does when aesthetic choices gain political traction, curator Gilane Tawadros argues that in work by Sutapa Biswas, Sonia Boyce, and Lubaina Himid, "black women's creativity . . . expresses . . . the redundancy of exclusive and unambiguous absolutes." As it "dissolves the fixed boundaries between past and present, public and private, personal and political" (Tawadros, 1996, 277), such art contributed to the breakup of the hegemonic order whereby polarities of race and gender were also reproduced among post-1960s movements that saw women's liberation and black liberation as either/or options. Highlighting intersectionality among the multiple variables through which *all* social identities are constructed, black feminists argued that "rather than attempting to determine the primacy of race or class or gender, we ought to search for ways of articulating how these various categories of experience inflect and interrogate each other."[4] As a result, liberal humanist traditions that saw selfhood as a state of indivisible wholeness were decentered in light of the constructionist view that "identities are . . . points of temporary attachment to the subject positions which discursive practices construct for us" (Hall, 1996b, 5). Rather than the "practices of negation" by which T. J. Clark interprets early European modernism and its avant-garde as wholly rupturing bourgeois constructions of reality, the interruptive acts of late twentieth-century diaspora practice are closer in scale, and in their diacritical mode of imma-

1.2 Lorna Simpson, *Vantage Point*, 1991. Two black-and-white gelatin prints, two engraved plastic plaques, overall 50 × 70 inches, 127 × 177.8 cm. Courtesy of the artist.

nent critique of the master codes of representation, to the relational "differencing" put forward by Griselda Pollock (1999) as an analytic model from feminist art historiography.[5] Dialogic strategies from the 1980s onward thus accomplished the undoing of fixities whereby social actors are subjectivated into asymmetrical positions in the symbolic order of modern culture. But if art has powers to dissolve established versions of reality, does this imply that aesthetic innovation by itself leads to social change, or does Bakhtin's account of art's reaccentuating agency not also require context-dependent attention to the conflictual conjunctural forces that for Hall and Gilroy define cultural studies as itself an interruptive practice within the humanities?

Insofar as Hall's essays "New Ethnicities" and "Cultural Identity and Diaspora" (Hall, 1988b, 1990a) began as responses to hybrid cut-and-mix practices in black British film art and photography, such a confirmation of the primacy of the aesthetic dimension in cutting open new spaces for critical thinking is further underlined when we observe that the iconic image of ships navigating multidirectional journeys which *The Black Atlantic* (Gilroy, 1993) introduced to cultural studies was actually preceded by Keith Piper's installation *A Ship Called Jesus* (1991). For Piper and Gilroy alike, the ship acts as a multiaccentual sign. What matters in the oceanic interspace of migration and travel is the moment of "turnaround" when colonizing voyages of conquest and enslavement get rerouted by the acts of resistance in which diasporized subjects metaphorically redirect the ship toward new destinations. In the essay Piper wrote to accompany archival materials computer-montaged onto light boxes, alongside sounds and images projected over a pool of water, he summed up his research on the *Jesus of Lubeck*, a vessel owned by Sir John Hawkins, a fifteenth-century merchant granted a royal charter to trade in slaves by Queen Elizabeth I. Tracking the role of religion in the deculturation of enslaved Africans, Piper stressed moments of counterappropriation whereby the Afro-Christianity of the black Protestant church became an institution of modern black political self-empowerment.[6] Similarly, in his close attentiveness to the musical forms in which black resistance is expressed, Gilroy describes a dialogical volte-face in the aural aesthetics of Negro spirituals such that "what was initially felt to be a curse—the curse of homelessness or the curse of exile—gets repossessed. It becomes affirmed and is reconstructed as the basis of a privileged standpoint from which certain useful and critical perceptions about the modern world become more likely" (1993, 111).

In the deep historical perspectives opened up by the Black Atlantic paradigm shift, such insight into the semiotics of discursive antagonism vividly upholds Bakhtin's relevance to our understanding of the dialogical drama that has surrounded the very nam-

ing of ex-African peoples ever since they were thrown into the condition of diaspora from the fifteenth century onward. When it is said that "the word in language is half someone else's. It becomes 'one's own' only when the speaker . . . appropriates the word, adapting it to his own semantic and expressive intention" (Bakhtin, 1982, 293), we are compelled to agree that as peoples who were, variously, Akan, Bakongo, Mende, or Yoruba, for instance, came to speak the language of their masters, whether English, French, Portuguese, or Dutch, with no choice in the matter on account of their status as slaves, what they did within the symbolic order of Western culture was transform the signifier of difference—Negro—by making it their own. In their self-naming as Negro, Colored, and Black, among other variations, diaspora subjects produced a semantic and expressive "turnaround" in processes of cross-cultural dialogism which fully confirm Bakhtin's view that, "prior to this moment of appropriation, the word does not exist in a neutral or impersonal language. . . . But rather it exists in other people's mouths, in other people's contexts, serving other people's intentions: it is from there that one must take the word and make it one's own" (293).

Far from being hermetically sealed into ontologically separate essences, Africa and Europe have been meddling in one another's identities at least since 1492. In the agonism that is brought about by a struggle over the signifying materials through which reality is socially constructed, acts of appropriation reveal that meanings are rarely ever finally fixed, for they can always be opened to redifferentiation. Because all systems of signification are socially shared among dominant and subaltern identities, what matters most are the inflections and accentuations by which signifiers get lifted out of established codes in acts of appropriation that dispute what is accepted as reality. When Volosinov wrote in 1929 that "various different classes will use one and the same language [and] as a result, differently oriented accents intersect in every ideological sign," we can translate to historical worlds among masters and slaves to agree that "each living sign has two faces, like Janus. Any current curse word can become a word of praise, any current truth must inevitably sound to many other people as the greatest lie" (Volosinov, 1973, 23). Moreover, where "this *inner dialectical quality* of the sign comes out fully in the open only in times of social crisis or revolutionary changes," the "social *multiaccentuality* of the . . . sign" (23) is not just inscribed in the mutability that blackness has undergone over four centuries, from a mark of denigrated otherness to a self-empowering affirmation, but also pervades all of the cross-cultural modes of intermixture, whether named as hybridity, *mestizaje*, or créolité, that are irreducibly modern since they did not exist in Europe or Africa prior to the transformative contacts brought about by slavery and colonialism, which are most pronounced in the Caribbean.

Revealing the multiaccentuating agency of black semiosis as it travels through *all* of the historical periods of the modern age, the dialogical approach complements Atlanticist models. The Euclidean geometry that once posited a binary divide between diaspora and homeland, to be bridged only in reverse journeys of literal "return" in Pan-Africanism and Zionism, for instance, is now displaced in favor of a relational conception of the circulatory networks in which identities, like cultural artifacts such as books and vinyl records or photographs and sculptures, migrate in back-and-forth patterns across a fractal space of becoming that cannot be delimited by outside/inside boundaries. It matters, then, that having lifted the title of this book from a proverb carved on a boat I saw on Kokrobite Beach in Ghana, where to "travel and see" is to adopt an outward-looking attitude that ventures out into unchartered realms so as to put one's curiosity to the test, which aptly fits with the ethos of aesthetic experiment among contemporary black diaspora artists, I nonetheless refer to the practices discussed in these pages as part of a black rather than "African" diaspora. In the networks of Afro-modern world-making where a multitude of populations traverse cities and continents with identificatory attachments to a plurality of histories and geographies, the anthropological conception of cultural belonging that assumes organically bounda-ried totalities gives way to textual models of cross-cultural traffic in which transnational flows of images and information are constantly recombined and remontaged.

Inaugurated by "forced dispersal and reluctant scattering," the diaspora habitus is often an unhomely realm of intransitive unsettlement, for as Gilroy suggests, "life itself is at stake in the way the word connotes flight following the threat of violence rather than freely chosen experiences of displacement" (1997, 318). In this regard, we may behold the way that the backward-facing black female figure makes her presence felt in *Elevata* (2002) (fig. 1.3) by Afro-Cuban artist Maria Magdalena Campos-Pons. This photo-based work explicitly addresses the oceanic realm of diaspora that is also evoked in the title of the artist's midcareer survey, *Everything Is Separated by Water* (Freiman, 2007). Suspended in one of the Polaroid frames, the figure is the artist herself, although since she is upside down as well as back to front, her strategy avowedly subverts self-portraiture's ego-based conventions. As if contemplating an abyss of loss in the aqua-marine depths, the figure's unfacingness summons an oceanic sublime that exceeds the limits of the visual. Turning her face from the viewing plane, Campos-Pons slips away from monologic self-centering to evoke a rhizomorphic subject constituted in a network of affective ties to others, along the lines of dreadlocked strands of hair which re-semble plant roots equally at home in soil or water. In place of the tragedy that narrates diaspora as a terrifying loss of origins brought about by violent uprooting, her Atlantic

I.3 Maria Magdalena Campos-Pons, *Elevata*, 2002. Composition of 16 Polacolor prints, 20 × 24 Polaroid prints, 96 × 80 inches, 243.8 × 203.2 cm. Harvard Art Museums / Fogg Museum. Purchase through the generosity of Susan H. Edwards; Dorothy Heath; Saundra Lane; Richard and Ronay Menschel Fund for the Acquisition of Photographs; The Widgeon Point Charitable Foundation; Melvin R. Seiden; Dr. Daniel Tassel; Caroline Cunningham Young; and Alice Sachs Zimet. P2004.11.

space is recrossed, rerouted, and thus reclaimed by the fugitive beauty of a body that calls forth connectivity among scattered abstract elements. Arguing that art acquires autonomy when "the work is 'taken out' of the constant process of reality and assumes a significance and a truth of its own," Herbert Marcuse made the claim that "the truth of art lies in its power to break the monopoly of established reality." The breathtaking wonder we experience in beholding Campos-Pons's art delivers a momentary exstasis in which we ourselves are "taken out" of the ordinary as a result of art's ability to undo our habits of seeing, thinking, and feeling: Marcuse describes exactly such interruptive undoing in his view that "this rupture . . . is the achievement of aesthetic form" (1977, 8, 9).

But having cut openings into the smooth surfaces of ideologies that want to close up the signifying chain so that the world appears fixed and finalized—and let us recall that Toussaint Bréda, leader of the 1791 slave revolt in Haiti, chose to name his emancipated self Louverture, which translates as "the opening"—what happens to art's indeterminacy when works begin their travels through worldly contexts of reception that always go beyond the control of artistic intentions? Up to the mid-1990s, hybridity circulated as a vanguard term, breaking into the discursive closure held in place by the hegemon of nation, which as Guillermo Gomez-Pena observed of the U.S.-Mexico border, enjoined separatists and conservatives alike in fear-based calls to close up all boundaries, a stance "based on the modernist premise that identity and culture are closed systems, and that the less these systems change, the more authentic they are."[7] But in the postessentialist uncertainties voiced during the antihybridity backlash, we confront the peculiar twists and turns that black visual arts went through over the two decades in which new openings onto spaces of freedom came to be occupied by an ascendant neoliberalism that decoupled the border-crossing flow of cultural diversity from the politics of democratic equality.

An Endless Game of Give-and-Take

When critics who broadly supported the cross-cultural turn began to ask whether the politics of representation had become something of a problem, as it was rapidly institutionalized, the shift from discursive models to phenomenological approaches led Jean Fisher to insist, "Visual art remains a material-based process, functioning on the level of *affect*, not purely semiotics—i.e., a synesthetic relation is established between work and viewer which is *in excess of visuality*" (1996, 33). Directed, in part, at pressures to make cultural difference quickly legible and hence globally marketable, and, in part, at

reductionisms in visual studies methods that failed to recognize aesthetic autonomy among transcultural practices, such worries had led Sarat Maharaj to ask, "Is there a danger of hybridity . . . swapping places with the notion of stylistic purity?" In detecting a "tendency for hybridity to settle down into . . . what we might liken to bureaucratese or officialese," he argued that the critical priority was "safeguarding its volatile tension, its force as a double-voicing concept" (1994, 29).

At one level, now that the field of criticism could no longer be held in place by monocultural binaries of primitive and modern, the confusion as to which cross-cultural processes belonged to foreground matters of aesthetics and which were better addressed as rear-ground issues of context created an "optical wobble" (Mercer, 2005b, 52). Criticism that the hybridity concept was flawed due to its origins in the biological sciences led to productive considerations of syncretism and creolization as ethnographic and linguistic terms that refer to irreducibly cultural practices. But at another level the antihybridity trend (R. Young, 1995; Werbner and Modood, 1997) voiced a mood of disappointment that progressive hopes invested in border-crossing art forms had, by the mid-1990s, not only been neutralized by officialdom and commercialized by cultural industries but also been defeated by the rise of Islamic fundamentalism. The golden child of the postprimitivist breakthrough thus became the whipping boy for the clash of civilizations. The debate resolved with the recognition that concepts of translation had the theoretical flexibility to examine cross-cultural dynamics across different mediums and disciplines (Papastergiadis, 2000; Hall and Maharaj, 2001), which proved the resourcefulness of language-based methods in the humanities. But what had blocked art criticism from balancing aesthetic and contextual factors, and thereby giving historical depth to the interpretation of contemporary work by relating it to hybrid modernisms in African American, Caribbean, or South Asian art histories, was the short-term presentism whose capture of the 1990s conjuncture led to compulsory celebrationism.

Hybrids are combinatorial propositions. Boundary-crossing practices that mix identity categories to transgress the established order were present in the twentieth century art of collage and montage, but the principle of mixture also informs the way the aesthetics of the grotesque, the gothic, and the baroque took audiences by surprise in premodern periods. In the aesthetics of the "stereotypical grotesque" (Mercer, 1998, 45), what we find in work by Chris Ofili and Kara Walker is that hybridity's subversive potential had opened new routes for unfixing blackness from the visual codes of typification, although the formal ingenuity of their strategies was obscured when the reception of their practices got stalled around facile notions of "post-black."

With elephant dung as his signature material, discovered when he visited Zimbabwe as a student, Ofili uses topsy-turvy antics of carnivalesque laughter to interrupt and undo the racist equation between blackness and bodily waste, which must be abjected or cast out as "other" in the mind-set that equates whiteness with purity. But instead of seeking to repudiate it or reclaim it, he employs a strategy of excessive replication wherein the equation is rendered absurd. What one sees in paintings such as *Afrodizzia* (2nd version) (1996) (fig. 1.4), where spherical Afro hairstyles among cutouts of black music, film, and sports stars multiply and repeat the globular shape of the elephant dung attached to the picture plane, is a loop of escalating intensity in which a logic of mimetic exacerbation breaks up the coded equivalence Ofili signifies upon.[8] While the excess and the absurdity also deflate any view of the elephant dung as a sign of authentic Africanness, Ofili's intertextual dialogue with the trickster aesthetics of David Hammons, whose *Elephant Dung Sculpture* (1978) is a diasporic precedent, reaches even further back in time. Derived from *grotto*, following the fifteenth-century discovery of Roman vaults showing intermixtures among humans, flora, and fauna, the term *grotteschi* reflected Christian bias in its one-sided definition as something ludicrous, incongruous, and bizarre, yet what Bakhtin (1984) revealed in the "grotesque realism" of a Renaissance writer such as Rabelais was a shape-shifting aesthetic able to unsettle essentialist assumptions that social identities are unchangeable. When curator Robert Storr evokes "soul dizziness" to describe the genre's powers of interruption,[9] such insight into the recombinant border crossing that mixes up categories ordinarily kept separate—animal and human, beautiful and ugly, rational and irrational—serves to connect Ofili's mischievous wit to the hybridity to be found in Kafka's *Metamorphosis* (1915) and Goya's *Los Caprichos* (1799). "Humanimal" hybrids produced by Jane Alexander and Nandipha Mntambo in South Africa; cyborg fusions of body parts and machine fragments in the work of Kenya-born Wangechi Mutu; Ellen Gallagher's aquatic creatures inspired by the Drexyia science fiction scenario whereby pregnant slaves thrown overboard in the Middle Passage gave birth to hybrids that grew gills to absorb oxygen underwater (fig. 1.5)—all these practices underscore the protean semiosis that gives the grotesque deep affinities to hybridity. Such practices also reveal that corporeal iconography which takes the risk of reentering biopolitical discourse is what enables art to open embedded fixities of race toward future-oriented possibilities of resignification.[10]

In diorama-like installations that spill off the wall into the viewer's arena, works by Kara Walker such as *The End of Uncle Tom and the Grand Allegorical Tableau of Eva in Heaven* (1995) (fig. 1.6) tap into the subterranean domain associated with grotteschi

I.4 Chris Ofili, *Afrodizzia* (2nd version), 1996. Acrylic, oil, polyester resin, paper collage, glitter, map pins, and elephant dung on linen, 8 × 6 feet, 243.8 × 182.8 cm. (CO 28) Collection of Victoria and Warren Miro, London. Courtesy of the artist and Victoria Miro, London. © Chris Ofili.

1.5 Ellen Gallagher, *Deluxe* (detail), 2004–5. Courtesy of Gagosian Gallery.
© Ellen Gallagher. Photo: D. James Dee.

ı.6 Kara Walker, *The End of Uncle Tom and the Grand Allegorical Tableau of Eva in Heaven*, 1995. Cut paper on wall, 156 × 420 inches, 396.2 × 1066.8 cm. Installation view of exhibition *Kara Walker: My Complement, My Enemy, My Oppressor, My Love*, Hammer Museum, Los Angeles, 2008. Courtesy of Sikkema Jenkins & Co., New York. © 1995 Kara Walker. Photo: Joshua White.

in a strategy that lays bare something obscene, that is, literally offstage and hidden from sight, in the post–civil rights predicament of contemporary African American life. Although the paper silhouettes that define her medium carry expectations of the veracity entrusted to indexical signs, such as the portraits traced from shadows that were a prevalent genre in colonial America, any realist interpretation is thwarted by the combinatory excess whereby multiple bodies get conjugated without underlying narrative in Walker's friezes. Grotesque violations of bodily boundaries strain our suspension of disbelief—a potbellied man gives birth through his anus while skewering a baby with his sword, a one-booted child deposits a trail of excrement—yet the horror and fascination would not provoke such a powerful affective response if the syntax among the interpenetrating figures did not elicit some degree of recognition. The "real" that Walker throws into relief is the psychic reality of primal fantasies that are instantly recognizable in the hypersexualized subtexts roiling beneath conventional depictions of slavery, but which undergo a process of disavowal such that actors agree not to see the libidinal incitements that fuel all racializing modes of subjectivation. Antidiscrimination legislation made overt expressions of racism a punishable offense, yet racist imagery in low genres such as comedy, cartoons, and pornography acquires allure because it is officially forbidden and tabooed as unacceptable. In an era when politicians declare racism to be a thing of the past, Walker points to dynamics of abjection in public fantasy that seek to cast out and disown what is unwanted in the ego's sphere of identity, but which, in fact, only deepen and entrench the affective bonds by which racialized subjects get ever more intimately entangled.

In the personalized backlash against Walker's art, the critical concerns she shared with other black diaspora artists were blocked out in a double irony.[11] Her interest in unearthing fears and fantasies put Walker in line with earlier African American artists who used mockery and mimetic exacerbation to render the stereotype absurd, as Betye Saar did in *The Liberation of Aunt Jemima* (1972) by placing a mammy figurine in a museum display case as if it were an anthropological specimen, and as painter Robert Colescott did in his carnivalesque blackface parodies of masterpieces from the Western canon (Mercer, 2007c). Rather than seeking to combat toxic stereotypes by refuting distortions with allopathic responses, carnival traditions in black vernacular cultures have long performed fierce mockeries and cruel parodies that operate homeopathically to alter imbalances between poison and cure. Alongside Kara Walker, artists such as Michael Ray Charles (fig. 1.7), Gary Simmons, Laylah Ali, and Trent Hancock Doyle employ the stereotypical grotesque to address the conundrum that Spike Lee tackled in *Bamboozled* (2000), namely, if racism in its classical, boundary-defining rigidity now

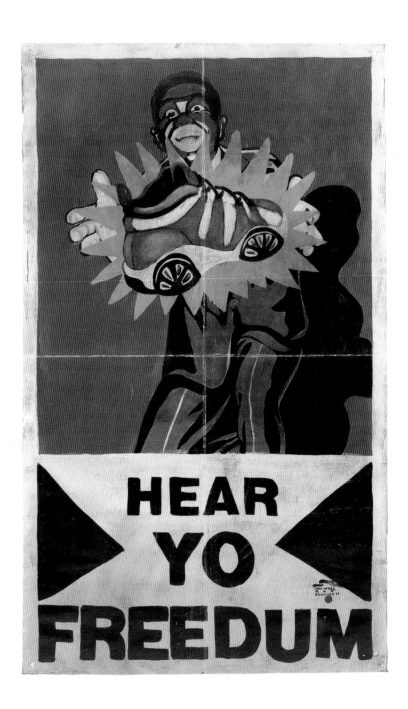

1.7 Michael Ray Charles, *Hear Yo Freedum*, 1997. 60 × 36 inches, 152.4 × 91.4 cm. Courtesy of the artist.

belongs to a seemingly bygone era, then how should we explain the enduring aura of racist icons inherited from the distant past, especially when such image repertoires persist in the present like undead zombies, corroding any clear-cut distinction between life and death?

As black images from the 1980s onward acquired hypervisibility in media and cultural industries, to the point where black popular culture is now synonymous with global pop culture per se, the resulting cultural condition of "hyperblackness" did not just dissolve the metaphor of invisibility that had positioned black voices in critique of Western modernity. It also ushered in a new regime in the capitalist production of spectacle as it affects our ability to imagine political alternatives to long-standing inequalities. In the postindustrial shift that made the production of images ever more important to consumer-driven economic growth, hyperblackness acts as spectacle which covers over intrablack disparities between a professional and managerial class that has grown since the 1970s, in part as a result of antidiscrimination legislation, and an urban underclass, including a huge prison population, that was also enlarged as a result of post-Fordist deindustrialization. Just as the ubiquitous N-word in hip-hop registers frustration at a predicament in which black visibility has become decoupled from collective empowerment, the assumption that alterations in the black visual image would correspond to real-world changes for the better was based on a referential model of race and representation that was edged out by the postmodern way in which hyperblackness functions as simulacrum—a phenomenon whereby images refer to other images and circulate as copies for which there is no identifiable original. But did such cultural conditions, prevalent from the 1990s onward, affect black artists alone?

In the view of one editor of *October*, "The postwar situation can be described as a negative teleology: a steady dismantling of the autonomous practices, spaces, and spheres of culture, and a perpetual intensification of assimilation and homogenization, to the point today where we witness what Debord called 'the integrated spectacle.'"[12] This conclusion reiterates the paradox Fredric Jameson (1984) noted when he observed that art's pluralistic condition since the 1960s crossed boundaries which previously separated the fine arts from popular culture, making art more accessible, yet this also integrated art more closely with turnover cycles in capitalist consumerism, thus cutting away at the critical distance that allows art to articulate social critique. But even in their valuable diagnosis of long-term structural trends, what goes missing from such Frankfurt school approaches is the Gramscian emphasis on identifying the architectonic contradictions of the historical conjuncture as the frontiers through which

popular-democratic forces might open the way to alternative possibilities by winning the ground on which social reality is construed in the day-to-day common sense of ordinary men and women. When Hall defines conjuncture as his object of inquiry, he insists on the double-edged need to acknowledge the *determinacy* of the contending forces shaping the terrain of the present without, however, succumbing to a *deterministic* view that the outcomes of contestation can be known in advance by any guarantees of theory. In his claim that "contingency is the sign of this effort to think determinacy without a closed form of determination," Hall argues, "If you do not agree that there is a degree of openness or contingency to every historical conjuncture, you do not believe in politics, because you do not believe that anything can be done about it. If everything is already given, what is the point of exercising oneself or of trying to change it in a particular direction?" (2007, 280, 279). Instead of an all-or-nothing dichotomy between art's autonomy or its terminal assimilation, a dialogical perspective acknowledges that questions of contingency—chance events that are impossible to foresee—are already built into diaspora consciousness in the form of philosophies of temporality that detour linear models of teleology by reckoning with the politics of time in ways that critically resonate with Bakhtin's concept of unfinalizability.

To say that black artists took control of the black image from the 1980s onward, thereby transforming the David-and-Goliath proportions of a cross-cultural story in which blackness had been visualized through white eyes for centuries, only to have control taken back by the global economies of spectacle at the start of the new millennium, is to say that tomorrow never knows. The contentiousness that makes art an essentially contested concept signals the degree of openness whereby future definitions of art's contributions to the common good are never decided in advance but must be fought for in the here and now, within the multivoicedness of public life.

Architecture provides a case in point. Contemporary art museums have flourished over the past two decades, in part as a result of expanding property markets that absorb surpluses from global financial centers. But even as privately owned art collections attract popular audiences, which in turn influences public sector institutions, creating what critic Michael Brenson calls "corporate populism," the actual contents and activities housed in such exhibition spaces must be decided by curators who need to make credible contact with prevailing concerns in the body politic.[13] To suggest that museums and art centers built by black British architect David Adjaye are predetermined by neoliberal agendas is to ignore the chance element of indeterminacy whereby the question of how the buildings will be used, and for what ends, acquires urgency because it cannot be answered in advance.[14] The question I posed to Rivington Place,

the London venue that since 2007 has provided a home to Autograph: Association of Black Photographers and the Institute of International Visual Arts—"the challenge of institution-building is in a safe pair of hands . . . as far as the bricks and mortar are concerned [but] am I alone in wondering *who exactly is going to go into these buildings and what exactly is going to come out of them*?" (Mercer, 2007a, 21)—is equally applicable to the National Museum of African American History and Culture, also designed by Adjaye Associates, which opens in Washington, DC, in 2015.

Relating our "now" to the "then" of the deep historical past, in which black diaspora art practices have contributed to the global formation of modernism from the start, thus requires a shift away from deterministic models that pit social context against aesthetic autonomy. In place of such either/or options, we need a dialogic conception of the relational networks through which art travels in circuits established among three ontologically different things: artists (who tend to be human beings), artworks (which are usually durable, material objects, even if they are documents of ephemeral performances), and art worlds (which are institutional structures, from art schools to auction houses, always embedded in the sociohistorical conditions of cultural production). Such a model insists on the conjunctural element of contingency put into play when momentary ruptures at any point of articulation within the circuit introduce something unforeseen.

When the African American reception of black British art, film, and photography gave them global circulation, as a result of exhibitions curated by Kellie Jones and Moira Beauchamp-Byrd, cinematic programing by Coco Fusco, Mbye Cham, and Claire Watkins, and books such as *Black British Cultural Studies* (Baker, Diawara, and Lindeborg, 1996), such flows could not have been foreseen during the Brixton riots of 1981.[15] Concrete acts of cooperation that reveal diaspora as a living reality, built through Black Atlantic travel, were not prescripted by the economics of transnational capital either. When the artist Rasheed Araeen grew disillusioned with minimalism in the 1970s as a result of his understanding of British racism, his political identification as black epitomized the postcolonial "turnaround" whereby incomers from India, Pakistan, and Bangladesh, having experienced discrimination as equivalent "coloureds," chose to join forces with Caribbean and African settlers in antiracist struggles that translated race out of a biological discourse of descent into a political discourse of elective consent.[16] But could any of this world-turning agency have been predicted or foretold in the post-1945 era of decolonization?

Observing that "analysis usually fusses about in the narrow space of small time," Bakhtin evokes the terms "surprisingness" and "nonpredetermination" when he calls

for an "investigatory boldness" capable of recognizing that "the mutual understanding of centuries and millennia, of peoples, nations and cultures provides a complex unity of all humanity . . . (a complex unity of human culture)" (1986, 167). This view allows us to tease out the paradox of Afro-modern contemporaneity and its far-reaching implications. In the last three decades, the defining feature of Black Atlantic visual arts was not the production of the new so much as the discovery of archives revealing that cross-cultural formations of modernity were fully under way from the very beginning of the modern age, even though the signifying powers of blackness that had multiaccentuated art and culture in Europe and the Americas from the start were recognized and acknowledged only belatedly after centuries of inordinate deferral and delay.

In this regard, David Scott's summation of Hall's intellectual achievement is salutary, for where cultural studies is a practice of ongoing responsiveness to the "non-necessary" character of the present, what it unsettles in humanities fields such as art history is the disciplinary drive toward "paradigm closure" whereby it is assumed that the goal of "*writing* the African diaspora might be brought to an end" (2005, 12). When blackness is investigated not as an essential identity given or fixed by nature but as a "historically constructed *semiotic field* . . . a vastly complicated terrain of contested significations, knowledges, discourses, images, dreams" (12), the definition of the very scope of our inquiry is radically shifted. *Where Africa, Europe, and the Americas entered into an oceanic interspace of cross-cultural encounter from the fifteenth century onward, the back-and-forth process set into motion by dynamics of travel and migration, whereby signifying materials come to be shared among asymmetrically positioned identities, created a dialogics of give-and-take in which no one actor can bring the signifying chain into a finalized condition of closure that is fixed for once and for all time.* Raising the stakes by providing an interpretive model addressing every period in modernity, the dialogical framework shows us that what is new to our present is primarily our changed disposition toward the past.

The knowledge generated today in the expansive dispersion of investigatory research among scholars, curators, and writers—from monographic studies of nineteenth-century artists such as Edmonia Lewis and Meta Warrick Fuller and early modernists such as Richmond Barthé, Jacob Lawrence, and Archibald Motley Jr. to thematic studies of slave daguerreotypes, art that was exhibited in world's fairs, picturesque postcards of West Indian colonies, or surveys of contemporary art in African, African American, European, and Caribbean contexts—all pursues lines of inquiry cut open by the postessentialist breakthrough.[17] As this critical activity redefines the intellectual commons of the field, not so much by telling wholly new stories but by retelling

the shared history of art from a richer array of perspectives, we would do well to heed the skepticism Bakhtin and Hall express regarding aspirations toward paradigm closure. Rather than aiming to discipline the field by setting out to have the last word that brings inquiry to an end, dialogical methods start out from the premise that art, like identity, exists in an unfinalizable condition for it is in a perpetual process of becoming. This means our quest for understanding is always in media res because, without absolute beginnings or endings, we find that rather than a transcendental position in which the researcher lays claim to definitive truth by virtue of being removed from the object of research in space and time, we inhabit an immanent relation to art's contentious world-making powers, which include quarrels and disputes in the intertext formed by the previous scholarship deposited in the field and its many genres. Far from implying relativism or anything goes, the processual ethos of dialogics holds that our common stock of knowledge can always be opened to redifferentiation and reaccentuation. Or, as Bakhtin put it: "There is neither a first word nor a last word and there are no limits to the dialogical context (it extends into the boundless past and into the boundless future). Even *past* meanings, that is, those born in the dialogue of past centuries, can never be stable (finalized, ended once and for all). . . . Nothing is absolutely dead: every meaning will have its homecoming festival. The problem of great time" (1986, 170).

Diaspora subjects often dreamed of homecomings, and as the hymn "Swing Low, Sweet Chariot" implies, death was accepted, not feared, as the transport of such return. It is a hard-won insight to say that even as artists, artworks, and art worlds enfold on multiple planes of mutual entanglement, it is art's condition of objecthood that matters most, since it allows the artwork to survive the passage of time in a way that the person who created it never can. Donald Rodney's *In the House of My Father* (1997) (fig. I.8), sculpted in shards of skin that fell from the artist's body during treatment for sickle-cell anemia, is double-voiced both as a son's loving testimony to the migrant journey by which his father uprooted himself from one place to make a home in another and as one individual's fearless confrontation with his own mortality that reiterates the universal question: Where do I call home? For me, the chance to study the work of photographer Rotimi Fani-Kayode was equally, if not more, important than critiquing presentism in leading to the historiographic turn I took in the mid-1990s. Crossing thresholds from living to posthumous, as Marlon Riggs and Maud Sulter have done, artists such as Rodney and Fani-Kayode urge us to consider the way art's objecthood outlives both its maker and the conditions under which it was made. My view that "the dignity of objecthood is very rarely bestowed on the diaspora's works of art" (Mercer, 2005b, 53) was not a call to switch from person-centered or context-centered to object-centered

I.8 Donald Rodney, *In the House of My Father*, 1997. Collection: Tate. Courtesy of
Diana Symons, Donald Rodney Estate, and Tate, London.

approaches but to plunge into the multicentric circuits through which works of art acquire universality as they travel across the imaginative realms of great time.

Once perceptions of time are emancipated from narrative beginnings and endings, to embrace instead a pluriverse of becoming, we recognize why angels and ghosts have loomed so large in black diaspora arts. Because they are time travelers, interrupting borders that ordinarily separate past, present, and future, such iconographic figures are "chronotopes" (Bakhtin, 1982). The tagline for the film essay *Handsworth Songs* (1986), directed by John Akomfrah—"there are no stories in the riots, only the ghosts of other stories"—tapped into seams mined by Toni Morrison's *Beloved* (1987) and Michael Ondaatje's *Anil's Ghost* (2000) in literature. Ghosts preside over emotional states of survivor guilt and grief in psychoanalysis, which is to say they encircle the unrepresentable wound by which trauma violates ontological boundaries between the psyche's inner world and the external terrors of history. But where painful memories repeatedly take possession of the self, the arrival of a witness allows the survivor to separate from the event by converting experience into testimony. As Isaac Julien's angels in *Looking for Langston* (1989) cross paths with *The Last Angel of History* (1995), Akomfrah's meditation on science fiction in black music, such art is in dialogue with Walter Benjamin's philosophy of history, as are angels in Kerry James Marshall's *Souvenir* (1997–98) paintings. Envisioning a counterhistoriography of modernity composed through montage techniques in which "what has been comes together in a flash with the now to form a constellation,"[18] Benjamin saw art as profane illumination, a value upheld in numerous Afro-modern practices. Embodying past hopes and dreams that went unfulfilled, but which were never finally extinguished, merely "asleep" in the archive, angels and ghosts face us with the demand for new futures in which past struggles for justice can be made good in the "now time" of critical awakening. As Afro-Futurist time travel recasts slavery's forced migrations as a form of alien abduction, it thereby distills something hopeful out of the diaspora's traumatic experience of having been "shot into a future that is not entirely one's own," as Cathy Caruth puts it.[19]

Looking back on my journey in art writing, I might conclude with a three-part dialectic in which identity politics circa 1980–89 was the thesis to which the 1990s backlash played antithesis, from which inclusion in the years 2000–2010 was the synthesis put into place by neoliberal globalization. But however neat and tidy, such narrative closure does not quite capture contemporary art's reckoning with the global predicament whereby life is today experienced as a state of aftermath. "Our condition is largely one of aftermath," says Hal Foster. "We live in the wake not only of modernist painting and sculpture but of postmodern deconstructions of these forms as well" (2002, 125). Terry

I.9 Christopher Cozier, *The Castaway* (from the *Tropical Night* series), 2006–present. Ink, graphite, rubber stamps on paper, 9 × 7 inches. Courtesy of the artist.

Smith's remapping of modern, postmodern, and contemporary posits aftermath as the outcome of an antinomial standstill, in which any dialectical synthesis is permanently postponed (Smith, 2006, 2010; Smith, Enwezor, and Condee, 2008). Addressing the idea of posthistory, as well as what he optimistically refers to as the post-West, Hall argues that instead of acting as a finalization, "post . . . always refers to the aftermath or after-flow of a particular configuration," for it designates a *turn* which is "neither an ending nor a reversal: the process continues in the direction it was travelling, but with a critical break, a deflection" (2001b, 9).

Caribbean artists and writers have long regarded such aftermath not as a present-day plight but as the unending legacy of the catastrophe of modernity, built on the foundations of slavery. In remorseless confrontations with questions of "social death" thrown forth from the region's histories of traumatic violence,[20] lines of inquiry ask whether the capacity to survive such permanent crisis and to build a common life out of cultural fragments scattered and dispersed from a multitude of ethnic origins may have also created the conditions in which the possibility of neo-human or posthuman life becomes thinkable as such. With his dialectical image of the limbo gateway, Wilson Harris's description of a phantom limb that guides the "re-assembly of dismembered man or god" suggests that in departing from wholeness as a desideratum, diaspora subjects seek not a return to ancestral origins but passageways into future freedoms; likewise, in Sylvia Wynter's bold conception of a world "after man," the afterhuman is not a tragic finality but a moment in a long story of becoming now facing the consequences of what it means to outlive our planet's "anthropocene" era.[21] In visual thinking inscribed in the *Tropical Night* series of drawings that include *The Castaway* (2007) (fig. 1.9), Christopher Cozier shows how art keeps company with such an outward-looking approach to life, accepting the unsettled condition of perpetual travel which Édouard Glissant (1997) names as "errantry" not as a drama of dispossession but as an epic journey into future uncertainties and possibilities that is best met with a light touch. Insofar as tomorrow never knows, the human-ship hybrid seems to suggest, staying alive in the realms of after-flow means accepting that there is always the possibility of a way out.

NOTES

1. Valuable introductions are provided by Tony Bennett, *Formalism and Marxism* (London: Methuen, 1979); Tzvetzan Todorov, *Mikhail Bakhtin: The Dialogical Principle* (Minneapolis: University of Minnesota Press, 1984); Peter Stallybrass and Allon White, *The Politics and Poetics of Transgression* (London: Methuen, 1986); and Craig Brandist, *The Bakhtin Circle: Philosophy, Culture, and Politics* (London: Pluto, 2002).

Ambiguities of authorship have been an issue from the outset in the Anglophone reception of

works by the Bakhtin circle, which include the coauthored text M. M. Bakhtin and P. N. Medvedev, *The Formal Method in Literary Scholarship: A Critical Introduction to Sociological Poetics* (1928), trans. Albert J. Wehrle (Baltimore: Johns Hopkins University Press, 1978). Relatedly, see Aleksandra Shatskikh, *Vitebsk: The Life of Art* (New Haven, CT: Yale University Press, 2007). In art history, see Deborah Haynes, *Bakhtin and the Visual Arts* (Cambridge: Cambridge University Press, 2008).

2. Christopher Pinney and Nicholas Peterson, eds., *Photography's Other Histories* (Durham, NC: Duke University Press, 2003).

3. Lauri Firstenberg, "Autonomy and Archive in America: Reexamining the Intersection of Photography and Stereotype," in Fusco and Wallis, 2003, 317.

4. Valerie Smith, "Split Affinities: The Case of Interracial Rape," in *Conflicts in Feminism*, ed. Marianne Hirsch and Evelyn Fox Keller (New York: Routledge, 1990), 285; see also Crenshaw, 1989.

5. T. J. Clark, "Clement Greenberg's Theory of Art," in *Pollock and After: The Critical Debate*, ed. Francis Franscina (London: Routledge, 1984), 71–86.

6. I discuss the significance of *A Ship Called Jesus* in Keith Piper's oeuvre in Mercer, 1997b.

7. Guillermo Gomez-Pena, "Border Culture: The Multicultural Paradigm," in L. Young, 1990, 96.

8. Nesbitt, 2010; Stuart Hall, "Chris Ofili in Paradise: Dreaming in Afro," in *Within Reach*, ed. Chris Ofili, vol. 1, 50th Venice Biennale Catalogue (London: Victoria Miro Gallery, 2003).

9. Robert Storr, *Disparities and Deformations: Our Grotesque* (Santa Fe: Site Santa Fe Biennial, 2005), 16.

10. Kobena Mercer, "Postcolonial Grotesque: Jane Alexander's Poetic Monsters," in *Jane Alexander: Surveys (from the Cape of Good Hope)*, ed. Pep Subiros (Barcelona: Actar, 2011), 26–35; on Nandipha Ntambo, see Kobena Mercer, "Radio Ethiopia: Africa's Transcultural Influences," in *Africa* (London: Phillips de Pury, 2010), 30–37;

Ellen Gallagher, *Coral Cities*, exhibition catalogue (Dublin: Hugh Lane, 2007); David Moos, ed., *Wangechi Mutu: You Call This Civilization?*, exhibition catalogue (Ontario: Art Gallery of Ontario, 2010).

11. An open letter criticizing Kara Walker was published in Juliette Bowles, "Extreme Times Call for Extreme Heroes," *International Review of African American Art* 14, no. 3 (1997): 3–15; see also *Kara Walker-No, Kara Walker-Yes, Kara Walker-? By Twenty-Eight Artists, Educators, Writers, and Poets*, introduction by Howardena Pindell (New York: Midmarch Arts Press, 2009). Critical accounts are offered in English, 2007, 71–135; and Amna Malik, "Shame, Disgust and Idealisation in Kara Walker's 'Gone' (1994)," in *Shame and Sexuality: Psychoanalysis and Visual Culture*, ed. Claire Pajaczkowska and Ivan Ward (London: Routledge, 2008), 181–202.

12. Benjamin H. D. Buchloh, "Roundtable: The Predicament of Contemporary Art," in Hal Foster, Rosalind Krauss, Yve-Alain Bois, Benjamin H. D. Buchloh, and David Joselit, *Art since 1900: Modernism, Antimodernism, Postmodernism*, 2nd ed. (New York: Thames and Hudson, 2011), 773. All co-authors are editorial board members of *October* journal.

13. Michael Brenson, "The Guggenheim, Corporate Populism, and the Future of the Corporate Museum" (2002), in *Acts of Engagement: Writings on Art, Criticism, and Institutions, 1993–2002* (New York: Rowman and Littlefield, 2004).

14. Peter Allison, ed., *David Adjaye: Making Public Buildings* (London: Thames and Hudson, 2003).

15. Coco Fusco, *Young, British and Black: The Work of Sankofa and Black Audio Film Collective* (Buffalo, NY: Hallwalls Contemporary Arts Center, 1988); Mbye Cham and Claire A. Watkins, eds., *Blackframes: Critical Perspectives on Black Independent Cinema* (Cambridge, MA: MIT Press, 1988); Kellie Jones, *TransAtlantic Dialogues*, exhibition, New York, Jamaica Arts Center, November–December 1989; Thomas Sokalowski and Kellie Jones, eds., *Interrogating Identity*, exhibition catalogue (New York: Grey Art Gallery, New York University, 1991);

David A. Bailey and Richard J. Powell, eds., *Rhapsodies in Black: Art of the Harlem Renaissance*, exhibition catalogue (London: Institute of International Visual Arts, 1997); David A. Bailey and Richard J. Powell, eds., *Back to Black: Art, Cinema, and the Racial Imaginary*, exhibition catalogue (London: Whitechapel Gallery, 2005).

16. Rasheed Araeen, *Making Myself Visible* (London: Kala, 1984). See also Avtah Brah, *Cartographies of Diaspora: Contesting Identities* (London: Routledge, 1996).

17. In African American art history, see Renée Ater, *Remaking History: The Sculpture of Meta Warrick Fuller* (Berkeley: University of California Press, 2011); Kirsten Pai Buick, *Child of the Fire: Mary Edmonia Lewis and the Problem of Art History's Black and Indian Subject* (Durham, NC: Duke University Press, 2010); Lisa Gail Collins, *The Art of History: African American Women Artists Engage the Past* (New Brunswick, NJ: Rutgers University Press, 2002); Huey Copeland, *Bound to Appear: Art, Slavery, and the Site of Blackness in Multicultural America* (Chicago: University of Chicago Press, 2013); Gwendolyn DuBois Shaw, *Seeing the Unspeakable: The Art of Kara Walker* (Durham, NC: Duke University Press, 2004); English, 2007; Jacqueline Francis, *Making Race: Modernism and "Racial Art" in America* (Seattle: University of Washington Press, 2011); Gonzalez, 2008; Patricia Hills, *Painting Harlem Modern: The Art of Jacob Lawrence* (Berkeley: University of California Press, 2010); Amy Mooney, *Archibald J. Motley Jr.* (San Francisco: Pomegranate Books, 2004); Shawn Michelle Smith, *Photography on the Color Line: W. E. B. DuBois, Race, and Visual Culture* (Durham, NC: Duke University Press, 2004); Mabel O. Wilson, *Negro Building: Black Americans in the World of Fairs and Museums* (Berkeley: University of California Press, 2012).

In European contexts, see Eddie Chambers, *Things Done Change: The Cultural Politics of Recent Black Artists in Britain* (Amsterdam: Rodopi, 2011); Richard Hylton, *The Nature of the Beast:*

Cultural Diversity and the Visual Arts Sector: A Study of Policies, Initiatives and Attitudes, 1976–2000 (Bath: Institute of Contemporary Interdisciplinary Arts, 2007); Elvan Zabunyan, *Black Is a Color* (Paris: Dis voir, 2004).

In the Caribbean, see Deborah Cullen, ed., *Caribbean: Crossroads of the World* (New Haven, CT: Yale University Press, 2012); Krista Thompson, *An Eye for the Tropics: Tourism, Photography, and Framing the Caribbean* (Durham, NC: Duke University Press, 2006); Leon Wainwright, *Timed Out: Art and the Transnational Caribbean* (Manchester: Manchester University Press, 2012); Ann Walmsley and Stanley Greaves, *Art in the Caribbean: An Introduction* (Port of Spain: New Beacon, 2010). In African contexts, see John Peffer, *Art and the End of Apartheid* (Minneapolis: University of Minnesota Press, 2009); Steven Nelson, *From Cameroon to Paris: Mousgoum Architecture in and out of Africa* (Chicago: University of Chicago Press, 2007); Enwezor and Okeke-Agulu, 2009.

18. Walter Benjamin, "Convolute N," in *The Arcades Project* (1936), trans. Howard Eiland and Kevin McLaughlin (Cambridge, MA: Belknap Press of Harvard University Press, 1999), 462.

19. Cathy Caruth, "Traumatic Departures: Survival and History in Freud (Beyond the Pleasure Principle, Moses and Monotheism)," in *Unclaimed Experience: Trauma, Narrative, and History* (Baltimore: Johns Hopkins University Press, 1996), 71.

20. Orlando Patterson, *Slavery and Social Death: A Comparative Study* (Cambridge, MA: Harvard University Press, 1982).

21. Wilson Harris, "History, Fable, and Myth in the Caribbean and Guianas" (1970), in Bundy, 1999, 158; Sylvia Wynter, "The Ceremony Must Be Found: After Humanism," *boundary 2*, 12/13, no. 1 (Spring 1984): 19–70; Sylvia Wynter, "Unsettling the Coloniality of Being/Power/Truth: Towards the Human, after Man, Its Overrepresentation—An Argument," *New Centennial Review* 3, no. 3 (Fall 2002): 257–337.

PART I

Art's Critique of Representation

From the 1980s onward, "black representation" was a rallying call to action not because artists wanted to produce more accurate or more pleasing depictions of identity but because the aim was to investigate the semiotic dominance of codes and conventions that determine the visibility some identities acquire but which others do not. In contrast to the mimetic model that thought of representation as mark-marking which passively reflects reality as an unchanging given, artists acted on the notion that images are formative in actively constructing social reality by inscribing positions of identification and othering that influence the way we make sense of the world and our place within it. This shift meant interventions capable of laying bare the signifying agency at work in prevailing codes of race and representation stood a chance not only of deconstructing perceptions of real-world relationships but also of opening social relations to the possibility of reconstruction in light of the repositioning of self and other that art practices make thinkable.

Questioning the museum's authority as an institution that stages representations of the past, whether its subject matter is the history of art or the ethnography of another culture, the installation art of Renée Green and Fred Wilson accentuated an archival turn in which the aim was not to counterpose one version of history to another, or to itemize omissions in need of repair, but to interrupt museological conventions so as to disembed artifacts from fixed narrative templates and thus ask how history might be opened to alternative interpretations. Engaging Michel Foucault's conception of genealogy, chapter 1 stems from a thematically curated group exhibition, as does chapter 2, which addresses African American, Caribbean, and black British artists in dialogue with psychoanalytic methods pioneered in Frantz Fanon's devastating critique of colonialism. Where the representational power of racist stereotypes fixates upon black bodies as visualizations of the fears and fantasies of socially dominant identities, Fanon's quest to disentangle colonizer and colonized alike from oppressive illusions of racial difference—"I will attempt a complete lysis of this morbid body" (1967a, 10)—was something contemporary artists reiterated, for the etymology of "analysis" also applies to their excavationary impulse in unearthing mutual entanglements buried beneath the representational simplifications of race.

The investigatory strategies that make the black body a target of critical interruption—from photo-text by Mitra Tabrizian and Carrie Mae Weems, performative tableaux in films by Isaac Julien and photographs by Lyle Ashton Harris, to collages by Sonia Boyce and Glenn Ligon's prints that pastiche nineteenth-century runaway slave notices—do not reveal essential selves waiting to be reclaimed once stereotypical distortions have been cleared away so much as they lay out the co-constitutive role of sexuality and gender in shaping the psychical realities that invest signifiers of race with meaning. Breaking apart discursive unities sedimented around the excessive visuality of the black body in Western modernity, the task of reassembly is left purposively open-ended, for this is exactly where the viewer's dialogic response comes into play.

1

THE FRAGILE INHERITORS

The tradition of all the dead generations weighs like a nightmare on the brains of the living.

—*Karl Marx*, THE EIGHTEENTH BRUMAIRE OF LOUIS BONAPARTE

In mourning it is the world which has become poor and empty; in melancholia it is the ego itself.

—*Sigmund Freud*, "MOURNING AND MELANCHOLIA"

There has been a death in the family of man: modernism. The morbid symptoms of its slow decline have been with us for some time now, but as a body of myths central to the shaping of Western culture, it has taken a long time dying and in so doing has forced us into an interregnum in which "the old is dying and the new cannot be born" (Gramsci, 1971, 275).

The death of modernism thus leaves an inheritance and makes us heirs of its own demise. The dead take a long time dying because by way of a legal contract, such as a will, they continue to exert a certain power and influence over those who survive them: hence, in the form of a bequest, the dead transmit their deeds to their descendants—the postmodernists. Whether one comes into a family fortune or inherits only ancestral debts, as survivors we remain bound to mythologies from the past which constitute our common heritage of modernity. The death of universal Man, and with it the traditional liberal humanist belief in the family of man, is one such mythology which, dying in squalor, weighs like a nightmare on the bad brains of the living. In the United States today there is a name for this nightmare as it is lived in the collective imaginary of contemporary society—multiculturalism.

When there is a death in the family, especially when someone has been disinherited, survivors often quarrel with one another in dispute over the legacy of the deceased.

The dead thus exert their power by reanimating jealousies, animosities, sibling rivalries, and resentments among surviving family heirs: all of which shows how much the family of man, like any family, was based not so much on love but on violence, error, and malice.

The museum has become one of the key institutions in which the death of modernism has bequeathed its terrible inheritance—it is the key site upon which the last will and testament of liberal humanist Man has been so bitterly contested by his illegitimate offspring as formed by "the African diaspora's peculiar position as 'step-children' of the West."[1]

The museum acts as a repository of cultural capital in which accumulated objects and artifacts are exhibited, ordered, classified, and made meaningful as evidence of the sovereign and centered identity of Western man as the historical subject of knowledge whose certainties are staged, displayed, and returned in representation as the sum total ratio of what it means to be human. As myth systems of cultural, political, and symbolic power and prestige, the great museums of Europe and America are today in ruins. The sight of the museum in ruins has been important to the recognition of the postmodern condition in that our ability to believe in the mythic narratives of human history embodied in the museum has been radically undermined by our counterknowledge of the exclusionary practices through which Western man acquired his identity as the fixed and stable center of the knowable world only by denying the differences and discourse of others.[2] While many have mourned "his" death, the decline and fall and decentering of the universal subject have revealed that "he" who historically monopolized the microphone in public culture, by claiming to speak for humanity as a whole while denying that right to representation to anyone who was not white, not male, and not Western, turned out to be merely a minority himself, an "other" among others (fig. 1.1).

The crisis of authority within the apparatus of cultural legitimation today thus reveals multiculturalism as the flip side of postmodernism, its other scene. It is 1992, and in the five hundred years since Columbus's voyage of destruction/discovery, the museum becomes the setting for diverse struggles over the very meaning of Americanness as a national identity. In Europe, desperately seeking a unified self-image in 1992, old imperial nation-states confront the postcolonial inheritance in their body politic, now the common home of countless people of the African, Caribbean, Asian, and Muslim diasporas.

Because he regarded crisis as a permanent condition of modernity, Gramsci argued: "If the ruling class has lost its consensus, i.e. is no longer 'leading' but only dominant, exercising coercive force alone, this means precisely that the great masses have become detached from their traditional ideologies, and no longer believe what they

1.1 Fred Wilson, *Friendly Natives* (detail), 1991. Four plastic skeletons in vitrines 47 × 72 × 27½ inches, 119.4 × 182.9 × 69.9 cm. Courtesy of Pace Gallery. © Fred Wilson. Photo: Dan Meyers.

used to believe previously." He then added, "NB. this paragraph should be completed by some observations on the so-called 'problem of the younger generation'—a problem caused by the 'crisis of authority' of the old generations in power" (Gramsci, 1971, 275–76).

The six artists featured in *Inheritance* may be regarded as exemplars of such a "younger generation" practicing a critical postmodernism which chooses the museum as the site for intervention in the mythmaking functions of the cultural imaginary. The artists each use (and creatively abuse) the conventions of museology as part of an art practice that exhibits a critical archival methodology, deployed in six very different ways around distinct topics, sites, and archaeological digs. It would be reductionist, however, to label these practices postmodern simply on account of their shared, overlapping concern with the museological artifact as an outcome of power/knowledge articulations; with the storytelling function of ideologies; or with the imaginary staging of representational access to an authentic past. All six are ipso facto pomo in their problematization of our perceptions of the past, but what intrigues me about their "detachment from traditional ideologies" is that they all seem passionately *genealogical* in their commitment to a methodology—a way of working through an ethical response to the museum's crisis of authority—that is best described by Foucault's conception of genealogy as an instrument of counterpractice.

What we have on display are six different ways of doing genealogy as part of a contemporary art practice that wants to get to the bottom of things with respect to the museum's crisis of credulity and to dig a little deeper into the depthless predicament of the postmodern. Whether this concerns the mise-en-scène of textual authority (in Brian Tucker's work) or a dread dystopian sci-fi fantasy of global endo-colonization (in Sylvia Bower's petri dishes), the methods and devices of genealogical inquiry are sharply felt not so much through the mere appropriation of the museum's codes and conventions but through the meticulous and ruthless *perversion* of the idea of a visible truth on which such conventions depend.

This strategy informs Melissa Goldstein's rereading of Freud and the Freudian concept of fetishism, parodying and playing to the nineteenth-century image-reservoir of the scientist of unconscious mental laws as an obsessed collector. Or from an adjacent angle, when Danny Tisdale's found objects, with all their faded aura from the Black Power era of the 1960s—dashiskis, black leather jackets, Afro combs, Ron O'Neal as *Superfly*, and Nu Nile pomade—are re-placed and re-presented in a fine art museum context as funked-up Duchampian ready-mades, the genealogical impulse in such art practices suggests a strategy of critical perversion which seeks to bend the clichés of

museum display to counterhegemonic purposes. As Foucault put it, *knowledge is not meant for understanding: it is meant for cutting* (1977, 154). The aim is to subvert the codes of museological authority precisely by perverting our aesthetic contract with the artifact as a signifier of power, knowledge, and truth. Quite literally, such methods are perverse insofar as they aim to "lead us away from" the search for a final or absolute meaning in historical events (Dollimore, 1991), and encourage us instead to take pleasure in a rigorously skeptical disposition toward the truth embodied by the museum as an imagined representation of our relationship to the events of the past that made us who we are today.

The museum in ruins has become a site of struggle over representations of cultural history because new social actors have sought to reclaim what had been hidden from history, to rewrite the distorted versions of the past inherited from the dominant, Eurocentric paradigm. Yet in countermovements such as feminist herstory or Afrocentrism, to cite two examples, there is often a tendency that unwittingly replicates the master codes of dominant historicism by reducing the desire for knowledge of the past to the discovery of heroic ancestors and their origins, which often comes about because such movements also assume that there is something called truth to begin with. Genealogy, on the other hand, *opposes itself to the search for origins* (Foucault, 1977, 140) and departs from history as the telling of fabulous just-so stories of innocent origins and happy endings, for oppressor and oppressed alike (figs. 1.2 and 1.3).

The artists gathered here resemble genealogists rather than historians in that whereas *historians take unusual pains to erase the elements in their work which reveal their grounding in a particular time and place, their preferences in a controversy—the unavoidable obstacles of their passion* (Foucault 1977, 156–57), in order to fabricate an "objective" account which *must hide its singular malice under the cloak of universals* (158), the genealogists on the other hand acknowledge their perspectival location. They thus resemble Gramsci's organic intellectuals as they *imply a use of history that severs its connection to memory, its metaphysical and anthropological model, and constructs a counter-memory—a transformation of history into a totally different form of time* (160). It is in this sense that the methods employed here refuse *the certainty of absolutes* in favor of an epistemological position of ambivalence and uncertainty through which the look solicited by their installations *corresponds to the acuity of a glance that distinguishes, separates and disperses, that is capable of liberating divergence and marginal elements—the kind of dissociating view that is capable of decomposing itself, shattering the unity of man's being through which it was thought that he could extend his sovereignty to the events of the past* (153).

Genealogy cuts away from the interpretive authority of the museum for, *if interpretation were the slow exposure of the hidden meaning in an origin, then only metaphysicians could interpret the development of humanity. But if interpretation is the violent or surreptitious appropriation of a system of rules, which in itself has no essential meaning, in order to impose a direction, to bend it to a new will, to force its participation in a different game, and subject it to secondary rules, then the development of humanity is a series of interpretations* (Foucault, 1977, 151–52).

As counterpractice, genealogy concerns what Foucault called *the search for descent*—a phrase which marvelously describes what Fred Wilson and Renée Green are doing in their *gray, meticulous and patiently documentary* searches (Foucault, 1977, 139) into the toxic mythologies of race, whose sedimented traces in the fantasia of the popular imaginary are being reworked in the resurgence of racism in the United States today. Green and Wilson *follow the complex course of descent* (146) in order to take up what Cornel West calls a genealogical materialist analysis of race as an ideological phantasm of U.S. history which haunts its sense of national identity and its sense of "who we are."[3]

In relation to the topos of race, I want to stress the importance of such genealogy in its critical difference from that abuse of popular memory which results, for example, in the Black History Month Hall of Fame version of the past in which the search for positive images, itself motivated by an urgent need to repair the damage done by the dominant paradigm, nonetheless has the effect of embalming and museumifying the past and thus paradoxically replicates its perceived marginality. By using genealogy, on the other hand, artists like Renée Green do not arrive at the therapeutic comfort of feel-good countermyths, but encounter the upsetting discovery that critical knowledge of the past *is a dangerous legacy* and that *we should not be deceived into thinking that this heritage is an acquisition, a possession that grows and solidifies: rather, it is an unstable assemblage of faults, fissures and heterogeneous layers that threaten the fragile inheritor from within and from underneath* (Foucault, 1977, 146).

This is a critical move in contemporary struggles over the symbolic economy of the museum because it disrupts the simplistic duality of arguing only about exclusion and inclusion (the rhetoric of bureaucratic multiculturalism). It goes beyond the binary mode of narration in which history's victims and victimizers can only trade places, and opens instead onto a third space in which it becomes possible to rethink the social function of the museum and contemplate its radical transformation. This is because genealogy, unlike history, *disturbs what was previously considered immobile; it fragments what was thought unified* (147). The introduction of such disturbance into the field of vision underlines that *what is found at the historical beginning of things is not the inviolable*

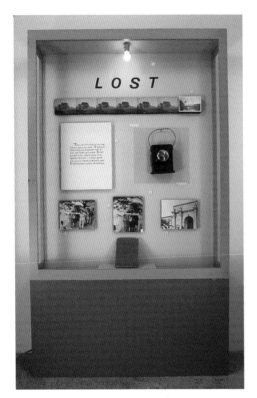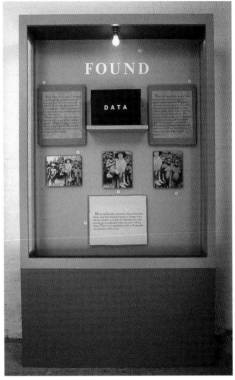

1.2 Renée Green, *Case II. Lost*, 1990. Vitrine, mixed media, 48 × 83 × 12 inches. Installation view, the Clocktower Gallery, New York. Image: Tom Warren.
1.3 Renée Green, *Case IV. Found*, 1990. Vitrine, mixed media, 48 × 83 × 12 inches. Installation view, the Clocktower Gallery, New York. Image: Tom Warren.

identity of their origins: it is the dissension of things. It is disparity (142). In their different ways, the six artists here remind us that *the purpose of history, guided by genealogy, is not to discover the roots of our identity but to commit itself to its dissipation* (162) (fig. 1.4).

Hold up. I'm a confirmed fan of Foucault, who remains one of my favorite dead, white, male thinkers, but like his other black readers I feel compelled to confront his Nietzschean emphasis on the total dissipation of identity with the question: Whose identity? It is one thing for Europeans like him to abandon any claim to identity, but some of us have struggled long and hard to grab hold of one and would like to hang on to it for the moment, thank you very much. What is missing from Foucault is Stuart Hall's (1987) counteremphasis on the necessarily provisional and arbitrary character of any identity that is historically formed in and through the process of struggle. But, on the other hand, when Foucault argues that *nothing in man—not even his body—is sufficiently stable to serve as the basis for self-recognition or for the understanding of other men* (Foucault, 1977, 153), I agree entirely. In taking aim at the Platonic prejudice against the body as an eternal and immutable substratum of an essential identity, Foucault emphasizes the painful and oppressive materiality of those phantasms—inscribed in old world ideologies of race, gender, nationality, sexuality, and ethnicity—which cut into the body and divide it from itself and hence undermine any claim to something as finished or as complete as an identity.

It is because "bodies (and not subjects) 'think' not through concepts, nor categories, nor even language, but through phantasms,"[4] that *genealogy, as an analysis of descent, is thus situated within the articulation of body and history. Its task is to expose a body totally imprinted by history and the process of history's destruction of the body [as] an inscribed surface of events (traced by language and dissolved by ideas), the locus of a dissociated self (adopting the illusion of a substantial unity), and a volume in perpetual disintegration* (Foucault, 1977, 148). En route to Los Angeles Contemporary Exhibitions, where the *Inheritance* exhibition is located in East Los Angeles, your encounter with homeless and dispossessed bodies—black, brown, and white—will confirm how much history "dissolves" the body according to "events," such as world recession, and "ideas" like masculinity, class, or ethnicity.

Insofar as they ruin our illusion of the museum as repository of truth, the artists in *Inheritance* allow us to think how our multiple identities as gendered, ethnic, racialized, sexual subjects are not essences but artifacts of lived experiences and violent histories saturated in blood. Against the essentialist logic of identity politics (which paradoxically reifies, dehistoricizes, and thus remains emotionally tied to the phantasms through which our identities were bound into the murderous hierarchies of the family of man), these artists remind us why we continue to need a sense of what Nietzsche

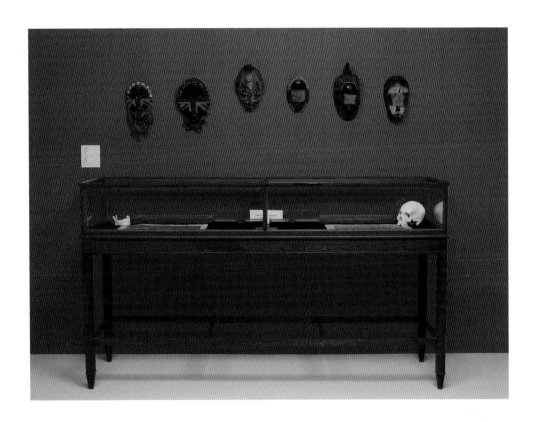

1.4 Fred Wilson, *Colonial Collection*, detail of *The Other Museum*, 1990. Insects in display boxes, jawbone, paper, and Mylar labels, *Harper's Weekly* nineteenth-century prints, skull, wood masks, and wood and glass vitrine, 48¾ × 86½ × 26¾ inches, 123.8 × 219.7 × 67.9 cm. Courtesy of Pace Gallery. © Fred Wilson. Photo: Kerry Ryan McFate.

called "effective history." This is because *the world we know is not this ultimately simple configuration where events are reduced to their essential traits, their final meaning or their initial and final value. On the contrary, it is a profusion of entangled events. If it appears as a "marvellous motley, profound and totally meaningful" then this is because it began and continues its secret existence through a "host of errors and phantasms"* (Foucault, 1977, 155).

In this respect, considering the diverse identities brought together in this group of artists, what the curators of *Inheritance* have achieved is an instance of critical multiculturalism which we need more of in contemporary arts programming. What I mean to suggest is that the curatorial process clearly acknowledges the fact that the phantasms of race, gender, and class constitute part of our legacy as the lost children of modernity; but in contrast to a certain bureaucratic multiculturalism which holds that such phantasms necessarily determine, finalize, and fully define what artists can and cannot do, or what curators can and cannot show, a counterpractice of critical multiculturalism, on the other hand, recognizes the emancipatory potential of the "discrepant cosmopolitanism" (Clifford, 1997) through which we locate ourselves in *mestizaje* cities like London, Lagos, or Los Angeles, where we sometimes discover differences to be cherished and learned from amid the otherwise hazardous experience of postmodernity.

The various art practices brought together here lead us away from the museum as such and invite us instead into the rich, strange, and quirky texture of that version of the postmodern in which *the will to knowledge does not achieve a universal truth; man is not given an exact and serene mastery of nature. On the contrary, it ceaselessly multiplies the risks, creates dangers in every area; it breaks down illusory defences; it dissolves the unity of the subject; it releases those elements of itself that are devoted to its subversion and destruction* (Foucault, 1977, 163). In so doing, the younger generation respond to the crisis of authority by gently reminding us that *the study of history makes one "happy, unlike the metaphysicians, to possess in oneself not an immortal soul but many mortal ones."*[5]

NOTES

This chapter was first published in *Inheritance*, edited by Roberto Bedoya and Jody Zellen (Los Angeles: Los Angeles Contemporary Exhibitions, 1992), n.p.

1. Paul Gilroy, "Cruciality and the Frog's Perspective: An Agenda of Difficulties for the Black Arts Movement in Britain" (1989), in Gilroy, 1994, 103.

2. The view of postmodernism as "a crisis of cultural authority, specifically of the authority vested in Western European culture and its institutions" (Owens, 1992a, 166), is echoed by Crimp, 1993. Although Crimp and Owens offer a corrective to the Eurocentric pathos evoked by Baudrillard, Jameson, Lyotard, and others, there is an irony for people of color pointed out

by Marcos Sanchez-Tranquilino and John Tagg, namely, "those who never made it now arrive to find the Museum in ruins. . . . They arrive to find their Identity already gone, their Culture in fragments, their Nationhood dispersed, and their Monuments reduced to canonical rubble. . . . Welcome to the New Art History. There is room for everyone and a place for none." Sanchez-Tranquilino and Tagg, "The Pachuco's Flayed Hide," in Grossberg, Nelson, and Treichler, 1992, 556.

3. Cornel West, "Race and Social Theory: Towards a Genealogical Materialist Analysis," in *The Year Left 2*, ed. Mike Davis, Manning Marable, Fred Pfeil, and Michael Sprinker (London: Verso, 1987), 73–90.

4. Scott Lash, "Genealogy and the Body," in *Sociology of Postmodernism* (London: Routledge, 1990), 64.

5. Friedrich Nietzsche, "The Wanderer and His Shadow," in *Human, All Too Human* (1880), quoted in Foucault, 1977, 161.

2

BUSY IN THE RUINS OF WRETCHED PHANTASIA

The power to define the other seals one's definition of oneself—who, then, in such a fearful mathematic, is trapped?

—James Baldwin, JUST ABOVE MY HEAD

Keith Piper's 1983 painting *The Body Politic* (fig. 2.1) depicts two bodies, one female and white, the other black and male. Both are denuded and beheaded on either side of two canvases joined by a pair of hinges. The two figures mime and mirror one another across the body of text which gives voice to mutual claims of misrecognition: "To you I was always (just) a body . . . I was your best fantasy and your worst fear. Everything to you but human." This early work can be read as embodying a matrix of concerns arising out of the visual arts sector of the postcolonial diaspora. Its depiction of doubling across the boundaries of sex and race—the chiasmus of difference that is inscribed as a relationship of both polarity and complementarity—draws attention to the danger zone of psychic and social ambivalence as it is lived in the complexity and contradictions of a multicultural society. The difficulty of articulating sexual and racial difference together, as sources of social division constantly thrusting identities apart while simultaneously binding them intimately beneath the cliché that opposites attract, pinpoints the key displacements brought about over the past decade by the hybrid interplay of postcolonial and postmodern paradigms in contemporary cultural politics.

But what strikes me as the most salient aspect of the diaspora aesthetics taking shape in a work such as *The Body Politic* is the unique way in which the fear/fantasy formulation came to be echoed and disseminated across a whole range of critical developments, for it was precisely the psychoanalytical implications of the concept of ambivalence that were being theorized in Homi Bhabha's influential text "The Other Question," which also entered public circulation in 1983. Structured around a diacritical rereading of *Touch of Evil* (1958), Orson Welles's film noir classic which depicts the

2.1 Keith Piper, *The Body Politic*, 1983. Mixed media with acrylic paint, canvas, and card on hinged wooden frame, 4 × 6 feet. Courtesy of the artist.

U.S.-Mexico border as the narrative setting in which textual dynamics of fear and fantasy revolve around the mixed-race identity of its Chicano protagonist, Bhabha's insights can be seen to double back into the re-presentation of interracial sexuality investigated in Piper's art: both lead us into the ambiguous realm where different differences intersect.

What is at stake is an understanding of how various critical practices helped create a shared space of mutual dialogue through which Fanon's writings have returned in all their force and fluidity as an indispensable resource for making sense of the psychopolitics of the multicultural social body. In this sense, rather than seek out directly Fanonian influences among postcolonial artists, or set out to ascertain a didactic translation of theoretical concepts into visual practice, what is called for is contextual appreciation of the multiple conduits and rhizomorphic connectivity that make diaspora a strategic site of "the dialogic imagination," in Mikhail Bakhtin's (1982) phrase.[1]

The hybrid character of this polyvocal space is nowhere more in evidence than in Mitra Tabrizian's series *The Blues*, which includes the individual work *Lost Frontier* (1986–87, in collaboration with Andy Golding) (fig. 2.2). Composed of large-scale color photographs, captioned in the manner of film stills, the work acknowledges its explicitly intertextual relationship to the highly imagistic quality of Fanon's writing in certain passages in *Black Skin, White Masks* (1967a). Just as the book begins its inquiry by looking at interracial relationships between the woman of color and the white man, and the man of color and the white woman, Tabrizian's starting point for the mise-en-scène of troubled encounters seems to concur with Fanon's point that "if one wants to understand the racial situation psychoanalytically . . . considerable importance must be given to sexual phenomena" (1967a, 160). Moreover, the reciprocal relation of visual practice to critical theory is underlined by the way Tabrizian's images have themselves been figured in the discourse of postcolonial intellectuals, when, for instance, Homi Bhabha writes, "I was a wanderer in another city. . . . I saw a black man freeze to stone, in the shadows of a woman's wide-eyed witness, the mirror turns the troubled scene around and fills the space, before and behind, with the hateful sight of questions of racist violence—interrogating identity."[2] As Griselda Pollock points out, the reference here is specifically to Tabrizian's "Out of the Past," one of the image-text panels from *The Blues*, which is embedded in Bhabha's allusion to coercive policing practices revealed in a publication by the journal *Race & Class*.

It is dialogic connections of this sort, cutting across disciplinary borders in order to forge exploratory pathways through the undergrowth of the multicultural unconscious, that set out the parameters of the projects featured in *Mirage*, especially com-

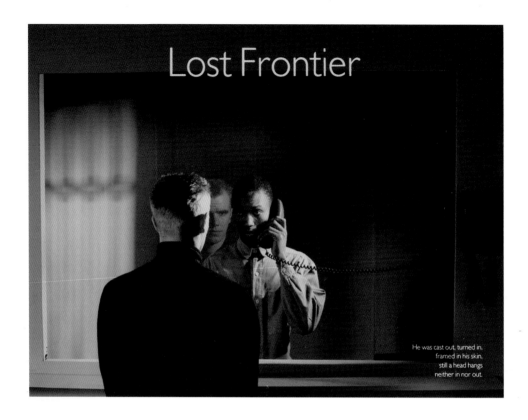

Lost Frontier

He was cast out, turned in,
framed in his skin,
still a head hangs
neither in nor out.

2.2 Mitra Tabrizian, *Lost Frontier* (from *The Blues* series, with Andy Golding), 1986–87.
Kodak Type C print, 48 × 60 inches. Courtesy of the artist.

missioned pieces by Sonia Boyce, Keith Piper, Isaac Julien, Keith Khan, Nina Edge, Glenn Ligon, Renée Green, Marc Latamie, Lyle Ashton Harris, Steve McQueen, Trevor Mathison, and Edward George. Each of these artists has contributed significantly to diaspora practices of critical displacement in postconceptual art, using a variety of materials and methodologies to examine and challenge the fears and fantasies that continue to enthrall us to the extent that we are each obliged to bear the bearers of an ego and its fictions of identity.

If Fanon has found a new generation of readers in this context, then it is important to note how their mapping of "Fanonian spaces," in Stephan Feuchtwang's phrase,[3] delivers the contemporary spectator into a place of radical uncertainty—a place where commonsense assumptions about the nature of identity are thrown into question. As a result of epochal shifts over the past ten to fifteen years, from post-Fordism to post-Communism, there probably is not anyone whose identity has not been touched by the bewildering uncertainties of living in a world with no stable center, and with precious few fixed points of reference besides death and taxes. These changed circumstances profoundly alter the way in which Fanon's writings speak to our contemporary crises. Whereas earlier generations prioritized the Marxist themes of Fanon's later work, above all *The Wretched of the Earth* (1967b), published at the height of the optimism of the postwar social movements, the fading fortunes of the independent left during the 1980s provided the backdrop to renewed interest in *Black Skin, White Masks*, Fanon's first and his most explicitly psychoanalytical text. Notwithstanding the continuities underpinning Fanon's oeuvre as a whole,[4] it could be said that it is precisely the multi-accentual quality of Fanon's voice—which engages with negritude, Pan-Africanism, and Black Atlantic traditions as much as the European legacies of Marx, Freud, Sartre, and Lacan—that encapsulates the hybrid character of the conversations which post-colonial artists have sought out in relation to his work. "O my body make of me always a man who questions," writes Fanon (1967a, 232) in the last line of a book whose authorial "I" constantly oscillates between multiple points of view: autobiographical, clinical, sociological, poetical, philosophical, political. Perhaps it is the many-voicedness of Fanon's text that gives rise to the highly contested contemporary interpretation of his oeuvre, as Henry Louis Gates (1992) draws out in his useful reading of the readings.

From the viewpoint of visual artists, it may be said that what is equally pertinent about Fanon's multiaccentuality (a term by which Bakhtin describes the presence of the body in language; the intonations, inflections, and emotive-evaluative elements of an utterance) is the passion with which he pursues the decolonization of interior spaces, a project which postcolonial artists extend by seeking to alter the constitutive role of rep-

resentations in the social construction of subjectivity. Artists working at the interface of the social and the emotional to unravel the contradictions of the inner worlds of migration, exile, and diaspora have revitalized the way in which Fanon's textuality is being read today as their work has had a major impact on the direction of theoretical debates.

The fear/fantasy formulation signaled a decisive shift with regard to the strategies of counterdiscourse performed by black artists in film, photography, and fine art. Breaking through the impasse of the outmoded negative/positive images dichotomy inherited from earlier phases in struggles for self-representation, it could be seen to punctuate what Stuart Hall prophetically called "the end of the innocent notion of the essential black subject" (1988b, 29). If what resulted was a moment of rupture asserting the hybridity and heterogeneity of diaspora subjectivities, the subsequent vicissitudes of black representation serve to caution whatever celebratory tendencies remain in a new world (dis)order of unending uncertainty and interminable anxiety. Once we locate the transnational interventions of postcolonial artists within the global context that differentiates their critical relationship to the visual ecologies of race and representation in popular culture, we find that the social field of fear and fantasy is never finally fixed. The oppressive regimes of myth and stereotype that inform the political management of multicultural discontent are themselves fluid, mobile, and highly unpredictable, constantly updating themselves in the service of the changing same. The heightened visibility of new images of otherness—from ragga girls and gangsta rap to Benetton billboards and the spectacular demonization of O. J. Simpson—demands that our attention be drawn to what filmmaker Isaac Julien has called *The Darker Side of Black* (1994). Issues of homophobia and misogyny have more than symptomatic meaning in current manifestations of black expressive culture: they concentrate the mind on what could be called the interior limits of decolonization.

Unhappy is the land in need of heroes, and nowhere was Brecht's maxim more applicable than when Malcolm X returned in 1992, deified and reified in Spike Lee's epic biopic as hustler, prisoner, prophet, and father figure—Malcolm's mercurial identities (in the plural) made him ideal material for the postmodern media apparatus of race and representation in which the same image satisfies competing demands. Such shifts exacerbate our need for understanding why the specter of race continues to haunt the violent and sexy phantasia of popular culture. Against the backdrop of the black gender wars of the Anita Hill / Clarence Thomas confrontation; against the foil of neo-racism driving the escalation of racialized violence, from the LAPD attack on Rodney King to the scores of unreported racist attacks in Fortress Europe; and against the media-led feeding frenzy surrounding the public parade of black men in gender trouble—from

Mike Tyson and Magic Johnson to Ice-T and Michael Jackson—in this contemporary context, we can neither ignore nor overlook the more problematic aspects of Fanon's sexual politics.

To fashion Fanon into a hero is to fetishize his text as a repository of truth. When Black Power activist Stokely Carmichael exalted the name of Fanon at the "Dialectics of Liberation" conference at London's Roundhouse in 1967, the sense of jubilation unleashed in the reversal of oppressor and oppressed was no doubt felt as an authentic experience of empowerment—yet from another point of view, such as that of Bessie Head, the Cape Colored writer exiled in rural Botswana, how could this have been a genuine change if victim and victimizer were merely trading places in the same binary structure of Manichean delirium? All too aware of chance, history, and contingency as forces obviating manifest destiny—for Bessie Head herself was born in a psychiatric asylum—her comments in a letter to a friend in Europe spell out why some contemporary artists continue to critically dialogue with the legacy of Fanon—in order to get at the things we do not yet know:

> Say, some merciful fate put me on the receiving end of brutality and ignorance, but what if I were born to mete this out to others? . . . This shout of rage of Mr Stokely Carmichael is a shout from the depths of the deep, true exultant power he is receiving by being the man down there. It's a kind of power that leaps from the feet to the head in a drunken ecstasy. I feel Mr Stokely does not know this. He might fall down on his knees and glorify his enemy. I feel these things go on in the subconscious and we give them the wrong names, and even when we try to explain them like Martin Luther, we don't reach the depths.[5]

Tasks and Masks: Undoing Identities

Identity has come to function as a sort of shorthand for the recognition of the politics of difference. However, as a static noun the term suggests a fixed category whereas the key shifts accentuated by diaspora artists over the past critical decade (Bailey and Hall, 1992) have been moving in the other direction—recognizing that the assertion of identity always depends on dynamics of differentiation; that the resulting forms of individual and collective identification are always relational, partial, and interdependent; and that the production of a differential is the mainstay of language and politics alike. While often apprehended as a shift from essentialist to constructionist conceptions of subject formation, politically accentuated as a debate between cultural nationalisms and a postnationalist emphasis on hybridity, it is crucial to note that postcolonial art-

ists have turned to psychoanalytically inflected notions precisely because the recognition that identities are constructed in language and representation then raises the more vexed question of how to account for the historical persistence of oppressive relations in which one's identity is continually positioned as Other in relation to someone else's construction of Self. As Mitra Tabrizian explains:

> Meaning only exists through differentiation—yet with uncertainty. In terms of power relations, white patriarchal society wants to make sure that meanings are fixed in order to maintain the status quo. But what I have been trying to do is deal with this uncertainty of meanings. As Freudian psychoanalysis bears out there is no such thing as innate femininity and masculinity, because we all share the same libido. Masculinity and femininity are constructed through language and culture. In the same way, there is no such thing as whiteness or blackness which pre-exists language and culture. In *The Blues* I wanted to explore these constructions. (quoted in Noble, 1989, 32)

It is from this viewpoint that black artists have wielded Fanon's insight that "the real Other for the white man is and will continue to be the black man" (1967a, 161) in order to deconstruct the way in which ideologies seek to fix and eternalize differences into absolute, categorical, binary oppositions, the logic by which "the legends, stories, histories and anecdotes of a colonial culture offer the subject a primordial Either/Or" (Bhabha, 1994, 61). Hence, if the task is to unfix and loosen up dichotomous codifications of difference, the terrain within which black artists intervene can no longer be adequately met by an aesthetics of realism or protest which seeks to counteract "misrepresentation," but requires an acknowledgment of the emotional reality of fantasy as that domain of psychic life that is also subject to the demands of the unconscious.

Various strategies in diaspora aesthetics have adapted as their point of departure the linguistic turn in poststructuralist theory wherein the black/white metaphor of racialization is understood not as an innocent reflection or neutral correspondence with preexisting entities, but as the imprint of an either/or logic of self and other in which colonial discourse brings into being the very identities that it discriminates within the optic of racial difference. The very concept of race as a natural, biological, and unchangeable essence is itself a historical fetish because there is only one race, the human species. In its dominant articulation, the chromatic metaphor seeks to conceal the artificial and historically motivated character of the mythologies of racial difference that it brings into effect by naturalizing the work of representation as a mere reflection of visible differences. As Tabrizian adds, "In the field of fantasy the black is imagined as

the Other to guarantee the status of the white man's identity. Racist stereotypical discourses reinforce power relations based on the fixation of the positions of the White/Black, Self/Other. They do this either by denigrating blacks as being completely different, a different race, blood—or by inviting them to identify, to be white, an impossible identification" (quoted in Noble, 1989, 35).

To glimpse the pivotal importance of vision and visuality in the historical sedimentation of racializing representations, consider Charles Cordier's *Aimez-vouz les uns les autres* (also known as *Fraternité*) of 1867, an abolitionist sculpture produced within the era when European nations disavowed their dependence on slavery by putting forward a self-image that defined them instead as the liberators of the enslaved.[6] The stark chromatic contrast between the two cherubs about to embrace in a kiss serves to connote both formal equality and absolute difference. While it enacts the sentimental trope repeated today in the exhortation that "ebony and ivory get together in perfect harmony," the very banality of its binary model of identity and difference serves to conceal the subtle disposition whereby it is the black cherub who actively moves toward the slightly superior upright posture of the white one, who is thus positioned as the universal human from which the Other is differentiated. Paraphrasing Ralph Ellison (1964), one might say that if the West had not discovered the Negro, then the Negro would have to be invented, for the invisibility of whiteness is thoroughly dependent upon the visible difference which the black subject is made to embody as the other needed by the self for its own differentiation, yet at the same time constantly threatening the coherence of that self on account of its unassimilable otherness.

This structural interdependence is the locus of the ambivalence called forth in the fantasmatics of cultural difference, and two interrelated but distinct issues are at stake. First, it entails on the part of the dominant culture a fantasy based on the epistemological privilege of vision in the West. What is common to the representational forms of the three distinct modes of othering that often get simplified as racism, sexism, and homophobia is that in each instance the historical construction of differences of race, gender, and sexuality is reduced to the perception of *visible differences* whose social meaning is taken to be obvious, immediate, self-evident, and automatically intelligible to the naked eye. The dominant ordering of difference thus attributes the origin of discrimination to the otherness that is held to be bodily inscribed: in the racial difference of skin and complexion, for instance, or in the sexual difference of anatomy, or in the ocular proof that betrays the hidden truth of a deviant desire.

Contemporary artists have created an archaeological space in which to re-view the fantasies of absolute difference at play in a work such as Cordier's. Drawing on

the conventions of museum display, artists such as Fred Wilson, Zarina Bhimji, and Renée Green have sought to enter the space of the archives, and in doing so have engaged in a dialogic partnership with cultural historians such as Sander Gilman who, between them, have unearthed the fossilized coils of myth and stereotype that continue to haunt the collective imagination. The contemporary rediscovery of Saartje Bartmann, a twenty-five-year-old African woman brought to Europe in 1810 to be displayed and exhibited as the Hottentot Venus—an object of scientific curiosity and circus-like entertainment until she died in 1820—provides a powerful instance of how black bodies were forcibly objectified under Europe's gaze to provide that foil against which discourses of physiognomy, medicine, and anthropology combined to construct the visible truth of absolute otherness. Summarizing the nineteenth-century views of Cuvier and Buffon, Gilman demonstrates the underlying "self-definition by antithesis" at work in science and art alike: "The antithesis of European sexual mores and beauty is the black, and the essential black, the lowest exemplum of mankind on the great chain of being, is the Hottentot. It is indeed in the physical appearance of the Hottentot that the central icon for sexual difference between the European and the black was found" (1985, 83).

In this context, the practice of re-vision that discloses the centrality of racialized differences to modernist representations of identity—rendered, for example, by Lauré, the black female maid proffering the bouquet to Manet's *Olympia* (1863)—has opened up new ways of imaginatively reentering the past. Renée Green's installation *Bequest* (1991) foregrounds citations from Herman Melville and Edgar Allan Poe to make visible the hidden centrality of chromatic codifications of otherness in American national and cultural identity—"It was the whiteness of the whale that above all things appalled me / The raven by its blackness represents the prince of darkness"—in a way that remarkably complements Toni Morrison's compelling interpretation of the Africanist presence in American literature.[7] Mark Twain's Huckleberry Finn would have no identity as such if it were not for the antithetical presence of Nigger Jim.

Another more immediate point that flows from the structural interdependence of opposites concerns the way in which the psychic imbrication of one-in-the-reflection-of-the-other serves to complicate simplistic notions of the Other's access to self-representation. African American art history shows multiple strategies undertaken to find lines of flight out of the dilemma of how one can posit a full and sufficient black self in a culture where blackness serves as the sign of absence, negativity, and lack (Gates, 1988a; Wallace, 1990).[8] In the black British context, this problematic has been taken on by Sonia Boyce in a series of self-portraits including *From Someone Else's Fear/Fantasy to Metamorphosis* (1987) (fig. 2.3), which features visual quotations from comic book

cartoons as well as from *King Kong* (1939), a film whose sex-race unconscious was brilliantly brought to light by James Snead, just as Lola Young has investigated the ways in which black women are constructed as exotic others mirroring (white) male fears and fantasies in contemporary films such as Neil Jordan's *Mona Lisa* (1986).[9]

Whereas the realist refutation of racist stereotypes often ended up with an idealized view of a black identity untouched by degrading images of otherness, one strand in the postmodern repertoire of hybrid appropriation and parodic repetition among black visual artists has been to suggest that such stereotypes, however disavowed, may nonetheless act as internal foreign objects around which self-perception is always alienated by the way in which one is perceived by others as *the* Other. This dilemma is at the heart of Fanon's analysis of racializing interpellation: being objectified under the imperial gaze—"Look, a Negro!"—to the point where the black self's own body is fragmented, dismembered, and thrown back as "an object in the midst of other objects" (Fanon, 1967a, 109). Unlike the infant in front of the mirror for whom the specular reflection returns as the basis of the ego's body image, when blacks are made to bear the repressed fantasies of the imperial master, they are denied entry into the alterity which Lacan sees as grounding the necessary fiction of the unified self. For Fanon this is because "the white man is not only The Other but also the master" (138). The implications of Fanon's conclusion—that the colonized is "forever in combat with his own image" (194)—have been explored by black visual artists for whom self-portraiture in its received sense is a structurally impossible genre for the black artist to occupy.

Carrie Mae Weems's *Mirror, Mirror* (1987–88) (fig. 2.4) signifies on the (de)formative experience of the black subject's mirror phase by captioning the nonreflective surface of the specular other with a parody of the nursery rhyme—"Looking into the mirror, the black woman asked, 'Mirror, mirror on the wall, who's the finest of them all?' The mirror says, 'Snow White, you black bitch, and don't you forget it!!'" Relatedly, in key works by Adrian Piper, from *The Mythic Being: I Embody Everything You Most Hate and Fear* (1975) (fig. 2.5) to *Vanilla Nightmares #8* (1986), the use of mimicry and masquerade subverts the cultural narcissism inherent in white supremacy's arrogation of otherness to itself alone (thereby condemning the black to stand in for or represent the mirror image which the white ego props itself upon). Piper thus problematizes the issue of self-representation in order to enact a practice of "non-self" representation, as it were, which makes whiteness visible as a historically constructed identity dependent upon antinomies of white/nonwhite, male/not-male, I/not-I.

Similarly subversive strategies were at work in mixed-media bricolage such as Betye Saar's *The Liberation of Aunt Jemima* (1972), which used counterappropriation to

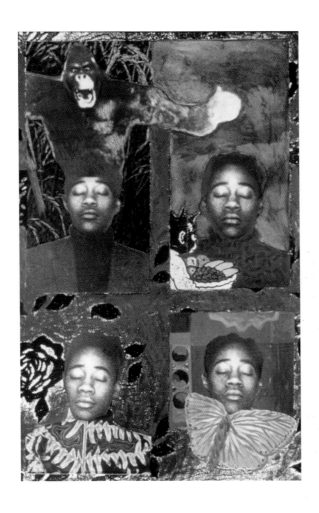

2.3 Sonia Boyce, *From Someone Else's Fear/Fantasy to Metamorphosis*, 1987.
Mixed media on photograph, 122 × 91.5 cm. Collection: Supata Biswas.
Courtesy of the artist.

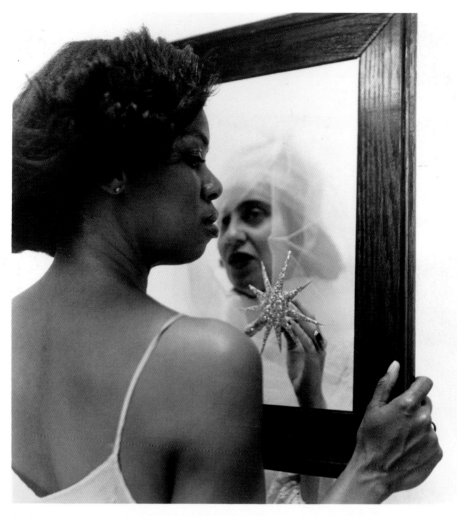

**LOOKING INTO THE MIRROR, THE BLACK WOMAN ASKED,
"MIRROR, MIRROR ON THE WALL, WHO'S THE FINEST OF THEM ALL?"
THE MIRROR SAYS, "SNOW WHITE, YOU BLACK BITCH,
AND DON'T YOU FORGET IT!!!"**

2.4 Carrie Mae Weems, *Mirror, Mirror* (from the *Ain't Jokin'* series), 1987–88. Gelatin silver print, 20 × 16 in. Courtesy of the artist and Jack Shainman Gallery, New York. © Carrie Mae Weems.

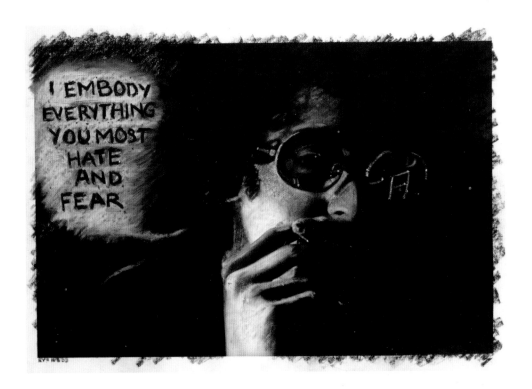

2.5 Adrian Piper, *The Mythic Being: I Embody Everything You Most Hate and Fear*, 1975.
Gelatin silver print photograph altered with oil crayon, 9¹⁵⁄₁₆ × 7¹⁵⁄₁₆ inches,
25.3 cm × 21.1 cm. Collection of Thomas Erben, New York. © Adrian Piper
Research Archive Foundation, Berlin.

acknowledge the psychic reality of what could be called "the stereotypical sublime"—so low you can't get under it and so high you can't get over it—which thus showed how alternative meanings could be made by passing through it, repeating the Mammy stereotype with a critical signifyin' difference: this time, she's got a gun. It strikes me that the deployment of such techniques in black women's art practices of the 1970s, in the name of transforming "Object into Subject," as Michelle Cliff (1987) put it, significantly predated the "crisis of authority" Craig Owens (1992a) subsequently identified in the forms of critical postmodernism.

The vertiginous sea changes associated with the advent of postmodernity brought about a crisis of representation whereby hitherto invisible subjects sought to assert their presence in and through practices of critical displacement that made visible for the first time the historical identity of liberal, humanist, universal Man. However, to the extent that straight white males may have been derisively demonized as an Other for our times (as if straight white males themselves do not feel burdened by the impossible task of having to represent the entire human race), what has resulted is a double-edged situation. While the recognition of multiple identities has helped skewer the double binds of minority/majority discourse, thereby unpacking the black artist's burden of having to be a representative—a process which has brought to light the sheer diversity of black identities previously repressed in cultural nationalisms—the flip side to the new pluralism has been a kind of identitarian closure. Indeed, the term "identity" often preempts understanding of subjectivity as constituted by alterity, and thus often results in new modes of policing access to self-representation. As Sonia Boyce has pointed out,

> Whatever we black people do, it is said to be about identity, first and foremost. It becomes a blanket term for everything we do, regardless of what we're doing. . . . I don't say it should be abandoned, [but] am I only able to talk about who I am? Of course, who I am changes as I get older: it can be a life-long enquiry. But why should I only be allowed to talk about race, gender, sexuality, class? Are we only able to say who we are, and not able to say anything else? If I speak, I speak "as a" black woman artist or "as a" black woman or "as a" black person. I always have to name who I am: I'm constantly being put in that position, required to talk in that place . . . never allowed to speak because I speak. (Boyce and Diawara, 1992, 194)

To the extent that diaspora artists have sought to escape the tyrannical demands of identitarian fixity, from whatever source they come, Glenn Ligon's self-fashioning in the series of lithographic prints entitled *Runaways* (1993) (fig. 2.6) offers a cutting read on modernism's efforts to make sure the black artist knew his or her place: "RAN

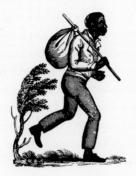

R AN AWAY, Glenn, a black male, 5'8", very short hair cut, nearly completely shaved, stocky build, 155-165 lbs., medium complexion (not "light skinned," not "dark skinned," slightly orange). Wearing faded blue jeans, short sleeve button-down 50's style shirt, nice glasses (small, oval shaped), no socks. Very articulate, seemingly well-educated, does not look at you straight in the eye when talking to you. He's socially very adept, yet, paradoxically, he's somewhat of a loner.

12/45 Glenn Ligon '93

2.6 Glenn Ligon, *Runaways*, 1993. One from a suite of ten lithographs, from an edition of forty-five plus ten artist's proofs, 16 × 22 inches, 40.64 × 55.88 cm. © Glenn Ligon. Courtesy of the artist, Luhring Augustine, New York, Regen Projects, Los Angeles, and Thomas Dane Gallery, London.

AWAY, Glenn, a black male, 5′8″, very short hair cut, nearly completely shaved, stocky build, 155–165 lbs., medium complexion (not 'light skinned,' not 'dark skinned,' slightly orange)." A case, perhaps, of postmodern *drapetomania*—the nineteenth-century slaveholder's psychiatric label for the slave's irrational desire to run away.

Running alongside the image-text work of Lorna Simpson, Lorraine O'Grady, Roshini Kempadoo, and others, whose deconstructions of self-other polarities have been examined by Kellie Jones (2011) and Lorraine O'Grady (2010), the concept of intersectionality put forward in critical race theory (Crenshaw, 1989) offers a spatial framework for examining the structural interdependence of differential elements in the social text as an alternative to the temporal fixity sought by micronarratives proclaiming innate hierarchies of oppression. As Valerie Smith states, "Rather than attempting to determine the primacy of race or class or gender, we ought to search for ways of articulating how these various categories of experience inflect and interrogate each other and how we as social subjects are constituted."[10]

In the work of artists such as Lyle Ashton Harris, Marlon Riggs, Rotimi Fani-Kayode, and Isaac Julien, unprecedented insights into Fanon's premise that Self and Other are always mutually implicated in ties of identification and desire have arisen precisely at the intersections of diverse artistic traditions. Rather than the reflection of a black gay aesthetic, the key feature of black lesbian and gay cultural production of the past decade has been its emphasis on the constitutive hybridity of the postcolonial and diasporic subject, which dislodges the authoritarian demand for authenticity and purity. Querying the way in which exclusionary notions of belonging have been replicated in the legacy of the post-1960s liberation movements, black lesbian, gay, and bisexual interventions have contributed creatively to a postnationalist politics of difference which seeks to bring new forms of imagined community into being.

This postessentialist conception of black selfhood has nowhere been more graphically displayed than in Lyle Harris's photographs—including *Americas* (1988–89) and *Secret Life of a Snow Queen* (1990)—in which the artist theatrically stages a self whose authentic identity gives way to the artifice of the mask, itself an iconic element of diaspora aesthetics. Making literal Fanon's metaphor of black skin / white mask, Harris performs a version of black masculinity that signifies upon the grotesque pathos of the minstrel mask in white popular culture (Sambo as sign of entertainment and enjoyment), and does so in such a way as to simultaneously evoke the masquerade of femininity as spectacle. Something vital differentiates the subversive ambiguity of Harris's critically parodic literalization from the mere illustration of the Fanonian metaphor to be found, for instance, on the cover of Chinweizu's 1987 book, *Decolonising the African*

Mind.[11] I think it is because the Snow Queen snaps pointedly, signifying on the worst fears and fantasies of a model of black masculinity in which the racial and sexual ambivalence of the mask provokes the mortal anguish of an inauthenticity that remains unsaid and unspeakable in the discourse of black nationalism. Am I not a man and an other?

After the innocence, modernist movements came to grief at the crossroads of difference. In traffic management, crashes are most likely to occur at junctions or intersections, which is one way of looking at how the race, class, and gender contingent got caught up in the mimetic loop whereby the very binary structures of self and other underpinning the hubris of the Western fantasy of sovereign identity were ceaselessly repeated in narratives which sought to deliver the wretched and unloved into the utopian spaces of total liberation, but which got stuck instead on the road to nowhere—or was it the road to hell? When Isaac Julien states, "I want to raise ambivalent questions about the sexual and racial violence that stems from the repressed desires of the other within ourselves" (1992, 260), he indicates the ruined scene that Fanon ghosts today, the incomplete project of decolonization pervaded by what Mathison and George, in their installation for the *Mirage* exhibition, call "the smell of disappointment."

Agonies of the Emotional Tie, or Oh Bondage! Up Yours

> *The dream is real, my friends. It is the failure to make it work that is the unreality.*
>
> —Toni Cade Bambara, THE SALT EATERS

Black Skin, White Masks begins with the question of desire, "What does a man want? What does a black man want?" (Fanon, 1967a, 8), and questions of sexuality are located at key points in the structure of the book. Chapters 2 and 3 are structured around interracial sexual relationships, and chapters 5 and 6, "The Fact of Blackness" and "The Negro and Psychopathology," investigate a wide range of materials—children's comics, Hollywood "race problem" films of the 1940s, the novels of Richard Wright and Chester Himes, and the psychiatric testimony of "some 500 members of the white race" (166)—to arrive at psychoanalytic interpretations of the neurotic and pathological significance of the symptomatic representations of colonial psychosexuality.

Reading Fanon today, however, a whole generation after external decolonization began, there is a pervasive sense that the forward march of liberation came to a halt precisely around the interior spaces of sexuality—it is as if sexual politics has been the Achilles' heel of black liberation. What happens to a dream deferred? It might explode

in your face. It was not just that the psychosexual scripts Fanon diagnosed in the 1940s and 1950s came to be reenacted in the highly sexualized clenched-fist aesthetics of the Black Power moment, as an embodiment of political self-empowerment. Nor was it simply that the fears and fantasies so adroitly mobilized in the confrontational visibility of the Black Panther Party, for example, also had the effect of provoking the worst fears and fantasies of the paranoid racist state, whose conspiracy theories laid waste to the lives of activists and set off the moral panics that demarcated the postpermissive 1970s era of neoconservative hegemony. The tragedy is that the modern dream of total liberation became a nightmare of unending antagonisms, spilling over dichotomies of inside and outside, left and right, margin and center, to become the shifting ground of the provisional and positional spaces which contemporary artists seek to keep open for debate and critical inquiry.

"At the risk of arousing the resentment of my coloured brothers, I will say that the black man is not a man. . . . I propose nothing short of the liberation of the man of colour from himself" (Fanon, 1967a, 9). Reading these lines today, announcing Fanon's radical humanist vision of self-liberation, what one hears is the sound of transcendental Man shattered on the grounds of gender antagonism, for the vision of universal brotherhood has given way to the fratricidal realities of life and death for young black men in the late-modern underclass, ravaged by the escalation of suicide and homicide, scapegoated as the personification of drugs, disease, and crime. In the bloody interregnum in which the beautiful ones are not yet born, "fear and fantasy came home to roost," as Keith Piper put it in his image-text piece *Go West Young Man* (1987) (figs. 2.7 and 2.8). Turning to psychoanalytically inflected concepts of ambivalent identifications across the visible boundaries of racial and sexual difference, postcolonial artists have returned to the scene of colonial psychosexuality which Fanon revealed with such clarity of insight. But this time, the psychic knots of sex and violence roiling through the ugly expression of misogyny and homophobia from within the broken heart of a "post-soul" culture demand that an unflinching gaze be directed to examine the way the emotional tie of identification often turns up on the "wrong" side, where it is least expected.[12]

As bell hooks has shown, underlying the racialized dualities of black nationalist discourses was a phallocentric identification with the Other that found expression in a range of sexualized metaphors and equations acted out around the ultimate either/or of the symbolic realm—having the phallus or losing it in castration: "The discourse of black resistance has almost always equated freedom with manhood, the economic and material domination of black men with castration, emasculation. Accepting these

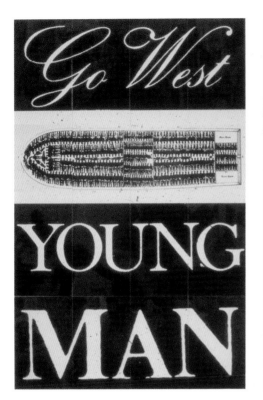

2.7 and **2.8** Keith Piper, *Go West Young Man*, 1987. Monochrome photo panels,
14 × 25 inches. Courtesy of the artist.

sexual metaphors forged a bond between oppressed black men and their white male oppressors. They shared the patriarchal belief that revolutionary struggle was really about the erect phallus."[13]

Overdetermined from the outset, the symbolic all-too-symbolic visibility of the black male body has become a central arena in which multiple crises of social chaos and political uncertainty have found expression in hyperbolic images of phallic black masculinity as embodying the ultimate Other—"I am the nigga you love to hate," as Ice Cube succinctly said, laughing all the way to the bank.

Rather than the functionalist circularity of internalization, it is the thin line between love and hate that complicates the Oedipal coding of desire and identification. Just as the commercial success of black rap performers who brag, "It's a black thing, you wouldn't understand," depends on the mostly white, male, suburban youth who buy their records, so the panics played out when George Bush used an image of an escaped convict, Willie Horton, in the 1988 presidential election to amplify the me/not-me dichotomy of ethnic absolutism have recurred with new symbolic substitutes in the role of sacrificial scapegoat. The media parading of black males as public enemies one, two, three, and four—from Ice-T in cop-killer drag; to the deracialization and reracialization of Clarence Thomas, first as race-blind neocon Negro, then as victim of a high-tech lynching; or the blurring of persona and performance in court cases involving Tupac Shakur and Snoop Doggy Dog—has all taken place in a political context where fundamentalist fixations on rigid gender roles now provide unanticipated alliances across ethnic lines as a result of the instrumentalization of homophobia in political life.

A key example of this sort of unthinkable political alignment (which may not be widely known in the European context) occurred in the U.S. presidential election in 1992 when populist right-wing columnist Pat Buchanan brazenly appropriated a clip from Marlon Riggs's video *Tongues Untied* (1989) to tendentiously suggest that George Bush was squandering taxpayers' money on the public funding of what the right, nowadays, is happy to call "victim art." Picking up the embers of the panic ignited by Jesse Helms's attack on the National Endowment for the Arts, played out on the body of Robert Mapplethorpe's photography, what was most bizarre about the fantasmatics of Buchanan being threatened by black gay art was that the clip he used did not feature any of the images of black men loving black men which many others found too hot to handle, but images of white gay leathermen in San Francisco's annual Folsom Street Fair. Projective identification is the mainstay of paranoid defenses that reverse positions of object and subject, such that what is coming from me is felt to be coming

toward me. In Buchanan's construction of Riggs as folk devil, his me/not-me boundary effectively edited a metonymic displacement such that the black gay body became all the more threatening for *not* being seen.

While the concept of homophobia risks psychic reductionism if it is isolated from the underlying sexual economy of compulsory heterosexuality, it has symptomatic status in contemporary black vernacular and intellectual culture alike. At issue is a logic of mimetic replication (doing to others what has been done to you) which Marlon Riggs discerned in the search for "the other within": "What strikes me as most insidious, and paradoxical, is the degree to which African American depictions of us as black gay men so keenly resonate majority American depictions of us as black people."[14]

The desperate refrain of ragga star Buju Banton's "Boom bye bye ina de batty man head," in 1992, may thus be juxtaposed to what can only be described as homosexual panic in an important exchange of responses to Isaac Julien's film *Looking for Langston* (1989), which took place in the Dia conference on black popular culture where a series of ambiguous undercurrents gave rise to Houston Baker's opening disclaimer, "I am not gay, but . . ."[15]

Because we are dealing not with persons, but with the imaginary and symbolic positions through which the contingent, historical, and psychic construction of personhood is spoken, it is important to recognize that there is no question of assigning fault. One of the virtues of psychoanalytic theory, based on the interpretation of the transference in the talking cure, is that it brackets the issue of culpability, and thus hears "it" rather than "I" speaking in the discourses of the symptom. If the differentiation of self and other depends on repression that splits ego from unconscious, then the ambivalence of identification can be seen to arise from the effects of unconscious phantasy in which the self oscillates between positions of subject, object, or spectator to the scene. Because libido and the drives are highly mobile, object choice and identification are rarely finally fixed; thus in the realm of cultural representation we access the ambivalence whereby ego and alter may trade places at any one time (fig. 2.9). If empathy depends on being able to put oneself in the other's place, other structures of feeling also arise which generate intolerable anxieties (does this feeling belong to you or me?), which may find expression through mechanisms such as splitting and denial at the level of the object (the realm of the not-me) or at the level of the ego (identification with the aggressor, for example).

My point is that Fanon returns as our contemporary precisely because "his" problems with psychosexuality come back as "our" problems. I want to briefly touch upon some of the key moments where homosexuality makes an appearance in *Black Skin,*

White Masks because contributions to the rereading of Fanon put forward by contemporary lesbian and gay cultural theorists offer compelling reasons "why there can be no facile equation of racist and sexist discrimination via the appeal to Fanon," which is precisely on account of "the place of sexuality, especially homosexuality, in his writing," as Jonathan Dollimore (1991, 334–35) has argued.

Against the background of Fanon's analysis of negrophobia, defined as "a neurosis characterised by the anxious fear of an object" (Fanon, 1967a, 154), lie the dread historical realities of white supremacist terror, which often culminated in literal acts of castration, torture, and dismemberment for colonized and enslaved men and women alike. From word associations in which "Negro brought forth biology, penis, strong, athletic, potent, boxer, Joe Louis, Senegalese troops, savage, animal, devil, sin" (166), Fanon filters a wide range of pathological evidence through a subtle comparison with the phobic logic of anti-Semitism in order to differentiate the violent sexualization of the black body under the scopic drive of the Other who is also the Master. He concludes: "The Negro symbolises the biological" (167), "For the majority of white men the Negro represents the sexual instinct" (177), "The Negro is the genital" (180), and that when "the Negro is castrated . . . it is in his corporeality that the Negro is attacked . . . that he is lynched" (162, 163). It is in the context of his clinical interpretation of psychic structures giving rise to such symptoms that Fanon asserts, "The Negrophobic woman is in fact nothing but a putative sexual partner—just as the Negrophobic man is a repressed homosexual" (155) (fig. 2.10).

As Dollimore notes, these stark remarks arise from Fanon's interpretation of sadomasochistic fantasies in which punishment is sought to alleviate the guilt involved in the wish to destroy the phobic object: "There are . . . men who go to 'houses' in order to be beaten by Negroes: passive homosexuals who insist upon black partners" (Fanon, 1967a, 177). While evoking the variations of active, passive, and observing positions which Freud showed in his analysis of the fantasy in which "a child is being beaten," Fanon draws out the mobility and reversibility of libidinal drives, yet there is an element of explanatory confusion in his highly judgmental reading of female masochism in the colonial fantasy he denotes as "a Negro is raping me." As Dollimore points out, "Whilst . . . *repressed* homosexuality is construed as a *cause* of a violent and neurotic racism, elsewhere Fanon regards *manifest* homosexuality as an *effect* of the same neurotic racism, though now in a *masochistic* rather than sadistic form" (1991, 334–35).

Drawing attention to such difficulties, Diana Fuss and Lee Edelman further delineate Fanon's preoccupation with the binary distinction of active and passive sexual aims.[16] This driving concern illuminates the phobic logic of black nationalism whereby

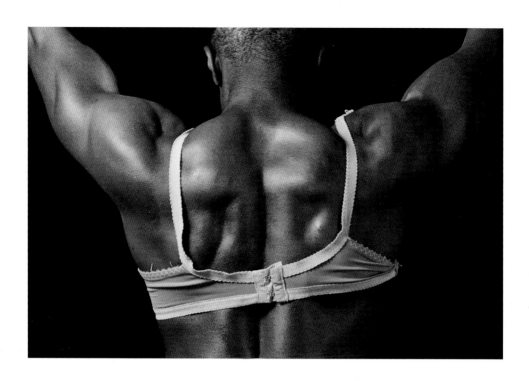

2.9 Ajamu, *Bodybuilder in Bra*, 1990. Gelatin silver print, 15 × 9½ inches.
Courtesy of the artist.

homosexuality is equated with whiteness as something inherently alien to African eroticism, something foisted and imposed by the European colonizer such that it is seen as a "white man's disease." Insofar as the psychoanalytical account of sexual difference assumes the Oedipus complex as a primordial either/or in which the boy's assumption of active, phallic masculinity depends on the repudiation and casting out of passive, and thereby feminine, aims, then the demonization of homosexuality in the black nationalist imaginary must require the expulsion of the feminine within the man in order for him to be a "real" black man.

On this view, black and gay are mutually exclusive terms for an empowered black male identity because the establishment of proud, upright, phallic manhood for black heterosexual men would depend on self-definition against the active/passive equation in which "white racists (literally) castrate others while homosexuals (figuratively) are castrated themselves."[17] Hence it is difficult not to hear a certain castration anxiety that is voiced in the self-canceling logic that punctuates another key instance in which Fanon discusses homosexuality:

> Let me observe at once that I had no opportunity to establish the overt presence of homosexuality in Martinique. This must be viewed as the result of the absence of the Oedipus complex in the Antilles. The scheme of homosexuality is well enough known. We should not overlook, however, the existence if what are called there "men dressed like women" or "god-mothers." Generally they wear shirts and skirts. But I am convinced that they lead normal sex lives. They can take a punch like any "he-man" and they are not impervious to the allures of women—fish and vegetable merchants. In Europe, on the other hand, I have known several Martinicans who became homosexuals, always passive. But this was by no means a neurotic homosexuality: for them it was a means to a livelihood, as pimping is for others. (1967a, 180)

Quoted in full, what becomes all too visible are a series of denials, negations, and repudiations. First there are no homosexuals in Martinique, then it is acknowledged that cross-dressed men exist, although such "he-men" are attracted to women, and then, third, it is claimed that Caribbean migrants in Europe "became homosexuals, always passive," merely as a means of economic survival. Surely something must be going on? And what is one to make of Fanon's denial of an Antillean Oedipus when the Oedipus complex lies at the foundation of psychoanalytic thought? At issue is how Fanon problematically enacts the psychic mechanisms which he analyzes. In a third instance in the book where homosexuality is addressed we see how his own definition of phobia—"it

2.10 Donald Rodney, *Untitled*, 1989–90. Mixed media collage. Courtesy of Diana Symons, Donald Rodney Estate.

must arouse . . . both fear and revulsion" (154)—comes to be autoinscribed when Fanon later says, "I have never been able, without revulsion, to hear a man say of another man: 'He is so sensual!' I do not know what the sensuality of a man is. Imagine a woman saying of another woman: 'She's so terribly desirable—she's darling . . .'" (201).

Fanon's resistance to the dehumanization effected when racism equates blacks with all that is bodily seems to take expression in homophobic form as a psychic defense against the terror of the very real threat of castration. Moreover, the preoccupation with passivity as unthinkable seems to form a sexualized counterpoint to Fanon's dilemma of the "actional man" (1967a, 222) who, having been acted upon by the forces of history, is envisioned as rising out of the experience of colonial alienation in the transcendental moment of mutual recognition. Finally, if what we are addressing is inferential, as much as overt, homophobia as a significant element in black psychosexuality, then the proximity between the replication of phobic mechanisms in Fanon's text and some of his most profound philosophical insights cannot be disavowed: "Fault, guilt, refusal of guilt, paranoia—one is back in homosexual territory. . . . Good-Evil, Beauty-Ugliness, White-Black, such are the characteristic pairings of the phenomenon that . . . we shall call 'manichean delirium'" (183).

Too close for comfort, in my view, especially when such proximity appears reiterated in the double-edged ambiguity to be heard in Toni Morrison's testimony of affection for James Baldwin: "I had been thinking his thoughts for so long I thought they were mine. . . . There was a kind of courage in him that I have not seen duplicated elsewhere. Part of it is to do with homosexuality, with the willingness to be *penetrated by the enemy*."[18]

Contemporary black gay scholars have questioned the psychic syntax implicit in the phrase "sleeping with the enemy" when used as a highly charged danger sign in the black nationalist imaginary to ward off anxieties around interracial sexuality.[19] The fact that black gay men may themselves demonize each other when racial preference in erotic life is raised to the level of object choice serves to question the certainties of the identity police who cling to essentialist notions of desire. It also shows why we need access to the speculative thinking of post-Freudian theory, even while the Eurocentric limits of the psychoanalytic institution are recognized, as Fanon himself articulated it in a double-voiced discourse that operated in and against the forms of knowledge which he contributed to as he criticized.

Hybrid Worlding: Two Sorts of Suture

*Hybridity . . . is the name for the strategic reversal of the process of domination
through disavowal. . . . It unsettles the mimetic or narcissistic demands of colonial
power but reimplicates its identifications in strategies of subversion that turn the
gaze of the discriminated back upon the eye of power.*

—*Homi K. Bhabha,* THE LOCATION OF CULTURE

Bhabha's insight finds a stunning constellation in postcolonial visual art forms as di-
verse as Isaac Julien's *Looking for Langston*, wherein the subject looks back and reimpli-
cates the gaze in transgressive visual pleasures, and in the meta-primitivist masks of
Jean-Michel Basquiat's paintings, which also return the gaze, as Dick Hebdige suggests,
to "smite" the eye of power.[20] That such art practices confirm the subversive poten-
tial of hybridity, in a world where neonationalisms of whatever stripe continue to de-
mand purity and authenticity, is to recognize the way critically multicultural practices
have enriched the legacies of the political and artistic avant-gardes which, for their own
purist sins, have more or less disappeared into the museum's ruins.

On this view, two overlapping issues emerge concerning the psychic dimensions of
history and geography. While the concept of hybridity enables the recognition of "new
ethnicities," and hence the formative and not merely reflective role of representation
in the cultural construction of transindividual affinities, the word comes with the bag-
gage of biologism associated with the old racism of genetics and breeding, an inheri-
tance heard in the circulation of the word "half-caste" as a label for flesh-and-blood
hybrids, which Saldaan suggests be recoded to "double-caste" if it is to have any refer-
ential bite.[21] Images of interraciality are so overdetermined by inchoate fears and fan-
tasies, of mixing as a threat to purity, that its cultural representation rarely escapes the
codification of a "problem-oriented" discourse, as seen in the films of Fanon's era such
as *Lost Boundaries* (1948), *Islands in the Sun* (1957), or *The World, the Flesh and the Devil*
(1959). Yet in the postwar treatment of miscegenation in the movies—in the transition,
say, from *Guess Who's Coming to Dinner* (1967) to Spike Lee's *Jungle Fever* (1991)—the
narrative shift from white patriarch to black patriarch merely reveals an implicit con-
tinuum in which interracial relationships are rarely portrayed for what they are, that
is, relationships, but for what they are made to mean as a token of one's true loyalties,
affiliations, and identifications.

Ngozi Onwura's early films, *Coffee Coloured Children* (1989) and *The Body Beau-
tiful* (1990), turned away from this duty to explain oneself, shifting the axis of the gaze

and tone of voice to sketch the complex space of relationships (such as that between daughter and mother) in all their fractured intimacy. The family is (always) a key site of representation for ideology, and yet even though actual spaces for independent practice have been remarginalized, one reaches for a word like "oppositional" to describe the critical signifying difference from Spike Lee's plea to restore the authority of the patriarch (even if it entails the murderous rage of an Oedipus in reverse; the father kills the bad son, whom the good son failed to protect because of his desire for the other) to be found in the experimental cinema of Camille Billops's and James Hatch's *Finding Christa* (1991), a fraught reconciliation between a mother and the daughter she put up for adoption; Marco Williams's autobiographical *In Search of Our Fathers* (1991); or Tony Cokes's *The Book of Love* (1993), a video interview with the artist's mother in which narrative presence is constantly interrupted by doubts, questions, memory, and silences.

Developing from black avant-garde work of the 1980s, this strand of hybrid cinema seeks a third way between the stratifications of individualist self-expression and mass-market popularity, and the work of Black Audio Film Collective in particular has continued to cross-fertilize various local-global idioms. This body of work has influenced African and Caribbean filmmakers such as Raoul Peck, whose *Lumumba: Death of a Prophet* (1992), like David Aschar's *Allah Tontu* (1991), follows the journey through the "war zone of memories" in which John Akomfrah tracked memory traces of the dream of liberation amid the ruins of the derailed project of decolonization in the Ghanaian setting of *Testament* (1988). There, the exiled Abena returns to find there is no home to go to: the utopian desires of her past, as a recruit at Kwame Nkrumah's Ideological Training Institute, are given over to loss and ruination, this latter term being a creolized verb frequently used by Michelle Cliff in her novel of return to Jamaica, *No Telephone to Heaven* (1988).[22] If the films ask whether the "post" in "postcolonial" really does mean that colonialism belongs to the past (or whether the exigencies of unending neocolonialisms merely demand a structural adjustment program of the soul), there is no final answer-word. Instead, as Abena enters a state of mourning for unsymbolizable loss, the hybrid soundscapes—designed by Eddie George and Trevor Mathison—induce an aesthetic effect that feels like "melancholia in revolt" (Bhabha, 1992).[23]

Zarina Bhimji's major installation work *I Will Always Be Here* (1991) (fig. 2.11), further evokes such melancholic structures of feeling, of survival in the face of losses that can never be repaired but only endured, in part, through the labor of symbolization. Bhimji's powerful evocation of an unnamable and unknown trauma brings the question of affect back into the struggle for signification (for the glass boxes containing

2.11 Zarina Bhimji, *I Will Always Be Here*, 1991. Burned child's kurtas. Installation view.
Courtesy of the artist.

various part-objects are modeled on the artist's use of shoe boxes as improvised play toys during her childhood in Uganda, which was interrupted by the expulsion of settled Asian communities during the 1970s). In this sense the implicitly psychoanalytical dimension of Bhimji's practice perhaps lies in the way it returns to the question of psychic pain at the very heart of psychoanalytic practice as a healing art. Bell hooks, too, has pushed the uses of psychoanalysis in this direction, in *Sisters of the Yam*, for instance, by starting from the view that the vitality of the pleasure principle in African American expressive culture cannot be separated from the sheer prevalence of psychic pain in subaltern life, which it seeks to answer.[24]

In this broader view of psyche in history, artists of the postcolonial diaspora inscribe a wide range of points of entry and departure within the Fanonian text. Their various practices refuse to flinch from the difficulties of difference, constantly tarrying the negative in critical dialogues operating on a number of fronts, or, as Glenn Ligon has it—"What do black audiences not want to hear?"[25] I think this commitment to difficulty differentiates the practice of critical hybridity, especially when the contested character of the term threatens to install it as merely a new orthodoxy for multicultural micromanagement. Rather than seek a new master, diaspora artists use Fanon as a resource for deepening the understanding of *unconscious phantasy as the psychic binding of social life*. In this sense, hybrid work arising from the interstices of difference makes contact with the diversity of psychoanalytic schools of thought, including object-relations theory, which has to an extent been minimized by the dazzling fascination exerted by Lacan as absolute master.[26] While the insights of postcolonial theory arose from what could be called an anaclitic relationship to the 1970s feminist turn toward psychoanalysis—for the purposes of thinking why it is that social relations are so *resistant* to progressive political change—there seems to be a paucity of acknowledgment of the genuine process of hybridization whereby diaspora practitioners have reaccentuated the dialogue that previous generations sought in the hyphenation of Freudo-Marxism (a word which today reeks of the funky, musty smell of hippy kinship arrangements).[27]

The fear/fantasy formulation probably had no one single origin, but I think it is crucial to acknowledge the importance of dialogic practitioners such as Laura Mulvey, whose "Fears, Fantasies and the Male Unconscious" was published in 1973.[28] In her retrospective glance, Mulvey situates the kind of suture or joining that was sought across theory and practice to create a critical space able to account for the ideological wiring of the pleasure principle as a conduit of power and subjection by which subjects appear to consent toward their own oppression, and the creation of new possibilities

for other pleasures, which her films with Peter Wollen, such as *Riddles of the Sphinx* (1977), sought to bring into being. This double vision of pleasure as ultimately a political problem, inseparable from the lived experience of psychic pain, is something I see being reworked and renewed in the film practice of an artist such as Julie Dash, whose *Daughters of the Dust* (1991) offers untold pleasures as it re-members and puts back together memories of a past that never passed into representation. As Mary Ann Doane notes, alongside *Riddles of the Sphinx*, other key films from the British independent sector of the past—the Berwick Street Collective's *Nightcleaners* (1975) and Sally Potter's *Thriller* (1979), for instance—each depicted black women as central narrative actants, even if the black figure was more in-itself than for-itself.[29] Contemporary hybridity, differentiated by the vocal and visible presence of others, enriches such inheritance to seek new forms of dialogic détente in an age of postimperial perestroika.

What differentiates the hybrid turn to the primal scene of difference, staged in all its horror and wonder in Onwura's *Body Beautiful*, where siblings struggle over the mother's body, is its recognition of psychic negativity as constitutive of subjectivity. In the ruins of the utopian fantasies that sought to "liberate" the transgressive potential of the id, there is an altogether more sorry storying of the postcolonial self which recognizes that love's body is also a festival of hate. This alters the dialogue between politics and psychoanalysis, for as Jacqueline Rose describes it, "Instead of the unconscious as the site of emancipatory pleasures, we find something negative, unavailable for celebration or release. One could argue that it has been too easy to politicise psychoanalysis as long as the structuring opposition has been situated between an over-controlling, self-deluded ego and the disruptive force of desire; that this opposition has veiled the more difficult antagonism between super-ego and unconscious, where what is hidden is aggression as much as sexuality, and the agent of repression is as ferocious as what it is trying to control."[30]

When Rose argues that "by seeing the unconscious as the site of sexual or verbal free fall, the humanities have aestheticised psychoanalysis,"[31] an important caveat follows for postcolonial practices, namely, the risk that hybridity might be recolonized by the apparatus of power either as compensation for our losses or as the velvet glove of enjoyment that goes hand in hand with the iron fist of exclusion. Perhaps such risks will be mitigated by the construction of new kinds of pleasures, available to anyone who travels the dark side of the postimperial city at night, which multiply the zones of engagement for critical dialogue. Beyond the field of vision alone, the diasporic sensorium whereby artists as diverse as Keith Khan and Sonia Boyce both use materials such as hair to touch upon the tactile dimensions of everyday fear and fantasy in the

proxemics of multicultural social space—do you want to touch?—provides a point of access to dark continents of intersectionality that remain as yet unexplored. Or, to plug into another orifice of the multiculti social body, the mixing desks which Mathison and George use to hollow out the ear of the other offer the prospect of exploring the joyful soundings of the black voice as it constitutes identity in the acoustic mirror of desire. "As soon as I desire I am asking to be considered," said Fanon (1967a, 218), in a dubwise echo acknowledging the intersection of desire and recognition that goes back to Hegel and which came out of the mouth of Marvin Gaye when he sang, "I want you, *and I want you to want me too.*"

History has not been kind to hybrids. The reason why Bessie Head was born in the Pietermartizburg Mental Hospital in South Africa "was that my mother was white, and she had acquired me from a black man. She was judged insane, and committed to the mental hospital while pregnant."[32] The remaking of our mongrel selves means more than a desire to heal the wounds of power's pathologies, it risks movement along the jagged edge of the abyssal borderlines that continue to define the policing of difference, as Chicana poet Gloria Anzaldúa fiercely recognizes: "Borders are set up to define the places that are safe and unsafe, to distinguish us from *them*. A border is a dividing line, a narrow strip along a steep edge. A borderland is a vague and undetermined place created by the emotional residue of an unnatural boundary. It is in a constant state of transition. The prohibited and forbidden are its inhabitants. *Los atravesados* live here: the squint-eyed, the perverse, the queer, the troublesome, the mongrel, the mulatto, the half-breed, the half-dead; in short, those who cross over, pass over, or go through the confines of the 'normal'" (1987, 3).

NOTES

This chapter was first published in *Mirage: Enigmas of Race, Difference and Desire*, exhibition catalogue, edited by David A. Bailey (London: Institute of Contemporary Arts, 1995), 14–55.

1. Ambiguities of authorship in texts by Bakhtin, Volosinov, and others are discussed in Gary Saul Morson, ed., *Bakhtin: Essays and Dialogues on His Work* (Chicago: University of Chicago Press, 1986).

2. Homi Bhabha, "Interrogating Identity," in *Identity: The Real Me*, edited by Lisa Appignanesi, ICA Documents no. 6 (London: Institute of Contemporary Arts, 1987), 11, quoted in Gri-

selda Pollock, "Veils, Masks and Mirrors," in *Correct Distance*, ed. Mitra Tabrizian, exhibition catalogue (Manchester: Cornerhouse, 1990), appendix 1, n. 20.

3. Stephan Feuchtwang, "Fanonian Spaces," *New Formations*, no. 1 (1987): 124–30.

4. See Jock McCulloch, *Black Soul / White Artefact* (Cambridge: Cambridge University Press, 1983). The interpretation of Fanon that prioritizes *The Wretched of the Earth* follows an emphasis that underpins David Caute, *Fanon* (London: Fontana / Collins, 1970); Irene Gendzier, *Frantz Fanon: A Critical Study* (London: Pan-

theon, 1973); and Renate Zahar, *Frantz Fanon: Colonialism and Alienation* (New York: Monthly Review Press, 1974).

5. Bessie Head quoted in *A Gesture of Belonging: Letters from Bessie Head 1965–1979*, ed. Ralph Vigne (London: Heinemann, 1990). See also Jacqueline Rose, "On the 'Universality' of Madness: Bessie Head's *A Question of Power*," *Critical Inquiry* 20, no. 3 (1994): 401–18.

6. The sculpture is discussed in Hugh Honour, *The Image of the Black in Western Art*, vol. 4, pt. 1 (Cambridge, MA: Harvard University Press / Menil Foundation, 1989), 251. See also Sander Gilman, "The Figure of the Black in German Aesthetic Theory," *Eighteenth Century Studies* 8, no. 4 (1975): 373–91.

7. Toni Morrison, *Playing in the Dark: Whiteness and the Literary Imagination* (Cambridge, MA: Harvard University Press, 1992).

8. Guy McElroy, *Facing History: The Black Image in American Art 1710–1940*, exhibition catalogue (Brooklyn Museum of Art, 1989). See also Gavin Yearwood, "Expressive Traditions in Afro-American Visual Arts," in *Expressively Black*, ed. Geneva Gay and Willie L. Barber (New York: Praeger, 1987); Richard Powell, *The Blues Aesthetic: Black Culture and Modernism* (Washington, DC: Washington Project for the Arts, 1989).

9. James Snead, "Spectatorship and Capture in King Kong: The Guilty Look," in *White Screens / Black Images* (London: Routledge, 1994), and Lola Young, "A Nasty Piece of Work: A Psychoanalytic Reading of Difference in Mona Lisa," in *Identity: Community, Culture and Difference*, ed. Jonathan Rutherford (London: Lawrence and Wishart, 1990).

10. Valerie Smith, "Split Affinities: The Case of Interracial Rape," in *Conflicts in Feminism*, ed. Marianne Hirsch and Evelyn Fox Keller (New York: Routledge, 1990), 285.

11. Chinweizu, *Decolonising the African Mind* (Lagos: Pero, 1987).

12. Nelson George, *Buppies, B-Boys, Bohos, and Baps: Notes on Post-Soul Black Culture* (New York: Random House, 1992).

13. bell hooks, "Reflections on Race and Sex," in *Yearnings: Race, Gender and Cultural Politics* (Boston: South End, 1990), 55–60; bell hooks, "Reconstructing Black Masculinity," in *Black Looks: Race and Representation* (Boston: South, 1992), 87–113.

14. Marlon Riggs, "Black Macho Revisited: Reflections of a SNAP! Queen," in *Brother to Brother: New Writings by Black Gay Men*, ed. Joseph Beam and Essex Hemphill (Boston: Alyson, 1991), 255.

15. Houston A. Baker, "You Cain't Trus' It: Experts Witnessing in the Case of Rap," in Dent, 1992, 132. See also Henry Louis Gates Jr., "The Black Man's Burden," in Dent, 1992, 75–83.

16. See Diana Fuss, "Interior Colonies: Frantz Fanon and the Politics of Identification," *diacritics* 24, nos. 2–3 (1994): 19–42; Lee Edelman, "The Part for the (W)Hole: Baldwin, Homophobia, and the Fantasmatics of 'Race,'" in *Homographesis: Essays in Gay Literary and Cultural Theory* (New York: Routledge, 1994), 42–75.

17. Edelman, "The Part for the (W)Hole," 56.

18. Toni Morrison quoted in Paul Gilroy, "Living Memory: A Meeting with Toni Morrison," Gilroy, 1994, 180 (emphasis added).

19. Darieck Scott, "Jungle Fever? Black Gay Identity Politics, White Dick, and the Utopian Bedroom," *GLQ: A Journal of Lesbian and Gay Studies* 1, no. 3 (1994): 299–321.

20. See José Arroyo, "Look Back and Talk Back: The Films of Isaac Julien in Postmodern Britain," *Jumpcut*, no. 36 (1991), 2–12; and Dick Hebdige, "Welcome to the Terrordome," in *Jean-Michel Basquiat*, ed. Richard Marshall, exhibition catalogue (New York: Whitney Museum of American Art, 1993), 60–70.

21. See Saldaan, "Colour: The Skin I'm In," in Bailey and Hall, 1992, 92–95.

22. Michelle Cliff, *No Telephone to Heaven* (London: Methuen, 1988).

23. Bhabha (1992) rereads Freud's intrapsychic account of melancholia when he cites Fanon from *The Wretched of the Earth*, who regards

acts of petty theft as anticolonial resistance and writes, "The native's guilt is never a guilt which he accepts: it is rather a kind of curse, a sword of Damocles . . . he is overpowered but not tamed" (Fanon, 1967b, 249), and thus reinterprets the superego's persecutory attacks on the ego in melancholia—in which "everything they [melancholics] say about themselves is at bottom said about somebody else" (Freud quoted in Bhabha, 1992, 65)—as a structure of psychic positions that is inverted (that is to say, exteriorized) in the colonial situation. To the extent that the "Damoclean sword installs ambivalence in the symbolic order, where it is itself the immobile Sign of an authority whose meaning is continually contested by the fantasmatic, fragmented, motility of the signifiers of revolt" (Bhabha, 1992, 65), then what becomes manifest when the colonized "wears his psychic wounds on the surface of his skin like an open sore—an eyesore to the coloniser" (65) is, in Bhabha's view, a psychic structure of "projective disincorporation" that both resists the authority of colonial law and acknowledges the loss of indigenous tradition. Hence, according to Bhabha, "The colonial sword is constituted in an indeterminate doubling; the native 'super-ego' is itself displaced in the colonial contention. Here, in this order signifying a double loss, we encounter what may be a symbolic space of cultural survival—a melancholia in revolt" (65).

24. bell hooks, *Sisters of the Yam: Black Women and Self Recovery* (Boston: South End, 1994). On the use of psychoanalysis in critical legal theory, see Patricia J. Williams, *The Alchemy of Race and Rights* (Cambridge, MA: Harvard University Press, 1991).

25. Glenn Ligon, "Glenn Ligon, Untitled (Two White / Two Black) 1992," *Print Collector's Newsletter* 24, no. 6 (January–February 1994): 6.

26. Mikkel Borsch-Jacobson, *Lacan: The Absolute Master* (Palo Alto, CA: Stanford University Press, 1993). See also Melanie Klein, "Some Theoretical Conclusions regarding the Emotional Life of the Infant," in *Envy and Gratitude and Other Works* (London: Hogarth Press and Institute of Psycho-Analysis, 1964), 61–93.

27. Freud introduced "anaclisis" as a technical adjective in "Three Essays on the Theory of Sexuality" to describe the psychic specificity of sexual drives and to differentiate forms of sexual object choice. In the first instance, the oral drive, for example, is initially dependent on the biological function of feeding which provides a source, orientation, and aim for the drive: but the drive only becomes a drive—the psychical representative of erotic impulses—when it enters symbolization, whereupon the breast becomes a primordial signifier for the "experience of satisfaction," and in which the pleasure of oral eroticism (suckling) becomes progressively detached from the satisfaction of hunger or need. In a second sense, in the context of his major distinction between self-preservative and sexual instincts, Freud discusses an "anaclitic type of object choice," which is later distinguished from a narcissistic object choice, in order to account for the refinding of a love object along the lines of an earlier relationship of attachment to, and dependency upon, the mother (in the case of a heterosexual male, for example). See Jean Laplanche and J. B. Pontalis, *The Language of Psychoanalysis* (New York: Norton, 1973), 29–32.

I invoke the term here to suggest that, in terms of recent intellectual history, postcolonial theory emerged in the 1980s from a relationship of attachment and dependency in relation to feminist materialist discourses from the 1970s—such as Juliet Mitchell's *Psychoanalysis and Feminism* (London: Pelican, 1974)—which, in my view, is an important connection that has been somewhat overlooked by the marginalization of sexual difference and sexuality within the discourses of postcoloniality. In this regard, see Gayatri C. Spivak, "Psychoanalysis in Left Field and Fieldworking," in *Speculations after Freud: Psychoanalysis, Philosophy and Culture*, ed. Sonu Shamdasani and Michael Munchnow (New York: Routledge, 1994), 41–76.

28. Laura Mulvey, "Fears, Fantasies and the Male Unconscious or 'You Don't Know What Is Happening, Do You, Mr Jones?'" (1973), in *Visual and Other Pleasures* (Basingstoke: Macmillan, 1989), 6–13.

29. Mary Ann Doane, "Dark Continents," in *Femmes Fatales: Feminism, Film Theory, Psychoanalysis* (New York: Routledge, 1991), 215–48.

30. Jacqueline Rose, "Negativity in the Work of Melanie Klein," in *Why War?* (Oxford: Blackwell, 1994), 143–44.

31. Rose, "Negativity in the Work of Melanie Klein," 144.

32. Bessie Head, "Notes from a Quiet Backwater" (1982), in *A Woman Alone: Autobiographical Writings* (London: Heinemann, 1990), 3.

PART II

Differential Proliferations

Examining work by Keith Piper, Rotimi Fani-Kayode, Isaac Julien, and Yinka Shoni-bare, the chapters in this part attest to the paradox whereby monographic attention to individuality reveals shared concerns that have a transpersonal character. As they begin to identify three distinctive thematics — archives, bodies, travel — recurring in recombi-nant form in each artist's strategic choices and procedures, these chapters develop an analysis of the interruptive practice by which black diaspora artists engage with West-ern visual traditions of race and representation in a critical dialogue that, as a result of their intervention, changes the terms of the conversation.

Where Piper enters the archive to examine an allegorical image of Africa in a Victorian monument, or Julien performs a queerly cross-cultural translation of a slave-trading scene in an abolitionist painting, the moves being made are critically dialogical, for the bodies in question are disentangled from the "othering" to which blackness was subjected. Fani-Kayode contests the fetishistic legacies of modernist primitivism, and yet to note what differentiates his homoerotic portrayal of black male nudes from Robert Mapplethorpe's, for instance, is to register only one of the intersecting planes through which the hybrid translation of signifying materials he took from Yoruba and Western sources was conditioned by his diasporic positioning. Whereas the nude was a focal point of iconographic contest for interruptions that cut openings through which questions of sexuality contributed to the differencing of postmodern blackness, the bodies which are adorned in the Dutch wax prints Shonibare employs as his signature materials shuttle attention back to the archive, for such textiles have hybridity woven into their very fabrication. Originating in East Asian batik, copied by Dutch colonials, then exported to West and Central Africa, such textiles were produced in transnational circuits that make travel a metathematic principle in Shonibare's practice. The act of transporting materials from one place to another, emblematized by the Black Atlantic image of the ship, is exactly what artistic practices do in unfixing elements from dominant codes, changing their meaning by transposing them into new configurations, thus moving the signifying chain into unexpected directions.

As these monographic writings unpack assumptions that block deeper understanding of the aesthetic singularity through which artistic intentions are expressed, there is frequent back-and-forth movement as to what pertains to the background and what demands close attention in the foreground. Leaving such matters unresolved, the dialogical method assembled throughout these writings eschews the desire for mastery that aims for definitive readings, which is to say that in keeping interpretation open-ended, there is an ongoing invitation for further critical response.

3

MARRONAGE OF THE WANDERING EYE: KEITH PIPER

Keith Piper became the history painter of postimperial Britain. Considering that History was officially abolished with the advent of the postmodern, one might wonder what remained for artists to represent. When social bonds disintegrate between market space and the security state, all that seems to be left are the visible traces of disappearance and absence—the social body feels abandoned by its narratives of manifest destiny and lies shivering in the shop fronts of national glory, naked beneath filthy blankets piled up by the debris of empire's loss and ruination. But even if they have lost it now, did the British ever really have a national identity in the first place?

Tom Nairn remarked that if there was such a deep-seated confidence about the coherence of the nation's identity, then why does this country have not just one name but three? Great Britain, United Kingdom, and England.[1] While the answer lies, in part, in the discrepancy between the citizenship rights conferred by the nation-state and the more nebulous ties of cultural kinship and ethnic exclusivity that draw on the language of race to define the limits of its membership, the breakup of any unifying narrative of imagined community has brought to light the jagged and volatile sediment out of which Britishness has been historically composed. Across some fifteen years of practice, Keith Piper has established himself as one of the most important British artists of our time by virtue of his ability to journey through the densely compacted layers of collective cultural history and bring back fresh insights into the social and emotional realities of the images and symbols through which political identities come into existence, and through which they also depart from it.

From early paintings, such as *The Body Politic* (1983) and *The Four Horsemen of the Apocalypse* (1986), through image-text work such as *Go West Young Man* (1988), to such multimedia installations as *A Ship Called Jesus* (1991), *Step Into the Arena* (1992), and *The Exploded City* (1994), Piper's oeuvre bears witness to a Britain becoming other to what it always thought it was. His gift to the nation is to offer an alternative vantage

point for a conversation about this time of crossroads we are passing through. If there is "no future" in "England's dreaming," as the Sex Pistols once told us, then Piper's work draws upon the double consciousness of a diaspora formation to pierce the consensual hallucination of a homogeneous past and to activate the lived experience of uncertainty in the present as a compass with which to navigate a middle passage through our ambivalent age of extremes.

The computer-generated image-text panels forming *The Twelve Disciples* (1996) (fig. 3.1) invite further travels into the fossilized coils of the national imaginary, whose legacy Piper has been exploring with digital technologies in such multimedia installations as *Surveillances (Tagging the Other)* (1991), *Cargo Cultures* (1994) (fig. 3.2), and *Long Journey* (1995). The works offer a distillation of three overlapping strands that have consistently featured in his projects: a concern with unraveling the constitutive role of representation in the West's racializing perceptions of difference; how the black body thus comes to be visually produced both as an object of fear and fantasy and as a site of colonial power and knowledge; and an interest in the political consequences of such fantasia in disciplinary practices of policing urban space, which seek to control that excess or surplus of symbolism with which the otherness of the black male body has been historically burdened. Captioned by click-on commands, the densely textured palimpsest of each triptych encapsulates Piper's archaeological methodology, for through the windows of the new technologies of the future we are confronted with the saturated residue of the nation's visual archive that is buried in the imperial past.

Invoking the fragmentation of the colonized subject into body parts under the master gaze of Europe's anthropometric photography, the works feature a hand holding a magnifying glass that shows a brain scan pattern which in turn illuminates a black male profile of a computer-generated photo-fit. Implying the incontestable evidence of the body's biological "truth" when perceived through the optics of science, the juxtaposition suggests how the body remains the fixed locus of a racist fantasy that wants to "see" the signs of absolute difference—moving from the outer surface of skin and bones to the interior map of brain wave activity now that biological determinism is officially discredited (even though, as the recent bell curve controversy in the United States attests, such absolutist fantasies are not altogether widely repudiated).

Collage has been the premise for Piper's practice of art and politics from the very start. Far from being didactic or accusative, the seductive fluidity of the lines of inquiry he opens up within the frayed text of his polysemic sources implies the viewer's self-positioning in a subversive effect of desuturing, unstitching the identifications that bind us to genealogies we do not yet know. Hence, when an early work such as the

3.1 Keith Piper, *The Twelve Disciples*, 1996. Amiga computer montage.
Courtesy of the artist.

painting *An Allegory* (1982) quotes the figure of Africa from William Theed's Hyde Park monument, *Prince Albert Memorial* (1872), the image induces the eye to explore unanticipated art historical connections by setting up a puzzle of sensual color and detail that reveals, in the rearground, further quotations from news photographs of the 1976 Soweto uprisings.

In the panel from *The Twelve Disciples*, arms, hands, fingers, and a book's spine enjoin our gaze to pass through multiple viewing planes which are aligned around the gesture of contact signifying England's civilizing mission, which Piper quotes from Thomas Jones Barker's painting *Queen Victoria Presenting a Bible in the Audience Chamber at Windsor* (c. 1861)—a work quite literally dredged up from the vaults and recently shown at London's Tate Gallery in *Picturing Blackness in British Art*. As Paul Gilroy commented, in the context of that exhibition, "The changing perception of blackness and Britishness . . . is not a minority issue. It is an essential ingredient in the development of a sense of nationality free of 'racial' division, [which] is an urgent goal for us all."[2] And it is for this very reason, considering the generosity of his contribution to this process, that Piper may be regarded as a history painter of the postcolonial decoupling of nationality and ethnicity. A painter not on account of his chosen medium, for he is happy to move and migrate across generic boundaries of representation, but by virtue of a methodology that refuses to flinch from the obstinate and vexing questions of our troubled relationship to the memories, narratives, and myths that constitute the collective past. For the notion of modernity itself is precisely about an unstable relation to the past that cannot be fixed, guaranteed, or agreed upon and which is thus in a condition of permanent contestation at the level of representation. As the Martinican writer Édouard Glissant, puts it, "It seems that at least one of the components of 'our' modernity is the spread of the awareness we have of it. The awareness of our awareness (the double, the second degree) is our source of strength and our torment" (1989, 51) (fig. 3.3).

Piper has never wished to apologize for his passionate interest in the political. What is most political about his project is how Piper critically positions himself in relation to a subaltern's understanding of history, not as a grand narrative of progress in which an abstract ideal awaits fulfillment, but as an errant wandering of bodies and flows passing through chance, accident, and material circumstance to make themselves anew. It is a conception of history strongly associated with Caribbean writers and intellectuals such as Wilson Harris, Frantz Fanon, and Derek Walcott, for whom the Atlantic triangle maps a space of becoming in which the unrecoverable trauma of lost origins is tragic only when it is experienced as the deprivation of a fixed destiny—alternatively,

3.3 Keith Piper, *The Fire Next Time* section of *A Ship Called Jesus*, 1991. Installation view, Ikon Gallery, Birmingham.

3.4 Keith Piper, *The Rites of Passage* section of *A Ship Called Jesus*, 1991.
Installation view, Ikon Gallery, Birmingham.

diaspora opens opportunities to exert freedom and responsibility by making a home for subjectivity in the space and time of its own choosing.

Aquatic imagery has antecedents in cultural conceptions of time that go back to Heraclitus and his image of a river that never passes the same point twice. Yet when Walcott invokes "history is sea,"[3] or Harris recounts his voyage on Guyana's Tumatumari Falls when a near-death encounter erupts with the "angelic, terrifying, daemonic phantoms and figures of my own antecedents—the Amerindian/Arawak ones,"[4] it is this Caribbean-inflected experience of submarine memory and "ex-isle" consciousness that we see reworked in Keith Piper's meditations on mourning and moving on in one of his major works, *A Ship Called Jesus* (1991) (fig. 3.4).

"Only a dialogue with the past can produce originality," argued Wilson Harris in elaborating his notion of *fossil identities*, that is, the view that insights into futural possibilities arise from a journey into the past that seeks to liberate ancestral memories from historical erasure, in a search not for the end of history but for the chance to begin again.[5] Glissant, in turn, coaxes the verb *marronage* out of the story of the Maroons—who sought lines of flight out of plantation space by escaping to the hillside forests of Haiti, Cuba, and Jamaica, and whose resistance defiantly turned away from the frontiers of the nation-state—to describe the cross-cultural dynamics of a creolizing aesthetic of migration and translation that found fertile soil in the ruins of European decline that were implanted in the Americas. In the sense that Piper practices a visual marronage that steals away fresh insights from the archival sources which his work draws upon, in order to enable his audiences to imagine how a changed relation to the past might reconfigure present-day predicaments, his art offers much to "this island race." England, or Britain, or this medium-sized offshore enterprise called UK Ltd, has already become something other that what it was, and would recognize as much in Piper's art should it wake up from the sleep of History to walk about and look and see.

NOTES

This chapter was first published in *Portfolio: The Catalogue of Contemporary Photography in Britain*, no. 23 (June 1996): 54–55.

1. Tom Nairn, *The Break-up of Britain: Crisis and Neo-nationalism*, 2nd ed. (London: Verso, 1981).

2. Paul Gilroy, *Picturing Blackness in British Art: 1700s–1990s*, exhibition brochure (London: Tate Gallery, 1995), n.p.

3. Derek Walcott, "The Sea Is History," in *Collected Poems, 1948–1984* (London: Faber and Faber, 1992), 366.

4. Wilson Harris, "A Talk on the Subjective Imagination," *New Letters* 40, no. 1 (October 1973): 37–48.

5. Wilson Harris, *Enigma of Values* (Mundelstrup: Dangeroo, 1975), 16.

4

MORTAL COIL: EROS AND DIASPORA IN THE PHOTOGRAPHS OF ROTIMI FANI-KAYODE

What threatens man today is not material pleasure at all. In principle, material pleasure conflicts with the accumulation of wealth.... The accumulation of wealth leads to overproduction, whose only possible outcome is war. I am not saying that eroticism is the only remedy against the threat of poverty. Far from it. But unless we consider the various possibilities for consumption which are opposed to war, and for which erotic pleasure—the instant consumption of energy—is the model, we will never discover an outlet founded on reason.

—*Georges Bataille,* THE TEARS OF EROS

Experiencing the intense beauty of the photographs Rotimi Fani-Kayode made before his death in December 1989, we encounter nothing short of an enigma. The blend of elements from African and Western sources creates a cohesive visual world out of the almost "indecipherable" (Enwezor and Zaya, 1996, 42) meeting of disparate cultural signifiers. We are compelled to look, but we may never know what we are actually seeing: the plunge into uncertainty is exhilarating.

A viewer already familiar with Fani-Kayode's oeuvre would instantly recognize its allusions to the European and American modernist canon, ranging from references to painters such as Édouard Manet, René Magritte, and Francis Bacon to photographs of the male nude by George Platt Lynes or Robert Mapplethorpe. But anyone unfamiliar with Nigerian Yoruba iconography (such as myself) is strangely positioned with regard to grasping the meaning(s) it produces as a consistent and defining feature of Fani-Kayode's work. Without access to the signified, I cannot reach the referents these elements inscribe, yet the sheer affect involved is overwhelming. The last photographs, in particular, bring back a vision of the human body that is almost unbearably charged with the feeling of having been executed in the presence of death. And yet, in tracing the passage of a body that bursts into a state of ecstasy, these images emit an aura of

calm, a "tranquility of communion with the spirit world," as Robert Farris Thompson (1983, 16) might put it, discussing the cardinal value of *ashé* in Yoruba cosmology. Creating a world in which the black male body is the focal site for an exploration of the relation between erotic fantasy (sex) and ancestral memory (death), Fani-Kayode brought something new to the illumination of an ancient enigma: astonishing the gods, as novelist Ben Okri might say.[1]

Posthumously entitled *Communion* (1989), this suite of photographs, curated by Mark Sealy of Autograph: Association of Black Photographers, was exhibited for the first time in Britain in 1995.[2] The photographs suggest a series or a sequence: but there is a puzzle because there is no script indicating a narrative order to which the photographs belong (or, indeed, whether there is one). Rotimi died, at age thirty-four, without leaving a will, much less any directions about how these photographs should be exhibited or seen.

The set includes *The Golden Phallus* (1989), an image made by Fani-Kayode in collaboration with his partner, Alex Hirst, which was widely disseminated at the time of its production. Appearing on the cover of *Ecstatic Antibodies: Resisting the AIDS Mythology* and in "Critical Decade: Black British Photography in the 80s" (Bailey and Hall, 1992), this individual picture has acquired a pivotal resonance of its own.[3] Deciphering its meaning, however, is made all the more complex by issues of attribution which have come to haunt its circulation and reception. Although it is widely understood that Fani-Kayode and Hirst worked collaboratively in producing this body of work as a whole, confusion has arisen over the authorship of the individual pieces that have appeared in various permutations. The ambiguity has been compounded by the fragmented condition of the work's dissemination and by the inclusion of some of the photographs in Alex Hirst's solo exhibition, *The Last Supper*, held at Lighthouse Gallery, Wolverhampton, in 1992.

Similar ambiguities surrounded the first memorial exhibition, *Rotimi Fani-Kayode, Photographer (1955–1989): A Retrospective* (1990), organized by the Friends of Rotimi Fani-Kayode and held at London's 198 Gallery, at the top of Railton Road in Brixton, where Rotimi and Alex lived. Ever since, I have sensed that perceptions of the interracial character of Alex and Rotimi's relationship have somehow colored the way in which the aesthetics of hybridity are read off the photographs themselves. But what happens when anxieties about interracial homosexuality are elided with the dynamics of interculturality that underpin Fani-Kayode's art is that the edge and depth of his photographic world is misrecognized and is seen in only limited ways that obscure the broader implications of his visual *métissage*.

Reviewing critical approaches to the reading of Rotimi Fani-Kayode's work, what seems to emerge is a conceptual displacement of background and foreground. When his work is enframed by questions of identity and otherness, it is subjected to a categorical either/or in which his gayness is acknowledged but his blackness can only be exotic or alien; whereas when his Africanness is recognized, his homosexuality is downplayed or evaded.[4] While the identity-and-alterity couplet has played an important role in addressing art that comes from more than one kind of cultural context, it also hinders appreciation of the ways in which diaspora artists may take their hybrid conditions of existence for granted as simply the starting point and not the terminal destination of their projects.

Fani-Kayode occupied multiple subject positions as a postmodern African artist, an out black gay man, and a key animateur in the field of black British photography. Although it remains crucial to recognize his ability to move between such diverse worlds as an important influence on his artistic choices, the irony is that while many critics seem beguiled by the combination of plural adjectives, identity is really the last thing that his body of work can be said to be about. The body is transfigured in Rotimi's pantheon of "smallpox gods, transexual priests and desirable black men in a state of sexual frenzy," by an aesthetic which transforms photography into a "technique of ecstasy" (Fani-Kayode, 1988, 42). Filtering African and Western elements through his lens, his optic nerve brings about a heightened encounter with the emotional reality of the flesh in which it is precisely the ego's ecstatic *loss of identity* that his vision celebrates and bears witness to. The concept of identity is singularly inappropriate here because it overlooks what is most transgressive about Fani-Kayode's art: namely, its Dionysian quest to liberate the body from the ego and its obligations of identity.

Widely underrecognized during his lifetime, Fani-Kayode's artistic journey cut a path through long-standing traditions in which art and religion alike produce representations of what happens to the human being when it crosses the boundary that links sex and death. Where religious iconography summons such themes in the *Every Moment Counts* series (1989), flowers preside over a similarly ritualistic scene of ego dissolution in the *Nothing to Lose* series (1989) (fig. 4.1), also produced in the last year of Fani-Kayode's life. Venturing into realms where it is hard to tell where sexuality ends and where spirituality begins, Fani-Kayode was, I think, profoundly immersed in a critical inquiry into the human universality of such limit-experiences. In this essay I want to seek out alternative routes into the interpretations which the enigma of the *Communion* suite provokes.

Intercultural Spaces: After Identity and Otherness

Is there such a thing as pure origin? For those of the post-colonial generation this is a difficult question. I'm bi-lingual. Because I was brought up in Lagos and London—and kept going back and forth—it is extremely difficult for me to have one view of culture. It's impossible. How do I position myself in relation to that multi-faceted experience of culture?

—Yinka Shonibare, "ART THAT IS ETHNIC IN INVERTED COMMAS"

The preceding statement, from London-based Nigerian-British artist Yinka Shonibare, serves as a succinct distillation of the postcolonial conditions which have shaped the outlook of African artists who have lived and worked outside of Africa itself, either as exiles and expatriates or as migrant settlers and itinerant travelers who constantly shuttle between more than one geographical location. Once we locate his biography within the postcolonial lifeworld, and recognize the characteristic diaspora experiences of critical displacement and dislocation, we can see that far from being unique to Fani-Kayode, such conditions have been taken for granted as ordinary, rather than exceptional, among successive generations. In the case of Nigeria's artistic diaspora, from the painter Uzo Egonu who moved to Britain in the 1940s or Taiwo Jegede based in the United Kingdom since the 1960s, to such contemporaries as Sokari Douglas Camp (London) or Iké Udé (New York), the experience of moving between cultural territories has persisted over time as a commonplace and amounts to a viable (minor) tradition as such.[5]

Born in Lagos in 1955, Rotimi Fani-Kayode grew up as a child in Africa, as an adolescent in Europe, as a young adult in America, and he returned to Britain as an artist. His father—Chief Remi Fani-Kayode—was the Balogun of Ifé, a high priest in a city of ancestral importance in Yoruba culture. The Kayode family held the traditional title of Akire and were endowed with custodial responsibilities as keepers of the shrine at Ifa, the Yoruba oracle. Chief Fani-Kayode also held prominent positions in Nigerian politics, for at the time of political independence in 1960 he was leader of the opposition in the Nigerian Parliament and later became deputy prime minister (Western State) in 1964, when the family moved from Lagos to Ibadan.

As a result of the military coup in 1966, the Kayode family moved to England and settled in Brighton. Rotimi attended various schools in Sussex, Gloucestershire, and Somerset. He completed his studies in the United States, where he took his first degree in economics and fine art at Georgetown University in 1980 while living in Washington,

4.1 Rotimi Fani-Kayode, *Nothing to Lose IV* (from *Nothing to Lose* series), 1989. Courtesy of Autograph: ABP, London.

DC. He then moved to New York and completed his MA in fine art and photography at the Pratt Institute in 1983 before returning to the United Kingdom later that year. He met Alex Hirst while at Brighton Polytechnic in the mid-1980s, and Rotimi and Alex lived and worked together in Clapham and Brixton up to Rotimi's death in 1989. Alex Hirst also died of HIV-related causes in 1992.

During his brief career, which spanned a mere six years between 1983 and 1989, Rotimi exerted prodigious energy at the intersection of the crosscutting movements which defined the insurgent cultural politics of the 1980s. His chosen focus on the male nude featured significantly in his MA portfolio. Often staged in an overtly performative or theatrical manner, these early experiments in color photography, such as *Batu* (c. 1984), depicting a male figure adorned with a raffia headdress, found their way into metropolitan gay culture via the weekly listings press that provided Fani-Kayode with an initial commercial outlet. Contributing images to the queer arts magazine *Square Peg*, of which Hirst was one of the founding editors, Fani-Kayode inhabited a bohemian space whose irreverence for gay orthodoxy was influenced by such precursors as Derek Jarman and Andrew Logan (with their Genet-inspired predilection for an aesthetics of homosexual baroque).

The supportive environment provided by London's gay culture, and Rotimi's role in its diversification, is indicated by the fact that his first collection of photographs— *Black Male / White Male* (1987)—was published by Gay Men's Press (run by Aubrey Walters and David Fernbach, formerly activists who helped found the Gay Liberation Front in the United Kingdom in the early 1970s). Rotimi's significance in the broader dissemination of a postliberationist sexual politics was reflected in the selection of one of his images, *Stations of the Cross*, for the cover of Jonathan Dollimore's *Sexual Dissidence* (1991).

Concurrently, Fani-Kayode played a crucial role in the black British visual arts sector. His interest in the studio-based tradition of the nude led to the opening of artistic trajectories that broke away from the predominance of documentary realism. Alongside image-text work by Joy Gregory and Roshini Kempadoo, Fani-Kayode's richly elaborated tableaux marked a newfound confidence in the production of constructed imagery that helped to pluralize the scope of black photography. Moreover, considering anxieties that often inhibit artistic exploration of the nude, when volatile relations of race and representation overdetermine perceptions of the black body, his forthright interest in exploring the realm of sexuality threw a vital challenge to complacent orthodoxies that would proscribe the nude as off-limits to acceptable black art practices (fig. 4.2).

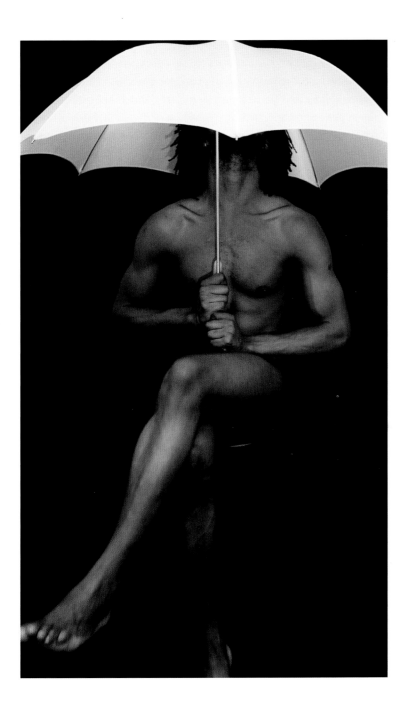

4.2 Rotimi Fani-Kayode, *Umbrella*, 1987. Courtesy of Autograph: ABP, London.

His impact on black visual culture was registered beyond photography in *Twilight City* (1989), the film by Reece Auguiste of Black Audio Film Collective which featured a sequence that enacted the *Fish Vendor* (1989) photograph, and in a filmic portrait of Fani-Kayode himself, *Rage and Desire* (1990) by Rupert Gabriel. Above all, his work holds a prominent place in the spectacular culmination of the audiovisual survey of a decade of black British photography, *Recontres au Noir*, shown at the Arles Photography Festival in 1993, not only on account of his generosity in opening up new possibilities for diaspora aesthetics, but also on account of the pivotal role he played in helping to create an infrastructural basis from which black British photography has flourished.

Fani-Kayode was a founding member and the first chair of Autograph: Association of Black Photographers. Formed in 1987 among black practitioners within commercial and public-funded sectors, the organization has played a key role in gaining wider commissioning and exhibition opportunities for British photographers of Caribbean, African, and South Asian descent. That it has also helped to pluralize the public sphere by creating a context for criticism and debate is a tribute to the breadth of vision that Rotimi and his peers, including Sunil Gupta and Armet Francis, pursued. Advocating an initiative that challenged official discourses of multiculturalism by presenting new positions on the politics of black representation, Autograph emerged in a moment of rupture, which jumped over parochial boundaries so as to connect with broader developments that internationalized the circulation of black British work. It is precisely at this stage, however, that we encounter the double-edged politics of identity and difference that has come to overdetermine the reading of Fani-Kayode's work.

On the one hand, bringing together the diverse strands of his practice, his contribution to the formation of a transnational black gay culture singularly encapsulates his role as an intercultural translator. The American black gay scene had been a particularly formative influence—*Black Male / White Male* is dedicated to "Toni and the spirit of the Clubhouse, DC"—and the book contains portraits of Steadman Scribner, with whom Rotimi lived for several years while in the United States. The intimate portraits of poet Essex Hemphill and activist Denis Carney, of musician Blackberri, and of performance-poetry diva Assoto Saint all speak of Rotimi's involvement in a moment of vibrant cultural renewal among artists who were also his friends. There is no confrontational shock effect being sought in the portraiture, but an empathic ordinariness that speaks to the way Fani-Kayode lived his gayness and blackness as integral to his mode of being in the world. But because it gained wider exposure at a time when the backlash against the new cultural politics of difference precipitated the turmoil of the U.S. culture wars, his subject matter has been misread as a mere inscription of identity politics.

An image from *Black Male/White Male* was chosen for the cover of *Tongues Untied* (1987), a poetry anthology featuring Isaac Jackson, Dirg Aarb-Richard, Essex Hemphill, and Assoto Saint, published by Gay Men's Press. The book was taken up as the inspiration for Marlon Riggs's video *Tongues Untied* (1989), a first-of-its-kind work which borrowed the title in an act of intertextual translation by which all cultures create themselves through acts of citation and reiteration. But when a clip from Riggs's film was then appropriated by fundamentalist politician Pat Buchanan in his 1992 U.S. presidential election campaign, a further twist was added which implicated black gay cultural production in the moral panic over arts funding that had been previously played out when Jesse Helms used the charge of obscenity against Mapplethorpe's photographs to attack the National Endowment for the Arts (Wallis, Weems, and Yenawine, 1999).

Such reductive polarizations were implicit in the either/or evaluations that had earlier bedeviled Fani-Kayode's work with a misleading comparison to the photographs of Robert Mapplethorpe. Black gay artists were certainly in dialogue with Mapplethorpe's gaze: returning the look in films such as Isaac Julien's *Looking for Langston* (1988); playing with reversibility, as suggested by Lyle Ashton Harris's self-presentation in whiteface in his *Americas* (1988) and *Confessions of a Snow Queen* (1989) series; or examining the interracial dynamics of sameness and difference more broadly, as the title of Rotimi's *Black Male/White Male* had implied (Mercer, 1994). And yet to posit the dialogic relationship to the visual tradition of Mapplethorpe's racial fetishism as providing the *only* context for the appraisal of Fani-Kayode's approach to the male nude is to overlook how he lived as a black gay artist whose primary narcissism was fully intact: "He did not have an identity crisis," as Mark Sealy (1996, n.p.) aptly puts it.

It is not so much ironic as merely tragic that, despite numerous group shows including *Sacred and Profane Love* at South West Arts in Bristol (1985), *Same Difference* at Camerawork, London (1986), *Misfits* at Oval House, London (1987), and *Transatlantic Dialogues* at Camerawork, London (1989), Rotimi Fani-Kayode enjoyed only one solo exhibition in Britain during his lifetime, *Yoruba Light for Modern Living* at Riverside Studios, London (1986). To what extent did this marginalization occur because of the way his supposed identity was exoticized as "other" on account of the art world's narrow view that there could only be *one* way of seeing the black male nude? At stake here are three interlocking issues—about institutions, intentions, and agency—which can be disentangled by rereading Fani-Kayode's 1988 essay "Traces of Ecstacy."

Aware of the risk of being anthropologized by the transcultural position he was placed in with regard to the Western art world, Fani-Kayode commented, "It is no surprise to find that one's work is shunned or actively discouraged by the Establishment. The homosexual bourgeoisie has been more supportive—not because it is especially

noted for its championing of black artists, but because black ass sells almost as well as black dick. . . . But in the main, both galleries and the press have felt safer with my 'ethnic' work. Occasionally they will take on board some of the less overtly threatening and outrageous pictures—in the classical liberal tradition. But black is still only beautiful as long as it keeps within white frames of reference" (1988, 42).

Identifying the residual dominance of modernist primitivism in the institutional inertia whereby African artists are obliged to address this art historical category simply by virtue of their ethnic origin, it was his acute analysis of this predicament that led him to define his own project as arising from a counternarrative of rage and desire in which photography would perform the task of alchemical transformation: "The exploitative mythologising of black virility on behalf of the homosexual bourgeoisie is ultimately no different from the vulgar objectification of Africa which we know at one extreme from the work of Leni Riefenstahl and, at the other, from the victim images which appear constantly in the media. It is now time for us to reappropriate such images and transform them ritualistically into images of our own creation" (Fani-Kayode, 1988, 42).

In diacritical response to such institutional conditions, Fani-Kayode produced the following self-description as a mission statement to convey his artistic intentions: "My identity has been constructed from my own sense of otherness, whether cultural, racial or sexual. The three aspects are not separate within me. Photography is the tool by which I feel most confident in expressing myself. It is photography therefore—Black, African, homosexual photography—which I must use not just as an instrument, but as a weapon if I am to resist attacks on my integrity and, indeed, my existence on my own terms" (1988, 39).

Understanding how these positions informed his attitude toward the politics of identity is complicated, however, by the views of Alex Hirst, which changed emphasis at different times. While Hirst's statement that Fani-Kayode "was not interested in being seen as a 'gay' or 'black' artist and especially not as a 'black gay' artist" seems flatly contradicted by Fani-Kayode's own words, his broader comment that Rotimi's "approach to his work was political, but it had no manifesto beyond an anarchic desire to create something that would shake the established view of the world, his own included," valuably elucidates the anti-identitarian stance they shared (Hirst, 1990, n.p.).[6] Such a skeptical disposition toward fixed political alignments may be seen in the light of his family's experience of being forced into exile as a result of political exigencies. Yet rather than disclaim it, what is more compelling to consider are the ways he chose to position his black gay identity in relation to the multiple and complex locations that shaped his postcolonial lifeworld. As Fani-Kayode emphatically announced, "It has

been my destiny to end up as an artist with a sexual taste for other young men. As a result of this, a certain distance has necessarily developed between myself and my origins. The distance is even greater as a result of my having left Africa as a refugee over twenty years ago" (1988, 39).

Echoing Audre Lorde's self-description as "sister outsider,"[7] Rotimi foregrounds his condition of outsideness as a liminal space of critical (dis)location that is valued for the new practices of freedom it makes possible:

> On three counts I am an outsider: in matters of sexuality, in terms of geographical and cultural dislocation; and in the sense of not having become the sort of respectably married professional my parents might have hoped for. Such a position gives me a feeling of having very little to lose. It produces a sense of personal freedom from the hegemony of convention. It opens up areas of creative enquiry which might otherwise have remained forbidden. Both aesthetically and ethically, I seek to translate my rage and my desire into new images which will undermine conventional perceptions and which may reveal hidden worlds. (Fani-Kayode, 1988, 39)

The paradoxical emphasis on finding one's freedom in the loss of one's origins locates his outsideness in a diasporic condition which, far from offering the dubious comforts of minoritarian self-certainty, produces "a kind of essential conflict through which to struggle to new visions" (Fani-Kayode, 1988, 39). To the extent that diaspora entailed a rupture between "myself and my origins," it can be seen as opening up an abyss out of which Rotimi tapped into the catalytic energies of rage and desire that formed the mainspring of his unique aesthetic. On this view, the dynamic equilibrium brought about by Fani-Kayode's techniques of visual interculturation can be located in the broader representational matrix formed by the historical convergence of modernism, colonialism, and diaspora.

At the apex of this triangular relationship lies the vexed question of the mask and what it masks. This includes art histories of cultural traffic, as well as struggles over the psychic reality of the masks Frantz Fanon spoke to in *Black Skin, White Masks* (1967a), where he sought to decolonize the black body from its representation as the Other. To recontextualize Fani-Kayode's photographic transfiguration—in which the body becomes a site for translation and metaphor, transporting meanings across codes of racial, cultural, and sexual difference—we can separate two strands whose interrelationship is poorly understood: the dynamic between interracial homosexuality and the aesthetics of interculturality. Both come together in the enigmatic function of the mask that lies at the heart of Fani-Kayode's visual world.

The Mask and What It Masks: The Loss of Difference

In African traditional art, the mask does not represent a material reality; rather, the artist strives to approach a spiritual reality in it through images suggested by human and animal forms. I think photography can aspire to the same imaginative interpretations of life.

—Fani-Kayode, "TRACES OF ECSTACY"

In the sense that the body serves as a site for exploring the relationship between the sexual and the spiritual, it is crucial to address the question of Fani-Kayode's relationship to his Yoruba sources. What we find, however, once we incorporate his self-understanding as an African artist, is that we cannot romanticize this relationship as an Afrocentric return to one's roots. In place of continuity with one's origins, Fani-Kayode's critical outlook foregrounds the ruptures of diaspora. Commenting that "an awareness of history has been of fundamental importance in the development of my creativity" (Fani-Kayode, 1988, 38), he implies that far from being a naturalistic inheritance, his knowledge of Yoruba cosmology was acquired through negotiating its (mis)representation within the West as an embodiment of the exotic or the primitive. He wrote, "In exploring Yoruba history and civilization, I have rediscovered and revalidated areas of my experience. I see parallels now between my work and that of the Osogbo artists in Yorubaland who themselves have resisted the cultural subversions of neo-colonialism and who celebrate the rich, secret world of our ancestors. It remains true, however, that the great Yoruba civilizations of the past . . . are still consigned by the West to the museums of 'primitive' art" (41).

Aware of the ideological equivalence between the exotic and the erotic in the construction of the primitive as modernism's Other, he delineated the interstitial conditions which shaped his mediated relationship to his Yoruba sources:

Modern Yoruba art (amongst which I would situate my own contributions) may now fetch high prices in the galleries of New York and Paris. It is prized for its exotic appeal. Similarly, the modern versions of Yoruba beliefs carried by the slaves to the New World have become, in their carnival form, tourist attractions. In Brazil, Haiti and other parts of the Caribbean, the earth reverberates with old Yoruba rhythms which are now much appreciated by those jaded Western ears which are still sensitive enough to catch the spirit of the old rites. In other words, the Europeans, faced with the dogged survival of alien cultures, and as mercan-

tile as ever they were in the days of the Trade, are now trying to sell our culture as a consumer product. I am inevitably caught up in this. (Fani-Kayode, 1988, 41)

While Picasso's 1907 epiphany before the tribal African masks he encountered in the storerooms of the Trocadero Museum is a commonplace in the received narratives of Western modernism, there are two other strands to this history of interculturation that are less widely known. On the one hand, among artists such as Aina Onabolu in Nigeria, whose paintings date from 1906, it was paradoxically the post-Renaissance aesthetic of Western verisimilitude that inaugurated a modernist break in African consciousness, for indigenous artifacts which Europeans valued for their alienness were taken by their African counterparts to epitomize mere traditionalism.[8] And on the other hand, there is a third strand to the story: namely, the shared fascination with African masks among African American artists of the Harlem Renaissance who were as alienated as Matisse or Modigliani from the indigenous meanings of such foreign objects.

Responding to Alain Locke's 1925 essay "Legacy of the Ancestral Arts," which suggested that an alternative apprenticeship for the New Negro could be found by turning to the formal discipline of African art, artists such as Palmer Hayden, in his *Fetisches et Fleurs* (1926), Malvin Johnson, in his *Self-Portrait* (1938), and Lois Mailou Jones, with her *Fetiches* (1938), all embraced the iconicity of the generic African mask.[9] As objects which had entered diaspora consciousness mostly through Western museum collections and ethnographic photography, the mask was appropriated into African American art as a touchstone for an altered identification which enunciated a pan-African ethnicity. Indeed, acknowledging its recurrence as a distinctive visual trope, from the photomontages of Romare Bearden through to the parodic neoprimitivism of Jean-Michel Basquiat, it may be argued that by appropriating that which was always already appropriated by the West, the mask functions in black modernism not so much to allude to Africa as it is but to an idea of "Africa" as it exists within the diaspora imagination. It is the signifier of a lost origin reconstructed in collective memory as the presiding symbol for the production of syncretic subjectivity. Alongside other contemporary artists who share an interest in the body as it is hinged between material and spiritual worlds—such as Renée Stout's *Fetish #2* (1988) (fig. 4.3) or Alison Saar's *Lazarus* (1988) in the medium of sculpture, or the *I-Traits* (1982–85) photographs by Jamaican-Chinese artist Albert Chong (fig. 4.4)—the aesthetic mixity brought about by Fani-Kayode's use of such elements as the mask sits full square within this diasporic tradition.

The sight lines which thus cut across Fani-Kayode's field of vision are clearly illuminated by Stuart Hall's lucid observations in which he points out that "the black male

4.3 Renée Stout, *Fetish #2*, 1988. Mixed media, plaster body cast, 162.56 cm high.
Dallas Museum of Art, Metropolitan Life Foundation Purchase Grant, 1989.27.
Courtesy of the artist.

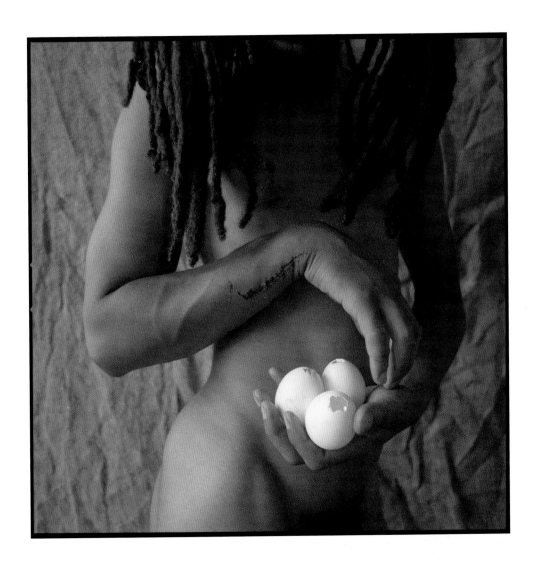

4.4 Albert Chong, *Self-Portrait with Eggs*, 1987. Courtesy of the artist.

body becomes the locus for a number of intersecting planes of meaning. The hieratic, carefully ritualised posture of the figures, their central framing, the deliberate use of costume, body decoration, *and above all*, masks, reference Fani-Kayode's exploration of his Yoruba background. . . . Yet this 'African' plane of reference is, almost immediately, subverted by other meanings and languages. The symbolism hovers between a public or collective, and a more private and personal, set of codes" (1990b, n.p.).

These "other meanings and languages," I would suggest, come from Fani-Kayode's mastery of Western modernism and the subcultural codes of modern gay iconography. Hall places "African" in quotation marks precisely to indicate that what is at issue is not the unconcealing of an authentic Africanity but the bringing into vision of a new and unprecedented body whose presence, so often fetishized by the difference that history has written on the skin, is transformed in its meaning by the unresolved and open-ended interplay of incommensurable codes. The blind spot to the Mapplethorpe comparison is that it fails to see how the racialized dynamics of the gaze are radically interrupted by the auratic presence of the mask. Although it is obvious and logical that a mask deflects the exchange of direct looks (which is central to the power-laden polarities of the male gaze), it is remarkable that its presence in Fani-Kayode's work has been overlooked. It is a central motif whose recurrence, from works such as *Ebo Orisa, Farewell to Meat (Carnavale)*, and *Bronze Head* (all 1987) to *The Golden Phallus* (1989), inscribes a carnival of condensation and displacement in the critical difference that Rotimi brings to his visual depiction of the black male body. As Hall continues:

> The faces are all "masked." In his most compelling erotic image—*Technique of Ecstacy*—the face, concentrated in desire, is finally hidden from the viewer's gaze. Fani-Kayode "subjectifies" the black male, and black sexuality, claiming it without making it the object of contemplation and at the same time without "personifying" it. Because the masking is not a compositional trick, but an effect drawn from another iconographical tradition, the truncation of the body condenses the visual effect, displacing it into the relation between the two figures "at rest" with the weight, the specific gravity of concentrated sexual pleasure, without translating them into fetishes. (1990b, n.p.)

Whereas the scopophilic force exerted by Mapplethorpe's gaze fetishized the black body in order to ward off a threat to the ego's loss of control, in Fani-Kayode's tableaux the viewer's look is drawn into a scenario of sexual enjoyment in which the loss of difference dissolves the ego's boundaries of self and other. Genital-centered excitement gives way to a sensation of erotic reverie and drift (fig. 4.5).

4.5 Rotimi Fani-Kayode, *Mask (Ecstatic Antibodies)*, 1989.
Courtesy of Autograph: ABP, London.

Concluding that "Rotimi has both learned from Mapplethorpe, and fought him off, and brought another tradition of representation to his work,"[10] Hall allows us to recognize such influences in early formalistic sketches such as *Knave of Spades* or *Joining of Equal Forces* (1987), and also to move on to a wider view of the "other meanings and languages" that Fani-Kayode plays with. *White Bouquet* (1987), for example, is a queer diasporic parody of Manet's *Olympia* (1863). Through a point-by-point reversal of the painting's racial and gendered positions, it playfully suggests a subtextual homoeroticism in the original (between white courtesan and her black female maid). By perverting the copy, which shows a white man offering flowers to a black man who reclines on a couch, it subverts Olympia's gesture of withholding, which is now a reciprocal exchange of gifts (as the prone body presents its rear).

In contrast to the phallic jouissance prompted by Mapplethorpe's fixation on the visible difference of black skin, which uses interraciality to excite the sharply defined subject-object polarities of the gaze (thereby substituting racialized positions in a masculinist fantasy of mastery staged around the possession or lack of the phallus), Fani-Kayode quietly steps outside such Manichean absolutism (which often accompanies the Catholicism that was part of Mapplethorpe's Irish American ethnic background). Because black bodies are coupled and contextualized in Rotimi's vision, the loss of difference arising in the *petite mort* of sexual pleasure is infused not with the terror of castration but with a sublime depth of feeling that reveals sexuality as something both animal and divine. Returning to *Technique of Ecstacy* (1987), which refers to the expressive homoeroticism of Francis Bacon's painting *Two Figures* (1957), we can see how Fani-Kayode's approach to the ecstatic dissolution of the ego differs from that of gay artists working in a monocultural tradition alone. The frenzied liquidation of boundaries in Bacon's radical loss of self is here becalmed in a state of postcoital *triste*.[11] Commenting on how the picture came about, Alex Hirst reveals how hybridity was integral to their working methods: "*Technique of Ecstacy* [stems from] the idea that the babalawo (father of the secrets or priest) goes into an ecstatic trance in order to communicate with the god. Rotimi and I understood the artist to be doing something parallel to that and also, on a more jokey level, we wanted to show that two black men can have sex as a means of communicating with the spirits" (1992, 8).

As a limit-experience in which the feeling of self gives way to something that is not-self, the "I" plunges outside its being, and the relation of self and other is torn apart. The subject crosses over into a state of nonbeing that, for thinkers like Georges Bataille, is likened to death.[12] Fani-Kayode's photographic vision embraces a pictorial classicism that evinces his mastery of Western art historical traditions of the male nude, yet his

interest in the way AIDS transformed equations of sex and death was grounded in the temporal specificities of his time. This needs to be borne in mind considering his complex relationship to Yoruba spirituality which his self-defining mission statement from "Traces of Ecstacy" expresses: "My reality is not the same as that which is often presented to us in western photographs. As an African working in a western medium, I try to bring out the spiritual dimension in my pictures so that concepts of reality become ambiguous and are opened to re-interpretation. This requires what Yoruba priests and artists call a technique of ecstacy" (Fani-Kayode, 1988, 38).

When he says that "my reality is not the same," far from implying an essential self behind the mask, I take him to mean that his contingent conditions of existence led Rotimi to an artistic position in which the ritual function of the mask presaged the transformation of reality. Art was his life-affirming motivation for examining the relationship between ancestral memory (death) and erotic fantasy (sex). It may be pointed out that there is nothing ordinary about being the gay son of a high priest who was also a member of the political aristocracy. And yet far from rebelling against his background, he overcame the feared loss of love that his individual difference might bring to his fate, by honoring his Yoruba traditions in the most postmodern way imaginable. As Hirst revealed, almost comically, their inspiration for works such as *Technique of Ecstacy* came from stories encountered in ethnographic texts such as Suzanne Wenger's *A Life with the Gods*.[13] In other words, the natives had to become who they were by first reading the anthropologists!

Although the man in the pictures is often Rotimi himself, his work is not about an autobiographical or confessional self because the use of the mask foregrounds the "I" over the "me." By depolarizing the ego's boundaries, what results is the sensation of "hovering" between two worlds that Hall described. It is the oscillation activated by this "fugitive aesthetic" that delivers the viewer's response to a liminal place of voluptuous indeterminacy.[14] Worldly codifications of difference are freed up by movement *between* the fixed polarities—sacred and profane, masculine and feminine, Africa and Europe—which have anchored the messy edges of human corporeality to the social obligations of identity.

It is therefore crucial to recognize that, as well as an elegiac vision of transience, there is the laughter of a trickster's mischief that flows from the freedom Rotimi found in the abyss that opened between "myself and my origins." In *Milk Drinker* (1987), a man drinks eagerly from a gourd, a cultural artifact whose presence connotes Mother Africa. And while the overflowing milk makes the container a metonymic symbol of the maternal breast, the gourd is also a metaphorical penis, and a connotation of fel-

latio inescapably arises by virtue of the way it looms above the mouth, as if it belonged to a saint or a god. Interposed between gods and mortals, the mask serves a limbic or gateway function which does not conceal a "true" self (as masquerade in Western traditions often assumes), but rather serves to liberate heterogeneous elements from the psyche. As Hirst elucidates one of Fani-Kayode's key works, *Bronze Head* (1987), we realize that the task is to de-anthropologize the interpretative enigma. Knowledge of Yoruba codes, although necessary, does not fix the meaning or arrest the ambiguity of the image but expands critical awareness of the psychic realities which the photograph communicates:

> In *Bronze Head* Rotimi is "giving birth" to an Ife bronze. Ife, the cradle of an ancient Yoruba culture, is also his city of origin. The head, *ori*, which for the Yoruba is the seat of the spirit, *orisha*, represents a god. Symbolically, the artist is transforming his old culture into contemporary terms, having understood that the old values no longer "work" but still have power as archetypes. Also, he is presenting his rear-end, a traditional affront to the powers that be. The image contains the idea of the head as a "higher phallus," penetrating and fecundating the artist. Although a man, destined to penetrate the depths of the unconscious, here the artist is also a feminine "receiver" who is fertilised by it and thus able to bring forth a "son" of God. (Hirst, 1992, 8)

The mask configured in *Bronze Head* thus reveals what Freud called the universal bisexual disposition of the human psyche, reaching a view not only shared by Yoruba beliefs but echoed by James Baldwin when he wrote, "[We] are all androgynous, not only because we are all born of a woman impregnated by the seed of a man but because each of us, helplessly and forever, contains the other—male in female, female in male, white in black, black in white. We are part of each other."[15]

Of the many orisha evoked in Fani-Kayode's depiction of acts of propitiation—the gift by which the protection of the gods is requested—there is a strong sense in which Eshu Elegba, the orisha of fate, chance, and indeterminacy who inhabits a place of crossroads, pervades the oeuvre as a whole. This is because Eshu, "the childless wanderer, alone, moving only as a spirit," is the messenger of all the gods as well as "the imperative messenger-companion of the devotee" (Thompson, 1983, 19). In an earlier exhibition in which he presented *Abiku* (1988)—a work that depicts the changeling or protean spirit child of Yoruba mythology with a caul around its neck—Fani-Kayode illuminated the logic of his visual thinking by showing how human laws of sexual difference are overturned by the sexual *in*difference of the gods:

Esu presides here, because we should not forget him. He is the Trickster, the Lord of the Crossroads, sometimes changing the signposts to lead us astray. At every masquerade (which is now sometimes called Carnevale — farewell to flesh for the period of fasting) he is present, showing off his phallus one minute and crouching as though to give birth the next. He mocks us as we mock ourselves in masquerade. But while our mockery is joyful, his is potentially sinister. In Haiti he is known and feared as Baron Samedi. And now we fear that under the influence of Esu's mischief our masquerade children will have a difficult birth or will be born sickly. Perhaps they are *abiku* — born to die. They may soon return to their friends in the spirit world, those whom they cannot forget. We see them here beneath the caul of the amniotic sac or with the umbilical cord around their neck or wrist. We see their struggle for survival in the face of great forces. Esu's phallus enters the brain as if it were an asshole. He drags birth from the womb by means of a chain gangling from his own rectum. These are examples of his "little jokes." These images are offered now to Esu because he presides here. It is perhaps through him that rebirth will occur.[16]

Numerous artists have visited this liminal place of gender hybridism. More relevant than Robert Mapplethorpe as precursors to Rotimi's project would be the Trinidad-born Geoffrey Holder, whose *Adam* (1980) reworks the biblical creation myth of Genesis, or George Platt Lynes, whose *Birth of Dionysus* (1935–39) drives from a reinterpretation of Greek myth through surrealist photomontage. Patriarchal religions may harbor the male fantasy of a god whose birth occurs without women, but the idea of rebirth often calls sexual difference itself into question. The quest for renewal enters a psychically androgynous zone which Audre Lorde called a "resource within each of us that lies in a deeply female and spiritual plane, firmly rooted in the power of our unexpressed or unrecognised feeling," when she put forward the view that "the erotic is a measure between the beginnings of our sense of self and the chaos of our strongest feelings."[17] This pansexualist view was voiced in the *Black Male / White Male* introduction, when Alex Hirst wrote, "Male: in which the female-fantasy is ever present, even in remaining unseen. No threat in these images but only a delicious vulnerability, learned from our mothers and our sisters. [We] see no woman here, but I don't feel I've swaggered into one of those gloomy men-only places where tired infibulators can relax and get away from their responsibilities for a night, while they marvel at themselves in the full-length mirrors."[18]

Grounded in an implicitly political critique of gay masculinism, Alex and Rotimi's collaborative project in *Bodies of Experience / Every Moment Counts* (1989) led them to

investigate the spiritual realm as the fulcrum of their syncretic turn. Against the grain of AIDS activism as such, the aim of their journey was to ask what art could do to "produce spiritual antibodies to HIV." And as they put it:

> There is nothing easy or straightforward about it. . . . [We] have drawn on transcultural and trans-historical techniques to offer our response to a phenomenon which is specific only in terms of the individuals it affects here and now. We (happen to) have been inspired in this by ancestral African, ecclesiastical, and contemporary "Western"/erotic images. HIV has forced us to deal with dark ambiguities. Where better to look for clues than in the secret chambers of African shrines, the sumptuous ruins of Coptic and Eurasian temples, and the boarded-up fuck rooms of the American dream. In the European "Dark Ages" faith in ancestral values ensured a survival of sorts until a time of rebirth or enlightenment (resurrection was a good idea even then). (Fani-Kayode and Hirst, 1990, 78, 80)

While their apparently poetic rather than political stance appeared controversial in a context where AIDS activism had seen mourning and militancy as either/or responses,[19] we can come to the photographs of the *Communion* suite with a view to unraveling the broader question of rebirth or resurrection as it is envisaged in their transfiguration of the body which, in the code-switching of their visual syncretism, transmits a cool glow of almost angelic indeterminacy.

Eshu Dionysus: Love Will Tear Us Apart (Again)

A nude black male sits in a darkened space and looks out to us across the viewing plane. His masked face is obscured by a birdlike visage painted in white, and his penis, painted gold, is suspended on a piece of string, creating diagonal lines that bisect the axis of his gaze. Hirst eloquently describes the picture's aims: "*The Golden Phallus* is there to show that we were dealing with issues of stereotyped black male sexuality, linked to issues of AIDS, but not directly. We wanted to challenge [this idea that black men are studs—The Phallus]. The gold makes the dick the centre of attention but the string shows the burden is too much to live up to. It's a very subversive picture" (1992, 10).

Indeed, *The Golden Phallus* (fig. 4.6) gains visual power by deploying syncretism to subvert any attempt to master its plural meaning(s). The two isolated body parts— penis and head—entail elements of Yoruba color symbolism and the use of animal forms: But what is the nature of their relationship to the stereotype? Discussing the untranslatable concept of ashé as "the power-to-make-things-happen," which is identified

4.6 Rotimi Fani-Kayode, *The Golden Phallus*, 1989. Courtesy of Autograph: ABP, London.

as the substance of God—Olorun—who "is neither male nor female but a vital force," Robert Farris Thompson examines conceptions of beauty and character in Yoruba aesthetics. "Artistic signs communicating this noble quality, *iwa*, are often white," he says, adding:

> A main focus of presentation of ideal character (*iwa rere*) in Yoruba art is the human head, magnified and carefully enhanced by detailed coiffure or headgear. . . . According to traditional authority, shrines of the head also conceal an allusion to a certain perching bird. This is the "bird of the head" (*eiye ororo*) enshrined in whiteness, the colour of *iwa*, and in purity. It is the bird which God places in the head of man or woman at birth as the emblem of the mind. The image of the bird of mind fuses with the image of the coming down of God's *ashé* in feathered form. (1983, 5)

Insofar as the white bird's elongated beak visually rhymes with the gold penis at the center of the field of vision, a contrapuntal dynamic of similarity and difference is established. Recalling the symbolism of the head as a "higher phallus" that was seen in *Bronze Head*, it may be suggested that *The Golden Phallus* deploys the mask in order to seek protection against the historically material force of the gaze that appropriates the black penis as the *objet petit a* that is fixed in colonial fantasy to secure the jouissance of the Other "who is also the Master," as Fanon (1967a, 138) would say. Engaging the mind/body dichotomy of racial fetishism, the picture could also be read as an ultimate answer-word to Mapplethorpe's *Man in a Polyester Suit* (1980) as it changes the terms of the conversation about what the black penis supposedly symbolizes.

Fani-Kayode and Hirst are operating in the psychic terrain described by Fanon when he experienced the look that comes from the place of the Other—"Look, a Negro!"—as a violently shattering force in which "I found I was an object among other objects" (1967a, 109). Because the black body has already been objectified into a symbol that represents, for the West, all that is not-self, the colonized subject cannot constitute its ego on the basis of the neutral bodily schema ordinarily identified with in the mirror stage. Instead of mutual recognition, Fanon says that "when I had to meet the white man's eyes [a]n unfamiliar weight burdened me," namely, the, "legends, stories, histories," by which colonial racism perceives the body as the locus of absolute otherness. Hence, "assailed at various points, the corporeal schema crumbled, its place taken by a racial epidermal schema. . . . I was responsible at the same time for my body, for my race and for my ancestors" (110, 112). The burden of having to represent otherness so that someone else's self may be constituted by antithesis means that the Negro does not have an Other of its own. Like the structural position of the woman, whose lack de-

fines the power and plenitude that possession of the penis confers on the man, when the black male body is colonized by the symbolic duty of *being* the phallus, rather than merely *having* it, access to subjectivity is annulled because one is already the signifier of the Other's desire and therefore cannot have a desire of one's own. Where the phallus is the signifier of desire, the Other *is* it to the extent that she or he does not *have* it: or, as Fanon puts it, "One is no longer aware of the Negro, but only of a penis; the Negro is eclipsed. He is turned into a penis. He *is* a penis" (170).

The existential dilemma that arises from this dialectic of being and having results in the torment of an impossible identification with the object of the Other's desire. The black penis is overburdened with the symbolic weight of too much meaning, or, as Clyde Taylor has put it, in the context of the 1994 *Black Male* exhibition, "The psychic sickness of America is such that everyone, White Man, White Woman (and Black Woman too), wants to tell the Black Man what they would do if they had his penis."[20] The trouble is, however, that the black male subject himself does not know what to do with it either because he does not even enjoy the possession of his own penis—it has always been already appropriated into the master code of the symbolic order as the prize signifier of absolute difference. It was precisely a desire to liberate black masculinities from this no-win situation, where self-definition which fixates on the phallus can only confirm the symbolic control of the master's power, that Essex Hemphill expressed in his poem "Black Machismo": "When his big black dick / is not erect / it drags behind him, / a heavy, obtuse thing, his balls and chains / clattering, making / so much noise / I cannot hear him / even if I wanted to listen."[21]

On this view, *The Golden Phallus* is gold because gold symbolizes a universal standard of absolute value which governs the fetishism of commodity exchange. Because gold functions as a signifier of material desire (and, like the phallus, is the symbolic measure by which all differences are evaluated), its presence in the photograph is to condense the history of commodification through which the black male body was colonized into a double bind: black men can only be valued or desired for their bodies in a Manichean world in which the mind/body split already devalues the body as the symbol of the Other's undesirable ontology. Gold thus turns to lead as history unleashed the violence of castration against the weight it condemned us to carry between our legs—"balls and chains," indeed.

At yet instead of Sturm und Drang in rage and resentment at history's cruelty, which crucified black male bodies in a Lacanian knot where the signifier claims its pound of flesh, *The Golden Phallus* produces a structure of feeling in which the mask protects the shrine of the mind and casts the body in cool repose.

Elsewhere, in *Sonponnoi* and *Babaoluaye* (both 1987), Fani-Kayode invoked the smallpox god Obaluaiye, and he worked with a deep interest in the homeopathic logic of the pharmakon, whereby poison and cure may share an identical substance and the critical difference depends on finding the right equilibrium. In that the white *ororo* bird may signify an appeal to Osanyin, the orisha of herbal medicines, the prophylactic role of the white mask may be illuminated by Farris Thompson's observations in which he states, "Birds, especially those connoting the *ashé* of 'the mothers,' those most powerful elderly women with a force capable of mystically annihilating the arrogant, the selfishly rich, or other targets deserving of punishment, are often depicted in bead embroidery clustered at the top of special crowns worn by Yoruba kings, signifying that the king rules by mastering and participating in the divine command personified by them. The veil that hangs across the wearer's face protects ordinary men and women from the searing gaze of the king in a state of ritual unity with his forebears" (1983, 7–8).

Is the black man in *The Golden Phallus* protecting himself from our desire to look, or is he protecting us from his own gaze which is in contact with a divine power? It is the undecidability that unsettles our response. While it has been noted that "the averted gaze of the models enhances the sense of reverential calm" (Sealy, 1996, n.p.), the underlying complexity of the syncretic code-switching which engenders this aesthetic effect in Fani-Kayode's visual world also produces a further critical difference that has been so far overlooked: namely, the absence of the mortified body that lies at the heart of Christianity. Examining *Communion* may bring us to a provisional answer.

Although *The Golden Phallus* was first exhibited alongside the *Bodies of Experience / Every Moment Counts* series (1989) (which featured nudes adorned with flowers in a mise-en-scène reminiscent of the Sicilian ephebes depicted by Baron Wilhelm von Gloden), the recurrence of key elements suggests it has pivotal interpretative importance in the *Communion* suite as a whole. There is an alternate version in which the masked figure crouches with a downcast gaze, despondently contemplating his penis; in another, the head is cropped and the gold penis thereby becomes the nose of a horned animal (like an antelope) painted onto the pubis and torso, with the model's upturned hands showing the feathery red tassels of a beaded waistband. To these are added a shot in which the model is seen from behind, holding the white birdlike mask on top of a glass jar held above his head, with another man's hand emerging from between his buttocks to grasp his cheeks. Finally, there is a fourth variant showing a frontal view of the figure with the lower-body painting of the animal form and the gold penis but now clasping a black horsetail fly whisk to his chest as his head, which is concealed by the white mask, is thrown back sharply to reveal his opened mouth (figs. 4.7 and 4.8).

4.7 Rotimi Fani-Kayode, *Gold Phallus*, 1989. Courtesy of Autograph: ABP, London.
4.8 Rotimi Fani-Kayode, *Golden Phallus*, 1989. Courtesy of Autograph: ABP, London.

Without a script to plot their relationship, the five images nonetheless imply the sequential depiction of an act being performed in a time-based ritual. Because the potential sequence has not been narrativized by authorial intentions, we are obliged to travel through a more circuitous route in order to arrive at an idea of what this act might be. It seems to me that the *absence* of the crucified body supplies a clue. With the exception of *Crucifix* (1987) and the image of Rotimi himself that appeared in Hirst's memorial work *The Last Supper* (1992) — of which Alex said, "After he died I found the Crucifixion picture, which I had forgotten about. It had been a joke — a naked dread posing as 'Our Lord' — but it was much more poignant after his death" (Hirst, 1992, 6) — it is strikingly unusual that such an iconic way of seeing is missing from Fani-Kayode's field of vision.

Portrayals of the male nude within the symbology of the crucifixion can be seen as a significant point at which the visual codes of the African diaspora and of Euro-American gay culture converge, producing different meanings out of a shared interest in what the body-in-pain can be made to say. Once we consider the central role that depictions of a "black Christ" have played among visual artists of the African American diaspora, where the spectacular suffering of the body-in-pain is implicated in the broader Afro-Christian envisioning of redemption, we are confronted with yet another enigma: namely, the absence of the sadomasochistic dynamic that makes the cruciform body an equally central point of reference within the homoerotic imagination of the West. Although the accoutrements of sadomasochism are present in works such as *Punishment and Reward* (1987), and a black man strapped into a leather harness contemplates a mask in one image in the *Every Moment Counts* series (1989), the Christian belief in the redemptive power of pain is not. In his regard we may observe how Fani-Kayode's syncretic transgression opens fugitive lines of flight that bypass the polarities of difference on which the tragic view of human desire depends.

In the light of the previous discussion of the black phallus, the recurrence of the crucified body in African American art — from Aaron Douglas's *The Crucifixion* (1927), through David Hammons's *Injustice Case* (1970) bodyprint, to the skinless and skeletal bodies of Jean-Michel Basquiat's paintings, such as *Untitled* (1981) — may be taken to imply a tragic vision of black desire. Where history has condemned black bodies to be overburdened with more meanings than any mortal could ever hope to bear, the sacrificial scapegoat represented in "the nude of pathos" can be understood to express a belief that freedom can be found only in death.[22] Discussing configurations of pain in Basquiat's work to reveal how they speak "the anguish of sacrifice," bell hooks insightfully reads the masochistic emphasis on self-immolation as a distinctly masculinist response that remains unreconciled with "a world of blackness that is female."[23]

On the other hand, revisiting the question of femininity in male homosexuality,

Kaja Silverman identifies the volitional suffering chosen in ecstatic masochism as a complex and subtle strategy that subverts phallocentrism's gendered equations of passive and active aims.[24] Similarly, following Bataille's view that what eroticism transgresses is precisely the subject-object dichotomy from which identity and difference arise, Leo Bersani reveals the primacy of masochism in sexual pleasure *tout court*. He suggests that because "the self which the sexual shatters provides the basis on which sexuality is associated with power," gay sadomasochism entails a radical disidentification with patriarchal power: it involves a transvaluation of powerlessness as a source of exuberant self-shattering.[25] Once we situate Fani-Kayode's body of work in the purview of Jonathan Dollimore's summation of this far-reaching debate, new light is shed on the Dionysian "nude of ecstacy" which we see in the *Communion* suite:

> On the one hand is the yearning to compensate for the loss which haunts desire, to overcome or redeem a loss experienced as unwelcome, unbearable, yet seemingly unavoidable (the Aristophanes myth). This is the drive towards unity. On the other hand there is the yearning to become lost: to annihilate the self in ecstasy: to render oblivious the self riven by, constituted by, loss. This is the drive to undifferentiation (Schopenhauer, Freud, Bataille). *Now* an attempt to flee that sense of separation and incompletedness, a wish for difference without pain, for unity, identity, and selfhood, through union with the other; *now* a desired, even willed, loss of identity in which death is metaphor for, or fantasised or the literal event guaranteeing, the transcendence of desire.[26]

To the extent that this enables us to recognize how the cruciform body resonates in gay culture as masochism's life-risking symbol of self-shattering desire, and in diaspora culture as the site in which the redemptive transformation of the pain experienced in being shattered by the Other finds transcendence in death, both are circumscribed by Christianity's injunction to identify with the self-sacrifice that is displayed on the cross. The *Communion* photographs, alternatively, deliver us to a place that is beyond good and evil: although the gift relationship of propitiation involves an act of sacrifice, the relationships between humans and gods at issue in the values of beauty, character, and ashé do not entail self-sacrifice as such but the humility of honoring the memory of the ancestral dead. Is this the reason why, as well as the absence of the crucified body, we can find no trace of self-pity or guilt in Rotimi's work?

Bataille reminds us that the sexual is but one route into the realm of the sacred, itself a word derived from the verb "to sacrifice." Moreover, spiritual belief systems often overlap when the loss brought about by death is held to lead to renewal. Yoruba-derived religious systems, such as candomblé in Brazil, vodun in Haiti, and Santeria in

Cuba, or syncretic forms of Afro-Christian revelation such as glossolalia, or speaking in tongues, all involve psychic states such as the trance in which the elective loss of self enables the loa or orisha to descend. Nonetheless, it strikes me as suitably ironic that the awe-inspiring exstasis of the postcolonial body depicted in *Communion* can be clarified by the (West-centric) views of art historian Kenneth Clark. Moving from the nude of pathos and the nude of energy to discuss the nude of ecstasy in the poses and movement of Greek art, "which expressed more than physical abandonment, which were in fact images of spiritual liberation achieved through the Thiasos or processional dance," his remarks vividly encapsulate the dynamism of the final image in which the masked man's head is thrown back with mouth agape and the camera's shutter speed traces the fugitive movement of his indecipherable levitation: "In the nude of energy the body was directed by will. In the nude of ecstacy the will has been surrendered and the body is possessed by some irrational power; so it no longer makes its way from point to point by the shortest and most purposeful means, but twists and leaps, and flings itself backwards, as if trying to escape from the inexorable, ever-present, laws of gravity. The nudes of ecstacy are essentially unstable."[27]

Offering his view of Michelangelo's drawings, including *Risen Christ* (c. 1532), which dates from "a period in his life when the physical beauty of the antique world had laid its strongest enchantment on him, and seemed to have been reborn in the person of Tommaso Cavalieri [his patron],"[28] Clark not only (inadvertently) reveals the centrality of homoerotic desire to the West's most cherished self-representations of the sacred, but (equally unwittingly) provides us with an enhanced understanding of the pagan joy of Rotimi Fani-Kayode's syncretic aesthetic, which I would therefore describe as somewhat Afro-Greek:

> Like all Dionysiac art they celebrate the uprushing of vital forces breaking through the earth's crust. For the nude of ecstasy is *always a symbol of rebirth*. . . . Of all the themes which [his Christian meditations] suggested, *none was more apt for pagan interpretation* than that of the slain God emerging from the tomb. Iconographic tradition had shown him only half awake from the trance of death; but Michelangelo imagined him as the embodiment of liberated vitality. . . . A finished study of the risen Christ is perhaps the most beautiful nude of ecstasy in the whole of art. The thrown back head, the raised arms, the momentary pose, the swirl of drapery, are all those of the old Dionysiac dancers.[29]

In the sense that Yoruba orisha and Hellenic gods are brought into a dance that encircles death with a vital desire for rebirth, Rotimi and Alex's shared lifework brings a

new interpretative challenge to the ways we perceive the relationship of sex and death. Their aim was not to answer this ancient enigma for once and for all time, but to enhance our awareness of ecstacy as a sovereign moment in "the ruined fabric of the shattered human," which has the potential to bring forth renewal from loss of the self.[30] This is the beauty of their creative gift. Remembering his partner, Alex Hirst shares insights into the wonder which contemporary art and imagination has acquired by way of Rotimi's journey of exilic regeneration, when he wrote:

> It is important to know that he kept faith with many of the values which his background had given him. Leaving Africa as an exile at the age of eleven meant that he was haunted for the rest of his life by a desire to get to grips with certain mysteries he had glimpsed there: in the traditions and beliefs of his ancestors. He tried to make sense of them in the context of a dislocated world. Brighton and school in the English countryside was obviously quite different from that of Lagos and Ibadan. He never really considered returning to Nigeria permanently, although he visited it often during the Seventies and early Eighties. In any case, Nigeria was in his imagination. (1990, n.p.)

NOTES

This chapter was first published in *Over-Exposed: Essays on Contemporary Photography*, edited by Carol Squires (New York: New Press, 1999), 183–210.

1. Ben Okri, *Astonishing the Gods* (London: Picador, 1996).

2. The *Communion* exhibition was presented in the context of the africa95 arts program.

3. Tessa Boffin and Sunil Gupta, eds., *Ecstatic Antibodies: Resisting the AIDS Mythology* (London: Rivers Oram, 1990).

4. Compare the differential emphasis in Emmanuel Cooper, *Fully Exposed: The Male Nude in Photography*, 2nd ed. (London: Routledge, 1995, 160), and Oguibe, 1996, 236. On the other hand, the critical analysis of the work itself is entirely displaced into the background by an anxious concern over the status of Fani-Kayode and Hirst's collaborative authorship in Octavio Zaya, "On Three Counts I Am an Out-

sider: The Works of Rotimi Fani-Kayode," *Nka: Journal of Contemporary African Art*, no. 4 (Summer 1996): 24–29.

5. See Olu Oguibe, *Ozu Egonu* (London: Karla, 1996); on Taiwo Jegede, see *The Artpack: A History of Black Artists in Britain* (London: Haringey Arts Council, 1988), n.p.

6. The 1990 commemorative exhibition brochure with texts by Stuart Hall and Alex Hirst was produced by the Friends of Rotimi Fani-Kayode, which comprised Sonia Boyce, Michael Cadette, Alex Hirst, and Margaret Proctor.

7. Audre Lorde, *Sister Outsider: Essays and Speeches* (Freedom, CA: Crossings, 1984).

8. On Aina Onubulu, see Everlyn Nicodemus, "Inside Outside," in *Seven Stories about Modern Art in Africa*, ed. Clementine Deliss, exhibition catalogue (London: Whitechapel Gallery, 1995), 29–36.

9. Alain Locke, "Legacy of the Ancestral Arts," in *The New Negro* (1925), ed. Alain Locke (New York: Atheneum, 1977).

10. Stuart Hall quoted in Derek Bishton, "A Black British Photographer," in *Rotimi Fani-Kayode and Alex Hirst: Photographs*, ed. Mark Sealy and Jean Loup Pivin (Paris: Editions Revue Noir, 1997), 69.

11. Ernst van Alpern, *Francis Bacon and the Loss of Self* (London: Reaktion Books, 1992).

12. Georges Bataille, *Eroticism: Death and Sensuality* (1960) (San Francisco: City Lights, 1986).

13. Suzanne Wenger with Gert Chesi, *A Life with the Gods* (Berlin: Perlinger, 1983).

14. The concept of a fugitive aesthetic in African American aesthetics is developed by Nathaniel Mackey, "Other: From Noun to Verb," *Representations*, no. 39 (Summer 1992): 51–70.

15. James Baldwin, "Here Be Dragons," in *The Price of the Ticket, Collected Nonfiction, 1948–1985* (New York: St. Martin's, 1985), 685.

16. Rotimi Fani-Kayode, "Abiku—Born to Die," in *The Invisible Man*, ed. Kate Love and Kate Smith, exhibition catalogue (London: Goldsmiths Gallery, 1988), n.p.

17. Lorde, *Sister Outsider*, 53–55.

18. Alex Hirst, "Introduction," in Rotimi Fani-Kayode, *Black Male/White Male* (London: Gay Men's Press, 1987), 3.

19. See Douglas Crimp, "Mourning and Militancy," *October*, no. 43 (Winter 1987): 3–18; and Lee Edelman, "The Mirror and the Tank: 'AIDS,' Subjectivity and the Rhetoric of Activism," in *Homographesis: Essays in Gay Literary and Cultural Theory* (New York: Routledge, 1994), 93–117.

20. Clyde Taylor, "The Game," in Golden, 1994, 168.

21. Essex Hemphill, "Black Machismo," in *Ceremonies: Prose and Poetry* (New York: Plume, 1992), 130.

22. Kenneth Clark, *The Nude* (1956; Harmondsworth: Penguin, 1987), 264–65.

23. bell hooks, "Altars of Sacrifice," *Art in America*, June 1993, 74.

24. Kaja Silverman, *Male Subjectivity at the Margins* (London: Routledge, 1992).

25. Leo Bersani, "Is the Rectum a Grave?," *October*, no. 43 (Winter 1987): 218; see also Leo Bersani, *The Freudian Body: Psychoanalysis and Art* (New York: Columbia University Press, 1986).

26. Jonathan Dollimore, "Sex and Death," *Textual Practice* 9, no. 1 (1995): 48.

27. Clark, *The Nude*, 264–66.

28. Clark, *The Nude*, 264–66.

29. Clark, *The Nude*, 296, 297, 298.

30. Wilson Harris quoted in Ann Walmsley, 1992, 174, 17. The concept of sovereignty is also developed by Georges Bataille, *The Accursed Share*, vol. 3 (1976; New York: Zone Books, 1991).

5

AVID ICONOGRAPHIES: ISAAC JULIEN

Isaac Julien has created a body of work that enters into the phantasy spaces of the public sphere. "I use the construction of iconic figures," he says, "as a way for me to seduce audiences into witnessing something that may surprise them" (quoted in Muhammad, 2000, 92).

Of all the elements involved, including color, sound, editing, and composition, the figurative vocabularies of narrative and iconography are important to Isaac Julien's artistic practice because this is where his stylistic choices are in contact with the damp patches and dark corners of the culture's collective imagination. Viewing his work in film, video, and installation, the experience is one in which the dreamlike quality of the image flow induces a luxurious mood of drift. In this condition of critical reverie, which feels at once "transgressive and hallucinatory,"[1] thoughts and sensations are directed by a poetic touch that loosens the stream of semiotic material from rigid adherence to sedimented conventions. Amid the flow, there are sharp moments felt as a piercing of the commonplace which create a *punctum*—a moment of surprise offset by the holding environment of the surrounding pictorial narrative. The slow-motion sequences in *Territories* (1984), which interrupt the newsreel footage—like the chorus of angels in *Looking for Langston* (1989), who provide the *studium* to the dream sequence that takes place on the Norfolk fen—reveal moments when Julien's film practice choreographs an art of surprise.

One of the undercurrents to the major themes explored across different genres, from 1980s film and video work in *Young Soul Rebels* (1991) and *This Is Not an AIDS Advertisement* (1987) to 1990s performance and installation in *Undressing Icons* (1990–91) and *Trussed* (1996), is the recurring motif of the interracial male couple. In fact, this emblematic device is often implicated in those moments of puncture and repair—the killer's glance at the black male body in the shower, and then Caz and Billibud playing records in the bedroom scene in *Young Soul Rebels*—which reveal something distinctive about Isaac Julien's expressive standpoint as a whole.

Although its presence as a signature motif could be taken as indexical evidence of Isaac's innermost desires, such a haplessly biographical reading would fail to explain why the visual trope of interracial coupling features fairly repeatedly in films by Rainer Werner Fassbinder, in photographs by Robert Mapplethorpe and George Platt Lynes, in paintings by Edward Burra, Glynn Philpot, and Duncan Grant, or in literary texts by Ronald Firbank and James Baldwin. What is glimpsed through some of the portals opened by the expressive handling of this trope in Isaac Julien's work suggests something interesting about his artistic relationship to the archival relations of the Western canon. When the use of style cuts an opening into the closed codes of a culture, and an artist is said to touch upon a nerve, making a mark that alters habitual ways of seeing, you could say that such practices involve a turn, or a "swerve" in Isaac Julien's case. Elements previously found or fixed in one code or tradition are freed up to travel through unexpected conduits and passageways, along the lines of the trickster's tap dance through Sir John Soane's Museum in *Vagabondia* (2000). The stylistic choices involved in Julien's characteristic handling of highly charged representations thus seem to lift whole clusters of cultural signage out of their given anchoring points into an interstitial flow or streaming which is then led astray to fresh connective possibilities.

• • •

John Goto's image showing Isaac standing beside the marble effigy of T. E. Lawrence in London's National Portrait Gallery (fig. 5.1) evokes the archival realm explored in the trilogy that comprises *Vagabondia, Three (The Conservator's Dream)* (1996–99), and the video *The Attendant* (1993). Goto's photograph reveals Julien's chosen relation to the archive as a place for a practice of critique that exhibits a careful rather than confrontational relation to the other who is discovered in the spaces of cultural memory. Isaac's proximity to the sculptural sarcophagus calls to mind his strangely funereal self-portrayal where, in the manner of James VanDerZee's *Harlem Book of the Dead* (1943), he placed himself in a coffin in *Looking for Langston*. Was it an act of identification with the lost object that the film's narrative quest was looking for? What is the romance of the ghost that presides over this scene of creative discovery?

• • •

When I first saw the anonymous, nineteenth-century photograph from the British Museum's ethnographic archive (fig. 5.2), depicting a Saint Sebastian scene in a studio that seemed designed for anthropometric measurement, I thought I was looking at an outtake from *The Attendant*. Underlining the view that "a photograph can seduce us by in-

5.1 John Goto, *Isaac Julien Next to T. E. Lawrence Effigy in the National Portrait Gallery, London*, 1995. Courtesy of John Goto.

viting us to create a meaning or narrative for it,"[2] my feeling was that this anonymous image nonetheless transmitted a residue of erotic energy in its own right. Perhaps the optical engineers of the colonial gaze had nothing more to do on a Thursday afternoon during the rainy season. Even if it were possible to recover its originating intention, the agency of the image had activated a receptive capacity in which the beholder was implicated in the libidinal imprint left behind by someone else who was doing the desiring. In my encounter with this archival oddity, the icon was looking back at me: I had been cruised by an image on "one of those rare and wonderful days when two strangers come together in deliberate mutual ignorance of each other."[3]

· · ·

Iconographies have a life of their own. Artists and authors come and go through the code, leaving individual imprints of the investments they bring to a particular motif, creating stylistic variation within any given tradition, period, or paradigm along the way. Or, as Orson Welles once put it, parting company with the emphasis on author names, "I believe there are only works."[4]

What is significant about the conceptual basis of *The Attendant* as a film essay is not so much that topical issues of sexual and civil liberty were taken as subjects for a stylistic treatment—based on a pictorial reference to Francoise-Auguste Biard's academic painting *Slaves Off the Coast of Africa* (1833)—but that the video's perverse copy provided the starting point for a process of translation in which iconographic elements were systematically led astray.

Located in Wilberforce House in Hull as a museum artifact of the abolitionist movement, Biard's master text suddenly yields to a strangely sadomasochistic subtext. The punctum has already been delivered, for the film's very premise posits previously unlinked correspondences in the image worlds of antislavery and perverse sexuality. With his initial background as a painting student at Saint Martin's School of Art, Julien's choice of art historical reference points can be situated among such projects of critical revision as Fred Wilson's *Mining the Museum* (1992) and Renée Green's *Bequest* (1992), or the version of William Theed's personification of Africa in the Royal Albert Memorial in Hyde Park that Keith Piper quoted in *Allegory* (1982). Julien's film work has crossed paths with this trajectory in a way that distinguishes his standpoint as a practice of querying. *The Attendant* (fig. 5.3) is a work of connective translation carefully embodied by actor Thomas Baptiste, who personifies a museum guard, as in Fred Wilson's *Guarded View* (1991). His surprising encounter with the leather-wearing gallery visitor induces a satin-clad Eros to make a pixilated appearance, shooting arrows

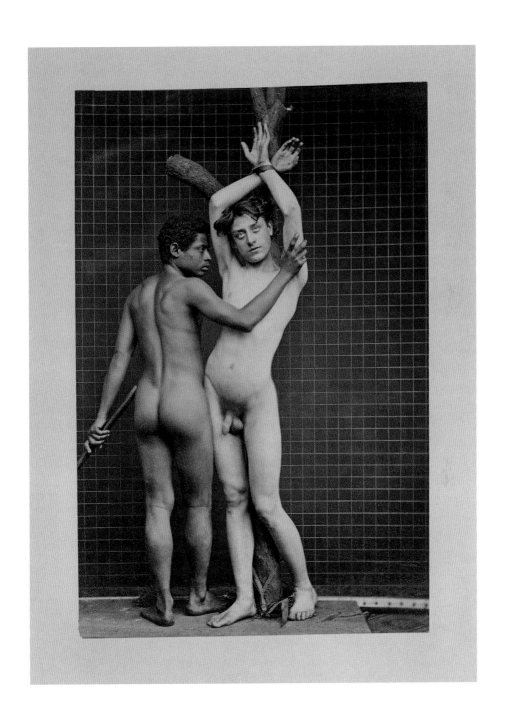

5.2 Unknown, *Posed Studio Portrait Showing Two Nude Males*, n.d. British Museum, London, No. Eu, BF.6, PRN: EPF135477.

of desire. It is not so much a question of labeling it queer or postcolonial, which it is, but of getting inside the diagonal moves whereby Isaac Julien's critical outlook and connective procedures resonate with Michel Foucault's view that "homosexuality is a historic occasion to reopen affective and relational virtualities, not so much through the intrinsic qualities of the homosexual but because of the 'slantwise' position of the latter, as it were, the diagonal lines he can lay out in the social fabric allow these virtualities to come to light."[5]

• • •

The Attendant opens a portal to the Black Atlantic image world of *The Deluge* (c. 1805) (fig. 5.4), a painting by J. M. W. Turner which depicts an interracial couple in the foreground to an apocalyptic scene of the biblical flood, evoking the Romantic sublime. As an image of boundary crossing in a symbolic universe where social identities were held to be defined by clear separations, the trope of the interracial couple is oversaturated with emotive associations. It is a visual cliché of the modern imagination in which the double contrast of sexual and cultural difference, thrown into relief by the chromatic contrast of race, makes it an irresistible attractor to an either/or way of seeing and thinking. The semantic coupling of "the black man" and "the white woman" seems always to be already full to bursting with explosive extremes of horror and wonder, terror and utopia, love and hate, gurgling beneath the hackneyed encoding of ebony and ivory's mutually forbidden fruit. As oceanic dissolution reveals the Black Atlantic as a space where terror and beauty merge, as in Théodore Géricault's *Raft of the Medusa* (1819), art shows how deeply abstract notions of race and nation were given form by an optical trope of extreme contrast. Representations of Europe and Africa were reduced to opposites in a visual world of antithesis where, perversely enough, the paradoxical rule is that opposites attract.

The "inter" in interracial often interrupts or intervenes in the anchoring points of a dichotomy which is heterotropic, or other-directed, in its need for clear-cut boundaries. The homotropic realm of same-sex desire, on the other hand, "presupposes a desiring subject for whom the antagonism between the different and the same no longer exists."[6]

We see such a homotropic dimension in Charles Cordier's *Fraternité* (*Aimez-vous les autres*) (1851), which portrays two cherubs meeting in a kiss to commemorate the abolition of the Atlantic slave trade. The sculpture's avowed declaration of equality is strangely belied by the chromatic polarity of black stone and white marble, which implies a separate-but-equal belief in absolute alterity. Cordier's allegory starts to prevari-

5.3 Isaac Julien, *The Attendant*, film still, 1993. 35mm film, color, sound, 7 min. 59 sec.
Courtesy the artist and Normal Films.

cate around the specter of homoness: a quality of strangeness-in-sameness that denatures the normative rules of representation. His cherubim are coupled in an interplay of uncanny similitude and vivid contrast in which their interdependent identities are entangled in extremis.

The homotropic view also brings out of the archive a subgenre of punishment scenes in abolitionist paintings such as Marcel Verdier's *Chatiment des quartre piquets dans les colonies* (1849), which depicts a naked black slave who is about to be whipped while the plantation owner and his family behold the spectacle of cruelty. By virtue of slantwise connections that reveal hidden layers to the master/slave dialectic, the violent extremes played out in the periphery betray their affinity to the founding texts of modern civility. Robinson Crusoe and Man Friday shared an intimacy in Daniel Defoe's story that was matched only by the barely sublimated homoerotic attraction that permeates Mark Twain's tale of the homosocial bond between Huckleberry Finn and Nigger Jim.

* * *

Querying the canon acts upon the perverse, the inverse, and the reverse as key terms in the "swerve" of contemporary critical revision. It can be seen in the photographic sketch, *White Bouquet* (1987) by Nigerian-British artist Rotimi Fani-Kayode, which offers a retranslated diagram of Manet's *Olympia* (1863) that reverses each of the dichotomies on which the confrontational shock of the master text depended.

Lorraine O'Grady's image-text work *The Flowers of Good and Evil* (1996–99) explores similar scenes of entanglement. Charles Baudelaire's lover Jeanne Duval, a mixed-race woman born in the French West Indies and who died in France, left behind a myth of the Black Venus. Highlighted in a novella by Angela Carter, Duvall also appears eyeless in a portrait by Édouard Manet, *Baudelaire's Mistress Reclining* (1862), and in the detail of Gustav Courbet's *The Artist's Studio* (1851), where her fleeting presence as Baudelaire's "black swan" is both acknowledged and erased (Pollock, 1999, 270–77).[7] Art history thus discovers black diaspora subjects in transatlantic spaces—Wilson the model who posed for George Dawe and Benjamin Haydon in London circa 1810, Joseph in Géricault's portrait studies, or the dancer Chocolat in Toulouse-Lautrec's drawings—who were already there in the imaginary institutions of the modern visual world, complicating its genealogies (Boime, 1989; Bindman and Gates, 2012).

Differencing the canon, Julien's homotropic practice of revision unearths zones of cross-cultural entanglement across Europe, Africa, the Caribbean, and America which reveal sexuality as a sticky membrane of interaction, whether actual or imaginative. The

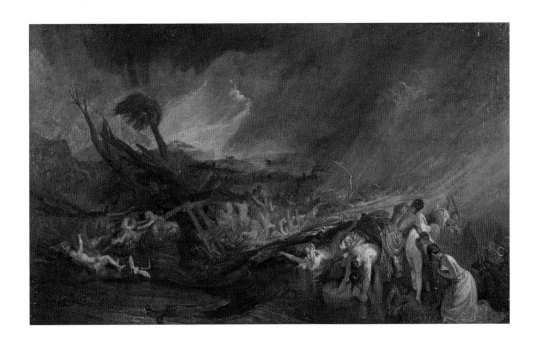

5.4 J. M. W. Turner, *The Deluge*, c. 1805. Collection: Tate. Courtesy Tate, London.

sub-Orientalist strand of interracial lesbian coupling seen in *Les Amis* by Jules-Robert August, or *The Victory of Faith* (1891) by St. George Hare, is merely another portal into the realm of public fantasy opened up by the perverse turn.

"The *studium* is ultimately always coded," wrote Barthes, "the *punctum* is not." The interracial trope makes a sudden appearance in *Camera Lucida*, which is richly populated with photographs of blacks. Barthes continues: "Nadar, in his time (1882), photographed Savorgnan de Brazza between two young blacks dressed as French sailors; one of the two boys, oddly, has rested his hand on Brazza's thigh; this incongruous gesture is bound to arrest my gaze, to constitute a *punctum*. And yet it is not one . . . (for me, the *punctum* . . . is the other boy's crossed arms)" (1981, 51). The object of attention here belongs to the archival studio portraits of the nineteenth-century cult of male friendship associated with Walt Whitman (which calls to mind that the interracial trope in David Hockney's work is set in the Arab world of Cavafy); but the quality of Barthes's attention reveals race as strangely central to the visual histories of modernity. Was it a kind of overidentification with the other that led Barthes to misidentify his own ancestors in the James VanDerZee *Family Portrait* (1926), or to somehow magnify the young black soldier on the *Paris-Match* cover who is discussed at the conclusion of *Mythologies*?

. . .

What would account for the fascination that images of interracial coupling exert? Taken as a lens onto an interactive history of the different cultures brought together in Black Atlantic modernity, the trope acts as a fascinum for the gaze by virtue of its dynamic quality of oscillation. The graphic polarity of the black/white contrast invites the eye to oscillate between the plural meanings that arise out of the sign's connotative extremes. In a social world that aspired to the discipline of clear-cut separations, interracial coupling was not in itself transgressive, but revealed an "idea" of boundary crossing in which sexuality was both dreaded and desired as the most intimate point of contact among the cultural differences held in place by the political fiction of race. An image of a European woman and an African man together was rarely allowed to be just that—a picture of a couple—because where each identity was obliged to represent some larger abstraction, his race against her sex, as it were, the notion that coupling brings together two halves to form a whole was constantly at risk of being torn apart by the threat of mutual antagonism between two opposite extremes. The lure of dynamic oscillation thus animates the ambivalence found in the strange logic of sameness whereby images which once incited the segregationist imagination with printed handbills depicting an interracial kiss during America's Jim Crow era were virtually identi-

cal to the images that sought to embody an egalitarian ideal of integration in the public sphere of modern liberal politics.

. . .

Twentieth-century cinema was punctuated by an arc that enjoined the violent con-fusion acted out in the "Gus chase" sequence of D. W. Griffith's *The Birth of a Nation* (1915), which imagined miscegenation as the total annihilation of separate ethnici-ties, to the platitudes of tolerance and reconciliation put forward in reply by *Guess Who's Coming to Dinner* (1967). But whereas the prohibition on heterosexual fusions was driven by anxieties over progeniture that were bound up with the drama of the mixed-race child, which was an underlying theme of problem-oriented race films in 1940s American cinema such as *Pinkie* and *Lost Boundaries*, it would be mislead-ing to suppose that homo couplings were simply excluded from the algebra of inter-racial iconography. The four-square matrix that paired Dorothy Dandridge and James Mason as one taboo coupling alongside the alternate pairing formed by Joan Fontaine and Harry Belafonte in *Islands in the Sun* (1957) merely disclosed the heterotropic or other-directed axes of identification and desire that were merged by sameness in the intense homosocial bonding of *The Defiant Ones* (1958), in which Sidney Poitier and Tony Curtis "begin as enemies in a jam and end as buddies in each other's arms after Tony gives up a white woman and freedom to save Sidney's life."[8] In fact, the pietà at the film's ending, which actually places Poitier in a relation of mothering to Curtis, an-ticipates the underlying ethos of the 1980s genre of interracial buddy movies whose odd couplings reply on the frisson of homoerotic attraction that has to be managed by the story line so that the homosocial does not suddenly give in to the homosexual (ex-cept as a joke).

What would it take to tamper with a code like that? Produced in a period when *My Beautiful Laundrette* (1985) brought a twist to the kitchen-sink realism of the postwar paradigm, substituting an Asian entrepreneur and an English skinhead to personify a divided nation (of which Noël Coward once quipped, "I am England and England is me—we have a love-hate relationship with each other"),[9] the artistic choices involved in the making of *Looking for Langston* showed that Isaac Julien had swerved away from realism's problem-solving fixations. He had entered instead into the shadow realms of intercultural entanglement historically buried in the crypt of the twentieth-century avant-garde.

Looking for Langston (fig. 5.5) made an imaginative return to the Harlem Renais-sance, querying the archival relations of the high modernist moment of the 1920s in

which the first generation of African American artists had been buried as merely a passing vogue. Opening the codes that had been closed around Langston Hughes as a canonical figure in African American literature, the film put forward a reconstructive synthesis of cinematic quotation, cutting through the patina in which cultural memories of Harlem had been entombed. Julien's stylistic choices lifted evidence out of the canon's crevices to reveal a scene of cosmopolitan intermingling taking place in the nocturnal spaces of a speakeasy. During the period of primitivism and Pan-Africanism, when artists shared a mutual interest in the otherness of tribal objects, the interracial networks of art world patronage often spilled over into the realm of personal relationships. Such figures as philosopher Alain Locke and writer Carl Van Vechten played the role of go-betweens or translators, connecting black artists and white patrons in a milieu in which their homosexuality was tacitly accepted as such a conduit of cultural exchange in a segregated society.[10]

The nightclub realm thus forms an archival studium of surplus quotation which provides a holding environment for critical reverie: its cave-like spaces are brought alive by a flickering light that reveals Eros as a source of connective possibilities in the Orphic underworld of modernism and the modern.

• • •

"Transplanted from the privacy of a book or an art gallery to a film concerned with power, voyeurism and sexual desire," Martha Gever observed, "these iconographic representations of 'the black male body' are incorporated into a more expansive context, where Julien confers on his characters the license to look and, therefore, the power to envision fantasies. In the process, he stakes the same claim for himself and, likewise, for the audiences for his film."[11] The expansive sensation registers the lifting or loosening of heterogeneous elements previously closed by the caption points of the modern art story.

In his work of contemporary revision, Isaac Julien's style of poetic translation surpasses the technicalities of mere appropriation. At its core, *Looking for Langston* takes a photograph by George Platt Lynes, *Two Men, John Leapheart and Buddy McCartney* (1947), through a stylistic treatment in which the original image and its diasporic versioning pursue a lyrical chase. Platt Lynes's photograph imbues the graphic contrast of interracial chiaroscuro with an asymmetrical oscillation, heightened by one man's hand upon the other's shoulder, which was subject to a subtle modulation under Julien's stylistic handling. By virtue of the merging skin tone of the actors in Julien's version, a strange quality of sameness reconfigures what has been erased but which is still legible.

5.5 Isaac Julien and Sunil Gupta, *Looking for Langston* series, *The Last Angel of History*, 1989. Gelatin silver print, 58 × 40 cm. Courtesy of the artists.

The trope travels elsewhere and resurfaces at the navel of the film work, in the dream sequence ending with Alex and Beauty entwined on the bed, where Julien transposes another nude study by Platt Lynes, depicting two men undressing while another lies on the bed, into the iconographic register of the interracial code.

• • •

Paul Colin and Josephine Baker, like Nancy Cunard and Henry Crowder, epitomized hetero entanglements in modernist negrophilia. In the work of Edward Burra, the enjoyment of difference for its own sake led to a homotropic emphasis on sameness. The two black shoremen in *Market Day* (1926) form a queer sort of couple, as do the two men in *Harlem* (1934) pictured on the street in front of a Chinese restaurant, where the one in the raincoat with the exaggerated posterior has his cigar-holding hand gesturing toward the other man's crotch.

Isaac Julien's ability to imaginatively reoccupy the pictorial spaces of Glynn Philpot, Duncan Grant, and other Bloomsbury modernists cuts a swathe into the archive, revealing capillaries of influence that cut across the visual cultures of the twentieth century. "We look for Langston, but we discover Isaac,"[12] and yet we also find, in his work of diaspora imagination, that the ancestors one encounters in modernism's caverns do not always have an identity that was already known in advance. Quoting Toni Morrison and Maya Deren in equal measures of antiphony, *Looking for Langston*'s filmic ancestry can be traced back to the moment when the English avant-garde produced *Borderline* (1930), a film directed by Kenneth MacPherson, featuring H. D. and Paul Robeson, whose story turns on the relationships between two couples in an interracial pairing.[13]

• • •

After 1945 it could be said that the avant-garde went through massive disillusionment with the interracial motif, as the bleak cinema verité of John Cassavetes's *Shadows* (1959) suggested that a utopian vision was no longer historically available. The postlapsarian strand that connects Stanley Spencer's painting *Love among the Nations* (1935) to the rather more campy polysexual camaraderie of *What I Believe* (1947–48) by Paul Cadmus, drew inspiration from the jubilant pansexual mingling of Hieronymus Bosch's *The Garden of Earthly Delights* (c. 1500); but the late modern constellation of the interracial motif owed more to Bosch's vision of hell that was revisited in Alan Parker's movie *Angel Heart* (1986).

In the film cycle bookended by Neil Jordan's *Mona Lisa* (1986) and *The Crying Game* (1993), which would include such works as Spike Lee's *Jungle Fever* (1991) and Mira Nair's *Mississippi Masala* (1991), what accentuates the tragic version of interracial

coupling is a double bind of loving the alien with divided loyalties and no exit. This was also one of Fassbinder's themes—highlighted in *Fear Eats the Soul* (1973)—suggesting that gay/straight distinctions matter less to the ethics of intercultural ambivalence than the cultivation of an enjoyment of difference, or heterophilia, which is inscribed in the hybrid drift that accompanies depictions of interracial relationships in Colin McInnes's Notting Hill novels or the East Village worlds of Audre Lorde and Samuel R. Delany in the 1950s and 1960s.[14]

Thinking of how such influences were available to the context-of-choice in which Isaac Julien arrived at his index of stylistic references, it is significant that his choices refract upon the postcolonial aspects of London's heteropolis. The city's migrant flows, seeping into the Powis Square locale of Nicolas Roeg's *Performance* (1970), and across the interracial pairings hovering over the East End in Gilbert and George's photo piece *Fair Play* (1991), have played an important part in shaping Julien's "creole" outlook. His insights into the interplay of power and transgression are wrought from chances taken and choices made in the spatial discrepancies found in the city's unexpected routes and passages.

The superimposed pan shot of the policeman's gaze that meets Pedro's in *Territories*, like the sharp rotary sweep of the white man's gaze that breaks contact as the black boy enters the bar in *Looking for Langston*, produces moments that also occur in the documentary work—such as when "Fanon" turns away from the boys kissing in the background in *Frantz Fanon, Black Skin White Mask* (1996) (fig. 5.6)—which puncture and deflate the affective extremity played out in the iconography of interracial relationships.

The soft focus of Mapplethorpe's *Abbrachio* (1982) is strangely at odds with the clinical precision of epidermal separation seen in his double portrait of Ken Moody and Robert Sherman (1984). Whether this sentimental exception, marked by a rococo title, was implicated in the twists and turns of Mapplethorpe's relationship with boyfriend Milton Moore, who is forever known as the subject inscribed in *Man in a Polyester Suit* (1980), is not for us to say, other than to observe the contrast between his binary sensorium, which is split off into Manichean division, and the melancholy intelligence of Julien's image world, in which a tolerance for ambiguity has created a fluid sensibility that enjoys sumptuous surprises more than scary shock effects.

• • •

The group portrait of Isaac with Jimmy Sommerville and Derek Jarman on a demonstration against Clause 28 in the 1980s makes me think how the giddy 1960s excitement of the interracial fashion photography seen in magazines such as *Nova* gave way to the

5.6 Isaac Julien, *Frantz Fanon, Black Skin White Mask*, film still, 1996. 35mm film, color, stereo sound, 68 min. 36 sec. Courtesy of the artist and Normal Films.

arch severity of the subcultures styled by Ray Petrie in *The Face* and other magazines, insofar as magazines provide an index of visual culture's slow fade into multicultural drift as a norm of modern life. Playing with the iconography of the cowboy in *The Long Road to Mazatlán* (1999), with the care shown to his pictorial reference points as a consistent feature of his imagistic or aestheticist bent, there is a camp quality to some of Isaac's choices, such as the selection of Tom of Finland drawings that appear in the background to *The Attendant*.

There is a perverse levity to Isaac Julien's translation of the pietà in *Trussed*, but not the evasive self-protecting irony associated with embarrassment. Without pathos either, the quality of cathexis imparted to the icon lifts it out of stasis into an associative flow that leaks into wider spaces of dissemination by virtue of its translation through the "perverse dynamic" that enlivens the interracial motif (Dollimore, 1991).

Isaac Julien's critical vision accomplishes a quality of aliveness in contemporary art. It would seem to be heightened by a chosen proximity to images of dying and fading, as they arise in such moments as when Langston Hughes, reading a poem on American television, appears and then suddenly fades out into the monochrome pulse of the edit. There is avidity in this elliptical relation to the image which comes near to the rituals of dying without being afraid of the nothingness that the ontology of the image stands in for. As an artist trusts his or her audiences to follow through some of the portals opened up by their practice, being led astray by the creative errancy of Isaac Julien's aesthetic means staying true to a view he expressed at the outset of his career, that "there exist multiple identities which should challenge with passion and beauty the previously static order" (Julien, 1988, 36).

NOTES

This chapter was first published in *Isaac Julien*, Ellipsis Minigraph 3 (London: Ellipsis, 2001), 7–21.

1. David Dietcher, "A Lovesome Thing: The Film Art of Isaac Julien," in *The Film Art of Isaac Julien*, ed. Amanda Cruz (Annandale-on-Hudson, NY: Bard College Center for Curatorial Studies, 2000), 15.

2. Chris Wright, "Being Led Astray," in *The Impossible Science of Being: Dialogues between Anthropology and Photography*, ed. Ruth Charity, exhibition catalogue (London: Photographer's Gallery, 1995), 34.

3. Alan Hollinghurst, *The Swimming Pool Library* (London: Penguin, 1988), 226.

4. Orson Welles quoted in Peter Bogdanovich and Orson Welles, *This Is Orson Welles* (New York: Da Capo, 1977), xxxi.

5. Michel Foucault, "Friendship as a Way of Life" (1981), in *Ethics: Subjectivity and Truth*, ed. Paul Rabinow (New York: New Press, 1997), 138.

6. Leo Bersani, *Homos* (Cambridge, MA: Harvard University Press, 1995), 59–60.

7. See also Angela Carter, *Black Venus and Other Short Stories* (London: Picador, 1985).

8. Parker Tyler, *A Pictorial History of Sex in Films* (Secaucus, NJ: Citadel, 1974), 249.

9. Noël Coward quoted in Bracewell, 1997, 222.

10. Family trees of relations between artists and patrons are featured in Steve Watson, *The Harlem Renaissance: Hub of African-American Culture, 1920–1930* (New York: Pantheon, 1995), 60, 96.

11. Martha Gever, "Steve McQueen," in *Spellbound: Art and Film*, ed. Ian Christie and Phillip Dodd, exhibition catalogue (London: Hayward Gallery, 1996), 98.

12. Henry Louis Gates, "The Black Man's Burden," in Dent, 1992, 77.

13. Richard Dyer, *Heavenly Bodies: Film Stars and Society* (London: Macmillan, 1987), 130–32.

14. Colin MacInnes, *Out of the Way: Later Essays* (London: Martin Brian O'Keefe, 1979); Audre Lorde, *Zami: A New Spelling of My Name* (London: Pandora, 1982); Samuel R. Delany, *The Motion of Light on Water: Sex and Science Fiction Writing in the East Village, 1957–1965* (New York: Arbour House, 1988).

6

ART THAT IS ETHNIC IN INVERTED COMMAS: YINKA SHONIBARE

Poised between two cultures and enjoying every minute of it, Yinka Shonibare produces a playful and inquisitive art out of ironies that arise when the postmodern and the postcolonial collide. Since graduation he has fused skepticism, modesty, and wit in a desire to reinvent painting and sculpture as a point of public dialogue and visual pleasure.

The result is work such as *Installation* (1992), composed of some fifty panels in which stretched canvas has been replaced by brightly colored African fabric, each piece bearing references to color-field painting either frontally or on the edges of the frame. In this disarmingly simple move, he spins the equations of modernist primitivism right off their axis. Opening up all sorts of spaces in which the viewer's assumptions can be played with, seduced, and abandoned, Shonibare enjoys calling into question the dodgy ideology of authenticity held in common by discourses on aesthetics and ethnicity alike. "I am actually producing something perceived as ethnic, in inverted commas," he says during our interview, "but at the same time the African fabric is something industrially produced, and given its cultural origins my own authenticity is questioned." Cut loose from the often overbearing seriousness that adheres to issue-based art about identity, the key terms of Shonibare's postconceptual turn are excess, seduction, desire, and complicity.

As he put it in an artist's statement for a 1994 exhibition at Center 181 Gallery in London, "Just imagine being a primitive, a proper primitive that is. A primitive that is beyond civilization, a primitive in a state of perpetual indulgence, a primitive of excess. I think I would really enjoy that. Here too I can be a kind of urban primitive: a kind of back to nature cliché with a twist. Oh how I long to be ethnic, not just ethnic, but authentic ethnic. I love paint, it's really sumptuous, yum."

With *Double Dutch* (1994) (fig. 6.1), the basic premise of the earlier installation received a fresh inflection of excess. Adding thick dollops of impasto, often in variegated

patterns that play off the gaudy designs of the fabrics, and setting them off against a wall painted shocking pink, Shonibare brings minimalist abstraction into dialogue with the semiotic density of the connotations woven into the African textiles. For although the fabrics may be stereotypically taken to signify an exotic African otherness, they have a hidden history of interculturation written into them.

Popular in West Africa since the 1960s when their jazzy colors captured postindependence verve, the Dutch wax print actually originated in Indonesia. Indigenous batik techniques were later industrialized by Dutch colonizers and manufactured in Holland. The British copied, then monopolized, the process, with factories in Manchester employing Asian workers and English designers to produce goods for export to West African markets. Alluding to this ambiguous import-export history (as well as to Malcolm McLaren's wheezy mid-1980s appropriation of South African township jive), *Double Dutch* teases out the way in which, far from being intrinsic to an origin, meanings are stitched into an artifact by the circuits of translation and exchange through which it travels.

As in his subsequent *Sun, Sea and Sand* (1995) — in which a thousand paper bowls are wrapped in similar fabrics and set on a blue flooring — Shonibare's strategy achieves a wobbly distancing effect which draws attention to the object-like presence of the material from which the connotations of the fabric float off as signifiers gone astray in the circuits of cultural value. What is interesting is how this undermines the double binds into which diaspora artists are often stitched by the demand to be dutifully representative of one's ethnicity. "Really, I haven't got anything didactic to offer," he explains. "I want audiences to experience the work, which relates to my home background, but then that's me quoting the received stereotypes of my background. What I've found, making work in Britain, is that when you make work about your origins, all it can be about is your origins. But if you don't make work about your origins, people will say you're an African artist who doesn't make work about African subjects, so your identity becomes suspect."

Damned if you do and damned if you don't: black artists are often bedeviled by expectations that there must be biographical associations in the art. "What I've noticed with a lot of black artists is that even if you do not put yourself in that box, other people will," he adds, and indeed some English critics have come away from Shonibare's work feeling that it is not quite African enough. Informed by the late 1980s debates around Rasheed Araeen, Sonia Boyce, Keith Piper, and other black British artists, Shonibare refuses to be an otherness machine; yet far from sidestepping politics in favor of art that is ideology-lite, he is wary of taking fixed positions precisely because he has an in-

6.1 Yinka Shonibare, *Double Dutch*, 1994. Installation view. © Yinka Shonibare MBE.

sider's intimate knowledge of the crisscrossing of cultures that has made modern African identities as hybrid and as polyvocal as they are today.

"Is there such a thing as pure origin? For those of the postcolonial generation this is a very difficult question. I'm bilingual. Because I was brought up in Lagos and London—and kept going back and forth—it is extremely difficult for me to have *one* view of culture. It's impossible. How do I position myself in relation to that multifaceted experience of culture?"

The question is answered when Shonibare stages himself as an eighteenth-century aristocrat, somewhat resembling Oluadah Equiano, a Yoruba who participated in English labor politics in the 1790s (fig. 6.2). Far from revealing an essential self, the hilarious irony wrought by his costume shows that excess depends on others. "In order to have aristocratic freedom to indulge, others need to be colonized. Fine art is excess par excellence. It is not going to emancipate you in any direct way. Even though the upper class is supposed to be dead, multinationals are based on those colonial trading structures. Rather than make overtly political work, I actually become part of the framework by using African fabrics as surrogates for aristocratic trappings. Corporations use the fabric for advertising Western goods, such as footballs and radios, that the natives can aspire to own, and the print becomes a surrogate for the commodity." The fabric serves as the sign that ignites desire—in Africa it has the allure of imported goods, in Europe it evokes exotica—but it is when our conversation turns to its appropriation as an emblem of political nationalism among blacks in the diaspora that Shonibare reveals just what a marvelously pliable found object he has alighted upon. "To show an affinity with Africa, young black British use these fabrics for head wraps, robes, and shirts. But the essentialism they associate with the fabrics is actually a myth because their origins are already questioned. At the shop in Brixton Market, they are never quite sure of the origins."

"Postmodernism made it fashionable to take things from here, there, and everywhere," he remarks, bringing to mind Katherine Hamnett's comment on 1980s textiles trends, "Ethnic, ethnic, everywhere." But what happens when ethnics appropriate others' appropriations of ethnicity? In recent years, ceremonial kente cloth, originally woven in Ashanti in Ghana, has found its way via prints manufactured in Korea into sweatshirts and baseball caps worn by African Americans to signify Afrocentric allegiances. Aware of the ambiguities, Shonibare questions kente's iconic status. "Although it's a strong, defiant statement for an African American to wear kente, the very reason why I don't wear things like that is that I will not play the exotic for anyone. The wax prints are surrogates that are out there for anyone to use. What interests me is that area of not quite knowing whether I'm celebrating difference or building a critique."

6.2 Yinka Shonibare, *Untitled (Effnik)*, 1997. © Yinka Shonibare MBE.

6.3 Yinka Shonibare, *How Does a Girl Like You Get to Be a Girl Like You?*, 1995.
Dutch wax cloth, mannequins, mixed media, 168 cm high, installation view.

In this way Shonibare offers an interesting response to the question posed by Anglo-Ghanaian philosopher Kwame Anthony Appiah (1992) as to whether the "post" in postmodernism is the same as the "post" in postcolonialism. Yes, no, and maybe. By playing with metonymic links between the origins of the cloth, and his own origins among a transnational generation of hyphenated hybrids, Shonibare disinters modernism's fixed equations in which the high serious gesture, culminating in Clement Greenberg's doctrine of formalist purity, required a subordinate set of negatives: if colorfield = abstract = heroic, then fabric = decorative = frivolous. Shonibare's strategy is about representation, but it is not figurative. It is about abstraction, but it is not expressive. It is about what he calls "purloined seduction or pretend authenticity," in which the polarities of masculine, Western, high art, or feminine, non-Western, and craft, are sent packing by means of his elegantly simple substitutive ploy. Hence his recent work—*How Does a Girl Like You Get to Be a Girl Like You?* (1995) (fig. 6.3)—consisting of Victorian dresses made over in African fabric, shown as part of the africa95 program of exhibitions. As ideologies of otherness exhaust themselves in an era of increasingly global interdependence, Shonibare has fun making a mockery of the artifice of authenticity: "Actually, I'm not angry. I have no authentic expression to offer."

NOTE

This chapter was first published in *frieze: contemporary art and culture*, no. 25 (November– December 1995): 38–41, and is reproduced with the kind permission of *frieze*.

PART III

Global Modernities

Just as the Dutch wax fabric constitutes material whose meaning changes as it travels through networks of global trade and exchange, the photographic medium shows how an image originally created for one purpose, to send to family members, for instance, gains altered significance when it migrates into contexts where it is repositioned as art on gallery walls. In the hands of African practitioners active from the 1940s onward, such as Seydou Keïta in Mali and Mama Casset in Senegal, photography's indexical nature reveals the double-sided significance of studio portrait traditions that were only brought out of the archives during the 1990s. On the one hand, even though factual information regarding the sitters is now lost and irretrievable, every image offers evidence of the self-fashioning through which modern African subjects exerted creative agency under colonial conditions. With richly pattered fabric backdrops, the photographer's studio is converted into a space for the theatrical staging of Afro-modern identities. But on the other hand, as we behold the aura created by stylistic differentiations and accentuations among individual photographers, we recognize that their aesthetic choices in framing and composing the portraits surpass mere documentation. As a result of the diasporic journeys whereby mid-twentieth-century images traveled out of African archives into European and American galleries, what came to light was a fresh understanding of the ways in which acts of appropriation meant that modernity was never a unitary or homogeneous phenomenon, but was always differentiated by the local conditions in which cross-cultural encounters were lived.

Multiple experiences of global modernity do not imply harmonious coexistence. In contrast to the deep historical perspectives opened up by archival material, the 1990s shifts that gave rise to the Young British Artist (YBA) phenomenon revealed how the bewildering challenges unleashed by a new phase of capitalist modernization, where global flows cut across the territorial borders of the nation-state, were met by localized and inward-looking responses that retreated into jokey renditions of Britishness to cover over burgeoning uncertainties and insecurities. The "don't care" attitude of populist irreverence altered the ground on which black artists made their choices. To the extent that the YBA enacted a backlash phase against identity politics, the gradual trend in art world attitudes whereby inclusion came to be accepted as a norm circa 2000 was registered in Documenta 11. Here, an ecumenical approach to globality put matters of difference in the rearground so as to foreground the unstable identity of "documents" that, in a digital age, open access to a cross-cultural commons beyond the confines of locality. If my report carries a discomfited tone, perhaps this betrays uncertainties that affected all critical perspectives in the Clinton and Blair moment when inclusionism began to blur frontiers that were previously clear-cut. In this climate, perceptions of cultural diversity were decoupled from ideas of equality and reattached instead to the neoliberal consecration of free market forces.

7

HOME FROM HOME: PORTRAITS
FROM PLACES IN BETWEEN

Strange cargo bearing scattered traces from Africa and its diaspora is imported into the white cube of the gallery space, which becomes the setting for an encounter between continents and generations, past and present: an opportunity for discovery among strangers who nonetheless find something familiar when we look into each other's faces. With the work of five photographers from diverse times and places—Seydou Keïta from Mali, Mama Casset from Senegal, Ingrid Pollard from Guyana and Britain, Oladele Bamgboye from Nigeria and Scotland, Maxine Walker from Jamaica and Britain—we find ourselves invited into a space where connections are made with the materials of memory and desire.

Portraiture has been one of the primary vocations of photography from its beginnings in nineteenth-century Europe. Opening up an extended family album through the juxtaposition of two urban West African studio photographers, whose portraits date from the colonial era of the 1940s and 1950s, alongside contemporary approaches to self-portraiture among postcolonial artists located in black British contexts of the 1990s, what we see on display are some of the most powerful and creative transformations of photography's role as a mirror to the making of our modern selves. By running together the archival and the experimental, what is made self-evident are the connecting threads between these richly diverse images. Instead of leading back to a unitary point of origin that would be fixed in romantic myths of Mother Africa, they evoke memories and weave stories from the shared histories and multiple journeys by which black experiences speak universally to the subjective twists and turns of identity. Above all, among peoples who have endured the experience of being othered as the very antithesis of a once-imperialistic definition of what a self should be, the evidence suggests that in taking control of the technologies of representation, black artists have forged new practices of freedom by documenting a variety of desires and aspirations that flow from individuality and singularity as sources of collective belonging and mutual connectivity. As Stuart Hall says of photographer Vanley Burke, "The documentary, classi-

cally, is motivated by the search for 'truth,' authenticity. But these images seem to me to be motivated by something quite different: not truth, but 'love.' . . . These images were conceived and born in *desire*: a desire for the plenitude of blackness, the desire to 'come home' as the peoples and the lives they represent, have come home to themselves."[1]

A sense of homecoming arises when we meet the eloquent beauty and sheer presence of the African subjects in Mama Casset's and Seydou Keïta's portraits, even though they are being shown in the United Kingdom for the very first time. Born in 1908 in Saint-Louis du Senegal, Mama Casset set up his studio in the Medina of Dakar during the era of high colonialism, having been introduced to photography by a Frenchman, Oscar Lataque, and having served in the army to provide aerial reconnaissance photographs in World War II. Working within a similar context, Seydou Keïta, born in 1923 in Bamako, capital of Mali, where he still lives, took up photography in 1945 when his father bought him a camera. Encouraged by his elders who worked among the French-owned black-and-white laboratories used by the other four studio photographers of the day, he established Photo KEITA in 1949, working with thirteen-by-nineteen-centimeter negatives to produce *cartes-de-visite* for his clients up to the 1970s. Retrieved from obscurity by the archival work of curators André Magnin and Bouna Medoune Seye, the images evoke an uncanny familiarity even though we can know next to nothing about the individual stories of the people whose portraits we see.

We are aware that these historical artifacts were never intended to be shown as artworks, that notions of portraiture as much as authorial signature were imported by colonialism, but nevertheless there is a feeling of recognition evoked by their majestic and compelling aura. The urbane couple with hands entwined in intimacy; the proud father whose progeny is swathed and protected in his flowing robe; two women reclined in a profusion of gold, amber, and patterned fabrics—the sitters look out to us with quiet dignity, and we meet their gaze through a haze of unknowing. The effect is reminiscent of an encounter with the photographs of African American portraitists, such as James VanDerZee in Harlem and Richard Samuel Roberts in South Carolina, in the sense that Keïta and Casset have "documented" mostly urban, middle-class professionals, without ever intending to do so as such. The products of commercial activity between clients and skilled craftsmen, intended for private exchange between friends and family, have come to be repositioned as aesthetic objects in the public culture of museums and galleries. Acknowledging this process allows us to appreciate the feeling of recognition as, in part, an enjoyment of their critical difference from the codes of anthropological photography, shaped by the racialized power play of subject and object polarities, and, in part, as an empathic connection with the imagined selves staged in the almost theatrical space of the photographer's studio.

Whereas the depiction of Africans in prevailing idioms of photojournalism tends to imply a vertical axis which literally looks down upon the subject, thereby cast into a condition of pathos and abjection, Mama Casset's portraits are often set on a diagonal whereby the women he portrays seem to lean out of the frame to look straight out to the viewer, with a self-assured bearing that evidences an interaction conducted on an equal footing (fig. 7.1). It is precisely this intimate quality of the implicit relationship between the client's wishes and the direction provided by the photographer's skill and technique that underpins the uniquely balanced counterpoint between formality and familiarity. One might regard the portraits as a dialogue around the visual interpretation of the self *as it would like to be seen*, as the following comments by Seydou Keïta suggest: "On the walls of my studio I exhibited lots of models and samples of the photos I took. . . . Clients would say: 'I want to be photographed like that, you see? That's what I want.' And that's what I'd do. But sometimes it didn't suit them at all. I would suggest a position which would suit them better, and then it was I who decided on the right position."[2]

Keïta reveals that, as a modern genre of negotiated self-representation (fig. 7.2), his portraits do not depict a sovereign self that requires a binary or oppositional code in order to assert its independence; rather, they show the traces of a socially embedded relationship of self-among-others structured within a horizontal relationship of mutual understanding. With various props, accessories, and backdrops, the photographer stylizes pictorial space. Through lighting, depth of field, and framing, the camera work heightens the mise-en-scène of the subject, whose poses, gestures, and expression thus reveal a self not as he or she actually is but "just a little more than what we really are."[3] I think it is this imaginary dimension, shaped in the studio as what D. W. Winnicott called a "potential space," located somewhere between public and private lives, that brings about the sense of homecoming. Perhaps the key lies in the details: the telephone, the plastic flower, the white-walled car tire, the Bata shoes, the cigarette, and the radio set. Manifestly un-African, these icons of modernity are evidence of Africa's syncretic complexity unfolding among desiring subjects who have fun imagining the other selves they might yet become (fig. 7.3). As Keïta says, "In those days . . . city dwellers began to dress European style, they were influenced by France. But not everyone could afford to dress like that. In the studio I had three different European suits, with tie, shirt, shoes and hat . . . the lot. And some props: biros, plastic flowers, radio set and telephone. Clients could use them to pose with."[4]

To our eyes the props might at first sight be taken for what Manthia Diawara (1992) calls "afro-kitsch"—banal, everyday objects valued not for their intrinsic worth or meaning but for the aspirations they come to embody as tokens of exchange in the syn-

cretic imagination.[5] Africa's ability to select and combine elements of disparate origin to forge hybrid identities certainly predates its encounter with Europe, as the numerous Islamic influences among the embroidered robes of Keïta's subjects can testify. While such a pluralist sensibility might bring unease to adherents of the myth of authenticity—the view, shared by many ethnographic romanticists and black cultural nationalists alike, that "true" Africanity supposedly resides in a static time and place impervious to any "outside" influences—the subjects who sat before Seydou Keïta's camera show the worldliness of multifaceted African identities in tune with the rhythms of cross-cultural trafficking, identities on the move. Some of the details may elude our comprehension—the letters "RDA" on a woman's plastic handbag are the initials for the Union for African Democracy, formed in Mali in 1956; the wide stripes of the block print dress are inscribed with party political colors—which is to find oneself, like the aficionado of world music, without access to the signified and yet enjoying the play of the signifier nonetheless.

In relation to such disjunctures, Kwame Anthony Appiah (1992) carefully delineates the dangers, of neo-exoticism and neoprimitivism, as well as the pleasures, of elective affinities and altered outlooks, that arise with the global movement of aesthetic objects in the cultural marketplace of the modern art world. Considering photography as a museum without walls, one might characterize the idea of bringing the work of Mama Casset and Seydou Keïta into dialogue with contemporary artists of the African and Caribbean diaspora as a hypersyncretic cultural move. For although the former cannot be viewed either as they were originally intended to be, since they have been translated into an alien environment, or as equivalent to the latter, for Pollard, Bamgboye, and Walker avowedly identify as independent artistic practitioners, the interstitial space of dialogue brings about a convergence of postmodernity and postcoloniality within the realm of aesthetic response. The compositional conventions of the studio photographers are indeed "artistic," in the descriptive sense, but it strikes me that it is in relation to the contingent or aberrant detail, which Roland Barthes (1981) called the *punctum*, that we may encounter a more surprising kind of experience: something that pierces the ego's fictive skin. Such experience occurs in potential space in Winnicott's terms:

> The place where cultural experience is located is in the potential space between the individual and the environment. . . . This third area has been contrasted with inner or personal psychic reality and with the actual world in which the individual lives, which can be objectively perceived. I have located this important area of experience in the potential space between the individual and the environment, that

7.1 Mama Casset (1908 Saint-Louis du Senegal–1992 Dakar, Senegal), *Portrait in His "African Photo" Studio*, Senegal, c. 1950–60. Vintage print, 9 × 14 cm. Courtesy of Revue Noire, Paris.

7.2 Seydou Keïta, *Untitled*, 1956–57. Gelatin silver print, 19 × 15 inches, 50 × 40 cm. Courtesy CAAC—The Pigozzi Collection, Geneva. © Keïta / SKPEAC.

7.3 Seydou Keïta, *Untitled*, 1952–55. Gelatin silver print, 19 × 15 inches, 50 × 40 cm. Courtesy CAAC—The Pigozzi Collection, Geneva. © Keïta / SKPEAC.

which initially both joins and separates the baby and mother when the mother's love, displayed or made manifest as human reliability, does in fact give the baby a sense of trust or confidence in the environmental factor.[6]

Alongside the passion for doubling and symmetry that runs across many of Keïta's photographs, one recurring element that caught my eye immediately was the merging of figure and ground amid great swathes of fabric. To me, this evokes a correspondence with Sonia Boyce's pastel drawing *Big Women's Talk* (1984), in which a young girl looks up and out of a woman's lap, surrounded by the folds of a floral-patterned dress, with an expression of mute yearning and wonder. Such a blurring of boundaries, introducing uncertainty as to where "I" ends and "you" begin, brings artist and audience into the realm of intersubjective intimacy, which has been an important thematic concern among black British artists and photographers. Where Boyce has further explored aspects of intimate detail and ritual occasion in the genre of studio portraiture in drawings such as *Auntie Enid—The Pose* (1985) (fig. 7.4), her keen observation of decorative plenitude in the aesthetics of West Indian interior design finds a resonance in Maxine Walker's photographic study *Front Room* (1987). The portrait, within Walker's series *Auntie Linda* (1987), draws attention to the accumulated density of objects that are imbued with personal meanings as a synecdoche for self-possession, just as the frozen gestures of the studio portraits of Caribbean settlers to postwar Britain underline, as Stuart Hall suggests, "formality as a signifier of self-respect" (1984, 6).

Self-portraiture has been a key preoccupation of diaspora artists in the West not least of all because it has been a structurally impossible genre for black artists to occupy within societies which once regarded blackness as a sign of the absence or lack of selfhood. Yet rather than a reactive counterdiscourse, the reclaiming of portraiture in diaspora aesthetics can be said to eschew atomized individualism for an alternative emphasis on the relational composition of the social self. Informed by a hard-won awareness of the constitutive rather than reflective role of representation, black artists have sought to shift the codes of the genre by working in the gaps between commonplace oppositions which govern the knowability of the depicted self.

Insofar as a portrait is analogous to a proper name, it is rarely felt to be an arbitrary nomenclature of mere kinship but something that is an integral part of one's personhood itself, not to be taken in vain, which now becomes the locus of carnivalesque renaming. Masquerade, displacement, and a healthy sense of humor have all been integral to the flourishing of black narcissi in England's green and not-always-so-pleasant land.

If being at home implies a sense of place, imagine your response when you encounter a stranger on your afternoon walk in the countryside who innocently assumes

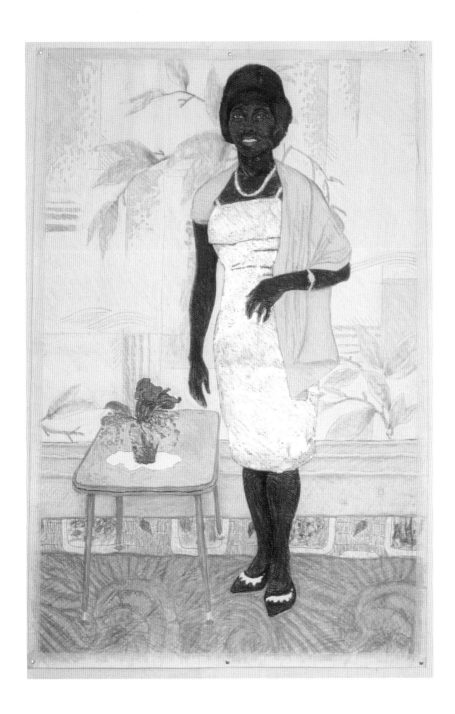

7.4 Sonia Boyce, *Auntie Enid—The Pose*, 1985. Pastels on paper. Courtesy of the artist.

the prerogative to ask: "And what part of Africa do you come from?" Because you come from Croydon, you would probably burst out laughing! Such structures of feeling have formed the point of departure for Ingrid Pollard's photographic journeys across the urban/rural divide, which continues in an ongoing exploration of the highly ambivalent place of black people in the English countryside. Because of the breakthroughs into visibility associated with the documentary interventions of Armet Francis, Vanley Burke, Sunil Gupta, and other black British photographers, Pollard is of a generation able to move beyond protest in order to access the ordinariness of black experiences in Britain. Here she is able to find a wry source of pleasure in the absurdities that often arise when diverse cultures and ethnicities overlap and intertwine in unanticipated ways. Framing full-length portraits of friends and cohorts in lush outdoor settings — including those who insist on bringing along their watermelon and fried chicken — Pollard offers a holiday from the often overbearing seriousness of so much of the discourse on race and representation; yet she also inscribes a sure sense of intimate respect within the playful ambience of her portraits (figs. 7.5 and 7.6). Juxtaposed with images of children, the mawkish sentimentality of the so-called positive image is erased in favor of allowing a more open-ended reflection on the future generations of multicultural England: If our identities were borne on the journeys between here and there, then where will theirs come to be?

Oladele Bamgboye's photographs, like those of his precursor Rotimi Fani-Kayode, similarly inscribe the movement of journeys across both geographical and psychic spaces. His voyage of return to Nigeria, after growing up with his family in Scotland, inscribes a poetic meditation on attachment and loss, traveling through ambivalent structures of feeling that are often overlooked or minimized, among diasporized subjects in the West, by romantic narratives of a return to roots which imply the kind of happy endings that are much sought after but rarely attained. Bamgboye's intercultural border crossing informs his strategic moves out of the categorical ghettos of race, class, and gender to find a visual vocabulary in which differences can create comfort rather than confrontation. As he himself describes it, "I deliberately choose to photograph the male body in the most common, but often under-represented situation: the domestic home. I choose to photograph the nude . . . as this is the most natural state of the human body, stripped of all material wealth and status. I concentrate on self-portraiture in order to give me total control over the image-making process, and ultimately to be directly responsible for the statements that I make in my work."[7]

While black artists, up to now, may have had to shoulder responsibility for representing the entire race, the liberating profusion of innovative work over the past de-

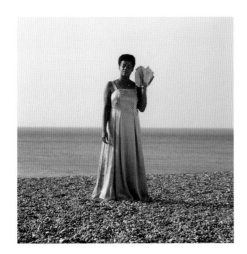 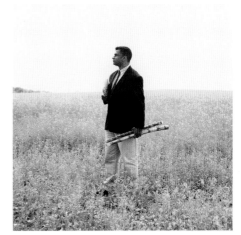

7.5 Ingrid Pollard, *Untitled*, 1994–95. Color light box, 20 × 20 inches.
Courtesy of the artist.
7.6 Ingrid Pollard, *Untitled*, 1994–95, Color light box, 20 × 20 inches.
Courtesy of the artist.

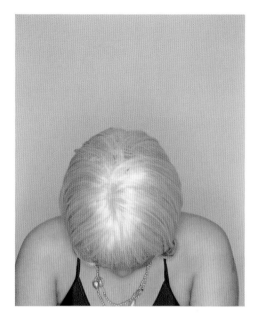

7.7–7.10 Maxine Walker, *Untitled*, 1995. Courtesy of Autograph: ABP, London.

cade has brought about a new kind of critical individuality, nowhere more self-evident than in the compelling auto-portraits of Maxine Walker (figs. 7.7–7.10). While earlier projects such as the *Black Beauty* series (1989) acknowledged the constructed character of images of black women, Walker's current work explores the performative dimension of black women's possible modes of self-presentation. The use of props such as wigs, clothes, and makeup undermines the cult of authenticity, which implied that there was only one way in which racial and sexual difference could be reconciled into identity. Instead, such props employ artifice as a strategic tool of estrangement, along parallel lines to Lyle Ashton Harris's avowedly theatrical questioning of whether any one, singular mode of representation of the self can encapsulate the plurality of "the real me." Informed by stories of family genealogy, and the intrinsic hybridity of New World societies where race mixing is, in a sense, the norm rather than the exception, Walker negotiates multiple identities, both chosen and imposed—by descent and consent—in order to share and celebrate the freedom and responsibility of becoming who you already are. It is this unknown destination of the potential self that is made evident and universally relevant by these portraits from places in between. As Appiah's reflections conclude, "If an African identity is to empower us, so it seems to me, what is required is not so much that we throw out falsehood but that we acknowledge first of all that race and history and metaphysics do not enforce an identity: that we can choose, within broad limits set by ecological, political and economic realities, what it will mean to be African in the coming years" (1992, 176).

NOTES

This chapter was first published in *Self-Evident*, exhibition catalogue (Birmingham: Ikon Gallery and Autograph: Association of Black Photographers, 1995), n.p.

1. Stuart Hall, "Vanley Burke and the 'Desire for Blackness,'" in *Vanley Burke: A Retrospective*, ed. Mark Sealy (London: Lawrence and Wishart, 1993), 12–15.

2. Seydou Keïta in André Magnin, *Seydou Keita* (Paris: Fondation Cartier pour l'art Contemporain, 1994). See also *Mama Casset: Les precurseurs de la photographie au Senegal, 1950* (Paris: Editions Revue Noir, 1994).

3. André Magnin in *Seydou Keita: Studio Work, 1946–1970* (CD-ROM) (Paris: Lux Modernis, 1995).

4. Seydou Keïta in Magnin, *Seydou Keita* (1994).

5. The notion of "afro-kitsch" originates with Donald John Cosentino, "Afrokitsch," in Vogel, 1991, 240–55.

6. D. W. Winnicott, "The Location of Cultural Experience," in *Playing and Reality* (London: Penguin, 1971), 118, 121.

7. Oladele Bamgboye, unpublished artist's statement, April 1994.

8

AFRICAN PHOTOGRAPHY IN CONTEMPORARY VISUAL CULTURE

African photography came into global circulation during the 1990s. Contemporary audiences have been introduced to a range of photographic practices as a result of several large-scale exhibitions, including *In/sight: African Photographers, 1940 to the Present*, at the Guggenheim Museum in New York (1996); *L'Afrique par Elle-même* at the European House of Photography in Paris (1998); and *Africa by Africa* at the Barbican Arts Centre in London (1999). The work of Seydou Keïta, Malick Sidibé (born 1936), and Samuel Fosso (born 1962), among others, has received widespread attention as a consequence of the image flow associated with the production of these exhibitions. Indeed, as well as creating new sources of visual pleasure, the stylistic features surrounding the distinct "look" of African photography raise new questions about understanding the cosmopolitan character of photography's history. This overview reflects upon the contrasting approaches in curatorial selection and examines the motivations of the underlying research paradigms, revealing significant differences of emphasis in the way that African photography is written about and brought into discourse.

According to the Roman scholar Pliny, *ex Africa semper aliquid novi*—that is to say, there is always something new out of Africa. The sheer wealth and variety of the photographic materials which have now come to light would appear to confirm this ancient insight. The second of the three exhibitions, whose catalogue was published in English as *Anthology of African and Indian Ocean Photography* (Saint Léon and Fall, 1999), was truly breathtaking in its historical scope. Showing studio portraits from Zanzibar, Dakar, Lagos, and Cape Town from the 1890s to the 1920s, as well as photojournalism and press agency reportage from the 1950s and 1960s, and concluding with art photography from the African diaspora in African American, black British, and Latin American contexts, the evidence suggests that what is "new" about the history of African photography is that it is as old as the history of photography in the West.

Considered as a whole, the materials shown in the three exhibitions suggest a transcultural parallel which reveals the history of African photography to be coexten-

sive with the general history of photography, that is to say, the history of photography as it is understood in the West. The chronology whereby African photography developed from portraiture through photojournalism to artistic practice confirms the view that, as a picture-making technology, photography is defined not so much by the specificity of the medium as by the multiplicity of its social and cultural uses. Furthermore, as evidence of what Olu Oguibe, writing in the *In/sight* catalogue, calls "the indispensability of human agency" (1996, 247), the images that African photographers produced bear witness to a historical dialectic in the visual culture of modernity. On the one hand, photography was an integral part of a visual technology that made representation central to the politics of colonialism. The camera was used to document the deeds of explorers, armies, missionaries, and administrators, all of whom produced images that depicted Africans as "other." On the other hand, however, in order to actually obtain the pictures, Europeans required assistance from Africans who often carried the bulky thirty-by-fifty-centimeter box-camera apparatus upon which the so-called colonial gaze would depend. What arose out of this interactive dynamic was a situation of technology transfer whereby the skills Africans acquired as apprentices to European photographers were gradually adapted to convey the expressive needs and imaginative choices that African subjects made for themselves.

The numerous photographic studios that opened in harbor cities and coastal towns from the 1890s onward are testimony to such an underlying process of adaptation and appropriation. Alex Agbaglo Acolaste (1880–1975) produced elegant portraits of the Togolese bourgeoisie, like the sepia-toned portraits of the local elite created by Ramilihoana (1887–1948) and Razakar (1871–1939) studios in Madagascar. This is important because it enriches our understanding of cross-cultural moments of hybridity in photography's history. Contrary to the commonplace myth that depicted fearful or superstitious natives who were anxious that the camera should steal their souls, what we find in a picture such as the 1939 Congolese village scene by Antoine Freitas (fig. 8.1), showing the photographer surrounded by curious and engaged onlookers as he takes an outdoor portrait in the Democratic Republic of Congo village of Kasaï, is archival evidence that undermines Eurocentric assumptions which once regarded African cultures as inherently antithetical to modernity. What is revealed instead is an interactive history in which elements of African and European cultures were opened to modification as a result of a dynamic encounter that took place under the unequal conditions of colonial societies. It is against this background that I set out to evaluate the insights and limitations of the three main research paradigms with a view toward arriving at an interpretative synthesis.

Contrasting Approaches

It may seem odd to begin with Anglophone and Francophone contrasts—as if national differences have any explanatory role—but it is important to acknowledge that the prime movers who initiated the research are French. The *Anthology of African and Indian Ocean Photography* was the result of research undertaken by the *Revue Noire* editorial team of Jean Loup Pivin, Pascale Martin St. Léon, N'Goné Fall, and Simon Njami since the inception of their quarterly arts magazine in 1988. Around the same time, curator André Magnin, who has stated that "photography has played a central role in the study of art in sub-Saharan Africa that I began in 1987," started collecting Seydou Keïta's photographs, and Magnin is also the author of a monograph on Malick Sidibé.[1]

Writing up the research into descriptive commentary about the empirical facts and circumstances surrounding the production of the images, Magnin has collaborated with Malian scholar Youssouf Tata Cissé (who provided the descriptive captions for Keïta's photographs), just as Jean Loup Pivin has worked with Bouna Medoune Seye at Mali's National Museum in Bamako. Gathering data about the quantity and condition of material, about the lives and careers of the photographers, and about the surrounding milieux in which they practiced, the Francophone writers may be considered as primary actors in a process that has initiated an image flow in which hitherto anonymous materials have been "translated" from one cultural environment to another. Whereas Magnin's prose is rich in factual information, it does not self-consciously reflect on the processes by which it actively participates in giving new meanings and values to the materials that have been "discovered." Magnin offers an aesthetic appreciation of the stylistic qualities of Keïta's images, but ignores the fact that as a Bamako studio photographer producing portraits for his urban clientele in the 1950s and 1960s, Keïta did not intend his photographs to be viewed as objects of artistic appraisal or exhibited in museum or gallery spaces (fig. 8.2).

The *Revue Noire* team, on the other hand, acknowledge their interest in the pleasurable appeal exerted by the generic styles of African photography, although the often impressionistic character of their poetic commentaries tends to downplay a critical account of the colonial and postcolonial contexts in which the images were culturally produced. Because such writings tend to underplay a self-reflexive awareness of how images travel and circulate, the concern inevitably arises that the research motives are commercially driven and perhaps amount to a kind of neocolonial appropriation that severs the aesthetics of African photography from its social and historical contexts.

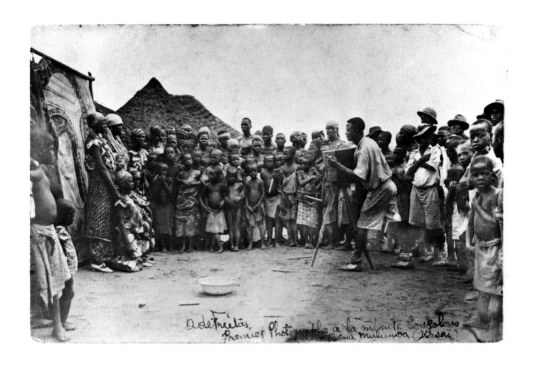

8.1 Antoine Freitas (1919 Angola–1990 Kinshasha), *Democratic Republic of Congo, Kasaï, 1939*. Vintage print, 9 × 14 cm. Courtesy of Revue Noire, Paris.

Such concerns enter the picture with a third contrast introduced by the writings of Okwui Enwezor and Olu Oguibe, founding editors of *Nka: Journal of Contemporary African Art* and also curators behind numerous international exhibitions, such as the 2nd Johannesburg Biennale in 1997, which have transformed the global reception of contemporary art.

In contrast to the Francophone approaches, Okwui Enwezor and Octavio Zaya's (1996) introductory essay for the *In/sight* catalogue, "Colonial Imaginary, Tropes of Disruption: History, Culture and Representation in the Works of African Photographers," is driven by a critical ambition that sets out to account for the historical, social, and political factors that differentiate African photography as an object of aesthetic attention. What emerges from their wide-ranging perspective is a creative dialectic whereby African photographers are seen to actively disrupt the stereotypically primitivist imagery generated by nineteenth-century networks between art, science, and entertainment that were put into place by photography as a picture-making apparatus of colonial power par excellence.[2]

Writing that "because there is now no prior existence of a language *per se* with which to discuss photographic activity in Africa (although photography in Africa is not different from that in any other region of the world), what is revealed in interpreting the gaze or the field of vision is its implicit contest for the power of ownership," Enwezor and Zaya (1996, 21) explicitly foreground the ethics of cross-cultural translation. In a self-reflexive manner that is thoroughly aware of the political conditions which complicate Africa's and Europe's unequal interactions in the realms of art, commerce, and culture, they argue, "There are structures that historically have staked claim, appropriated, restricted, and controlled the access, diffusion, circulation, and representation of African art, from London to Paris to Zurich, which have also affected African photography. So how do we address questions of representation, self-imaging, and artistic freedom, when those initiatives are counteracted by stronger economic imperatives, and when the contingencies of social and epistemological control are made to bend to the influence of power and access?" (22).

At this stage we can see a sharp disparity. Whereas the Francophone writers offer a first-order description that is close to the primary research process, the Anglophone writers are concerned with the cultural politics of aesthetic interpretation. Although one may observe that the influence of André Bazin and Roland Barthes is notable by its absence from the concerns of André Magnin, and that the poststructuralist vocabulary of critical theory is not the main idiom of *Revue Noir*'s prose, there are also limitations to the *In/sight* approach which arise when its readings of stylistic difference tend to be

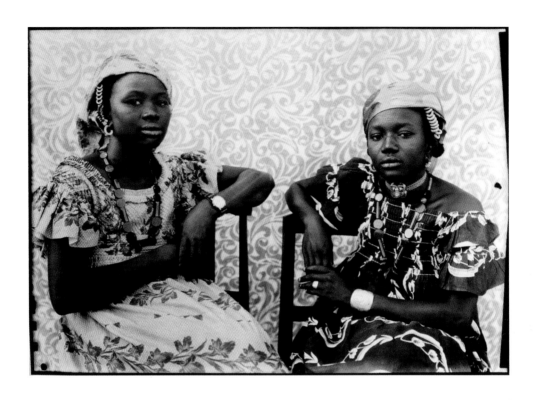

8.2 Seydou Keïta, *Untitled*, 1956–57. Gelatin silver print, 19 × 23 inches, 50 × 60 cm. Courtesy CAAC—The Pigozzi Collection, Geneva. © Keïta / SKPEAC.

overdetermined by a political standpoint that is concerned with redressing wider inequalities inherited from the colonial past (figs. 8.3 and 8.4).

Such qualitative contrasts indicate disparate institutional locations. The validity of Enwezor and Zaya's concerns is not in doubt, for the circulation of Seydou Keïta's photographs provide a case in point. First shown in *Africa Explores*, curated by Susan Vogel at the Center for African Art in New York in 1991, Keïta's work was then taken up by Magnin, who is associated with the Fondation Cartier in Paris and the collection of Jean Pigozzi, the Zurich-based industrialist whose interest in contemporary African art is said to have been inspired by the 1989 *Magicienes de la Terre* exhibition at the Georges Pompidou Centre in Paris.[3] Questioning the "neo-primitivist" reading of contemporary African art, the *In/sight* model reveals the volatile tensions of a historical dialectic between the apparatus of colonial photography and the cultural formation of African photography as a distinct genre of picture making. But taking a closer look, we nonetheless find some surprising areas of convergence in the way that the contrasting approaches translate hitherto anonymous artifacts into objects that are now experienced as art.

How Images Travel: Translating Art and Culture

To what extent does the contemporary image flow of African photography echo the inflow of non-Western tribal sculpture as a modernist influence at the start of the twentieth century? In light of James Clifford's (1988) account of the "art and culture system" in which Western practices of classification and taxonomy actively translate non-Western artifacts into objects that acquire aesthetic value as a result of their passage through this process, we may say that the increasingly global circulation of African photography involves a similar process of cross-cultural translation. A mass of hitherto anonymous pictures, many taken for all sorts of reasons as formal portraits, snapshots, or eyewitness accounts, are being repositioned into museum and gallery settings as individuated and differentiated art objects that acquire aesthetic and commercial value as a result. To the extent that such acts of translation have historically taken place under political and economic conditions of inequality, debates on how to conceptualize Africa's and Europe's cultural interaction involve a complexity that is often obscured by ethnical anxieties over the decontextualization of African art. The theft and plunder of tribal objects in colonial conquest inevitably reads as an analogue to the inhuman terror of the abductions carried out by the Atlantic slave trade.

Discussing modernist primitivism, Hal Foster (1985) observed a strong parallel between the extractive logic of colonial economics and the "abstractive" role of African

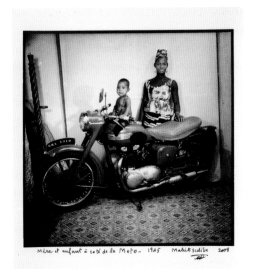

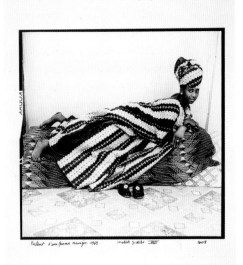

8.3 Malick Sidibé, *Mère et enfant à coté de la moto*, 1965/2008. Gelatin silver print,
20 × 16 inches. Courtesy of the artist and Jack Shainman Gallery, New York.
© Malick Sidibé.
8.4 Malick Sidibé, *Portrait d'une Femme Allongée*, 1969/2008. Gelatin silver print,
20 × 16 inches. Courtesy of the artist and Jack Shainman Gallery, New York.
© Malick Sidibé.

artifacts in the cubist rupture with representation in Picasso's *Demoiselles d'Avignon* (1907), where the otherness of the black female body served as midwife to the Western male artist's self-discovery. More broadly, opposing views on the interpretation of African art have often ignored decontextualization as a structural consequence of market-based modernity (which includes markets for art and culture). Adopting anthropology's salvage paradigm, some have argued for a purist or folkloric view which regards decontextualization as a loss of authenticity; while others, arguing from a culturally essentialist perspective, interpret such loss as grounds for restitution and reparation, which implies that the full meaning of "stolen" objects can only arise when they are returned to the original culture(s) to which they once belonged. Where both viewpoints treat culture as the fixed and final property of an ethnic identity, there is an implicit convergence that underplays the extent to which decontextualization is a structural consequence of modernity in which cross-cultural interactions deliver all identities into a state of ambivalence.

By taking account of the ways in which decontextualization is also one of the primary conditions of a photograph's polysemy, it becomes possible to loosen up the relationship between aesthetics and politics so as to reveal a hidden complexity in the colonial encounter. It is to Oguibe that we owe the insight that African photography exists only in a dialectical or dialogical relationship to the history of photography in the West. However, *In/sight*'s overall emphasis on issues of "social and epistemological control" implies a proprietorial conception of culture which would appear to replay the previous debate on ownership and authenticity even though what it brings to light are the interactive dynamics of cultural mixing or hybridity in which discrete cultural elements, such as the camera, cannot be said to possess a necessary belonging as the fixed object of ideological "ownership" in the discourse of any one cultural identity. Oguibe provides a clear example of how, once it is shared as a system of signs, photography itself opens on to unanticipated modifications and unexpected alterations as a result of practices of cross-cultural translation.

Discussing *ere ibeji*, or twin images that are traditionally produced in Yoruba contexts to commemorate a deceased twin, Oguibe describes how photographs which reproduce an image twice in a single frame act as spiritual effigies in a role that was previously performed by wooden carvings. In contrast to realist or naturalistic values, he shows that when photography, or rather photomechanical reproduction, was adapted, indigenized, and customized to such local conventions, what was valued in the reproducibility of the image was its aura of invocation rather than its empirical veracity or likeness (Oguibe, 1996, 239–46).[4]

As a diagram for the dynamics that animate the formation of African photography, we can see the process of translation in the turn-of-the-century emergence of African portrait studios in harbor cities. Describing the nineteenth-century West African portrait photographer George Da Costa (born 1853)—who gave up his job as manager of the Church Missionary Society bookshop in Lagos and opened up a studio in 1895—Oguibe writes that, "rather than conjuring a society of 'cannibals' and 'heathens,' Da Costa's photographs of early twentieth-century Africa lead us to a cosmopolitanism steeped in awareness of other cultures," for his clients included "international merchants, high-flying attorneys, widely travelled politicians, newspaper tycoons and society ladies" (1996, 233). Described by London publisher Allister Macmillan as "the ablest and best-known professional photographer in Nigeria" (quoted in Oguibe, 1996, 233), Da Costa had several counterparts such as the Lisk-Carew brothers (Alphonso Lisk-Carew, 1887–1969, and Arthur Lisk-Carew), who produced *cartes-de-visite* in Sierra Leone, and N. Walwin Holm (born 1865), who opened a studio in Accra in Ghana in 1883, and who was inducted into London's Royal Photographic Society in 1897. The cosmopolitan worlds that engendered the African studio photography tradition thus reveal a dialectics of professional apprenticeship and subsequent autonomy. Practitioners such as Mama Casset (1908–92) in Senegal had initially learned from French expatriate Oscar Lataque in the 1920s prior to establishing his own Dakar studio in the 1930s. Similarly, Meïssa Gaye (1882–1982), a former civil servant who took identification photos for the government, subsequently opened his own Tropical Studio in Senegal in 1945.

While revealing the agency of appropriation in the entrepreneurial initiative of early African photographers, which demonstrates that photographic technology was not inherently "owned" by its initially oppressive uses, Oguibe's view nonetheless tends to underplay the sociological phenomenon of transcultural "sameness" whereby photography made self-representation more accessible to the urban middle classes and photographic portraiture served a similar social function for the national bourgeoisie as it did in the West. What is at stake is a question of emphasis that revisits the disciplinary tensions between art history's and anthropology's competing understandings of the stylistic and semiotic differences produced in modern African cultural texts. Although critically self-conscious of the political determinants that influence African practitioners in colonial, neocolonial, and postcolonial periods, the *In/sight* approach is driven toward an auteurist model that seeks to identify an artistic intention on the part of individual artisans who may not necessarily have intended their work to be experienced as an aesthetic expression. Under such circumstances, where the need for an

author is a function of our contemporary reading of hitherto anonymous images, is there not also a need for a greater degree of self-consciousness about the role that critics and curators play in actively constructing the very object that is exhibited and put into discourse as art?

Identifying intentions in order to establish authorship was always central to the operations of the modernist art and culture system. When the images by Cornelius Yao Augustt Azaglo (born 1924), who took passport photos of laborers and market traders in his open-air studio on the Ghana/Cote d'Ivoire border, are now regarded as artistically expressive—the impassive self-regard of the sitters seemingly "looking back" to confront the viewer's gaze—to what extent is this our own creative *misreading* of the object at hand? (fig. 8.5). It is not so much that Azaglo's intentions are now irrelevant to the translations we perform as an audience, when it feels impossible for us not to see the images in relation to a work such as Irving Penn's *Worlds in a Small Room* (1970), but that the logic of decontextualization means we can never fully recover or reconstruct their original meaning as mere passport photographs that were intended for use in local customs and immigration regulations. In such a situation, is there not a potential mismatch between an author-based view which gives priority to the encoder's intentions, and a reception-based view which gives the reader a greater role in decoding photographic polysemy?

By suggesting an "oppositional" role for African photographers, Oguibe is led to the view that studio portraiture sought to counteract imperialist imagery and refute stereotypical perceptions. The hypothesis that African photographers sought to answer back to misrepresentations engendered by the colonial gaze helps to anchor stylistic qualities within a social and historical context, but it also runs the risk of conflating the multiplicity of Africa's photographic practices into an auteurist model of art photography. For example, one of the key qualities of African studio portraiture noted by most writers is the intimate and relaxed atmosphere whereby the shared lifeworld between photographer and client created a visual repertoire that is markedly distinct from the extremism of Western views, which tend to create a sharp polarity between object and subject of representation. However, our reception and interpretation of this qualitative difference do not necessarily imply a purposive and deliberate artistic intention to subvert, challenge, or disrupt the colonial gaze. May we not also consider the possibility that African practitioners and their clientele were more or less indifferent to how they were seen by Europeans?

Interpreting the semiotic difference of African photographs against the grain of colonial visual codes, the *In/sight* model also runs the risk of overlooking the crucial

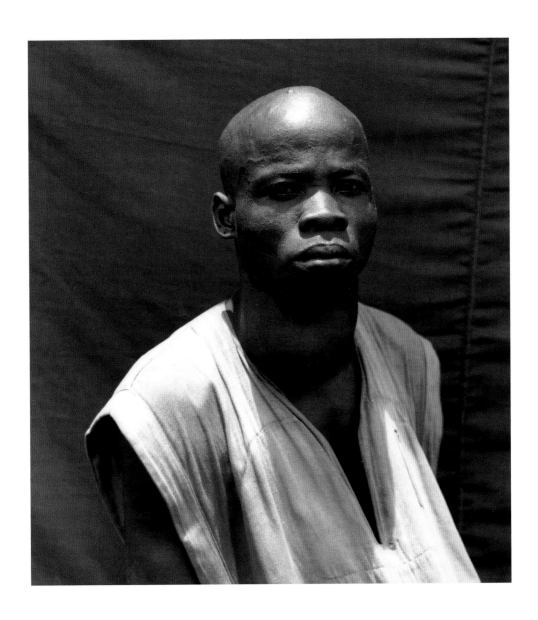

8.5 Cornelius Yao Augustt Azaglo (1924 Togo–2001 Korhogo, Ivory Coast), *Portrait of a peasant, Northern Ivory Coast*, c. 1960–70. Courtesy of Revue Noire, Paris.

fact that colonial photography was not primarily exhibited in Africa itself, but was first and foremost produced and distributed for Western consumption. To the extent that visual culture developed in the West on the basis of print culture, with newspapers, magazines, and books providing a medium for photographic circulation, the imperialist image flow had its greatest impact not in sub-Saharan Africa but in metropolitan societies that included African diaspora populations. Once we consider African American studio portraitists from this period, such as the Ohio-based James Presley Ball (1825–1905), one might say that the need to refute the racist gaze was strongest among black diaspora subjects, who could not easily identify with "Africa" in any case because of the imaginary barrier of otherness historically interposed by colonial fantasy (Willis, 2000). Whereas the dialogic model of answering back operates as a formative necessity of black self-representation in diaspora environments, this cannot be equated with African environments where political relations were shaped by forms of cultural adaptation and resistance that "replied" to colonial dominance under very different historical conditions of social structure and cultural agency.

Crosscutting Image Flows

Where the auteurist model replays the dilemmas of decontextualization as an unresolved issue across the *In/sight* and *Revue Noire* exhibitions, my suggestion is that the study of visual culture might be able to offer a way out. Both exhibitions featured photojournalism from Jim Bailey's weekly *Drum* magazine in Johannesburg, which had a multiracial staff that included Bob Gosani (1934–72) and which helped launch the careers of Alf Kumalo (1930–2012) and Peter Magubane (born 1932). What we find in the South African tradition of hard-edged documentary reportage, from David Goldblatt (born 1930) to Santu Mofokeng (born 1956) and Zwelethu Mthethwa (born 1960), is a process whereby the urban development of commercial infrastructure allowed a degree of photographic specialization, which in turn enabled the emergence of individual auteurs identified by a signature style within the realm of art photography. Thus the role of print media may be regarded as a structural factor in African photography in the postindependence era. The transnational network of lifeworld connections whereby many contemporary African photographers live and work in the West may also be considered as a further structural condition for the development of art photography. The diaspora's thematic of displacement features prominently among such practitioners as the Algerian Mohammed Dib (1920–2003), the Paris-based Moroccan artist Touhami Ennadre (born 1953), and the Nigerian-born and London-based artist Rotimi

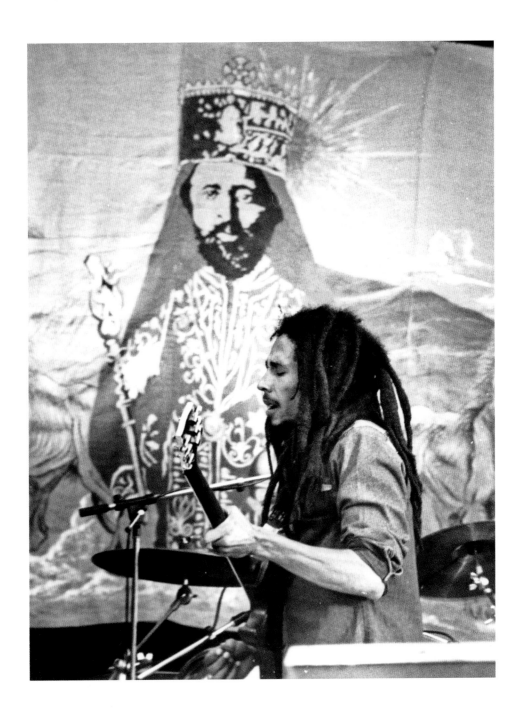

8.6 *Bob Marley, Bob Marley and the Wailers Exodus Tour, Santa Barbara,* 1979.
Photo: Chris Walter. © Getty Images.

Fani-Kayode (1955–1989). As well as regional specificity, what calls for reflection are the intertextual routes whereby diaspora aesthetics folds back onto the imagined spaces of the "homeland" itself.

The writings of Manthia Diawara provide an example of a visual studies approach. Placing Seydou Keïta's Bamako studio into a memory map that situates it among the key institutions of this African cityspace—alongside the railway station, the market, the cinema, and the prison—he writes: "I get the same feeling looking at Keïta's portraits that I get watching Chaplin's film *Modern Times* (1936). Even though Keïta's subjects look like us, they are not us" (Diawara, 1998, 70).[5] Drawing on autobiography to loosen the stasis of art historical and ethnographic modes of writing, Diawara takes the two-way traffic of Afro-modernity as the conceptual horizon of his situated readings. He is open about the aesthetic attraction that the ambivalence of identification exerts among contemporary audiences. His approach recognizes that the seductive semiotics of African photography depends precisely on this "us/not us" oscillation, which makes the visual worlds depicted all the more fascinating in their photographic polysemy.

It strikes me that the current circulation of African photographs owes much to this polyvocal quality. For some audiences the ambiguity may be settled by taking the view that it expresses cultural incommensurability, while for others it may offer the lure of overidentification, and some audiences may experience all these options at once. The mimicry of Samuel Fosso's self-portraits in Janet Jackson's music video "Got Till Its Gone" (1998) implies that the cultural expression of the black diaspora may itself depend, in part, on the processes of decontextualization that opens appropriated images to unintended consequences. For me, one of the most surprising moments in the *Revue Noire* exhibition was the 1920s portrait of Emperor Haile Selassie by the Armenian photographer Torkom Boyadjian (1868–1928), who was employed as the official court photographer to Ethiopian royalty.[6] His image of Selassie is a global icon of Rastafarian culture that appears on the gatefold sleeve of Bob Marley's album *Exodus* (1977) and as a stage backdrop on tour (fig. 8.6). By identifying authorship, we now realize how deeply the different diasporas, such as the African and the Armenian in this instance, have been intertwined in the making of the visual cultures of modernity.

Lastly, in moving from a proprietorial conception of culture into the unsettled mix of worldly appropriation and counterappropriation in the field of cultural production at large, the recurring theme of transcultural parallax would underline Jan Nederveen Pieterse's view on the global sociology of hybridity. Showing that hybrid mixtures do not always disrupt the norm by virtue of difference alone, Pieterse (1995) suggests that cross-cultural correspondences and "sameness" also have the potential to challenge

commonsense classificatory systems which seek to fix an absolute boundary between "us" and that which is "not us." What is interesting about the archival treasures of African photography that have been brought to light by the diverse paths into its current interpretation is that these are just some of the broader avenues for future inquiry into the past that lie before us.

NOTES

This chapter was first published in *Camera Austria International*, no. 75 (2001): 28–37.

1. André Magnin, *Seydou Keïta* (Zurich: Scalo, 1997). See also Youssouf Tata Cissé, *Seydou Keita* (Paris: Centre National de la Photographie, 1995), and André Magnin, *Malick Sidibé* (Zurich: Scalo, 1998). One of the earliest publications in the Francophone research was "Photographies," *Revue Noire*, no. 15 (December 1994–January-February 1995): 42–83.

2. Elizabeth Edwards, ed., *Anthropology and Photography: 1860–1920* (New Haven, CT: Yale University Press, 1992); Nicholas Monti, *Africa Then: Photographs, 1840–1919* (New York: Knopf, 1987).

3. The Jean Pigozzi collection is discussed in John Picton, "In Vogue, or the Flavour of the Month: The New Way to Wear Black," in

Oguibe and Enwezor, 1995, 114–26. See also *Contemporary African Art from the Jean Pigozzi Collection*, auction catalogue (London: Sotheby's, 1999).

4. Oguibe's account of Yoruba twin images draws from Stephen Sprauge, "Yoruba Photography: How the Yoruba See Themselves," *African Arts* 12, no. 1 (November 1978): 52–59.

5. On the use of autobiography in visual studies, see also Manthia Diawara, "The 1960s in Bamako: Malick Sidibe and James Brown," *Paper Series on Arts, Culture and Society* (Pittsburgh: Andy Warhol Foundation for the Arts, 2001).

6. Richard Pankhurst and Denis Gerard, "Court Photographers," in Saint Léon and Fall, 1999, 118–33.

9

ETHNICITY AND INTERNATIONALITY: NEW BRITISH ART AND DIASPORA-BASED BLACKNESS

Now that the Young British Artist (YBA) phenomenon is mostly tired and expired it seems timely to ask: What was all that about? To tell the story as a simple sequence that starts with the 1988 *Freeze* exhibition, organized by Damien Hirst and other Goldsmiths' students in a Docklands warehouse, and that ends with the Royal Academy of Art's 1997 *Sensation* exhibition of Charles Saatchi's collection, is to collude with the mythology. Taking account of the aesthetic, cultural, and, above all, ideological aspects of "the myth of the young British artist" (Ford, 1998), this chapter considers the curious position(s) of diaspora artists amid the contradictory forces of art world globalization and regressive localism which, I shall argue, are the key factors in critically understanding recent shifts around cultural identity.

Viewed as an artistic phenomenon, New British Art was neither new nor British. Loosely defined to include renewed interest in painting (Gary Hume, Richard Patterson) and sculpture (Anya Gallacio, Jake and Dinos Chapman), it was characterized, above all, by neo- or postconceptualist approaches to the installation genre. The choice of medium, whether film (Douglas Gordon), video (Gillian Wearing), or photography (Sam Taylor-Wood), was secondary to the provocative and irreverent attitude whereby, as Michael Bracewell observed, "the new generation of British artists had taken irony and punning—on materials, roles and titles—as the keynote of their projects" (1997, 229–30). This much-vaunted matter of "attitude," however, would be more usefully described generationally rather than nationally, for its hyperironic ambiguities actually originated in the aesthetics of abjection that first emerged among American artists such as Mike Kelly, Paul McCarthy, and Sean Landers.

Hal Foster (1996) argues that the early 1990s cult of abjection signaled a generational reaction against an impasse in which art became embroiled in the culture wars. He suggests that an interest in abjection—that which is cast out and expelled from identity as an unrepresentable excess or remainder—led younger artists to break out

of the left/right stalemate over identity politics in favor of a "return of the real." Reactivating the crux of 1960s pop, minimalist, and conceptualist strategies, with a knowingly intertextual twist absorbed from such 1980s appropriation artists as Cindy Sherman, the neo- or postconceptualist outlook has brought about a massive disarticulation of the values that made questions of representation central to the critical ambitions of various twentieth-century avant-gardes.

While the consequences of this displacement cannot be underestimated— rejecting high seriousness for ephemerality and fun, for example—it would be mistaken to view YBA irreverence as merely the antipolitical animus of Thatcher's children. Whereas curator Andrew Renton wrote in *Technique Anglais* (1991) that "a certain kind of irresponsibility seems to me to be a very key concept that brings these people together aesthetically,"[1] Angela McRobbie has observed that "the don't care attitude had the effect of freeing artists from the burden of being classified in terms of great, good, mediocre or bad."[2]

Viewed as a cultural phenomenon, the YBA mytheme did indeed reveal unresolved fault lines in 1990s Britain. As it developed from an underground scene, comprising entrepreneurial dealers, quick-witted curators, and an overabundance of unemployed art school graduates, the YBA won widespread media attention. Its arrival as a news item was marked by tabloid outcries over Rachel Whiteread's public commission *House* (1993) and by further controversy when pop group KLF burned a million pounds after she won the Tate Gallery's 1993 Turner Prize.

With "the appropriation of Damien Hirst's tanked-halves aesthetic to advertise Ford cars," a network of new connections between art markets, youth cultures, urban spaces, and cultural industries emerged as a "creative ménage-à-trois between popular culture, fine art and metropolitan fashionability" (Bracewell, 1997, 231, 229). By virtue of an unprecedented synergy (to use marketing-speak) between these hitherto disparate sectors, the YBA meshed with other strands in popular culture—laddism, football, BritPop. It was repackaged for mass consumption as a rerun of the Swinging Sixties. Notwithstanding the invention of the 1960s myth by two American journalists, the highly "retro" 1990s version equally centered on London as the creative hub for trends in music, fashion, art, and design. Brand new, you're retro, one might say, for it was precisely the all-pervasive retro-ness that characterized the Britishness of New British Art in this much-hyped moment of going overground.

In contrast to what was called "pathetic art" or "loser art" in the United States, which overlapped with the slacker or grunge aesthetic in youth culture, YBA Britishness revealed itself in the jokey way it practiced "the conceptual gag with an ironic

punchline" (Bracewell, 1997, 230). Sarah Lucas's *Two Fried Eggs and a Kebab* (1992) was a visual pun on a pathetic male colloquialism for breasts and vagina. Gavin Turk's *Pop* (1993) was a life-size waxwork of the artist posing as Sid Vicious, after the manner of Andy Warhol's *Triple Elvis* (1964). A lot of it was hilarious, some of it was silly, and as Bracewell noted, "In a media-literate age of some sophistication, the immediacy or obscurity of British neo-conceptualism was either the first test of its intentions or the last." He adds, "Whether this was a rampant complicity with the branding of meaning invoked by cultural commodification, or a grapeshot expression of violent alienation in the face of it, remained the fulcrum on which much of its ambiguity—in terms of a generational solidarity—was balanced" (Bracewell, 1997, 230).

In the thick of this promiscuous interplay between neoconceptual cleverness and a nudge-wink vernacular, some artists accentuated the ambivalence to offer wry insights on everyday life. Taking Royal Ascot horseracing as subject matter in *Race, Class, Sex* (1992), Mark Wallinger addressed national identity in the realm of sports, as did Roddy Buchanan's photographs of Glasgow soccer fans wearing Inter Milan strips. Gillian Wearing's *Dancing in Peckham* (1995) brought a deadpan populism to a playful neo-conceptualist questioning of vox pop authenticity, as did her photo-text piece *Signs that say what you want them to say and not Signs that say what someone else wants you to say* (1992–93) (figs. 9.1 and 9.2).

However, as Simon Ford argues, "The question of whether the myth of the YBA is nationalistic does not exhaust itself with an examination of individual works: how the work is used and promoted abroad should also be taken into account" (1998, 135). Over and above the pastiche patriotism that often surfaced as the jokey signature of a self-deprecating Englishness, the London-centered localism of the New British Art scene gradually became a touchstone of an official institutional ideology. With salon-style annual exhibitions such as Saatchi's *Young British Artists* (1992–97) and the Arts Council's touring *British Art Show* (1993–96), a new private-public partnership pattern took hold. This in turn led to the export-driven promotional aims of British Council–sponsored exhibitions such as *General Release* (1995) at the Venice Biennale.

With the spate of exhibitions marked by *Live/Life* (Musee d'Art Moderne, Paris, 1996), *Brilliant!* (Walker Art Center, Minneapolis, 1995), and *Pictura Britannica* (Museum of Contemporary Art, Sydney, 1997), however, the limitations of relying on highly stereotypical invocations of Britishness to market the YBA internationally became all too apparent, as Patricia Bickers astutely observed.[3] Foreign audiences were undoubtedly entertained by its quirky cultural specificity, but relative indifference to the hype in New York or the German-hosted Documenta 10 (1997) made one wonder whether it was not the British themselves who really needed to believe in it.

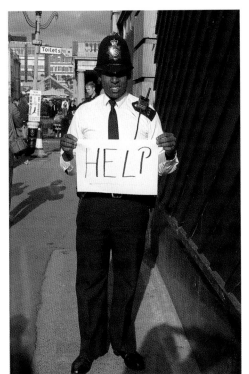 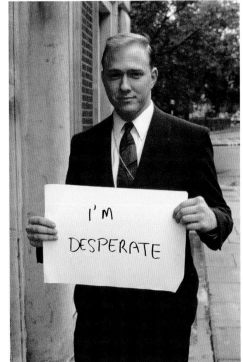

9.1 Gillian Wearing, *Signs that say what you want them to say and not Signs that say what someone else wants you to say* HELP, 1992–93. C-type print mounted on aluminum. Courtesy of Maureen Paley, London. © Gillian Wearing.
9.2 Gillian Wearing, *Signs that say what you want them to say and not Signs that say what someone else wants you to say* I'M DESPERATE, 1992–93. C-type print mounted on aluminum. Courtesy of Maureen Paley, London. © Gillian Wearing.

Such underlying insecurities about Britishness received momentary relief with the 1997 arrival of New Labour, which added a final twist to the tale by assimilating the YBA to its cultural industries marketing pitch dubbed Cool Britannia (ouch!).[4] While the volatile mix of Blairite populism is examined later, at this stage it is precisely the discrepancy between parochial YBA inwardness and art world internationalism that obliges us to interrogate the ideology of New British Art as a defensive and, above all, regressive response to the bewildering effects of globalization.

Whatever Happened to the New Internationalism?

Once seen as a local response to art world globalization, the nationalistic content beneath the cheeky neoconceptual irony revealed itself by contrast with a countervailing tendency which emerged at the same time, but which, it seems fair to say, did not win out, namely, the so-called new internationalism.

In 1994 the Institute of International Visual Arts (INIVA) was established by the Arts Council in the aftermath of a failed attempt to convert London's Roundhouse into a black arts center. Seen from abroad, INIVA is unique. Unlike European countries in which multicultural arts policy is either nonexistent (Germany, France) or relatively recent (Holland), it shows how far UK policy has come in what Gavin Jantjes optimistically described as "the long march from 'ethnic arts' to 'new internationalism'" (1993, 59–66). Closer to home, however, INIVA has been ignored or disparaged either on account of its state subsidy (which is at odds with entrepreneurialism) or, more important, on account of the vagueness with which it has implemented its mission to "promote the work of artists, academics and curators from a plurality of cultures."[5] Critic Niru Ratnam regards INIVA's founding decision not to be associated with a dedicated exhibition venue as an evasion of the difficult question of "how [to] exhibit, rather than write about, art that addresses identity politics."[6]

Considering the discrepancy between YBA localism and INIVA's pluralism, we get a glimpse into the perplexing conditions occupied by diaspora artists such as Steve McQueen, Chris Ofili (fig. 9.3), Hamad Butt, and Permindar Kaur. Making artistic choices fully congruent with the return to the crux of pop, minimalism, and conceptualism, their highly individualized projects mark out a strong contrast with the collectivist ethos of the 1980s, as writers such as Stuart Morgan noted.[7] However, to reduce such generational shifts to a before-and-after story about the fate of identity politics is to fail to recognize that the goalposts of cultural practice have themselves radically shifted. Individual choices are conditioned by structural changes in institutional policy

9.3 Chris Ofili, *Spaceshit*, 1995. Acrylic, oil, polyester resin, map pins, and elephant dung on linen, 72 × 48 inches, 182.8 × 121.9 cm. (CO 13) Collection: Janet de Botton and Rebecca Marks. Courtesy of the artist and Victoria Miro, London. © Chris Ofili. Photo: Stephen White.

and ideology, and such altered art world outlooks have arisen, in part, because the critique of multiculturalism debated so vehemently in the 1980s was not entirely unsuccessful, even though the resulting consequences were entirely unpredicted.

One of the distinctive features of the contemporary international art world is that although cultural difference is now more visible than ever before, the unspoken rule is that you would look a bit dumb if you made a big issue out of it. How did this Janus-like turnaround come about? Following the *Magiciens de la Terre* exhibition in 1989, a slew of large-scale survey exhibitions such as *The Other Story* (1989) and *The Decade Show* (1990) inaugurated the blockbuster model of multicultural inclusion as a problem-solving response to criticisms of ethnocentric exclusion. As the multicultural paradigm passed through the fashion cycle, the institutional embrace of cultural difference reached saturation point with hostile responses to the 1993 Whitney Biennial exhibition. After "the Other is in," as Coco Fusco once observed, there was a subsequent reaction, in Britain at least, in which alterity was booted back out again.[8] Taking a global view, however, what emerged was not simply a backlash but a complex compromise between ethnicity and internationality.

On the one hand, the overinclusive mega-exhibition format became paradigmatic for the expanding circuit of biennales which extended beyond the Euro-American axis to include geopolitical spaces in Australia, Latin America, South Africa, Korea, and Turkey. In this respect, the outward face of globalization installed an ideology of corporate internationalism whose cumulative effect was to *sublate* the discourse of multiculturalism. Cultural difference was acknowledged and made highly visible as the sign of a "progressive" disposition, but radical difference was gradually detached from the political or moral claims once made in its name, such as the demand for recognition that was at stake in the 1980s debates on black representation.

The moment of sublation simultaneously cancels and preserves the antagonism of thesis and antithesis; but far from arriving at a happy synthesis, what we witness—on the other hand—in the dialectical mismatch between INIVA's critical pluralism and YBA "don't care" localism is a lingering tension around questions of responsibility that made matters of representation crucial to the articulation of aesthetics and politics throughout twentieth-century art movements. Local disdain toward INIVA's approach must be seen through the lens of post-Thatcherite ideology. Artist Stuart Brisley revealed its outlook when he remarked that New British Art "has a particular energy because . . . it doesn't suffer from the constraints of state patronage. There is an atmosphere of libertarianism and a release from social responsibilities."[9] Gallerist Jay Jopling provided further insight when he said, "I am not at all interested in issue-based art. . . . I am inter-

ested in art which has a certain degree of universality and is able to transcend certain cultural and generational differences."[10] While the YBA's populist edge defined itself against 1980s multiculturalism,[11] we can see in the British art world habitus the fallout of two contradictory responses to globalization as a new phase of capitalist modernization.

Viewed as a branding campaign in the transnational marketplace, the YBA's pathetic neonationalism must be understood as a paradoxical attempt to hook up with global flows of art world capital, not by joining in and moving outward to embrace new art from Hong Kong or Africa or Scandinavia or anywhere else, but by standing apart and turning inward to promote its own cultural identity as an "extra added value." Rather than align itself with corporate internationalism by confidently welcoming the difference of others, the YBA stridently asserted its own cultural distinctiveness such that it moved forward to embrace the challenges of globalization only by moving backward and ever inward into its own ethnicity. The arsey-versey dynamic of "regress as progress" pinpoints the YBA's reliance on outmoded stereotypes of Britishness, whether Tommy Cooper or the Sex Pistols.[12] Such jokiness unwittingly betrayed what Stuart Hall describes as

> one of the most profound historical facts about the British social formation: *that it had never, ever, properly entered the era of modern bourgeois civilisation. . . .* It never transformed its old industrial and political structures. It never became a second capitalist-industrial-revolution power in the way the US did, and by another route (the "Prussian" route), Germany and Japan did. Britain never undertook that deep transformation which, at the end of the nineteenth century, remade both capitalism and the working classes. Consequently, Mrs Thatcher knows, as the left does not, that there is no serious political project in Britain today which is not also about constructing a politics and an image of what *modernity* would be like for our people. (1988a, 164)

Hall's concept of regressive modernization, far from applying to Thatcherism alone, helps us to grasp how New Labour's project to modernize all aspects of society nonetheless resulted in the retrocentric idiom of Cool Britannia. It also illuminates the way New British Art dealt with the collapse of the critical distance between mass culture and avant-garde ambition that took place under postmodernism, namely, by withdrawing and retreating from difference into an identity politics of its own: come back to what you know. And where did that leave African and Asian diaspora artists? Highly visible yet evasively mute.

Multicultural Normalization

Amid the uneven coexistence of corporate internationalism and regressive localism, the 1990s generation of black British artists were neither invisible nor excluded from the hyperironic attitude in which the YBA was immersed, but enjoyed access to an art world in which ethnicity was admitted through an unspoken policy of integrated casting.

Like their transatlantic counterparts such as Kara Walker, Michael Ray Charles, and Ellen Gallagher, they arrived into a habitus in which the defunding of public subsidy gave the market a greater role in distributing opportunities for hitherto "minority" artists. Whereas Howardena Pindell's 1980s research found that few New York galleries and museums represented Latino, Asian, Native, or African American artists, today one would be hard-pressed to find a commercial gallery or public museum that did not represent at least one or two artists of color.[13] Diversity is now normal, not "special."

Taking stock of this unprecedented turnaround in art world attitudes, Jean Fisher argues that "cultural marginality [is] no longer a problem of invisibility but one of excess visibility in terms of a reading of cultural difference that is too easily marketable" (1996, 35). Cultural difference appears more visibly integrated into mainstream markets than ever before, but it is accompanied by a privatized ethos in which it is no longer an "issue" for public debate. How have these changes influenced the choices diaspora artists make? To explore this question, it is necessary to take account of parallel changes in black popular culture, not only because some artists take it as source material for conceptual inquiry, but because the visible integration of cultural difference into the global spheres of postmodern capitalism—whether Benetton, Nike, or Coca-Cola—informs the cultural horizon against which diaspora art practices are widely interpreted.

Taking account of hip-hop in the music industry, of black-themed cinema in Hollywood, and the plethora of African American images on network television in the United States, especially Rupert Murdoch's Fox channel, Herman Gray observes that, "given the level of saturation of the media with representations of blackness, the mediascape can no longer be characterized using such terms as invisibility. Rather, we might well describe ours as a moment of *hyperblackness*" (1995, 230). The marked degree of concurrence between the observations of Gray and Fisher allows us to suggest that United States–centered globalization has moved the goalposts around the rights and wrongs of "black representation" so profoundly that we now have a scenario in which the long-standing metaphor of minority invisibility has given way to a new and wholly unanticipated predicament of hypervisibility.

Associated with Ralph Ellison's modernist classic, *Invisible Man* (1952), the trope of invisibility addressed the demand for recognition Frantz Fanon articulated in *Black Skin, White Masks* (1967a). Voiced in relation to the clear-cut political boundaries of colonial domination or supremacist racism, the metaphor posited an equivalence between political empowerment and public visibility. While this overarching equation was held together during late modernity, such that struggles for voice and for visibility meant that blackness embodied a diacritical difference as a source of protest or resistance in relation to the culturally dominant, the era of postmodernity has given rise to the post–civil rights predicament which has torn such equivalences apart. Visibility has been won, in the African American context, through complicity with the compromise formations of cultural substitutionism. "Hyperblackness" in the media and entertainment industries serves not to critique social injustice, but to cover over and conceal increasingly sharp inequalities that are most polarized within black society itself, namely, between the so-called urban underclass and an expanded middle class that benefited from affirmative action.

The sociological dimension in black Britain is quite distinct, although the underlying discrepancy whereby media-visible figures like footballer Ian Wright coexist with the murdered Stephen Lawrence points to similar turmoil. Henry Louis Gates observed, "There you have the central contradictions of post-Thatcherite England: the growing cultural prominence of black culture doesn't mean that racism itself has much abated" (1997, 199). In the realm of the visual arts, the highly vocal dissidence of 1980s artists and arts activists like Keith Piper and Eddie Chambers sought visibility against exclusionary boundaries that regulated access to the art world such that black artists were burdened with the responsibility of speaking on behalf of the socially excluded. Although Fisher regards their efforts as a "limited success" (1996, 35), I would argue that it was the institutional response to their agenda, during the late 1980s moment, that brought about a sea change in the relations of race and representation, that created the scenario in which 1990s black artists sought distance from the hyperpoliticization of difference.

Seemingly released from the burden of representation, black artists now enjoy a sense of permission that contrasts with the gravitas associated with the frontier effects of institutional racism fifteen years ago. However, after they won such individual freedom of expression (which was mostly always normative for Euro-American modernisms), the pendulum swung to the opposite extreme, such that difference became almost unmentionable. What arose was a trade-off whereby the excess visibility associated with both multicultural exhibitionism *and* its sublation into corporate interna-

tionalism was offset by a mute or evasive positioning on the part of younger artists who no longer felt "responsible" for a blackness that was itself increasingly hypervisible in the global market of multicultural commodity fetishism.

Despite the variety of individual artistic concerns, the generational shift was of a piece with the overall loss of direction consequent upon the collapse of clear-cut frontiers in the cultural politics of difference. The neo-black subject of the 1990s, born under a bad sign of global risk and uncertainty, faced the false choice of three new identity options: neo-assimilationist, closet resegregationist, or genuinely confused. Moreover, when so-called Generation X fully embraced the mass consumption of ironic and parodic blackness in gangsta rap, club culture, or designer label clothing—all common currency in global youth culture—the ground was pulled from under the diacritical or even "oppositional" positioning of blackness. It was this gradual *decoupling* of political empowerment and cultural visibility that ushered in a new regime of multicultural normalization.

Norms are slippery things. Not as formal as rules or laws, they require social consent and psychic investment in order to regulate structural contradictions and social antagonisms. But what happens when hitherto contested notions of cultural difference become socially normative? Be as visibly different as you want to be, says the all-inclusive idiom of free-market enterprise, but woe betide you if you try and make any critical or dissident claim on the basis of your pathetic little identity, says the social authoritarianism of neoliberal managerialism. The art world mirrors this Janus-like constellation. Its growing informality (and popularity) among younger audiences is said to have overcome modernism's great divide between fine art and everyday life, although the production of such we-feeling is accompanied by the managerialist rhetoric of making "tough choices" among curators. Under such circumstances, the now-you-see-it, now-you-don't equivocation around difference, which is often employed in framing the projects of contemporary diaspora artists, is understandable as a response to another interrelated process. To the extent that diversity is increasingly administered as a social and cultural norm of postmodernity, it has become part of the establishment. Artists have therefore sought to slip out of its tendency toward fixity in the visual management of cultural difference.

In neo-conceptualist installations using wax print fabric, such as *Double Dutch* (1994) (fig. 9.4), Yinka Shonibare eludes the heavy-handed approach to ethnic authenticity in official multiculturalism by unraveling the intercultural story woven into the threads of his source materials. Seen as exotically African, the material originated in Indonesian batik, was reinvented for mass manufacture by Dutch and English textile

9.4 Yinka Shonibare, *Double Dutch* (detail), 1994. © Yinka Shonibare MBE.
All rights reserved, DACS 2014.

factories, was exported to West and Central African markets as luxury goods, and then appropriated by African Americans as a badge of countermodern blackness (Mercer, 1997a).

Chris Ofili's paintings, such as the *Captain Shit* series (1997) (fig. 9.5), are engorged upon a carnivalesque repertoire of art historical allusions, all of which are embedded in a self-deprecating take on the foibles of black macho in gangsta nihilism or blaxploitation hyperbole. Whereas Shonibare is happy to describe his outlook as that of a "post-colonial hybrid" (1996, 40), the story of Ofili's scholarship year in Zimbabwe, and his discovery of elephant dung, did the rounds so often as to become a bit of a joke, although it alludes to David Hammons's *arte povera* of unwanted waste materials.[14] The subtle interplay of sacred and profane in Ofili's devotion to decorative beauty is covered over by the artist's willingness to play along with the jokey YBA demeanor.[15] When adjectives like "funkadelic" arise in critics' responses, on the other hand, one wonders whether, rather than engage with Ofili's interests, the concern lies with conveying a postboomer whiteness that is *au fait* with the black vernacular—a whiteness of the sort Quentin Tarantino enacted in *Pulp Fiction* (1993) in a frenzy of overidentification with the abjected nigga.

Steve McQueen's early trilogy—*Bear* (1993) (fig. 9.6), *Five Easy Pieces* (1995) (fig. 9.7), and *Stage* (1996)—seemed to offer critical distance by creating subtle provocation around the intimacy and anxiety of bodies in the spatial cube of video installation. Taking up much-debated fears and fantasies around the black male body—which today, in the form of Nike's Michael Jordan Jumpman logo, makes hyperblackness a visual cliché as lame as Linford Christie's lunchbox—McQueen's postminimalist approach emptied the image of such stereotypical investments. Arousing intense yet undefinable feeling, the work called for careful critical response; but when asked, in a broadly sympathetic interview, whether *Just Above My Head* (1997) dealt with "questions of visibility," McQueen seemed irritated at the mere mention of the idea and replied, "When I walk out into the street or go to the toilet, I don't think of myself as black. Of course, other people think of me as black when I walk into a pub. Obviously being black is part of me like being a woman is part of you."[16] An equally tetchy tone came across when he announced, "Just like everyone else I want people to think beyond race, nationality and all that kind of crap. This debate is tired, ugly and beat up . . . it is boring."[17]

"Playing dumb . . . and taking your knickers down has become an attractive move in the face of the institutionalisation of critical theory," quips John Roberts, whose neopopulist reading of New British Art, although problematic, nonetheless pinpoints some

9.5 Chris Ofili, *Captain Double Shit and the Legend of the Black Stars*, 1997. Acrylic, oil, polyester resin, paper collage, glitter, map pins, and elephant dung on linen, 8 × 6 feet, 243.8 × 182.8 cm. (CO 34) Collection: Tate, London. Courtesy of the artist and Victoria Miro, London. © Chris Ofili.

9.6 Steve McQueen, *Bear*, film still, 1993. 16mm, black-and-white film, video transfer, silent, 10 min. 35 sec. © The Artist, Thomas Dane Gallery, London.

9.7 Steve McQueen, *Five Easy Pieces*, film still, 1995. 16mm, black-and-white film, video transfer, silent, 10 min. 35 sec., 7 min. 34 sec. © The Artist, Thomas Dane Gallery, London.

possible reasons for McQueen's boredom and spleen.[18] Roberts perceives the YBA's dumb pose as a knowingly "philistine" rejection of the textualist politics of representation associated with the impact of poststructuralist theory over the past twenty years. The rapid incorporation of cultural studies into higher education in the 1990s both neutralized its critical ambitions and made it a target for the cynical reason of the short-lived British journal the *Modern Review*. Relatedly, to the extent that the postcolonial vocabulary, characterized by such terms as "diaspora," "ethnicity," and "hybridity," has successfully displaced earlier immigration narratives of assimilation, adaptation, and integration, its broad influence has extended to the apparatus of bureaucratic multi-culturalism that cultural studies once sought to critique.

For diaspora artists engaged in neo- or postconceptualist practices, an impasse had arisen in art's relationship to (postcolonial) theory. Renée Green mused, "There's a certain power dynamic that occurs in terms of how artists are positioned that disturbs me. I would like to restructure this dynamic so that it doesn't feel like art is merely a decorative element—something which is tagged on to the 'heavier ideas'" (1996, 146). When art is reduced to visualizing theory, or worse, when the aesthetic encounter is overdetermined in advance, McQueen's annoyance is intelligible as an attempt to evade ideological capture. Arising from both the institutional incorporation of critical theory's once adversarial idiom and the market's preferred solution—which is to imply that the way to a race-free future is to simply stop talking about divisive matters of difference[19]—these hidden pressures call for a more empathic understanding of McQueen's postidentitarian predicament when he says, "I'm in a position I am because of what other people have done and I'm grateful, for sure. But at the same time, I am black, yes, I am British as well. But as Miles Davis said, 'So what?' I don't say that flippantly but like anyone else I deal with certain things in my work because of who I am. I make work in order to make people think."[20]

Cosmopolitan Locales

Precariously poised between the art market's corporate transnationalism and the inward provincialism of the London scene, black diaspora artists inhabit the contradictory conditions of post-Empire Britain. "Capitalism only advances, as it were, on contradictory terrain. It is the contradictions which it has to overcome that produce its own forms of expansion," Stuart Hall (1991) has said on the subject of globalization and ethnicity. The particularities of Britain's skewed insertion into the world system of modernity enable the contradictory coexistence of regressive neonationalism and multicultural normalization within its art world.

In his insightfully wide-ranging story of "the pop cultural constitution of English-ness," Michael Bracewell evokes British modernity as a century-long "retreat from Arcady," which engendered a quintessential ambivalence best encapsulated when Noël Coward quipped, "I am England, and England is me. We have a love-hate relation-ship with each other" (Bracewell, 1997, 211–12, 222). Revealingly, Bracewell depicts New British Art as a loser in an either/or play-off between such ambivalent ironies of Englishness and the bland multiculti commodification of difference in United States–centered global capitalism: "With . . . the replacement of Englishness, as a current cul-tural term, with the multiculturalism of Britishness, the baton in the cultural relay race between fine art, literature, music, film and drama could be said to have been ex-changed for a basketball and a pair of Nikes" (231).

While sympathetic toward "the creative marriage" of African American–originated dance culture and the legacy of sixties psychedelia which he hears in Goldie's drum and bass (whose coexistence alongside BritPop's retrocentric ironies echoes the art world tensions we have examined), Bracewell's telling distinction between Britishness and Englishness is left symptomatically unresolved. In his ambivalently open-ended con-clusions, Morrisey's "Hang the DJ"—which "sings of England and something black, absurd and hateful at its heart" (Tony Parsons quoted in Bracewell, 1997, 222)—allows the sotto voce suggestion that multicultural otherness is an obstacle to the completion of English ethnicity. Although it stops far short of Enoch Powell's discourse of "alien cultures," is there a sense that what we see acknowledged in this irresolution is the open wound of whiteness that is otherwise fetishistically covered over and smoothed out by the managerial feel-good factor of Cool Britannia?

In an art world habitus shot through with these simmering tensions, we may understand INIVA's unpopularity as an outcome of its association with the bureau-cratic institutionalization of cultural theory. By virtue of its free-floating placelessness, or rather its reluctance to author a distinct curatorial signature, INIVA effectively with-drew from a public debate about misperceptions of minority artists. The Roundhouse project failed because black artists could not agree on a common purpose for it. Com-menting that, among arts administrators, "The resounding response was 'whatever you do, don't build a black gallery,'" INIVA director Gilane Tawadros disclosed the reason-ing behind the organization's obedience. She states, "There was a time when it was im-portant to make black people visible, but that time has passed. You cannot differentiate black art history from white. These things come together and both their currencies are intimately intertwined."[21]

While entirely valid and necessary as a starting point for a more inclusive account of contemporary art which assumes cultural mixing, or hybridization, as a cornerstone

of modernism and modernity as a whole, the problem is that the story of *how* "that time has passed," and the whys and wherefores of its passing, was not opened up for public discussion. By retreating from the challenge of examining why nobody likes "black art" as a classificatory or curatorial category, Tawadros's evasive positioning reciprocally mirrors and inverts Steve McQueen's, suggesting that INIVA too was vulnerable to hidden pressures. Whereas one tactic sought resolution by simply not talking about "it," another tactic was to talk about "it" all too much, using the language of postcolonial theory to cover over and conceal unresolved tensions in the art world's management of cultural difference. In this way, INIVA went along with the decoupling of aesthetic interests and social responsibility that made matters of representation crucial to the countermodern traditions of the various Caribbean, African, and Asian diasporas for whom Britain was also a place called home, whose cold comforts Permindar Kaur evoked in her *Cot* (1993).

While the subversive potential once invested in concepts of hybridity has been tempered by premillennial downsizing, the gray area of complicity that Nikos Papastergiadis (1994) perceives between identity-driven demands for minority representation and market-based adaptation to diversity suggests that the outcomes of social agonism over norms can never be guaranteed in advance. Such INIVA exhibitions as *Aubrey Williams* (1998) at the Whitechapel Gallery have drawn our attention to the Caribbean Artists Movement (CAM) as a loose network of artists, writers, students, and teachers who met at the West Indian Students Centre in London between 1966 and 1972. Although primarily literary in orientation, with Edward Kamau Brathwaite, Andrew Salkey, and John La Rose as its leading organizers, CAM articulated an "outernationalist" outlook among the postindependence generation. While some participants returned to the Caribbean to influence cultural policy, others remigrated to North America, and yet others stayed on to shape the black British arts sector in the seventies.

The CAM story was simultaneously culturally nationalist, exilically internationalist, and Black Atlanticist, and as such it offers a vivid example of Homi Bhabha's "vernacular cosmopolitanism," although the modest localism of the narrative might not fulfill the more bombastic claims that postcolonial theory sometimes aspires to (Bhabha, 1994). For me, the value of Ann Walmsley's (1992) lucid documentation lies in its provision of a genealogy of the mixed times and spaces inhabited by diaspora artists. This is a starting point for the "homework" which visual studies has yet to catch up with in terms of researching the distinct art historical milieux out of which Asian, African, and Caribbean artists in Britain crisscrossed paths with various critical modernisms.

Jean Fisher is an important contemporary art critic who has given time and trouble

to these genealogical matters that form part of the unexplored historical context of black British visual practices. However, her proposed distinction between hybridity and syncretism (Fisher, 1996) misleadingly contrasts different colonial attitudes to cultural mixing without recognizing that the mix among Anglophone, Francophone, and Hispanic dispositions is precisely what makes the Caribbean a diasporic location where the encounter with difference is a regulating convention of everyday life, that is, a norm. To regard "the Caribbean" as the name of a habitus in which hybridity is normal is not to say that everywhere else is like that now, but simply that the worlding of the ethnic signifier may take forms other than prevailing trends toward market-based multicultural normalization.

What I liked about the translocalism of the CAM story was that it was made possible by London's cosmopolitan status as a world city, which in my view makes CAM the site of a specifically British vernacular modernism. To the extent that this would imply that a certain Britishness was *always already hybridized* in the encounter with Asian, African, and Caribbean diasporas, it confirms Stuart Hall's (1996a) account of the postcolonial as the time of a double inscription, in which elements hitherto banished to the constitutive outside of society return through the gaps in the signifying chain of cultural identity to decenter its symbolic authority.

Doing our "homework" means opening out such stories so that they belong not just to British artists and audiences but to anyone interested in art's ability to survive the wreckage of modernity. Telling these stories reactivates ideas of syncretism, créolité, and métissage which are all conceptually hybrid. To paraphrase Johnny Rotten, one might say that such postcolonial hybrids are the flowers in the dustbin of art's history.

NOTES

This chapter was first published in *Third Text*, no. 49 (Winter 1999–2000): 51–62, and is reproduced with the kind permission of Taylor & Francis.

1. Andrew Renton quoted in Ford, 1998, 133.

2. Angela McRobbie, "But Is It Art?," *Marxism Today*, November–December 1998, 66.

3. Patricia Bickers, "How Others See Us: Towards a History of Recent Art from Britain," in *Pictura Britannica: Art from Britain*, ed. Bernice Murphy, exhibition catalogue (Sydney: Museum of Contemporary Art, 1997), 65–68.

4. On New Labour's reasoning behind Cool Britannia, see Mark Leonard, *Britain™: Renewing Our Identity* (London: Demos, 1997).

5. INIVA Annual Report (London: Institute of International Visual Arts, 1997), i.

6. Niru Ratnam, "Invisible INIVA," *Art Monthly*, no. 211 (November 1997): 16.

7. Stuart Morgan, "The Elephant Man," *frieze*, no. 15 (March–April 1994): 40–43.

8. Coco Fusco, "Fantasies of Oppositionality," *Screen* 24, no. 4 (1988): 80–93.

9. Stuart Brisley quoted in Ford, 1998, 135.

10. Jay Jopling quoted in Ford, 1998, 139.

11. When "fashion becomes the dictator as to how long an issue can be sustained in the public eye . . . whatever progress can be made in an 'in' area, like multiculturalism, will be lost as soon as the issue is no longer 'fresh,'" writes David Barrett, "First Generation Reproduction," in Murphy, *Pictura Britannica*, 1997, 126.

12. Peter Suchin, "After a Fashion: Regress as Progress in Contemporary British Art," in *Occupational Hazard: Critical Writing on Recent British Art*, ed. Duncan McCorquodale, Naomi Siderfin, and Julian Stallabrass (London: Black Dog, 1998), 96–111.

13. Howardena Pindell, "Art (World) & Racism," *Third Text*, nos. 3/4 (1988): 157–90. Similar shifts in the United Kingdom are examined in Janice Cheddie, "Storm Damage," *make*, no. 76 (June–July 1997): 15–16.

14. Kellie Jones, "In the Thick of It: David Hammons and Hair Culture in the 1970s," *Third Text*, no. 44 (1998): 17–24.

15. See texts by Godfrey Worsdale, Lisa Corrin, and Kodwo Eshun in *Chris Ofili*, exhibition catalogue (London: Serpentine Gallery, 1998).

16. Steve McQueen quoted in Patricia Bickers, "Let's Get Physical," *Art Monthly*, no. 202 (December–January 1996–97): 4.

17. Steve McQueen quoted in Iwona Blazwick, "Oh My God! Some Notes from a Conversation with Jaki Irvine and Steve McQueen," *make*, no. 74 (February–March 1997): 7.

18. John Roberts, "Mad for It! Philistinism, the Everyday and New British Art," *Third Text*, no. 35 (1996): 29.

19. Neoliberal wishes for a "race-free" future are critically dissected in Paul Gilroy, "Joined Up Politics and Post-colonial Melancholia," Institute of Contemporary Art Diversity Lecture, 1999, reprinted in *Nka: Journal of Contemporary African Art*, nos. 11/12 (Fall–Winter 2000): 48–55.

20. Steve McQueen quoted in Bickers, "Let's Get Physical," 5.

21. Gilane Tawadros quoted in Nikos Papastergiadis, "Global Proposals: A Conversation with Gilane Tawadros," in *Dialogues in the Diasporas* (London: Rivers Oram, 1998), 136. See also Nikos Papastergiadis, "Back to Basics: British Art and the Problems of a Global Frame," in Murphy, *Pictura Britannica*, 124–45.

10

DOCUMENTA 11

The video diary in one of Renée Green's *Standardised Octagonal Units for Imagined and Existing Systems* (2002) observed that the first Documenta, in 1955, coincided with the annual Bundesgartenschau (Federal Garden Show), which also took place in Kassel that year. Among the other images charting the utopian aspirations that have animated the city's garden festivals and international art exhibitions alike, the music of Alice Coltrane emanated from several such pavilions in the Karlsaue park. And on a screen that appeared to have sprouted out of the ground were a jam jar full of dust from the World Trade Center and a quotation—"small pleasures must correct great tragedies"—from an epic poem Vita Sackville-West wrote when she created her garden at Sissinghurst in the 1940s.

Where there is much in contemporary art that balks at the idea that art must "do" anything, let alone respond to great tragedies, Documenta 11 put forward a carefully composed survey of art that is engaged with the lived experience of the material world. What distinguished this Documenta was not so much the wide-ranging selection of artists from all over the globe as the way in which its outward-looking approach to internationalism was installed as a background feature, throwing the curators' specific conceptual interests sharply into relief. The exhibition made a convincing case for a view of contemporary art as exploring a genuinely diverse range of social and material conditions, despite the sometimes cumbersome language in which the artistic director, Okwui Enwezor, declared his aim of highlighting the kinds of "knowledge" produced in the visual arts as being on a par with philosophy or science.

Although Enwezor may have been hyped as delivering the multicultural Documenta, or the postcolonial Documenta, the outcome was an emphatically ideas-driven event that had much in common with the overtly intellectual aims of Catherine David's Documenta 10. Since inclusion itself has become increasingly commonplace in the art world, certainly since 1997, Documenta 11's "spectacular difference," as Enwezor put it in the giant catalogue-cum-encyclopedia (2002, 43), did not lie primarily in the exhi-

bition's generous sense of geography. More significant was the scale of the underlying ambition to stage a critical project in the transnational public sphere as the exhibition of art was presented as the fifth "platform" in a series of symposia held around the world over the last eighteen months.

In this sense, the overall thrust of Enwezor's initiative was to redress the past exclusions carried out by what he calls "Westernism." This far-reaching and almost utopian desire to make a case for contemporary art that responds to, even if it cannot redeem, the tragedies of history is very much in keeping with the whole tradition of Documenta. Eager to point out that the exhibition should not be seen as embodying grand conclusions, the show's critique of familiar adversaries—the museum, the canon, the avant-garde—was nevertheless an attempt to update the interaction between art and politics that was itself the motivating force behind numerous Western modernisms. Having rejected a chronological arrangement of material, cocurator Carlos Basualdo said the idea of the city was chosen as a spatial model for the exhibition because of the open-ended connections or passageways Documenta's audience might encounter as they moved between the works. Regarding the second half of the twentieth century as a period in which the West has had to come to terms with the long-range consequences of modernity, Basualdo's evocation of "the city as garden of memory" could be seen as revisiting the flowers-in-the-ruins model that Arnold Bode put forward when he first placed modern sculptures in front of the devastated Orangerie in the aftermath of World War II.

Alongside the significant emphasis on documentary practices, spatial topography was one of Documenta 11's clearest overall themes. Zarina Bhimji's film *Out of Blue* (2002) and associated photographs (fig. 10.1) presented a searing portrait of the Ugandan landscape the artist left behind when her family was among those expelled by Idi Amin in the 1970s. The dry facture of Leon Golub's paintings, next door, featured brushstrokes like the tire tracks on the runway at Entebbe airport. While Destiny Deacon grappled with similar experiences of enforced separation, as did Croatian filmmaker Sandja Iveković in *Personal Cuts* (1982), the sequence of places that unfolded in Bhimji's film was devoid of people but invested with a feeling that could be called the postcolonial sublime.

The story told in *Solid Sea* (2001), by the Milan-based group Multiplicity, of the Sri Lankan *clandestini* who drowned in 1996 when the "ghost ship" carrying them to Europe sank off the coast of Sicily, was compelling because it had all the elements of a classical tragedy being played out in the context of contemporary immigration. The incident was ignored by the Italian authorities until an identity card was found on one

10.1 Zarina Bhimji, *Bapa Closed His Heart, It Was Over*, 2001–6. Ilfochrome Ciba Classic Print, aluminum mount, Denglas, and frame, 50 × 63 inches, 1,270 mm × 1,600 mm. Courtesy of the artist.

of the corpses brought up by local fishermen. Underwater footage of the wreckage, along with floor-placed monitors featuring witnesses and participants, created an installation whose darkness amplified the importance of sound so that each of the separate voices could be heard even as the entire chorus was speaking.

The Atlas Group, formed by Walid Raad in 1998, also presented materials found, collected, or otherwise donated in the course of research. Among the "documents" was a six-minute video by an unnamed Operator 17, who was supposed to be recording undercover activities at the Corniche seafront in west Beirut, but who turned his attention to filming each day's sunset. The "notebooks" donated by a certain Dr. Farhouri included a volume that recorded photo-finish data from a group of Marxist and Islamicist historians who met at the racetrack in Cairo every Sunday for twenty years. An element of intrigue crept into the space between the suspension of disbelief required by Raad's fictions and one's readiness to accept information about the context in which the "documents" were found.

The prevalence of documentary clearly had a role to play in showing the range of geographical spaces Documenta wanted to connect, quite literally in the case of Pascale Marthine Tayou, who installed a live feed from Cameroon which, when I saw it, was showing World Cup soccer. Sverker Sorlin's summary, in the catalogue, of the "landscape studies movement" provided an additional context for the mini-retrospective of utopian architecture envisaged by Yona Friedman and by the Dutch Situationist Constant, who was represented by models, plans, and drawings from his *New Babylon* series (1956–73) showing elevated walkways in cities devoid of traffic. The reconstruction of urban dwellings was addressed by Isa Genzken's models for Berlin and by Bodys Isek Kingelez's maquettes, which (like Molly Nesbit's essay) related to Manhattan after Ground Zero. Sorlin makes use of the suggestive phrase "interventional carpeting" to describe what artists, architects, town planners, and ecologists do when they take an interest in the politics of place,[1] a notion that adds insight to the subjective remodeling of Havana that was proposed by Carlos Garaicoa as much as it applies to the Tuscany village re-created in the South African property developments shown in David Goldblatt's photographs.

The central presence of Bernd and Hilla Becher in the Kulturbahnhof building, like the punctuation created by Hanne Darboven's grid-based serial works in the Fridericianum and by Frédéric Bruly Bouabré in the Binding Brewery, suggested, however, a broader interest in curating the act of documentation itself. Several strands of work were underpinned by a process-oriented emphasis on collecting, classifying, sorting, and accumulating. Where Dieter Roth and Choreh Feyzdjou started with their

studio as the chosen setting for duration-based accumulations, Joelle Tuerlinckx took a walk around a sentence found on a Lisbon church—"Here was history-culture now nothing"—in a piece that documented the artist's investigation of the spatial possibilities of her allocated room. Showing legal articles of association relating to the public limited company she set up in such a way that her initial investment of 50,000 euros will permanently avoid any accumulated interest, the documents presented by Maria Eichorn were interesting because, where Eichorn's art consists of such ongoing activity, the real-world validity of the actual documents depends on the fact that they are not art at all. In a catalogue essay brimming with ideas, Boris Groys argues that contemporary interest in the ambiguities of such documentation could only arise in an age of biopolitics, where the modernist separation of art and life is constantly undermined by scientific, technological, and bureaucratic interventions.

The weight carried by documentary film and video, on the other hand, seemed to be split by a curatorial imperative to highlight artists who move between gallery and cinema spaces—such as Kutluǧ Ataman, Isaac Julien, and Pavel Braila—and to reinstate the case for the mixture of formal experiment and political inquiry that characterized the idea of Third Cinema. While the latter strand gave contemporary audiences a chance to see whether films by Colectivo Cine Ojo in Chile, for example, had influenced Black Audio Film Collective in mid-1980s Britain, more light could have been shed on Documenta's differential screening conditions. Whereas Jonas Mekas had his films shown in the Bali-Kino cinema, Trin T. Minh-ha's were repositioned as installations in darkened galleries, while Jean-Marie Teno's 16mm documentaries, like the campaign videos produced by Group Amos, were shown in daylight conditions on monitors in the Documenta Halle.

In one sense this split in the presentation of film-based works carried over into Steve McQueen's installations. McQueen has used "documentary" before, in *Exodus* (1992–97) (fig. 10.2), showing two men carrying a potted palm tree on the streets of London, but at Documenta his use of factual material carried rather mixed results. *Carib's Leap* (2002) came across as a hastily edited home movie and resorted to animation techniques to convey the gravitas of the Grenada landscape in which thousands of Amerindians chose mass suicide rather than slavery. Taking a camera and microphone into a South African gold mine, in *Western Deep* (2002), on the other hand, produced one of McQueen's strongest pieces to date, with a pulverizing soundscape adding emotional depth to the juddering images that flicker out of the dark.

So, what happens once you are included? Not a lot, apart from a fresh set of dilemmas. Where Documenta 11 erred on the side of caution, it did so by relying on familiar

names from the international biennale circuit, such as Mona Hatoum, Alfredo Jaar, and Shirin Neshat, to uphold what is by now a fairly conventional conception of global mélange. Which is to say that any interest in hybridity, or the poetics of cross-cultural translation, was somewhat damped down. Adrian Piper's interest in the color wheel found in Vedantic mysticism and the Pantone color system was not really conveyed by her pictures, whereas Jeff Wall could hardly go wrong with a subject based on such a strongly imagistic text as Ralph Ellison's 1952 novel *Invisible Man*. Fiona Tan updated August Sander's Weimar physiognomy, translated from photography to film, and Georges Adéagbo's hieratic display featured portraits of Harald Szeeman and Jan Hoet in the style of popular West African signwriters, but apart from Ken Lum's hall of mirrors pavilion the carnivalesque spirit of irreverence evoked by writer Jean Fisher, who explores the trickster figure across different cultures, was in short supply. If anything, it was performance art rather than painting or sculpture that was sidelined by Documenta 11's sobriety.

David Small's tactile digital book explored an analytical interest in language that also ran through Ecke Bonk's collection of every *Deutches Worterbuch* published since 1838. Inspired by the Grimm brothers' fairy tales rather than by their dictionaries, Stan Douglas's *Suspiria* (2002) featured a randomly generated flow of stories in Technicolor that was set over a monochrome relay from Kassel's Hercules Tower. But despite the erudite research, it felt as though the artist was doing Stan Douglas by numbers. Indeed, some of the artists associated with the art world's gradual embrace of globalism during the 1990s appear to be a bit stuck. Glenn Ligon has not found a way out of the questions raised by the stencil paintings he began over twelve years ago. Yinka Shonibare took the sexual shenanigans of the Grand Tour as his starting point. His mannequins are headless, which draws attention to the wax print fabric he uses, but in marked contrast to his self-portraiture, which depicts the artist as a Victorian dandy or as Dorian Gray, the avoidance of the face in Shonibare's art historical tableaux barely conceals the way his mannequins are always coded as European subjects.

A week after Documenta 11 opened, Steve McQueen was honored with an OBE. While his nomination has everything to do with the politics of representation practiced by New Labour, which, like other institutions, frequently parades a multicultural exhibitionism that strives to "show" how inclusive and diverse it wants to be, the artist's acceptance of the award is indicative of the new dilemmas that arise when inclusion becomes the rule rather than the exception. This suggests that the situation is not one of multicultural normalization gone mad, but one in which perceptions of cultural difference are still subject to someone else's spin. Strangely enough, in the twenty years since

10.2 Steve McQueen, *Exodus*, film still, 1992–97. Super 8 color film, video transfer, silent, 1 min. 5 sec. © The Artist, Thomas Dane Gallery, London.

writers such as Edward Said and Gayatri Spivak first defined the field of postcolonial studies, language remains an awkwardly unresolved (or unresolvable?) issue, for the discourse surrounding Documenta 11 unwittingly revealed that there is still no satisfactory or widely agreed vocabulary for critically dealing with difference in contemporary culture. More encouragingly, the repertoire of ideas explored in the catalogue by Sarat Maharaj, whose writing is influenced by Gilles Deleuze and Marcel Duchamp, and who sees otherness as a "dissolving agent," offers a more speculative and nimble alternative to the congested amalgam that often arises when theory-lingo meets UNESCO-speak.[2] Maharaj's concept of "xeno-sonics," as performed by the Turkish jokes in Jens Haaning's audio piece at the top of the Treppenstrasse, could possibly explain why the visual arts have been historically slower in accepting the creative inclusion of different cultures such that "world art" still sounds odd whereas "world music" is commonplace. Attempting to hold open a space for such unresolved debates in the present context of the public sphere, Documenta's desire to redeem difference inevitably revealed a persistent fault line that cuts between the huge questions of global politics and the small pleasures offered by art.

NOTES

This chapter was first published in *frieze: contemporary art and culture*, no. 69 (September 2002): 86–89, and is reproduced with the kind permission of *frieze*.

1. Sverker Sorlin, "Can Places Travel?," in *Documenta 11_Platform 5: Exhibition Catalogue*, ed.

Gerti Fietzek (Ostfildern: Hatje Cantz, 2002), 137–42.

2. Sarat Maharaj, "Xeno-Epistemics: Makeshift Kit for Sounding Visual Art as Knowledge Production and the Retinal Regimes," in *Documenta 11_Platform 5*, 71–84.

PART IV

Detours and Returns

Chapter 11 draws a vocabulary for critical writing on black diaspora art from Stuart Hall's (1978) cultural studies approach to the conjunctural analysis of "the ethnic signifier," which chapter 12 sets to work, calling for a historiography of twentieth-century modernism that acknowledges cross-cultural dialogues between African American and other Black Atlantic artists alongside their European and American counterparts as an ever-present dynamic. In this respect, the questions motivating my criticism of the misperception that such dialogues were a recent phenomenon (Mercer, 2005b) were not just directed at the ideology of multicultural presentism, but led me to initiate the four-volume Annotating Art's Histories series that set forth a globalized approach in which Black Atlantic practices were interpolated among African, South Asian, Latin American, and indigenous practices in Australian and North American contexts, as well as art in Europe and the United States. Chapter 13 sums up insights arising from this analytic shift, which integrates the cross-cultural dimension within a holistic understanding of the global formation of modernism, whose implications for rewriting art history are ongoing.

Surveys that not only redress previous omissions of race and ethnicity in the narrative of modern art, but which also foreground the ways blackness travels beyond national borders, such as *Black Art and Culture in the 20th Century* by Richard Powell (1997) and *African American Art* by Sharon Patton (1999), are indispensable to an inclusive humanities that accepts cultural difference as a normative constant in the history of art. What dialogical methods bring to art writing, whether the genre is a survey, a monograph, or an essay, is the view that the absences and gaps which previously excluded black and other artists of color from the story of modernism were not accidental oversights to be remedied by adding in extra information, but were built into the monocultural voicing of master narratives as a consequence of the "othering" that rendered black life invisible and marginal in the world of modernity at large. With her account of "the problem of the visual," Michelle Wallace (1990) pointed to the oppressive regimes of visuality surrounding black life, which Ralph Ellison (1964) and Frantz Fanon (1967a) were the first to identify in terms of the philosophical depths of the problem of the gaze as constitutive of black subjection. The reason why the iconography of masks matters in African American art, or Caribbean carnival arts, is because masking seeks to protect the inner world from the lethal powers of looking that positions whiteness at the imaginary center of the modern West. A counterhistoriography that takes account of such issues is one that embraces the critical potential of visual culture approaches, especially with regard to understanding the cross-cultural translation whereby African and Jewish diasporas, for instance, often intersect (Mirzoeff, 1999). As chapter 14 comes back to global contemporary art in light of questions thrown into relief by this detour into historiography, I express doubts as to whether the complex temporality of diaspora readily fits with linear transitions from modern and postmodern to contemporary, even as I underline the necessity of a world-historical conception of cross-cultural dialogue if we are to grasp the present, in all its agonistic predicaments, with some degree of interpretive depth.

11

A SOCIOGRAPHY OF DIASPORA

Stuart Hall's approach to the subject of diaspora is indirect or even circuitous, rather than programmatic or goal-oriented. Whereas such essays as "New Ethnicities" (Hall, 1988b) and "Cultural Identity and Diaspora" (Hall, 1990a) addressed the topic explicitly, the issue was implicit in Hall's early work on the sociology of immigration such as *The Young Englanders* (1967). Key contributions to postcolonial theory, such as "The Question of Cultural Identity" (Hall, 1992), are of recent provenance, although Hall's long-standing interest in conceptualizing diaspora dates back to such publications as *Africa Is Alive and Well and Living in the Diaspora* (1975).[1] In other words, Stuart Hall's writings on diaspora are themselves scattered and dispersed within his oeuvre as a whole.

This chapter does not attempt to synthesize a general theory of diaspora from these disparate texts and interventions. This is because it seems that what is distinctive about Hall's perspective is how his conjunctural approach touches on all aspects of the cultural studies repertoire, while at the same time moving across or against the borders of various disciplines in such a way that the connective dots between them remain valuably open. Stuart Hall does not write about diaspora as a discrete sociological object so much as he writes from the social worlds of diaspora to produce knowledge as a situated practice of interruption. The twists and turns involved in the journey of the diaspora concept have opened up one of the most compelling stories in recent intellectual life. Hall's influence on this broad trajectory has been crucial and subtle. It seems timely, then, to trace its passage within his own work, as well as to ask whether the diaspora concept is now due for some interruption of its own.

"The career of sociology has been coterminous with the career of nation-state formation and nationalism," observes Jan Nederveen Pieterse, who has taken the view that, in the context of late twentieth-century globalization, this trajectory "is in for retooling." "A global sociology is taking shape," he argues, "around notions such as social networks (rather than 'societies'), border zones, boundary crossing and global

society. In other words, a sociology conceived within the framework of nation-states is making place for a post-international sociology of hybrid formations, times and places" (1995, 63).

No one could overestimate Hall's contributions to such paradigm shifts. The displacement of sociology's immigration narrative and its transformation into the expanded field of postcolonial theory have given rise to far-reaching changes. Moreover, insofar as such theoretical developments have intertwined with cultural practices in the arts and throughout the public sphere at large, there has been a significant alteration in the commonsense terms available to liberal democracies as they try to apprehend the social, cultural, and political dynamics of multiculturalism. But just as the analysis of Thatcherism was one of the big success stories of British cultural studies in the 1980s, could it also be said that one of the ironies of the 1990s was that the keywords of postcolonial thinking became globalized as merely commonplace rather than critically interrogative?

To the extent that the postcolonial vocabulary, characterized by such terms as "diaspora," "ethnicity," and "hybridity," has displaced an earlier discourse of assimilation, adaptation, and integration, we have witnessed a massive transformation which has generated, in the Western metropolis, what could now be called a condition of multicultural normalization. When *Newsweek* described Tony Blair's New Britain as "one of the most comfortably multicultural nations in Europe" and accompanied its assertions with pictures of smiling black, brown, and white faces among a flurry of Union Jacks, should we be led to believe that the story of racism and reaction has been happily resolved by such a process of normalization?[2] Or should we recall Hall's trenchant remarks, from 1970, that although "black immigrants . . . are certainly going to be citizens of this society for a long time to come . . . this does not mean that they are necessarily going to be happy Black Britons"?[3]

From the vantage point of some of the cultural practices that some of the third-generation discontents went on to produce—in the visual art of Keith Piper, Zarina Bhimji, and Sonia Boyce, the films of Isaac Julien, Gurinda Chadda, or John Akomfrah, or the photography of Rotimi Fani-Kayode—one can see the story of the intervening thirty years in microcosm. In the transition from multiculturalism to globalization, artists who were once domesticated by paternalist notions of "ethnic arts" have seen the reception and interpretation of their work taken up and translated into a wide range of transnational milieux. The close articulation of aesthetics and politics in earlier debates about representation and cultural difference has been reconfigured. Although norms are not the same as trends, it could be said that the subversive potential once

invested in notions of hybridity has been subject to rethinking. Indeed, hybridity has spun through the fashion cycle so rapidly that it has come out the other end looking wet and soggy.

To the extent that hybridity theory has come in for a drubbing in the context of multicultural normalization, we need to take account of critiques of art world institutions put forward by Jean Fisher (2003) and Nikos Papastergiadis (1994). They perceive a major area of complicity between the demand for minority representation and the adaptation to diversity that the global marketplace seems happy to make. In contrast to criticisms of hybridity that take aim at postcolonial studies *tout court* (R. Young, 1995; Cheah and Robbins, 1998), the challenge implicit in rethinking hybridity as socially and culturally normative can be met by refusing the seductive attraction of simplistic polarities and turning to a historically specific account of the more messy and ambivalent intermezzo worlds between the local and the global, which in my view is something that Hall's work already provides, albeit within a fragmented form.

Revisiting such early texts as *The Young Englanders* and "Black Britons" provokes an eerie feeling. They speak in a sociological idiom from a world whose internal relations of race, class, and culture have been utterly transformed by struggles over the past thirty years, even though the uncanny familiarity of the issues implies that some things have not changed that much. When Hall pinpointed a political agon between "formal acceptance and informal segregation" in UK race relations,[4] as the period of laissez-faire accommodation in the 1950s gave way to the sharply polarized frontier effects of the late 1960s, it is hard not to see the same old story replayed in today's disjuncture between the pastiche patriotism of the New Brit Art and the critical pluralism of the new art world internationalism. But the consistency of Hall's analytical attention to black Britain as a local site of diaspora formation demands that, rather than frame this strand of work through a general theory of postcoloniality, the question is how the story of the intervening period is broadly (and even globally) understood—the story of how England became other than what it always imagined itself to be and, in a twist to sociology's immigration narrative, how the third generation "became black because they could not go back."[5] Revisiting Hall's diaspora-based writings casts a range of contemporary dilemmas in a critical light.

In 1967 Hall observed that "the lived experience of the immigrant teenager is a little like that of the traveller whose routes in and out of the home take him along extended bridges across deep and dangerous chasms."[6] It would be anachronistic, not to say merely academic, to note how the terms of Hall's account—voiced in the idiom of symbolic interactionism—anticipate the key theme of traveling cultures. Having said

this, however, when he described the teenage "natives" of the indigenous white working class (whom he taught in London schools and some of whom were active in the Notting Hill riots) and observed how they "held two quite separate and contradictory ideas" about West Indians, it is difficult not to infer the view of the racist stereotype as a representational fetish, complete with its ideational splitting of the Other.[7] Similarly, when black youth are described as "the busiest traveller[s] who have to 'translate' between the groups,"[8] Hall's account of the familial and intersubjective ruptures involved in becoming black *and* British emphasized the ambivalent push and pull of loyalties involved in negotiating multiple identifications. With regard to the national agony involved in Britain becoming a multicultural society, the recto/verso implications of this relational outlook led him to say that "it will be as hard for adult West Indians, Indians or Pakistanis to accept the fact that their children and grand-children will be progressively 'at home' in a different country, as it will be for white people to accept that the presence . . . of second and third generation black people will irreversibly alter *their* culture and social patterns."[9]

"Can we tackle change or will we allow it to tackle us?" he asked. While the conjunctural character of the question foreshadows his more recent queries about the time of the double inscription—when was the postcolonial? (Hall, 1996a)—the important point is that it remains unanswered insofar as Hall's culturally materialist view holds that the historical outcomes of struggles over social or cultural norms can never be determined or guaranteed in advance.

However misleading it would be to say that these texts magically anticipated the way postcolonial theory conceptualizes diaspora today, it is nonetheless compelling to examine the crosscutting passageways that connect Stuart Hall's writings on how Britishness has changed as a result of the migrancy of Caribbean, African, and South Asian peoples in post-1945 society, and his subsequent studies of postindependence Caribbean nations, which abut onto the question of diaspora from the other end of the transnational chain. In this regard we not only find that Hall's conceptual movement back and forth across disparate national sites and cultural locations is a vivid example of the sociological imagination thinking diasporically, but that there is also a kind of stereographic writing (in Barthes's phrase) in which ideas and issues from one problematic reverberate with others put forward in seemingly incommensurable contexts.

The strongest example of this dialogic interplay is the call-and-response relationship between "Pluralism, Race, and Class in Caribbean Society" (Hall, 1978) and "Racism and Reaction."[10] Both are centrally concerned with the articulation of race and class, but in two very different sorts of social formation. One addresses a postcolonial society, Jamaica, which only "became black" at a relatively recent moment of its

cultural history, and the other addresses Britain as a postimperial nation-state, which found its social predicament mirrored and magnified in moral panics over mugging. While the latter essay is widely known as a summary and introduction to the breadth of ground covered in *Policing the Crisis: "Mugging," the State and Law and Order* (1978), the former, which was contributed to *Race and Class in Post-colonial Society* (1978), was one of the earliest attempts to address the distinct structural features of the postcolonial moment.

It may seem odd to revisit the race-and-class problematic, but my interest lies in passages that connect the culturally materialist notion of "the ethnic signifier," which Hall develops in accounting for the volatile mix of cultural elements in Caribbean social structure, with one of the conclusions of the cultural studies account of British neoconservatism, namely, that "race is the modality in which class is lived."[11] The vicissitudes of the ethnic signifier, which illuminate the ways "race is the modality in which class is lived" in a formerly colonized setting, also shed light on the structural convulsions whereby Britain "became a multicultural society." Could the concept further help to clarify how these processes have given rise to a cultural mix that differs from, while overlapping with, situations of ethnic multiplicity found elsewhere in Western Europe or in the United States?

The synchronic rapport between Hall's 1978 essays turns around an impasse created by economic determinism and cultural reductionism with regard to conceptualizing social relations of race and ethnicity. Although often overlooked, "Pluralism, Race, and Class" was of pivotal importance because it mapped out the space subsequently addressed in the Althusserian vocabulary of "Race, Articulation and Societies Structured in Dominance," written in 1980, and in "Gramsci's Relevance for the Study of Race and Ethnicity," which was published in 1986.[12] These essays expanded the critique of Marxist ethnocentrism and Weberian pluralism in relation to the interdependence of units in a world system. The formidable scholarship Hall brought to bear on these intellectual traditions turned attention to Caribbean culture and society to test the minimum threshold of theoretical generality required to activate the question of hegemony. As he stated, "Once we grasp the two ends, so to speak, of this chain—differentiated specificity/complex unity—we see that we are required to account, not simply for the experience of culturally distinct institutions and patterns, but also for that which secures the unity, cohesion and stability of this social order in and through (not despite) its 'differences'" (Hall, 1978, 158).

It is precisely the "differentiated specificity/complex unity" couplet that underpins *Policing the Crisis* as a sustained analysis of the long-term crisis of hegemony in post-1945 Britain, in which the breakup of social democratic consensus led to the neoconser-

vative vision of governing a wholly different sort of society. The irony is not simply that one of the most radically distinctive contributions to modern British social theory was authored by someone who was neither British nor a sociologist as such,[13] but that the mix of conceptual tools in the cultural studies account of the crisis of Britishness was honed and refined through Hall's dialogue with the hybrid matrix of Caribbean societies as the "other scene" in which the postcolonial predicament was brought to light.

Another way of looking at the antiphony is to consider Hall's neo-Gramscian approach to the problem of structure and agency in the semiotic model of culture. Hall's notion of the ethnic signifier crosses over potentially unbridgeable spaces not by positing a comparative relationship in which the differences between Jamaican and British societies could be resolved in an anthropological conception of human culture, but by wielding a diacritical conception of antagonism in which relations of power and resistance enter representation and consciousness unevenly. A bald summary this may be, but it lies at the heart of the explanatory force of Hall's materialist conception of culture. "Racism and Reaction" offered an account both of the "differentiated specificity/complex unity" that articulated the populist and neonationalist unities sought by and secured for neoconservative hegemony *and* of the cultural construction of those counterhegemonic unities, found in symbolic and imagined practices of community, whereby black Britain articulated its political response. It would be hard to overestimate the decisive impact of these conceptual linkages in producing the conditions of possibility for *The Empire Strikes Back* (1982) and subsequent black interventions in cultural politics.[14]

The interrogative conception of diaspora has since flourished. Propelled by a far-reaching critique of ethnic absolutism and elaborating a conception of traveling culture as a mobile network of affinities, Paul Gilroy's (1993) pathbreaking work on the Black Atlantic reveals a tradition of countermodernity in relation to which Enlightenment ideals of democracy can be examined through the "double consciousness" bequeathed by racial slavery.[15]

What is at stake in the currency of the diaspora concept today? In asking this question, James Clifford (1997) maps the expanded field with a discerning eye. Alongside social science "ideal type" approaches—which hold that diaspora formations involve the catastrophic separation of a people from their natal origin; that ethnocommunal solidarity around myths of return to the homeland develops in the face of rejection by the host society; and that lateral connections among diasporic sites may generate metaphorical flows with other social groups around abstract ideals such as social justice (Cohen, 1997)—Clifford seeks to underline more nuanced contemporary views.

From the U.S.-Mexico borderlands of Chicano life in California, or the contact zones of Native American worlds, through the revisionist outlook on contemporary Jewish diasporas, his lucid account offers an indispensable overview of key insights and fault lines among potential candidates for the "post-international sociology" that Pieterse has called for. But what seems to have disappeared in Clifford's account is the knotted density of the "differentiated specificity/complex unity" of the social entanglements he describes, even though he has subsequently taken the view that "discrepant cosmo-politans guarantee nothing politically. They offer no release from mixed feelings, from utopic/dystopic tensions. They do, however, name and make more visible a complex range of inter-cultural experiences, sites of appropriation and exchange" (1998, 369).

Would this persuade Jean Fisher? She argues that the language of cultural studies is now actually part of the problem in a global art world where visible difference is highly marketable (Fisher, 1996). To the extent that multiculturalism implicitly prescribes black artists to be ethnically representative, and thus visibly different, arts policy is reduced to a simplistic equation whereby retroactive inclusion supplements and com-pensates for past exclusion. This makes the art world's demand for difference an insti-tutional fetish in a regime of visuality more or less continuous with the ethnocentric ideology it sought to modify. Fisher regards the 1980s black visual arts movement as limited in its impact because the actual artwork was absorbed and overwhelmed by identity politics. To what extent did diaspora-based artists get stuck in a critically mod-ernist episteme of visual culture?

Multicultural normalization means that global popular culture has moved the goalposts around matters of black representation. In fact, the stakes have changed so rapidly that the 1990s condition of black hypervisibility suggests that when hip-hop capitalism is the only game in town, the "hyperblackness" (Gray, 1995) associated with Nike advertising and Rupert Murdoch's Fox television channel may indeed conform to the McDonald's model of global standardization. Is this the background against which artists like Chris Ofili, Steve McQueen, or Yinka Shonibare have pursued a new indi-vidualism as a 1990s corollary to a new internationalism?

As the "post" acquired a viral-like pervasiveness in the social body, there was a countervailing trend toward minimizing or downsizing difference. When the available forms of "unity, cohesion and stability" constitutive of a society are said to belong to the past, would it be fair to say that the postmodern social—with multicultural nor-malization as a key feature—has led to the decoupling of "differentiated specificity/ complex unity" as we know it? For Gayatri Spivak, "the concept of a diasporic multi-culturalism is irrelevant," so far as women in the workplaces of the transnational world

are concerned, for she argues that "large groups within this space of difference subsist in transnationality without escaping into diaspora."[16] Does hybridity screen off the ugly side of the social?

While Fisher values the decentering of classificatory oppositions associated with Homi Bhabha's influence on the postcolonial turn, she echoes a criticism voiced by Sarat Maharaj that, "in its popularity hybridity risks becoming an essentialist opposite to the now denigrated 'cultural purity'" (Maharaj, 1994, 29). The idea that "two discrete entities combine to produce a third which is capable of resolving its 'parents'' contradictions" is something Fisher finds to be "fraught with connotations of origin and redemption [which] do not extricate us from a self/other dualism" (1996, 36). Counterposing syncretism to hybridity, however, evades historical differences among Anglophone, Hispanic, and Francophone dispositions toward cultural mixing, all of which can be found in the Caribbean region.

Ethnographic terms such as *mestizaje* in Mexico and *métissage* in Martinique seemingly denote cultural interactions signified by "miscegenation" in English-speaking regions such as the British West Indies. But the tolerance of cross-cultural leakages as complementarities in Latin American syncretism contrasts markedly with Anglo-Protestant anxieties of the Manichean variety which Fanon theorized psychoanalytically. As a geographical site of many, overlapping, diasporas—African, Asian, European, American—the Caribbean is constituted as a composite cultural unity formed out of a great many differentiated specificities. Forms of *créolité* in Haiti or Cuba, whose influence on the paintings of Wifredo Lam is discussed by Gerardo Mosquera, are intimately linked to but sharply distinct from the poetics of patois and other signifying practices of creolization in Jamaica examined by Kamau Brathwaite.[17]

The syncretism-versus-hybridity argument elides the issue of ethnicity in the construction of the social contexts of artistic reception and production. I would suggest that, in contrast to the deconstructive emphasis on difference as inherently subversive, the key concerns that Fisher highlights can be clarified by Pieterse's view that the flip side to hybridization as pluralization or multiplicity is the recognition and reevaluation of "transcultural correspondences" (1995, 60–63), where discrepant *sameness* disrupts social perceptions of the absolutism of symbolic categories and classificatory systems. This view shares common ground with Hall's concept of "new ethnicities" in taking the position that hybridization is a universalist, rather than minoritarian, process. Although the task has not been widely seized upon with much passion, this was the context in which Hall called for a rethinking of ethnicity: "The term 'ethnicity' acknowledges the place of history, language and culture in the construction of subjectivity and

identity, as well as the fact that all discourse is placed, positioned, situated, and all knowledge is contextual. Representation is possible only because enunciation is always produced within codes that have a history, a position within the discursive formations of a particular space and time" (1988b, 29).

Taking "the Caribbean" as the name of a habitus where hybridization is normal—where the encounter with difference is a regulating convention of social interaction—is not to elevate it into an ideal model but to say there are contingencies in the worlding of the ethnic signifier that are not predestined to take the form of multicultural normalization. In fact, the normative presence of hybridization, as the articulation of sameness and difference together, may actually have already happened in the cultural studies story itself.

During the late 1960s, Stuart Hall was peripherally involved in the Caribbean Artists Movement (CAM). This was a loose network of artists, writers, students, and teachers convened by John La Rose, Andrew Salkey, and Kamau Brathwaite at the West Indian Students' Centre in London between 1966 and 1972. In 1968 Hall took part in CAM's second large-scale conference at the University of Kent. The movement brought writers and artists like Wilson Harris and Aubrey Williams together with key intellectuals of the postindependence generation, including Orlando Patterson, Sylvia Wynter, and Jan Carew (who either returned to the Caribbean or remigrated to the United States), as well as those who stayed on and undertook initiatives that laid the basis for the black arts sector in the 1970s, such as the Race Today collective. But prior to Ann Walmsley's (1992) documentation of the CAM story, few had heard of it, even though CAM's transnational location in London made it the site of a specifically *British* critical modernism.

To conceptualize hybridization as socially normative for Western liberal democracies is to open up a dialogue with the cultural study of the plural modernities of mixed times and places in which the process of cultural mixing is more or less repressed or acknowledged, more or less disavowed or incorporated, as a general feature in the routines of everyday life.

In contrast to the readerly mode of speech characteristic of the naturalistic strategy of authority in the social sciences, it could be said that Hall's voice errs on the side of the writerly text. His oeuvre reveals an individual attitude toward authorship that is neither possessive nor patriarchal but which, rather, is collaborative, dialogic, and often decentered. While I have sketched tentative pathways between his dispersed writings on diaspora, the texts have another common feature inasmuch as they are instances of Stuart Hall's practice as a public intellectual. Whether published by UNESCO in Paris, or

the National Committee for Commonwealth Immigrants in London, they are texts that participate in the broad public sphere of democratic debate, of a piece with the diverse genres of writing that Hall has disseminated through magazines like *Marxism Today* and through the television programs of the Open University.

One could call this a practice of sociography in the sense that Hall's writing inscribes itself through such a wide variety of institutions and spaces in civil society. Although the UNESCO texts are often hard to track down (which makes one wonder how public the public sphere has to be), I have to say that in my own case, staying up watching BBC2 as a teenage insomniac in the 1970s and coming across Stuart giving a lecture on Althusserian Marxism, the encounter with this sociography was a brilliant introduction to cultural studies, even though one discovers that it does not help you get to sleep any more easily.

NOTES

This chapter was first published in *Without Guarantees: In Honour of Stuart Hall*, edited by Paul Gilroy, Lawrence Grossberg, and Angela McRobbie (London: Verso, 2000), 233–44.

1. Stuart Hall, *Africa Is Alive and Well and Living in the Diaspora* (Paris: UNESCO, 1975).

2. "Blair's Britain," *Newsweek*, May 5, 1997, 35.

3. Stuart Hall, "Black Britons, Part 1: Some Problems of Adjustment," *Community* 1, no. 2 (1970): 3.

4. Stuart Hall, *The Young Englanders* (London: National Committee for Commonwealth Immigrants, 1967), 10.

5. Hall, *Young Englanders*, 10.

6. Hall, *Young Englanders*, 10.

7. Hall, *Young Englanders*, 3.

8. Hall, *Young Englanders*, 10.

9. Hall, "Black Britons," 3.

10. Stuart Hall, "Racism and Reaction," in *Five Views of Multi-racial Britain* (London: Commission for Racial Equality, 1978), 23–35.

11. Stuart Hall, Chas Critcher, Tony Jefferson, John Clarke, and Brian Robertson, *Policing the*

Crisis: "Mugging," the State and Law and Order (Basingstoke: Macmillan, 1978), 394.

12. Stuart Hall, "Race, Articulation and Societies Structured in Dominance," in *Sociological Theories: Race and Colonialism* (Paris: UNESCO, 1980); Hall, 1986.

13. A point made by Michelle Barrett at the Stuart Hall Conference, Open University, May 15, 1998.

14. Center for Contemporary Cultural Studies, *The Empire Strikes Back: Race and Racism in 70s Britain* (London: Hutchinson, 1982).

15. See Gilroy, 1987; Paul Gilroy, "Cultural Studies and Ethnic Absolutism," in Grossberg, Nelson, and Treichler, 1992, 187–98; and Gilroy, 1994.

16. Gayatri Spivak, "Diasporas Old and New: Women in the Transnational World," *Textual Practice* 10, no. 2 (1996): 246, 247.

17. Gerardo Mosquera, ed., *Beyond the Fantastic: Art Criticism from Latin America* (London: Institute of International Visual Arts, 1996); Edward Kamau Brathwaite, *The Development of Creole Society in Jamaica* (London: Oxford University Press, 1974).

12

DIASPORA AESTHETICS AND VISUAL CULTURE

Contemporary artists offer intriguing insight into the often surprising ways in which blackness travels. Referencing works from African American and black British contexts, this chapter examines call-and-response dialogue in visual culture and asks why critics have so far failed to recognize the creative energies of such cut-and-mix aesthetics. By way of an overview of unresolved issues in African American art historiography, I suggest that one obstacle to the recognition of such dialogic interaction lies in the implicit notion of a hierarchy of bodily senses that assumes an inherent dichotomy between the aural and the visual.

Michele Wallace (1990) insightfully identified such dilemmas, although unprecedented shifts associated with contemporary globalization require a thorough rethinking of the Ellisonian metaphors of invisibility and visibility. While these terms have been profoundly influential in critical understandings of the politics of race and representation, there are limitations to dichotomous evaluations in which black cultural criticism often counterposes the innovative qualities of black music against what are seen to be the imitative qualities of black visual arts. Taking account of why this distinction arose, I argue that an interactive approach to diaspora aesthetics rejects the necessity of such either/or positions. Showing how the Fanonian iconography of the mask does indeed respond to "the problem of the visual" initiated by the colonial gaze, I suggest that the need to question the politics of visibility opens up a wider horizon for understanding diaspora culture's complex histories and future possibilities.

Web, Text, and Flow

In installation works featuring manufactured fabrics as ready-made materials for neo-conceptual interrogations of culture and identity, Yinka Shonibare unravels a fascinating story of cross-cultural exchange. In *Double Dutch* (1994), the dressmaking fabric known in West Africa as the Dutch wax print, or fancy print, takes the place of blank

canvas that is stretched over fifty individual frames arranged in a grid on the gallery walls, while in *Alien Obsessives: Mum, Dad, and the Kids* (1998), a sculptural family of science fiction creatures remade in wax print fabric provokes a visual pun on perceptions of cultural otherness by substituting space aliens in place of human "aliens" such as immigrants and travelers, a theme returned to in *Vacation* (2000) (fig. 12.1), where a family of astronauts are outfitted in the fabric.

Throughout his body of work, Shonibare's practice serves to unstitch a complex history woven into the very threads of the fabric chosen as his source material. Although wax print fabric is widely perceived in the West as quintessentially African due to its elaborate patterning and bold color combinations, it actually originated in Indonesian and Javanese batik fabric traditions typically employing wax-resistant color dyes, layered in organic patterns, and featuring exquisite cracking. Late nineteenth-century Dutch colonialists copied these indigenous crafts, converting the process into industrial manufacture whereby factories in the Netherlands would export mass-produced copies back into the Asian Pacific periphery. British competitors in the textile trade soon emulated the Dutch initiative when the process was imitated and translated by designers in factories in Manchester and other Midlands cities, producing fabrics specifically intended for export to West and Central African markets. Indeed, the circuit of supply and demand between center and periphery was so finely attuned that, as it continued into the postindependence era, photographic portraits of political leaders would often appear on fabrics commissioned to celebrate such occasions.

Shonibare's art brings to light the twist to the tale occurring when the wax print cloth is retranslated into diasporic cultural spaces. When African American fashions in the 1960s employed the fabric in head wraps and dashikis, it became a potent emblem of Pan-African identification. Worn with pride, the fabric enunciated the wearer's affiliation with an imagined community that connected black people globally by way of an instantly recognizable badge of belonging. In the early 1970s, Europeans also appropriated the fabric during the brief rage for "ethnic chic," which recycled modernist primitivism by fastening onto the wax print as an exotic icon of otherness. The irony in all this is that both strands of translation were equally dependent upon a prior history of circulation and exchange that effectively decontextualized the material from its origins.

Shonibare's art reveals that the cultural meaning of the fabric is not intrinsic to its ethnic origins. Rather, it constantly acquires layer upon layer of altered meanings as it travels through diverse sites and locations in which users and consumers encode their own local tastes and preferences into the intentions and interpretations of their semiotic choices.

Shonibare's project resonates with concepts of "traveling culture" put forward by James Clifford (1997) in that his art draws attention to the material entanglement of cultural identities, which is unthinkable for essentialist or separatist ideologies that require monologic notions of "pure" origins and symbolic unanimity. However, insofar as art's aesthetic autonomy cannot be reduced to an illustration of theory, it is helpful to have a sense of Yinka's self-description in which cultural mixing and hybrid interaction are taken for granted as the background to his artistic choices and procedures. Comfortable with the multiculture made available by his back-and-forth background in London and Lagos, and thus questioning monolithic conceptions of blackness, Shonibare suggests that the acceptance of hybridity is not the conclusion but merely the starting point for his open-ended investigations: "My own sense of culture evolved out of what I watched on television, the music I listened to, the people I knew and what I read and the obvious impact of a postcolonial history. . . . I listed to the music of Fela Kuti, James Brown, Sugar Hill Gang and King Sunny Ade. I read Shakespeare, Charles Dickens, Wole Soyinka and Chinua Achebe at school. I am a postcolonial hybrid. The idea of some kind of fixed identity of belonging to an authentic culture is quite foreign to my experience" (1996, 40).

What is striking about Shonibare's outlook as a postcolonial hybrid is the extent to which it is generationally shared. The Nigerian-born and New York–based artist Iké Udé has voiced a similar perspective on his artistic aims: "I have found that, irrespective of ideological rhetoric, any strict adherence to a single cultural approach is flawed and practically impossible. Looking beyond colonial impediments, I see the circumstances of my artistic practice as inextricably informed by the multiplicity of conflicting cultural influences I have inherited and delineated to serve myself. . . . I am nobody's artist but my own" (quoted in Bell et al., 1996, 296).

The main thread I want to pull out here is not that postcolonial hybridity is a uniform or universal experience for everyone in a given diaspora, but that the two-way process of cultural traffic is now increasingly understood not as special or exceptional but as an ordinary and normal aspect of everyday life. To better understand distinctive diaspora experiences (that are nonetheless deeply interconnected by the practice of culture) not as territory, property, or ownership, but as a living fabric of web, text, and flow, we can pinpoint three key issues arising out of such an interactive, rather than essentialist, model of cultural identity.

First, we can say that blackness travels through routes that were initially opened by trade, commerce, and market-based exchange. Each of these economic and political forces entails the exploitative inequalities determined by capitalism, but they also

encounter resistances, subversions, and stoppages in their path. Unlike the Marxist world-system model, which tends to assume that structural asymmetries in the control of production inevitably determine social and cultural inequalities, the concept of "traveling cultures" allows us to grasp the contradictions that capitalist globalization produces as an unintended consequence of its intrinsic need to find new markets. Paul Gilroy's (1994, 237–57) brief analysis of soul and funk LP covers is an excellent example of how profit-driven motives in the music industry were constantly accompanied by countervailing discourses created by the message in the music, if not the visual images through which it was marketed.

Second, insofar as Africa, Europe, and the Americas have been historically entangled in a global system more or less since 1492, then the big story of twentieth-century modernity is the story of black innovation and white imitation—a story that runs as a countercurrent to modernism in the realm of popular culture. I employed the phrase "black innovation / white imitation" in an essay on diasporic hairstyles so as to pinpoint a paradox (Mercer, 1994, 97–128). On the one hand, excluded from access to conventional channels of democratic expression, African Americans encoded political aspirations for self-determination in cultural forms such as music, dance, and vernacular speech, and even in the medium of hair. On the other hand, however, such stylistic innovation was also highly attractive to white Americans—and indeed to non-black people globally—who then copied and imitated such styles and, in the process, drained them of exclusively black content and detached them from their initial meanings as covert or encoded signifiers of resistance.

Since we have seen a similar dynamic in the cultural history of the wax print fabric, I would want to complicate the axis of black innovation / white imitation on two counts. It is crucial to bear in mind, however, that this axis subverts the one-sided colonialist view of mimicry as applying to blackness alone. In light of the critique of Marxist reductionism, the commonplace notion of commodification as a unilateral, top-down process of co-option is called into question. Rather than see the appropriation of stylized blackness as an inevitably exploitative practice perpetrated by nonblacks, we might want to bear in mind that one of the first African American millionaires was Madame C. J. Walker, whose hair pomade and preparations drew enormous profits from mainly black, female, and working-class customers. In Britain, the hair care products of Caribbean-born entrepreneurs Dyke and Dryden have also made millions. In other words, the "traveling culture" model encourages us to resist conflating cultural and economic processes. Departing from deterministic approaches, we can further identify contradictions that arise within and between spaces of the black diaspora itself.

In the realm of style and fashion, an interesting example of such contradiction arose with the African American passion for kente cloth in the 1980s. When kente was adopted to make unequivocally Afrocentric statements of pride in one's heritage, we saw on the surface a reworking of the 1960s repertoire that was extended from traditional garments, such as flowing robes or waistcoats, into everyday apparel such as sweatshirts and even baseball caps. Besides the irony that the fabric used was often printed material imported from Korea or China rather than traditionally handwoven kente from Ghana's Ashanti region, it might also be argued that, despite the intended Afrocentric message of authenticity, the translation of kente into what Manthia Diawara (1992) calls "afro-kitsch" may have been unintentionally disrespectful—the fabric, in its original context, is usually reserved for ceremonial occasions such as births, marriages, and funerals.

Third and finally, the key question of thinking about the future possibilities of the diaspora's cultural politics is to ask: What breaks the flow? What codes cover over and conceal the processes of cultural mixing that have generated the inventive energies of Afro-diaspora modernisms? What are the boundaries that cut off the flow, not just with the dualism of whiteness and blackness, but within and between the distinctive experiences that differentiate and enrich the internal diversity of Afro-diaspora identities?

To the extent that diaspora-based webs of cultural connectedness might offer alternatives to market-driven pressure to penetrate cultural barriers in the name of the performance principle of pure profit, I want to ask whether the historical demand for visibility that has been so vital to the counterpractice of expressive performativity in the aesthetic codes of black culture has now reached a turning point. I asked, "What breaks the flow?" I want to work through this question by looking specifically at the "problem of the visual" in the received narrative of modernism.

Modernism Was Always Multicultural

Romare Bearden's collage *Three Folk Musicians* (1967) (fig. 12.2) has a call-and-response relationship to Pablo Picasso's painting *Three Musicians* (1921) (fig. 12.3). Taking the blues tradition as subject matter, Bearden returned to the composition of his earlier gouache *Folk Musicians* (1942) (fig. 12.4). Having worked through social realism and abstract expressionism in the 1940s and 1950s, Bearden arrived at the photomontage projections that became his medium of choice in the 1960s. As Ralph Ellison observed, the visual methodology of collage was highly suited to Bearden's outlook on African American life.[1] The cut-and-mix approach involved in collage resonates with the im-

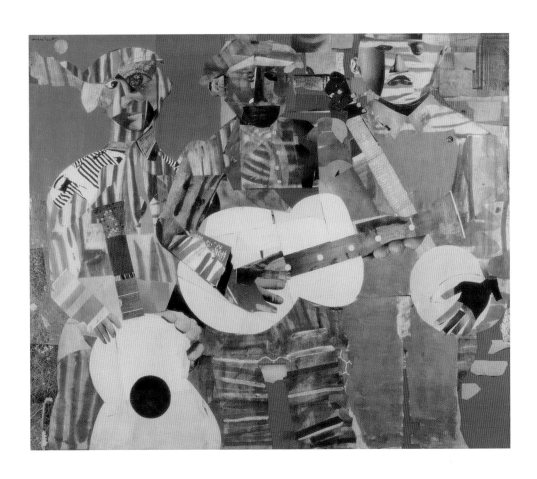

12.2 Romare Bearden, *Three Folk Musicians*, 1967. Oil and collage on canvas, 127.3 × 152.4 cm. Private collection. Courtesy of Sheldon Gallery, Birmingham, Michigan. © Romare Bearden Foundation / Licensed by VAGA, New York.

provisational aspects of the black vernacular, which selectively appropriates what is given or found in one's environment and transforms it into raw material for one's distinct stylistic signature. Just as bebop musicians transformed melodies from familiar standards as the basis for solo-in-the-circle antiphony, vernacular speech "signifies" on Standard English by using tropes such as inversion or irony that carry traces of the syntax and tonality of African oral languages (Gates, 1988a).

In the sense that the cut-and-mix collage aesthetic of *Three Folk Musicians* exemplifies a condition of "double consciousness," it can be said to bring about a quality of dialogic doubleness that enriches our understanding of how deeply African and European cultures interacted and intertwined under modernity. Bearden openly acknowledged his postcubist interest in the flatness of the picture plane against the realist illusion of verisimilitude. While his almost mathematical inquiry into geometric rhythm and formal spacing is indebted to Henri Matisse and Piet Mondrian, whose *Broadway Boogie Woogie* (1942) was inspired by African American stride piano, Bearden also brings into the mix his own intimate knowledge of the syncopated rhythms and angular intervals associated with the compositions of Thelonious Monk, for example.

Bearden, therefore, does not passively celebrate black culture. Rather, he actively "translates" back and forth between European modernism and the African American vernacular. In fact, this is how he arrived at collage as a pictorial method that refused the either/or dichotomies of an art world that often counterposed the terms "Negro" and "artist" as if they were inherently antithetical. Bearden's unique position as a mid-century African American modernist allows us to examine why this dialogic doubleness has thus far gone mostly unrecognized in twentieth-century art criticism. Briefly touching on moments from the Harlem Renaissance in the 1920s and the Black Arts Movement in the 1960s, I want to pinpoint two key reasons why this has occurred.

Broadly speaking, the first reason concerns the dominance of the formalist master narrative that tends to regard the history of modern art as a linear, goal-driven sequence in which the mastery of pure form triumphs over the chaos of random matter. This is my own simplification, admittedly; nevertheless, it conveys the ideological thrust of a grand narrative that began with critics Roger Fry and Clive Bell, was transferred to Alfred Barr, chief curator of New York's Museum of Modern Art, and continued with critic Clement Greenberg until it was radically called into question, during the 1960s, by conceptual artists who extended Marcel Duchamp's interrogative practice of institutional critique.

My point is that, insofar as this dominant version of the modern art narrative was widely influential, what results is a bicycle-race model of art history: Who got there

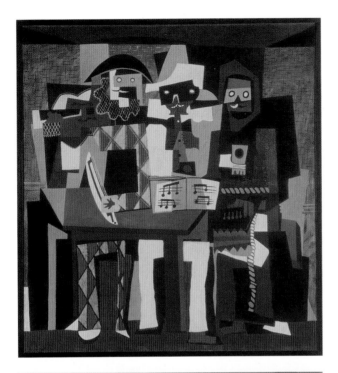

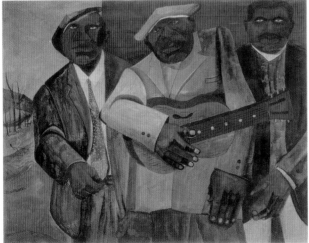

12.3 Pablo Ruiz y Picasso, *Three Musicians*, 1921. Oil on canvas, 80½ × 74⅛ inches, 204.5 × 188.3 cm. Philadelphia Museum of Art: A. E. Gallatin Collection, 1952. © Estate of Pablo Picasso / Artists Rights Society (ARS), New York.
12.4 Romare Bearden, *Folk Musicians*, 1942. Gouache on paper, 35½ × 45½ inches. Curtis Galleries, Minnesota. © Romare Bearden Foundation / Licensed by VAGA, New York.

first, who was fastest, and what prize did they win? When the story is told as a sequence of heroically transgressive acts, in which the mantle is passed from Manet and Cézanne to Picasso and Mondrian and then to post-1945 American modernists such as Jackson Pollock and Barnett Newman, what we find is that minority artists always tend to be excluded. I would argue that such exclusion from the canon is not so much accidental as obligatory, for the core modernist values of originality, transgression, and a unified oeuvre are based on an either/or logic. Just as the very existence of "high" culture entails the rejection and exclusion of "low" culture as its other (in the sense that the fine arts necessarily exclude folk crafts, for example), each of high modernism's core aesthetic principles excluded various minor traditions in order to provide a foil to its own identity. What is interesting is how this exclusionary logic of othering dovetails with ideologies of ethnocentrism.

When the beholder assumes the unquestioned values of high modernism, the dialogic interplay between Bearden and Picasso is canceled out. Because *Three Musicians* was made first, it attains pride of place and thus makes *Three Folk Musicians* secondary or derivative. Because Bearden restlessly experimented with diverse methodologies, moving through realism and abstraction to collage, whereas Picasso's stylistic shifts are held to be problem-solving progressions within a unified oeuvre, the former is seen as less accomplished than the latter, who thus wins accolades for his individuality. Finally, Picasso's transgressions were pitched against earlier masterpieces in European painting, such that the shock of his *Demoiselles d'Avignon* (1907) lay not so much in the influence of African sculptures but in the work's intertextual reference to Eugene Delacroix's *Women of Tangier* (1824), which was both acknowledged and undermined in a quasi-Oedipal drama of filiation and independence. For diaspora artists like Romare Bearden, however, the question of belonging to a tradition had been in doubt from the very beginning.

Because white supremacism posited that Africans were entirely stripped of an original culture by the Middle Passage, African American artists were obliged to refute such racist assumptions. Art historian Albert Boime (1989) reveals that such nineteenth-century artists as Robert Scott Duncanson, Edward Mitchell Bannister, Mary Edmonia Lewis, and Henry Ossawa Tanner were each obliged to demonstrate the Negro's capacity for artistic "competence." That each of these artists did so, enjoying successful careers that won them national and international recognition, serves only to highlight the disparity, at that time, between European American artists (who all emulated a European aesthetic) and African American artists who faced a double imperative. Not only did African American artists have to prove competence to gain

admittance to art world professions, but their achievements in searching for an artistic voice and style of their own were overshadowed by the need to refute widely held misrepresentations of the "Negro" as a whole.

Add to this scenario the intensified ideological investment in ethnic stereotyping after Reconstruction, and we can see how visual artists of the 1895–1925 New Negro movement were overburdened by contradictory expectations and demands. Implicitly expected to "represent the race," each generation of African American artists has had to negotiate a dual dilemma.

When W. E. B. Du Bois set forth his wide-ranging "uplift" agenda in his 1926 article "Criteria of Negro Art" he wanted artists to "represent the race" by demonstrating the cultural capacities and potential of black people.[2] At the same time, he wanted artists to refute vulgar and degrading stereotypes. When Alain Locke edited *The New Negro* anthology in 1925, emphasizing the cultural rather than political dimension of African American creativity, he too urged artists such as Aaron Douglas, Sargent Johnson, and Lois Mailou Jones to form a "racially representative idiom of group expression."[3] Less preoccupied with the need to refute stereotypes, but sharing Du Bois's concern that white Americans recognize the talents and achievements of black artists, Locke saw the nineteenth-century generation as broadly imitative of outmoded European academic conventions. He wanted the Harlem Renaissance generation to learn from the modernist example of Picasso and Modigliani, all the more so to reactivate the "ancestral heritage" of precontact African cultures as a source of originality and distinction for African American visual art.

Like many others, Locke felt that the distinctively expressive features of African American cultural identity were manifested mainly in speech, in music, and in dance. Although such broad brushstrokes inevitably simplify the complexity of cultural history, my point is that the second reason why the interactive energies of African American modernisms have not been fully recognized stems from the ideological pressures that led successive generations of intellectuals to assume a hierarchy of the arts. By placing literature and music at the top, the survivals and traces of African influences throughout the diaspora highlighted the distinctiveness of African American identity. By virtue of being culturally distinctive, the "Negro" was entitled to social recognition as an equal contributor to modern American civilization. Seeking to refute the supremacist idea that black culture was merely imitative, the emphasis on aesthetic distinctiveness in the literary and performing arts led cultural critics to an implicit hierarchy in which the aural culture of the voice would be championed over and above the visual culture of the eye.

Once we grasp that this move was being driven by the deeper demand for the social recognition of African American identity, we come to understand how aesthetics and politics were further conflated in subsequent moves that posited an entirely separate "black aesthetic" in the 1960s. When Black Arts Movement (BAM) advocates such as Amiri Baraka, Ron Karenga, and Larry Neale sought to fuse aesthetics and politics into the all-encompassing demand that black art be made "by, for, and about" black people, the result was a hierarchy in which music, theater, and performance poetry—being closer to the vernacular rhythms of the streets and the long-standing wisdom of folk belief—would be championed as more "authentically black" than potentially elitist and more esoteric fine arts like painting and sculpture.[4]

Curiously, the didactic and prescriptive rhetoric of the BAM agenda echoed the idealistic "uplift" espoused by Du Bois and Locke: artists in both eras were supposed to "represent the race" and refute stereotypes. Although the political atmosphere of the 1960s could not be more different than that of the 1920s, the common outcome was that visual artists were subjected to conflicting expectations. During the 1930s, the philanthropic agenda of the Harmon Foundation wanted black artists to win white approval by adopting conservative styles that would demonstrate their competence; but affluent white patrons, such as Charlotte Osgood Mason and Carl Van Vechten, whom Zora Neale Hurston dubbed Negrotarians, wanted black artists to fulfill primitivist desires for absolute otherness.

During the 1960s, when black artists had embraced abstract expressionism (painter Norman Lewis, for example, was invited to represent the United States at the 1956 Venice Biennale; MoMA purchased mid-1950s works by sculptor Richard Hunt), they now found that, because their work was nonrepresentational, they were not "black enough." Conversely, artists such as Wadsworth Jarrell and Jeff Donaldson, who participated in the Chicago-based artists' collective Africobra in the late 1960s, sought to produce a participatory aesthetic that was accessible to popular audiences and which represented populist aspirations. Despite innovative works, however, such artists were rarely valued by mainstream art institutions and are rarely remembered in BAM narratives. What we find from the 1920s through the 1960s is that when artworks are made secondary either to the artist's cultural identity or to the art world's institutional obligations to reflect society, then art is rarely appreciated for what it actually is—a painting, a mural, a sculpture, a collage—but is constantly interpreted for what it is held to "represent" about African American culture in general, or American society in the abstract.

One consequence of this overdetermined reading of artworks as necessarily "representing the race" or "reflecting society" is that art historians fail to observe the back-

and-forth dialectic set in motion when artworks talk to one another. Faith Ringgold's paintings *Flag Is Bleeding* (1967) and *Flag for the Moon* (1969) (fig. 12.5) articulated a searing indictment of America's inability to fulfill its democratic ideal. Yet such dissent depended on the signifying difference Ringgold inscribed in relation to a work such as Jasper Johns's *Flag* (1954–55) (fig. 12.6), which, despite its questioning of depiction (was it a representation of a flag or a flag abstracted into a painting?), does not address the underlying question of American national identity. When David Hammons's *African American Flag* (1990) (fig. 12.7) replies to Jasper Johns — it is an actual flag made of fabric, not a representation or a depiction — Hammons performs further critical "signifyin'" by substituting Marcus Garvey's red, black, and green colors in place of the red, white, and blue.

Art historians cannot "see" such critical conversations in visual culture because the interactive dimension is occluded by absolutist ideologies that assume a fixed or essential difference between European and African cultures. To examine the legacies of such hegemonic divisions, we need to locate the problems in African American art historiography in a deeper historical perspective. By defining "the problem of the visual" as a product of the cultural history of Western modernity as a whole, we may retain the value of Ellison's insights into the dilemma of invisibility while registering the conceptual limitations of the demand of visibility. This in turn opens wider perspectives on the complexity of the diaspora's cultural history and highlights dilemmas regarding future possibilities in an era of global media culture.

Unmasking Metaphors of Visibility and Invisibility

Observing the institutional history of African American exclusion from both the metropolitan art world and the mainstream narrative of modern art, Michele Wallace rightly argued that "the problem remains the unilateral unwillingness of Euro-American culture to admit and acknowledge its debt, or even its relationship, to African and Afro-American culture. In fact, this problem — which lies at the heart of the problem of the visual in Afro-American culture — has such a long and convoluted history that its enunciation has become one of the telling features of Afro-American Modernism. One of the early practitioners of Afro-American literary Modernism, Ralph Ellison, even gave it a name: invisibility" (1990, 43).

While this insight is crucial to understanding the obstacles African American visual artists faced in the struggle for recognition, it is, however, only one part of the story. For, as I have tried to indicate in this rapid round-trip from the 1920s through the

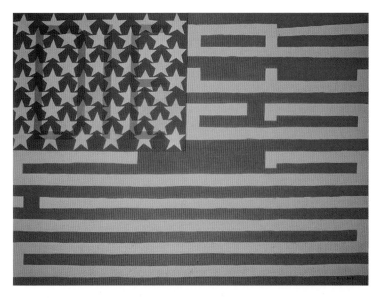

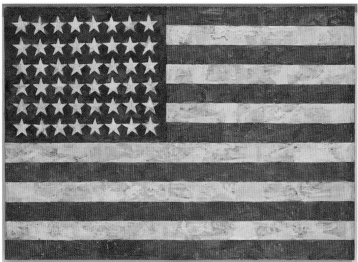

12.5 Faith Ringgold, *Flag for the Moon, Die Nigger, Black Light* series # 10, 1969.
Oil on canvas, 36 × 50 inches. Private collection © Faith Ringgold 1969.
12.6 Jasper Johns, *Flag*, 1954–55. Encaustic, oil, and collage on fabric mounted on
plywood, three panels, 42¼ × 60⅝ inches, 107.3 × 153.8 cm. Gift of Philip Johnson
in honor of Alfred H. Barr, Jr. Collection: The Museum of Modern Art, New York.
© The Museum of Modern Art / Licensed by SCALA / Art Resource, New York.

12.7 David Hammons, *African American Flag*, 1990. Courtesy of the artist and
Studio Museum in Harlem. Photo: Adam Reich.

1960s, the expectations and demands voiced by African American critics also heightened the pressure on artists to be representative, placing them at odds with the idea of individual freedom of expression that was taken for granted by Euro-American modernists.

In this light, "the problem of the visual" was reinforced when the artwork was overshadowed by an emphasis on identity and exclusion driven by the demand for social recognition. The implicit hierarchy of the senses, which regarded the aural cultures of black music as original and distinctive, at the same time that black visual arts were perceived as imitative or derivative, also diminished the aesthetic specificity of African American modernism.

As Wallace observed, once we go back to Ralph Ellison's text, there is a key distinction between music and visuality, characterized by the dichotomy between positive and negative scenes of instruction. As a site of cross-cultural interaction that created the soundtrack to twentieth-century modernity, from ragtime, blues, and jazz, to rock and hip-hop, music bears witness to the deep interinvolvement of African Americans and European Americans in creating uniquely modernist forms. In the aural domain of music, African American aesthetics are widely recognized and appreciated as universal values that, in terms of the recognition of cultural identity, created a space of autonomy in which black musicians have innovated and experimented freely.

So why, on the other hand, would the visual be the scene of negative instruction? Why is it that African American visual artists are often perceived through the lens of particularity as being dependent or even imitative in contrast to the freedom of expression that European American artists have enjoyed? The answer, in part, lies in the crucial role of vision and visuality in establishing the very ideology of race as a matter of visible difference.

While numerous societies may be characterized by structures of racialism, ethnocentrism, and ethnic chauvinism, what distinguished the worldview that sought to rationalize racial slavery with Enlightenment sciences such as biology, anatomy, and genetics was the reliance of its optical and chromatic distinctions on the epistemological privilege of vision. Western modernity is, in a fundamental sense, inaugurated by the privilege of the visual. The Copernican revolution in the natural sciences ushered in empiricism and placed the eye at the center of the observable world. In painting, the rediscovery of linear perspective regarded the world as immediately accessible to rational knowledge through the transparent "window" to which pictorial representation aspired. While art's increasing prestige and autonomy reflected a vision-centered world, the profound paradox of Western modernity is that its power and wealth depended on

the existence of others whose very humanity was denied by the color-coded optical and chromatic metaphors of a classical racism that made them invisible.

When Ellison wrote *Invisible Man*, his insights into the psychic and social worlds of African American identity resonated with those put forward by Frantz Fanon in *Black Skin, White Masks*. Originally published in 1952, both texts address what happens to human identity when the dialectic of mutual recognition is socially denied. For Ellison, when African humanity went unrecognized in American society, it created a condition of invisibility in which the all-too-visible difference of blackness was perceived within the supremacist imagination as the embodiment of its antithesis — whiteness needed the Other in order to know what it was not. For Fanon, the colonizer's fantasy of omnipotence meant that the colonized was also denied equal recognition. Fanon saw the colonizer, like the master in Hegel's master/slave dialectic, as being unable to acknowledge his dependence on the Other. In Fanon's (1967a) view, the colonized, by turning from the object of his labor to the unfulfilled demand for recognition, became — unlike Hegel's slave — locked into a double bind in which he wore the mask of compliance that performed alterity.

When Wallace underscores the unwillingness of the European American art world to acknowledge its indebted or interdependent relation to the African artifacts that inspired Picasso's cubist revolution, she reveals the enduring legacy of a worldview anchored by the privilege of vision. Whereas whiteness arrogates universality on account of an unmarked or anonymous existence that equates with a subject position of mastery, blackness is fixed into the field of vision primarily as an *object* for the gaze. To the extent that the subject/object dichotomy has been historically aligned with the visible polarity of whiteness and blackness, one may speculate that black visual artists were denied freedom of expression because their difference fixed them on the side of the object that they were expected to depict or represent. In contrast to the subjective freedom enjoyed by musicians, visual artists were seen as "representatives," expected to refute stereotypes, and to "uplift" black cultural identity. Such imperatives arose from the overarching ideology of the visual that had equated whiteness with the control of the gaze and thus assigned blackness, qua other, to the side of the object.

I want to conclude with two points in this regard concerning the past and the future, respectively. Both entail rethinking the value and limitations of the critique of invisibility that was predicated on political demands for cultural visibility as an emancipatory goal.

First, just as art historians have been unable to "see" the interactive back-and-forth that characterizes the dialogic forms of Afro-diaspora modernisms, art criticism

has failed to grasp the iconography of the mask in diaspora aesthetics. The image of the African mask recurs, from the Harlem Renaissance through Romare Bearden to Jean-Michel Basquiat, as a constant and distinctive visual trope of the diasporic imagination. It signifies something profoundly important to the condition of double consciousness, for it is crucial to note that a mask always has two faces.

Where the outward face of black masking performs survival strategies that comply with social roles scripted by the stereotype, it does so in order to tame and appease the predatory force of the master gaze. The paranoid and narcissistic fantasies Fanon diagnosed under colonialism were active under white supremacism, as both involved an anxious investment in the visual culture of the gaze. Looking relations were highly regulated under Jim Crow segregation, such that it was customary that blacks would avoid eye contact when addressing whites, and it was forbidden for black men to look at white women. Far from being securely centered in the world, such other-directed dynamics of paranoid projection betrayed the psychic insecurities of whiteness, which could only be equated with mastery by virtue of the social violence at its disposal. Relatedly, narcissism conceals dependence on the other such that, when blacks were related to as objects of pity or fear, the black subject who often appeared to play along with such ascribed identity did so in order to ward off and abate the potential for white violence. From minstrels and mammies to mau-mauing and woofing, the outward face of the mask performs otherness so as to ensure survival of black subjectivity and to create room for maneuver within the social asymmetry of power. But what was taking place on the other side of the mask?

To the extent that the inner face of the mask concerns its protective function, I would suggest that masking is a cultural form of central importance to the psychic life of the black diaspora because it seeks to hide and protect an inward relationship to "Africa." What it protects is a contemplative or meditative space that allows spiritual and emotional reflection on the time and place left behind by the trauma and rupture that inaugurated diaspora.

When poet Countee Cullen asked, "What is Africa to me?" his question was not so much a problem in search of a solution but a riddle voicing his awareness of a potentially unanswerable enigma.[5] To the extent that the catastrophic separation from one's origin or homeland engenders any diaspora's physical and metaphysical narratives of "return," the visual iconography of the mask may be placed alongside broader cultural patterns of masking, such as the survival and retentions of West and Central African religious elements beneath the expressive forms of Afro-Christianity. Just as New World syncretic religions, such as candomblé in Brazil, vodun in Haiti, or Santeria in

Cuba, masked and protected the worship of Yoruba deities hidden behind the outward face of Catholic saints, so the wide-ranging scholarship on the aesthetics of African diaspora spirituality calls for closer attention to the reworking of such mixed or hybrid forms in the more secular domains of modernist music or art (Thompson, 1983).[6]

Once we consider the enigmatic relation to "home" that is preserved on the inward side of the mask, we may understand its deeply layered meanings as performing a protective function for diaspora subjectivity. Not only does the mask seek to protect the inner world from the social violence of supremacist ideology; it also aims to conserve, through secrecy if necessary, a psychic or emotional space for open-ended contemplation wherein the enigmatic relationship to the unknown or unnamed ancestor may be nurtured as a source for the growth and renewal of black diaspora identities. These speculative lines of inquiry open a fresh angle on the interpretation of masking in the visual cultures of the black diaspora. Clearly, it cannot be reduced to a mimetic or dependent relationship to dominant forms of Euro-American visuality where masks and masquerade tend to be associated not so much with the release of the soul into spirituality but with concealing the self from social identification.

Leaping from past to present, I want to suggest that a broader understanding of the importance to diaspora aesthetics of double-faced masking—Janus-like in its acceptance of contradiction as integral to the flow of human existence—also helps us grasp the highly contradictory condition of black "hypervisibility" in contemporary culture. I would like to extrapolate here from the insights of Herman Gray (1995), whose observations on the rapid changes in black popular culture associated with media-driven globalization over the past decade cast the modernist demand for visibility in a critical light. Far from implying a simple shift out of invisibility to the excess visibility of the condition he refers to as "hyperblackness," Gray encourages us to take stock of the massive economic, political, and social changes that have made the clear-cut boundaries addressed by Fanon or Ellison much more ambiguous both in the post-colonial context and in what could be called the post–civil rights predicament in the African American context. Whereas the earlier modernist demand for public visibility implied a struggle for the full recognition of equal rights of entitlement to the claims of citizenship, it may be said that structural shifts brought about by postmodernism have decoupled the underlying equations between visibility and empowerment. What led to this contradictory turnaround?

Even though media images of blackness are now more globally visible than ever before, we witness the deepening of racial inequalities in U.S. society as evidence of the structural decoupling of culture and politics. The signifying difference of the black

vernacular now feeds into the global marketing of postmodern capitalism, yet such heightened visibility appears to merely mask a growing sense of disenchantment and disillusionment with politics per se.

Gangsta rap's almost grotesque exaggerations of stereotypical alterity are highly indicative as cultural symptoms of this ambivalent shift. While images of unlimited wealth and luxury seem to parody capitalism's normative definitions of the good life, the excessive irony can barely conceal the rage that results from a pervasive sense of disappointment with the very idea of political engagement in public life. As a generational emblem of this outlook, one might recall N.W.A's first music video, "Express Yourself," in 1988, when the group burst through a paper banner emblazoned with the words "I have a dream."

Under such changed social conditions it may be said that the visible signifiers of blackness have become detached from their referents in social reality. "Hyperblackness" in this sense concerns the proliferation of black representations that primarily refer to other representations. This process is characterized by an escalating reflexivity generating excessive parody and irony, as well as diminishing emphasis on the referential dimension in which blackness was once held to stand for, or represent, clear-cut ethical and political commitments. Whereas Gray's observations align "hyperblackness" with the broader dilemma of the hyperreal under postmodernism—in which media simulacra of reality appear more real than reality itself—I would regard the "hyper" as a form of hyperbole in which performative and rhetorical excess and exaggeration mask the decoupling of black culture and politics. "Too black, too strong" was a slogan often heard in the early 1990s; like the strident voices heard in gangsta rap or the defiant imagery associated with ghettocentric cinema after Spike Lee, the hyperbolic tone seems to suggest uncompromising resistance. But does the very loudness of such hyperbole not merely mask and mute an increasing sense of a loss of direction within the black body politic? To the extent that the post–civil rights era entails sharpened polarities *within* black society—between an expanded middle class struggling to coexist with a growing underclass, for example—the antagonistic and exclusionary boundaries once anchored by the chromatic distinctions of race are no longer so clear-cut. It may be said that it is precisely this postmodern condition of radical uncertainty that is evaded by performative hyperbole.

During late modernism, cultural forms encoded political desires that were blocked from official channels of representation. The increasing disenchantment with the belief that politics can deliver significant social change has led to a compromise formation of cultural substitutionism whereby an increasing number of media images are held to have satisfied the demand for public visibility. What was at stake in the very mean-

ing of visibility as a desirable and emancipatory goal of collective empowerment has been profoundly altered under contemporary conditions of hyperblackness; an ethics of commitment has given way to the seductions of consumption. As a provocation to further inquiry I want to suggest that hyperblackness amounts to a form of global branding in which the signifying difference of vernacular culture produces an instantly recognizable cultural identity. Such a view draws attention to the fact that hyperblackness would not be able to survive in the marketplace were it not for the presence of white consumers. Perhaps hyperblackness has merely updated the masquerade of performing alterity. When so-called Generation Xers are happy to embrace such hyperbolic expressions of blackness—in gangsta rap, club culture, or designer-label clothing—we find that, rather than a more open-ended or honest acknowledgment of the interdependence in which our cultural identities unfold, we are beholden to the most recent twist in a long-standing story: the interaction of African and European elements in American culture is thoroughly mediated and shot through with intransitive fantasies of otherness. If fantasy prevents the recognition of another's subjectivity and ethical autonomy, perhaps the interrogative space of the arts—whether literary, musical, or visual—allows room for a questioning outlook otherwise off-limits in a globally saturated media culture. In light of the wide-ranging journey into the diaspora's cultural history undertaken here, the search for alternatives to, and exit points from, contemporary dilemmas requires deeper understanding of the complexity of the spaces through which blackness has traveled so far.

NOTES

This chapter was first published in *Black Cultural Traffic: Crossroads in Global Performance and Popular Culture*, edited by Harry J. Elam Jr. and Kennell Jackson (Ann Arbor: University of Michigan Press, 2005), 141–61, and is reproduced with the kind permission of the University of Michigan Press.

1. Ralph Ellison, "The Art of Romare Bearden," in *Going to the Territory* (New York: Random House, 1986), 227–38.

2. W. E. B. Du Bois, "Criteria of Negro Art," in *Selections from "The Crisis"* (New York: Krauss-Thompson, 1983), 444–50.

3. Alain Locke, "The Legacy of the Ancestral Arts," in *The New Negro: An Interpretation*, ed.

Alain Locke (1925; rpr., New York: Atheneum, 1983), 254–67.

4. Larry Neale, "The Black Arts Movement," and LeRoi Jones, "The Changing Same (R&B and New Black Music)," both in *The Black Aesthetic*, ed. Addison Gayle Jr. (New York: Doubleday, 1970), 257–75, 112–25.

5. Countee Cullen, "Heritage," in "Harlem: Mecca of the New Negro," special issue, *Survey Graphic*, March 1925 (rpr., Baltimore: Black Classics Press, 1986), 674–75.

6. See also Theophus Smith, *Conjuring Culture: Biblical Formations of Afro-America* (New York: Oxford University Press, 1994).

13

ART HISTORY AFTER GLOBALIZATION: FORMATIONS OF THE COLONIAL MODERN

The phrasing of the term "colonial modern" is quite promising for it suggests a fresh approach to understanding the interrelationship between modernism and colonialism. In an attempt to tease out what the implications might be for art history, my focus in this contribution is to reflect upon the three cognate terms at the heart of the debate — "modernism," "modernity," and "modernization" — in light of what has become known, in the sociology of culture, as the multiple modernities thesis. Drawing on examples from the Annotating Art's Histories texts that I recently completed as series editor, my aim is to suggest what cross-cultural studies in art history might look like when we carry out archival research "after" globalization.

While there is the view that globalization is an intrinsically "new" phenomenon that refers to an increasing sense of worldwide connectedness brought about by new technologies, the alternative perspective of the *longue dureé* gives us the advantage of a much wider canvas upon which to theorize cross-cultural interactions as a variable in the social production of art. Describing the features of contemporary globalization that are indeed new — transnational corporations, neoliberal economies, the heightened role of information technologies and the culture industries — Stuart Hall nonetheless stresses that this is merely the most recent phase in a long-term process. In his scheme of periodization, "the fourth phase, then, is the current one, which passes under the title of 'Globalization' *tout court* (but which, I argue, has to be seen as an epochal phase in a longer historical *durée*)" (Hall, 2003, 194). In the context of discussing creolization as a specific modality of cross-culturality arising out of colonization and forced migrations, Hall states: "I date globalization from the moment when Western Europe breaks out of its confinement, at the end of the 15th century, and the era of exploration and conquest of the non-European world begins." Adding that "somewhere around 1492 we begin to see this project as having a global rather than a national or continental character," his account of this first phase of globalization makes it "coterminous with

the onset of the process which Karl Marx identified as the attempt to construct a world market, the result of which was to constitute the rest of the world in a subordinate relationship to Europe and to Western civilization" (193).

To say globalization is nothing new, and that it is simply our intellectual understanding of it that has changed in recent years, is to take a critical position with regard to routine orthodoxies in current thinking about cultural difference in the arts. Opting to start with ideas that are deliberately big in scale, I want to convey my sense of what is at stake in the paradigm shift that is currently under way in art history, to which the Annotating Art's Histories series has contributed some small steps. But the issue of scale also helps put in perspective those obstacles to historical thinking on cross-cultural dynamics that need to be addressed at a metatheoretical level before we can adjust our orientation toward the archive of colonial modernity. Two such obstacles can be characterized in the following terms—"inclusionism" and "presentism."

To the extent that difference is widely addressed today through an ideology of multicultural inclusionism, there is a strong tendency to elevate a horizontal axis that embraces an ever wider capture of identities over and above a vertical axis that would attempt a historical explanation of their mutual entanglement. Across survey exhibitions and anthology textbooks, the pervasive emphasis on the horizontal breadth of coverage tends to dehistoricize and flatten out the contradictory relations among the diverse elements brought together in the name of inclusion. What results is a pluralist illusion of plenitude that assumes each of the parts coexists in a side-by-side relationship, with little interaction or dynamism among them. Where the language of multiculturalism is evoked to compensate for past exclusions (as a kind of solution to a legitimation crisis on the part of art world institutions), we not only find the view whereby cultural diversity is seen as a mere "novelty" that belongs to contemporary art alone, but also find that such presentism works in insidious ways to preserve earlier canons of modern art whose monocultural authority thus remains intact. The consequences of ahistorical presentism can be seen in a conservative approach to descriptive ekphrasis whereby critics seek to match the contemporary theorization of globalization with art practices that supposedly embody such concepts. Niru Ratnam's chapter titled "Art and Globalisation" in *Themes in Contemporary Art* (2004), devoted to works shown in Documenta 11 in 2002, starts by qualifying the newness of globalization theory, pointing out that it "exhibits continuity with earlier practice and theory exploring the legacy of European colonialism," but then dismisses relations between globalization and postcolonialism on the basis of Negri and Hardt's view that, because "the post-colonialist perspective remains primarily concerned with colonial sovereignty . . . it may be suit-

able for analysing history, [but] it is not able to theorise contemporary global structures."[1]

Where theory takes precedence over the concrete actuality of the work of art as an object of study in its own right, we find that art is reduced to a passive illustration of a concept that the theorist has already arrived at, thereby denying art the autonomy of its own aesthetic intelligence. Moreover, traditional historiography remains intact and is unaltered by its encounter with other disciplines. In his edited collection *Is Art History Global?*, James Elkins (2007) assembles an international cast of contributors to debate the epistemological shifts of the past thirty years in which the canonical scholarship of Erwin Panofsky, Arnold Hauser, Meyer Schapiro, and others has been displaced by poststructuralism, feminism, visual culture, and postcolonial studies. Approaching the debate in such abstract terms, however, we find that no actual works of art are discussed by Elkins at all. Moreover, by merging the topic of globalization with the category of "world art," the area-studies model established in anthropological and archaeological orientations toward non-Western art maintains an essentialist notion of self-contained cultures as discretely boundaried totalities, offering no account of their interactions. When the non-Western is confined to premodern antiquity, we face another paradox, namely, that modern art, Western or otherwise, has no place within the category of "world art."[2] As I argue in my introduction to *Cosmopolitan Modernisms* (2005a), postcolonial theory (which originated in literary scholarship) is itself highly culpable with regard to the tendency toward theoreticism. Having revealed the constitutive rather than reflective role of representation in constructions of colonial reality, the emphasis on the positioning of Self and Other has led to an imbalance whereby studies of visual othering in Western art constantly refer back to the imperial ego, as it were, in such a way that overshadows the agency of colonial and diasporic artists as creators of representations in their own right.

Standing back for a moment, one might observe that the so-called dominant narrative of modern art has been under attack ever since conceptual art called the optical model of visuality into question, precipitating a crisis for modernism as such.[3] But it is one thing to dismantle an influential way of seeing, quite another to put forward a sustainable alternative. Rather than suggest a fully fledged model for the study of cross-cultural relations in art, my series drew attention to the gradual and incremental steps needed to both deconstruct the dominance of formalist universalism and also explore methods that refuse the converse tendencies of sociological or contextual reductionism. As a case in point we may consider how the modernism/colonialism relationship is mostly addressed within the episteme of art history within the extremely limited pur-

view of primitivism. Considering the amount of ink spilled on the subject of Picasso's *Demoiselles d'Avignon* (1907) during the 1980s and since, one might say that the disavowal of primitivism's colonial contexts within the formalist narrative of morphological "borrowings" was held fully intact for the best part of eighty years. The idea of "significant form" proposed in the 1920s by Bloomsbury critics Clive Bell and Roger Fry was only dislodged from epistemological privilege by the psychoanalytic concept of fetishism that informed readings of Picasso by Hal Foster (1985) and Simon Gikandi,[4] and by James Clifford's (1988) notion of the circulation of tribal artifacts in museum collections and other institutional sites of exchange in the art and culture system (fig. 13.1).

In the twenty-five years since this breakthrough moment, it is the concept of appropriation, above all, that has played a transformative role in our understanding of subaltern agency and authorship; but because such concepts have been mostly deployed in relation to contemporary art, it is only in the last ten years or so that its paradigm-shifting potential has been activated in archival and historical research. Perhaps more so than painting and sculpture, it strikes me that architecture further contributes to breaking primitivism's interpretative monopoly on our understanding of modernism and colonialism, for the 2008 exhibition *In the Desert of Modernity*, like my own series, shares a timeline of research that also includes work such as *Modern Architecture and the End of Empire* (2003) by Mark Crinson.[5]

For my part, starting from the premise that modernity defines a state of being or condition of life in which disparate material elements and social actors are constantly uprooted from their origins and brought into contact by proliferating networks of trade, travel, and market exchange, the Annotating Art's History series set out to demonstrate that, far from being limited to primitivism, cross-cultural dialogue plays a meaningful and ever-present role in the story of modernism as a whole. From movements such as surrealism, through major underlying processes such as abstraction or montage, to the "high/low" crossovers of pop that inaugurated the problematic of postmodernism, cultural difference is not aberrant, accidental, or "special," but a structural variable and an even normative feature of artistic production under the conditions of modernity that had become global by the late nineteenth century.

Modernism, one might say, was always multicultural—it is simply our consciousness of it that has changed. Each of the ruptures inaugurated in European modernism circa 1910 made contact with a global system of transnational flows and exchanges—from Malevich's conception of monochrome painting, shaped by his reading of Vedic philosophy and Indian mysticism, to Duchamp's ready-mades, which mirrored the decontextualized mobility of tribal artifacts. Modernist primitivism may be the generic

paradigm in which these (unequal) exchanges are most visible, but a broader under-standing of cross-culturality as a consequence of modern globalization also entails the necessity to question the optical model of visuality that determines how cultural differ-ences are rendered legible as "readable" objects of study.

Because current thinking on globalization breaks the foundational equivalence between modernization and Westernization, it interrupts the classical geometry of cen-ter and periphery that was indispensable for earlier approaches in development studies and world-system theory in Marxism. The assumption that becoming modern was at all times identical to the process of becoming Western (and hence giving up one's identity) has been wholly undermined by awareness of the agency of selective appropriation on the part of social actors who were indeed subordinate to the hegemony of the Western center economically and politically, but who nonetheless exercised choices in what they adapted and what they rejected in the space of the cross-cultural encounter. Whereas previous theories saw imperialist globalization in the age of empire as a steamroller of dominance, eliminating local, tribal, and indigenous differences in total, the agency of adaptation on the part of the colonized made the lived experience of colonialism a contradictory phenomenon on all sides, thereby creating multiple sites of resistance, antagonism, and negotiation. This emphasis on the mutual entanglement of contra-dictory forces is what distinguishes the multiple modernities thesis. With the greater focus given to spatial processes of globalization in the work of urbanist Anthony King (2011), along with Arjun Appadurai's (1996) studies of localized adaptations of material and symbolic goods in global circulation, and Ulf Hannerz's (1996) account of transna-tional flows, the range of analytical perspectives brought together in *Global Modernities* (Featherstone, Lash, and Robertson, 1995) defined a turning point in the sociology of culture which was further developed by Jan Nederveen Pieterse (2004). Far from result-ing in a pluralist free-for-all in which there are as many modernisms as you like, the at-tention that the multiple modernities thesis gives to complex dynamics of structure and agency shows that the process of modernization-as-Westernization rarely resulted in a fully achieved or finalized state of colonial subjectification because it was constantly made ambivalent by the generative agonism of power and resistance.

When told as a narrative that emanates from a unitary center, the material pro-cesses of modernization—the application of scientific knowledge to technologies of social infrastructure and wealth creation that act as engines of "progress"—are often conflated with the philosophical condition of modernity. This concerns the lived ex-perience or subjectivity of the atomized individual that is taken to characterize the rationalist self-consciousness associated with secularization. But by decoupling the

13.1 Fred Wilson, *Guarded View*, 1991 (left), and *Picasso / Whose Rules?*, 1990 (right), in *Primitivism: High and Low*, installation view of the exhibition *Fred Wilson: Objects and Installations, 1979–2000*, University of Maryland, 2001. Wood, paint, steel, and fabric, dimensions variable. Courtesy of the artist and Pace Gallery. Photograph © Dan Meyers.

equation between modernity and the West, contemporary globalization theory calls for historical investigation of the *combinatory formations* whereby certain aspects of the objective process of modernization were accepted while certain subjective features of modernity were deselected. Although never colonized, imperial Japan accepted modernization in science and technology but not democracy in politics; Arab nations of the Middle East similarly adopted capitalist infrastructure while retaining religious traditions instead of individualism. Whereas Eurocentric ideology told the story as a linear sequence from the Renaissance and Reformation to the Enlightenment and the Industrial Revolution, the alternative is to conceptually disaggregate the constituent processes, as David Morley explains in the context of cultural studies methodology: "The association between the Occident and modernity has to be viewed as radically contingent in historical terms. If there is no necessary relation between these terms, then it follows that to oppose either one of them is not necessarily to oppose the other."[6]

Taken up in their literary history of the modernism/colonialism relation, Booth and Rigby add: "This would mean for instance that modernity could be . . . welcomed in the non-Western world, even as the precise form it takes in the West, or the West's way of promoting or exporting it could be stridently opposed." Hence it is equally important to bear in mind the disjunctions whereby, "rather than thinking of empire as actively involved in the exporting or disseminating of modernism (which . . . might be ideologically or politically suspect in the eyes of imperialists), we could see it as exporting modernity."[7]

Understood as culture's answering response to predicaments and dilemmas thrown up by the lived experience of modernization, modernism was not only a multivoiced phenomenon within the West—at times celebrating the machine age, at times articulating critique of capitalist alienation—it was further fractured in the envelope of colonial modernity where the exported reality of the nation-state constituted a decisive frontier of cultural and political agonism. In the context of anticolonial struggles in India, Partha Mitter notes that the circulation of modernist ideas following the 1922 exhibition of Bauhaus artists in Calcutta (including Wassily Kandinsky and Paul Klee) played a catalytic role for painterly experimentation by Gaganendranath Tagore, Amrita Sher-Gil, and Jamimi Roy, who in his view articulated a variant of primitivism that acted as a *counterdiscourse of modernity* (fig. 13.2). Whereas nationalist artists of the 1890s such as Ravi Varma and the Bengal school embraced academic naturalism and inserted indigenous content, the formal break with verisimilitude on the part of Indian modernists combined local and global elements to forge a cosmopolitanism in which the binarist logic of imperialism and nationalism alike was displaced. Because "the very

13.2 Gaganendranath Tagore, *Untitled*, n.d. Watercolor on paper, 4½ × 4½ inches. Collection of P. and S. Mitter, Oxford.

ambiguities of primitivism provided a powerful tool for challenging the values and assumptions of modern industrial civilization, that is the West," Mitter regards its presence in early Indian modernism as a "counter-modern rather than an anti-modern tendency, because it is really the twin sister of modernity, its alter ego; it's within it and yet continually questioning it." Where indigenous traditions among Bengali intelligentsia created favorable conditions for the reception of modernism, the agency of appropriation produced semiotic transformations of the "primitive." As Mitter adds, "I think of Mahatma Gandhi, in this sense, as the most profound primitivist critic of western capitalism. He fashioned the philosophy of non-violent resistance, and the self-sufficiency of village life in India, as symbolised by the humble spinning-wheel, out of elements associated with the discourse of primitivism."[8]

Within the same timeline of the 1890s to the 1920s, Ian McLean examines formations of colonial modernism and anticolonial modernism in Aboriginal Australia. Breaking with the standard view that modern art by Aboriginal artists only began with the use of canvas and acrylic paints in the 1970s, McLean argues that an artistic response to Western modernity began at the point of first contact with remote desert communities in the late nineteenth century. Ceremonial dances received European visitors with acts of performative mimicry. Sacred carvings were refashioned for secular purposes in such a way that their "outside designs" sought to educate white foreigners even as they contained "inner secrets" known only to initiates. During the 1930s Albert Namitjira produced watercolor landscapes, but while his technical mastery rendered him inauthentic under Eurocentric eyes, McLean reveals how his choices "make a claim for his Aboriginal inheritance, especially for the sacred sites of Arrernte Dreaming." McLean accepts that exported modernization established a universal or worldwide condition, but he insists that "far from being a purely Western or European construct, modernity is a mode of living that has taken root in many traditions, including ones often considered antithetical to it."[9] Hence rejecting the view that indigenous peoples and cultures were passively "victimized" by modernity as an "alien invader," McLean's emphasis is on the combinatory logics of hybridization in art's answering response:

> Modernity's apocalyptic effects on all traditional societies, including Aboriginal ones, are undeniable. However, such argument easily slips into a binary logic that flattens the ambiguities of the colonial encounter and silences the historical adaptations of the colonised; thus colonising them all over again. This binary logic is the principal reason why western critics have had such difficulty accepting the modernism of non-western and especially tribal art. In reality, the agents of tradition did what they always had: they adapted and adjusted to the new, even ap-

propriated some of its ideas. Admittedly the adjustment was often bumpy and at times contradictory, but the history of Aboriginal modernism is the story of such adaptation.[10]

In my third example of the colonial modern I would cite the Adinembo House built in the Niger delta between 1919 and 1924 by the Nigerian architect James Onwudinjo (fig. 13.3), which is the focus of Stanley Ikem Okoye's contribution to the fourth volume in my series, *Exiles, Diasporas & Strangers*. Observing how the building's flat roof struck a double-sided contrast with both the clay and thatch materials of indigenous dwellings and the brickwork of British colonial architecture, Okoye devotes attention to the use of reinforced concrete as a "foreign" technology that found a receptive environment on the part of the local elite, including the wealthy Igbo trader who had commissioned the house. Where Okoye highlights the decorative and ornamental features on its external walls by way of contrast to Adolf Loos, the key point is the overlapping time frame in which modernist architects in Austria and West Africa explored similar concerns.[11]

My own contributions to the series focused on the modern black diaspora, from Caribbean abstract painters in the New Commonwealth era such as Aubrey Williams and Frank Bowling to the photomontage of Romare Bearden in the African American scene of the 1960s. In one sense, as products of forced migrations, diasporas are very distinct from colonies—in the latter your land has been taken away from you, whereas in the former you have been taken away from your land. But with methods opened up by Paul Gilroy's concept of the Black Atlantic as a circulatory space of migrant flows, the study of diasporic modernity provides a fresh point of entry into the archive, with sometimes surprising results. Surveys by Richard Powell (2001) and Sharon Patton (1999) acknowledge the global dimensions by which blackness tends to overflow the territorial boundaries of nationality, thereby widening the scope of previous work by Samella Lewis and David Driskell, and the encyclopedia Romare Bearden cowrote with Harry Henderson, which established African American art history as a distinct field of study.[12] The Harlem Renaissance tends to be viewed within this field as the originating moment of black modernism, but with the broader concept of modernity we not only see visual mediums such as photography as a key site in which the representation of autonomous selfhood was staged after the abolition of slavery, but we begin to notice that it was also in the earlier 1890s that a distinctive philosophical discourse of self-inquiry was generated among African American intellectuals such as W. E. B. Du Bois.

Du Bois took part in the Exposition Universelle held in Paris in 1900, traveling there to oversee the installation of the American Negro Exhibit (fig. 13.4)—a collection of photographs, maps, books, journals, and scientific charts documenting his re-

13.3 James Onwudinjo, Adinembo House, Nigeria, c. 1919–24.
Photo: Ikem Stanley Okoye.

13.4 W. E. B. Du Bois at Paris International Exposition, 1900. Department of
Special Collections and University Archives, W. E. B. Du Bois Library, University
of Massachusetts Amherst.
13.5 Exposition des Négres d'Amerique, Exposition Universelle, Paris, 1900.
Department of Special Collections and University Archives, W. E. B. Du Bois Library,
University of Massachusetts Amherst.

search at Atlanta University. World fairs and international expositions have been widely studied as spectacles of imperial power—and in the Dahomey Village in the French pavilion, Africans were put on display in 1900 as living specimens of otherness—but how much richer would our understanding of these contested sites of globality be once we factor in the *simultaneous* presence of African American diaspora subjects? What Du Bois exhibited, to be sure, was not art but information: however, the documents of self-improvement he displayed in the American Negro Exhibit were understood by Du Bois himself as a manifestation of black self-modernization (fig. 13.5). The nineteenth-century networks of travel that paved the way for the Pan-African Congress (whose first meeting, which Du Bois also attended, was held in London in 1900) encourage us to conceptualize the Black Atlantic as a "counter-culture of modernity" (Gilroy, 1993) not only in music and literature but in the visual arts as well. Dominant discourses of internationalism, designed to establish conditions for capitalist competition among rival nation-states (which, for Hall, defines the second phase of globalization up to the imperialist catastrophe of World War I), were themselves shadowed and antagonized by an internationalism-from-below, of which Black Atlantic spaces are exemplary. The transatlantic journeys African American artists took to Paris in the 1930s were prefigured in the nineteenth century by sculptor Mary Edmonia Lewis and painter Henry Ossawa Tanner—whose work was not modernist per se even though it was engaged with self-conscious reflection on the dilemmas of life under conditions of diasporic modernity.

Revisiting the formative period of the 1890s to the 1920s through the lens of the multiple formations of modernism on a global scale now gives us the opportunity to examine how each of these cross-cultural variants was structured in dominance and subordination. In other words, we can think of the genealogy of modernism not as an "internalist" or self-generating story that only begins and ends in the West but as the narrative of a decisive moment in which the driving contradictions of the modern global conjuncture gave rise to many different forms of artistic production. Having touched upon anticolonial appropriations that generated a cosmopolitan modernism which rejected neotraditionalism and nationalism, and a diasporic modernity that was inhabited by the transnational travels of black artists who acted as world citizens, it must be stressed that art history is only now—extremely belatedly—beginning to arrive at a truly universalist understanding of *the logic of transculturation* in the visual arts.

In periodizing globalization, Hall characterizes "the third phase, culminating in the post–World War II period," as marked by "the decline of the old European-based empires, the era of national independence movements and decolonisation," which

"coincides with the break-up of a whole visual, conceptual epistemological framework which we call 'modernism.' Modernism follows the wider index by shifting from its origins in turn-of-the-century Europe to the US" (2003, 194). In the trauma-based temporality of *nachträglichkeit*—that is, deferred action or "afterwardsness"—the interdependent or co-constitutive imbrication of modernism and colonialism only became visible with the breakup of hegemonic consensus brought about by the "post" in postmodernism and postcolonialism. Although concepts of hybridity soon fell out of the metropolitan fashion cycle, the multiple modernity thesis encourages us to reconsider the entire range of its cognate terms—creolization, syncretism, translation, dialogism—as conceptual resources for mapping the logic of transculturation in the visual arts. By clarifying the differential combinations of modernization and modernity in specific conjunctures of the global, we may move toward a more rounded view of modernism as a world-making practice of art that was always already driven by cross-culturality.

NOTES

This chapter was first published in *Colonial Modern: Aesthetics of the Past, Rebellions for the Future*, edited by Tom Avermaete, Serhat Karakayali, and Marion von Osten (London: Black Dog, 2010), 233–43.

1. Niru Ratnam, "Art and Globalisation," in *Themes in Contemporary Art*, ed. Gill Perry and Paul Wood (New Haven, CT: Yale University Press, 2004), 293, 295.

2. On "world art" approaches, see John Onians, ed., *Compression vs. Expression: Containing and Explaining the World's Art* (New Haven, CT: Yale University Press, 2006).

3. Victor Burgin, "The Absence of Presence: Conceptualism and Postmodernisms," in *The End of Art Theory: Criticism and Postmodernity* (London: Macmillan, 1986), 29–50.

4. Simon Gikandi, "Picasso, Africa and the Schemata of Difference," *Modernism/Modernities* 10, no. 3 (2003): 455–80.

5. Mark Crinson, *Modern Architecture and the End of Empire* (Farnham: Ashgate, 2003).

6. David Morley, "EurAm, Modernity, Reason and Alterity," in Morley and Chen, 1995, 349.

7. Howard J. Booth and Nigel Rigby, *Modernism and Empire* (Manchester: Manchester University Press, 2000), 28.

8. Partha Mitter, "Reflections on Modern Art and National Identity in Colonial India: An Interview," in Mercer, 2005a, 42.

9. Ian McLean, "Aboriginal Modernism in Central Australia," in Mercer, 2008, 92.

10. McLean, "Aboriginal Modernism in Central Australia," 76.

11. Stanley Ikem Okoye, "Unmapped Trajectories: Early Sculpture and Architecture of a 'Nigerian' Modernity," in Mercer, 2008, 28–44.

12. Samella Lewis, *Art: African American* (New York: Harcourt Brace Jovanovich, 1978); David Driskell, *Two Centuries of Black American Art*, exhibition catalogue (Los Angeles: Los Angeles County Museum of Art, 1976); Romare Bearden with Harry Henderson, *A History of African-American Artists, from 1792 to the Present* (New York: Pantheon, 1993).

14

THE CROSS-CULTURAL AND THE CONTEMPORARY

Contemporary art does not have one defining feature—it has many. But this condition of multiplicity is not exactly new to the twenty-first century. Previously, there was at least a name for this state of affairs—postmodernism—although since that term has dropped out of circulation, the period from 2000 to 2010 may well go down in history as the decade that could not be named. From one point of view, art's contemporary condition of manifold variety (which is how the *Oxford English Dictionary* defines multiplicity) is to be fully enjoyed for its all-inclusiveness. Precisely because it cannot be categorized by a fixed name, everything and anything is thereby allowed—and is that not what freedom in art was meant to be? But if all kinds of art from all over the globe are equally important as part of the "now," then what shared criteria would critically distinguish any one practice as being more interesting or valuable than any other? Is it still relevant to think of art's value in terms of its critical relationship to the society in which it was made, or is such an outlook now redundant if the boundaries separating art from entertainment are no longer clear?

Puzzling over these questions, I realize I am in a somewhat curious position. I can certainly feel the full force of their urgency as unresolved inquiries about art today, but looking back over the last decade, I was actually facing in a different direction. Between 2002 and 2008 I edited Annotating Art's Histories—four volumes of critical and historical essays that each took a fresh look at twentieth-century art from various cross-cultural points of view. Focusing attention on specific practices shaped by global conditions of production and reception, the broad aim of the series was to suggest what a comparative approach to multiple modernisms might look like as an alternative to the theory-driven model that preserves the old canon by assuming that the politics and aesthetics of cultural difference are of recent provenance. Paying attention to past and present art is not necessarily a conflict of interests. If it is a truism to say that hindsight provides a distance that allows us to view art in the round, then it is only in retrospect that I can situate my undertaking of the series as a response, in part, to a feeling of

being equally inspired and dissatisfied with the atmosphere that has surrounded "the contemporary" over the past ten to fifteen years. Reading through a 2009 issue of the journal *October* dedicated to the issues raised in my opening paragraph, I get the sense I'm not the only one with mixed feelings.

Taking the view that "in its very heterogeneity, much present practice seems to float free of historical determination, conceptual definition and critical judgement," *October*'s editors issued a questionnaire that set out to examine this ubiquitous free-floating condition by asking, "How can we specify some of its principal causes, that is, beyond general references to 'the market' and 'globalization'?"[1] But why the scare quotes? At one level, the syntax seems to imply two freestanding entities, although what drives the question is how the interconnections between "the market" and "globalization" are to be best understood. In which case, at another, more rhetorical, level, what is being suggested is that the explanatory reach of these two generalities is now conceptually depleted after thirty years of neoliberal governance in which these combined forces have not ceased to create ever-deepening inequalities on a worldwide scale. Or, as the curators of the 2010 exhibition *Uneven Geographies: Art and Globalisation* succinctly put it, artists and audiences today readily understand that "globalisation is taken to mean the processes by which economic activity around the world becomes increasingly integrated into a single global capitalist market" (Farquarhson and Demos, 2010, 3).

To the extent that the multicultural acts as the representational form through which the realities of the global market have entered everyday consciousness, it is the medium through which the economic, social, and political shifts of the late twentieth and early twenty-first centuries have been apprehended and acted upon. Hence, my focus is on three aspects of the contemporary that are now cast into a curious light by noticeable tonal changes in discourses that surround the "multi." To say that the condition of manifold variety signified by the linguistic prefix "multi" has no intrinsic ethical value and does not necessarily belong on any one point of the political spectrum—left, right, or center—is to state the obvious in two revealing ways. What associates the multicultural with optimistic social change is its *historical* contrast with the monocultural world picture that held sway for over eighty years during the past century. But the long-term view that distinguishes "multi" from "mono" in such a way as to align the former with a left-of-center politics is presently undergoing a shift. If the postcolonial turn of the 1980s was a decentering of monoculturalism, then the 1990s could be seen as a period of multicultural normalization in which difference and diversity were thoroughly institutionalized in art and culture. Where the post–Cold War settlement linked the market forces of transnational capitalism ever more tightly to the neoliberal direc-

tives of globalization, one of the salient currents of the period circa 2000–10 has been the countervailing view that, instead of being a force for the greater good, "multiculture" mainly covers over worldwide inequalities with a smiley face.

In the good old days of the so-called culture wars it was all so predictable that neoconservatives would decry multiculturalism (Wallis, Weems, and Yenawine, 1999). Today, knowing exactly which buttons to push, philosopher Slavoj Žižek (1997) plays devil's advocate by taking aim at the liberal-left acceptance of "group rights." In so doing, he challenges us to address the dilemma of how the "one" and the "many" are to be reconciled in the democratic public sphere. But his blanket assertion that the "multi" in multiculturalism is fully identical to the "multi" in the cultural forms of multinational capitalism abandons any careful analysis of how antagonistic players join forces to form contradictory alliances, as Žižek opts instead to simply throw the whole lot into one horrible ideological blob.

Yet the "multi" was never a mathematical problem about numbers, for it was always a qualitative matter of how various elements are structured into a whole. Hence, when it refers not just to societies made up of different ethnicities but also to policies that seek to make such diversity governable, the "ism" in multiculturalism does not denote one agreed-upon doctrine. As Stuart Hall observes, "there are very different multiculturalisms"—corporate, commercial, liberal, conservative, critical—and the discursive contest over definitions underlines the political character of the phenomenon (2001a, 210). Putting two and two together thus brings us to an unexpected point of view: the period circa 1900 to 1980 that placed classical modernism and the historical avant-garde in a critically left-of-center alignment—such that art was on the side of the future and of a better world to come—was also the era of monocultural governance that subordinated multiple differences to an assimilative or monopolistic center. Insofar as postmodernism (let's say, circa 1960 to 1990) called that symbolic universe into question, the contemporary moment is not a flip-flop reversal in which the "multi" becomes inherently bad (for it was never inherently good to begin with), but, rather, it involves a volatile situation where the political valence of multiplicity is everywhere up for grabs. I will come back to the realignment of art and politics momentarily—for the resurgence of the left has been an unexpected twenty-first-century trend—but before asking why the idea of "post-black" has gained appeal in this climate, I want to touch on the institutional drivers of current tendencies and the symptoms these changes register within the aesthetic realm.

The view that institutions, rather than artists or curators, act as today's primary agents of change is supported by key indicators—international biennales and art fairs,

museum-building projects, and wide audiences for art with a youthful demographic—that all point to economic activities whereby the art world (or art industry) has become more closely integrated into the global market for the consumption of culture. Observing auction prices that have withstood the financial downturn, the branding of artists as celebrities, and collectors who buy not for elite prestige but for monetary speculation, several critics argue that art cannot be understood in terms of the modernist concept of autonomy because it has now merged with the cultural industries and such a transformation brings with it a move toward the entertainment values of spectacle and consumerism.[2] As public and private institutions alike share an increasingly corporate outlook, contemporary art also reveals the market's quest to generate value not just from trading in commodity "things" like paintings but also in immaterial or ephemeral experiences that metropolitan audiences gladly pay to participate in.

Drawing on the principle that it is capitalism's unresolved contradictions that best explain its growth and expansion, such insights vindicate the Marxist tradition that some thought was dead and buried. But the Frankfurt school variety of high theory not only ignores the fact that market forces are culturally embedded—or, to put it another way, there is no such thing as naked money—but also tends to separate art world economics from the specifically multicultural forms taken by contemporary globalization in art. Casting my eye over television coverage of UK art events in the month of May 2010, from the Tate Modern's tenth anniversary and Yinka Shonibare's ship-in-a-bottle installation on the fourth plinth of London's Trafalgar Square (fig. 14.1) to an Otolith Group film clip on BBC News when its nomination for this year's Turner Prize was announced, it is clear that even if the high-end luxury sector of the art world calls the shots, it nonetheless shares the public stage with institutions of popular culture where the "multi" is the lingua franca in which national and international audiences participate in the discourses of contemporary art.

For his part, Julian Stallabrass notes the superficial way diversity is packaged by corporate multiculturalism, such that when global art is expected to advertise its "difference" as a unique selling point, it all starts to look the same in the standardized white cube of the biennale circuit.[3] Geographically based survey exhibitions at the Saatchi Gallery in London, such as *The Revolution Continues: New Chinese Art* (2008), *Unveiled: New Art from the Middle East* (2009), and *The Empire Strikes Back: Indian Art Today* (2010), would seem to confirm this view of globalized homogeneity. But because he argues that the "multi" only ever serves neoliberal interests, what Stallabrass has lost sight of is the other end of the dialectical chain in Marxist critical thinking, namely, that because of its inner contradictions, capitalism unleashes potentialities that can never

be brought under the control of any one single political actor. Following their claim that capitalism today operates as a headless "empire" sprawling across once-sovereign nation-states, Michael Hardt and Antonio Negri insist on the simultaneous presence of the "multitude" as a source of unbidden possibilities.[4] In more down-to-earth terms, the structural contradictions that shape contemporary African art provide a specific case in point.

Biennales in Johannesburg, Dakar, and Cairo have been entry points into the global market for African artists, whose twentieth-century precursors were often locked out of the monocultural discourse of modernist internationalism by primitivist paradigms that were effectively Bantustans into which ex-colonial generations were confined. As Okwui Enwezor and Chika Okeke-Agulu (2009) have noted, since the 1980s neoliberal policies have entrenched inequities and stimulated enterprise in roughly equal measure. Such conflictual dynamics are a source of the animating friction that has driven artistic ingenuity to flourish on the continent, as well as within the transmigration routes that have dispersed "Africa" into the new diasporas of the transnational era (Hassan, 2008). While South Africa hosted only two biennales after becoming a new nation in 1994, it may be said that art played a diplomatic role in rehabilitating that country's image in the eyes of the world. As a former settler state with an established infrastructure in studio training, museum collections, galleries, and an art press, what also informs the artistic inventiveness among such postapartheid contemporaries as Robin Rhode, Guy Tillim, William Kentridge, and Candice Breitz is a relationship to colonial history that carries the critical momentum of dissensus, against the grain of the global North, precisely because of South Africa's violent and traumatic past—not in spite of it (fig. 14.2).

For my money, this is one of contemporary art's main dividing lines—between a worldly impetus to aesthetic invention that engages with past, present, and future and an equally inventive attitude toward form, medium, and materials, but one that moves away from an interest in "meaning" in favor of aesthetic surrender to pure "sensation." When art theorist Alexander Alberro describes a contemporary shift in taste from the cognitive to the affective, we might pause because, logically speaking, thinking and feeling are not mutually exclusive.[5] When aesthetic experience takes us out of ourselves—interrupting the everyday flow by arresting the senses and intellect in concentrated acts of looking, thinking, and feeling—such a state of attentiveness and receptiveness pertains to the phenomenology of art from any time or place, whether ancient or modern. But when we recall how the Royal Academy's 1997 exhibition announced *Sensation* as the tagline for young British artists of the 1990s, what Alberro in-

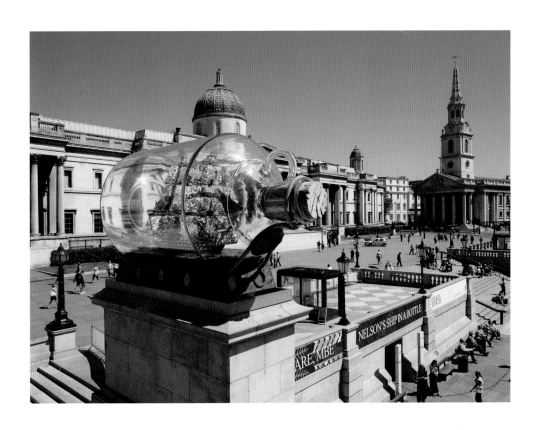

14.1 Yinka Shonibare, *Nelson's Ship in a Bottle*, 2010. Fiberglass, steel, brass, resin,
UV ink on printed cotton, linen rigging, acrylic, and wood, 290 × 525 × 235 cm.

deed lays out is nothing less than a political frontier effect whereby different aesthetic tendencies are positioned in an either/or face-off. Jeff Koons and Damien Hirst have won massive audiences for an art of spectacle predicated on the wow factor, and a parallel stance arises with the strident emphasis on "beauty" on the part of critics such as Dave Hickey.[6] This so-called return to beauty is rarely expressed in the language of neo-traditionalism but is voiced instead as a freewheeling libertarianism or else as a shouty populism which throws a challenge to liberal-left high seriousness over definitions of "the contemporary" that had earlier been the art world's default position for most of the post-1945 period.

Whereas modernism decentered the *formal* relations of representation, positing originality and authenticity as its core aesthetic values, postmodernism deconstructed the high/low hierarchy between the original and the copy and thus added a critique of the *social* relations of representation in a world of mass reproduction, asking who had access to the right to representation, as well as questions about the social life of images themselves. In the shift from analogue to digital, how does the omnipresence of instantly available images inform the aesthetic choices artists make today? Instead of the gap between art and life that Robert Rauschenberg claimed to operate within—like the gap separating objects inside the museum from the mundane stuff outside that Marcel Duchamp's ready-mades pointed to—contemporary artists who inhabit the all-encompassing realm of globally networked media face a crisis of value in the ontology of the image.

In this saturated world of total inclusion, where are the edges or gaps to create a significantly critical distance between the image and the "meanings" it might acquire once it travels out there into the real world? On the one hand, where the technocratic language of market formalism perceives digital data as ever so much "content," the criteria for distinguishing one stream of pixels as more valuable than another stem primarily from their exchangeability, not from any intrinsic or acquired meaning. On the other hand, however, where finance capitalism takes information technology as its very condition of existence, the virtual world of hyperreal simulation not only creates a spectator (or end user) who is desensitized by the unreality of having too much information, but such conditions also stimulate an appetite for the tangible materiality and sensory impact of an art and architecture of giganticism and monumentalism. It is not just the price of the diamonds in Damien Hirst's *For the Love of God* (2007) that attracts our attention; it is also their physical "thingness" in adorning the skull that generates visceral contact with uneasy feelings about excess and finitude.

Referring to artists such as Hirst, Koons, or Takashi Murakami as practitioners

14.2 Guy Tillim, *Colonial-Era Governor of Quelimane, Avenue Patrice Lumumba, Quelimane, Mozambique*, 2008. Archival pigment ink on cotton rag paper, 91.5 × 131.5 cm. Courtesy of Stevenson, Cape Town and Johannesburg. © Guy Tillim.

of spectacularism or retro-sensationalism, which is predominant for some definitions of "official contemporary art," art historian Terry Smith distinguishes this strand from another characterized as an art of the "struggling multiplicity" that has arisen as a result of the transnational turn (Tracey Moffatt, Thomas Hirschhorn, and Shirin Neshat are among his examples here). What differentiates these strands is their relationship to the ruins of representation: where the second strand enacts an "art that actually *is* in the world, of what it is to *be* in the world, and of that which is to come" (Smith, 2006, 692), the first strand withdraws from the social relations of representation by retreating into the sanctuary spaces of "remodernism." Smith uses this term to characterize the upholding of the Euro-American canon seen, for instance, in the 2004 rehang at the Museum of Modern Art in New York, where an atmosphere of timelessness seems to protect the art from any argumentative relation to the past or the future. Smith's map inserts a third strand, what he calls an art of small gestures, working with a do-it-yourself approach, but his observations bring us to a starkly contemporary paradox.

The market may have closed the gap between art and life, thereby depriving art of the relative autonomy that gave it a degree of separation from the society whose norms it critiqued, but numerous artists today are eager to have an influence on the public. Yet, it is as if they find themselves trapped behind the glass walls of a glittery art milieu in which, because anything goes, nothing is shocking or transgressive or different enough to gain traction out there in the real world—it all just slides off the glass. Although ruins are mostly imagined as picturesque fragments when seen through the lens of romanticism, it is the all-inclusive smoothness of the digital machinery driving the contemporary cultural economies (where every available surface, from cars to kitchens, has been aestheticized for consumption) that best serves as a symbol for the sense of bubble-like entrapment with which many contemporary artists are dissatisfied.

Three trends are intelligible as efforts to reactivate the critical agency of the aesthetic dimension in contemporary practice. In Isaac Julien's *Western Union: Small Boats* (2007) (fig. 14.3), beauty is not transcendental perfection, but is immanent to the treacherous Mediterranean journeys where unofficial migration patterns cross an aquatic space of mortal terror and the oceanic sublime. Yinka Shonibare's flamboyant theatricality in *Nelson's Ship in a Bottle* (2010) plays game, set, and match to a Matthew Barney, say, but as the only British artist to step out of the white cube and use Trafalgar Square's fourth plinth public art commission to address the imperial history of British maritime power that the site commemorates, Shonibare's installation also acknowledges Paul Gilroy's view of ships as icons of diaspora cultures.

Walid Raad and William Kentridge address the traumatic modernity that has

14.3 Isaac Julien, *Western Union: Small Boats*, 2007. Three-screen installation, Super 16mm film, color, 5.1 surround sound, 18 min. 22 sec. Installation view, Metro Pictures, New York, 2007. Courtesy of the artist and Metro Pictures, New York.

shaped numerous postcolonial worlds, yet by using a strategy of fictionalization (in the Soho Eckstein character of the latter's animated films, and in the former's Atlas Group projects), the factual materials from which such histories are written become amenable to alternative forms of narration. And a third strategy, namely, the renewed interest in documentary in photo-based work by Guy Tillim and Mitra Tabrizian, for instance, is equally pitched in a diacritical relation to problems of realism in an image environment saturated with simulation.[7] Where Emily Jacir's video *New York / Ramallah* (2004) connects disparate cities by streaming concurrent differences and sameness, Tabrizian's epic photographic tableau, *City, London* (2008) (fig. 14.4), which depicts bankers at the UK headquarters of J. P. Morgan, interrupts the verb "to document" by setting up an equally contrapuntal dynamic of sameness and difference. In the corporate minimalism of their architectural surroundings, the men's dark suits draw attention to similarities of gender and age. Variations of race and ethnicity are apparent as white faces are in the minority, but sameness makes an odd return in the look-alike indeterminacy of the majority, who could be mixed-race, Middle Eastern, South Asian, or Latin American. Far from merely demonstrating the nonidentity between the multinational (the bank) and the multicultural (its staff), contra Žižek, Tabrizian touches on the complex articulation of the two realities by way of her sameness-as-strangeness aesthetic. The picture's horizontal figure/ground relations evoke a headless form of corporate power in which no one identity is privileged, yet the artist is not passively "illustrating" Hardt and Negri, nor merely playing practice to someone else's theory—Tabrizian's formal choices immediately arrest our attention on her own terms.

Arguing for a "big picture" approach that posits a three-part distinction between modernity, postmodernity, and contemporaneity, Terry Smith gives us a map that gains critical purchase on the free-floating heterogeneity of the present by making the claim that it is antinomial reasoning which is best suited to examining the conjuncture or balance of contradictory forces that define our current moment (Smith, Enwezor, and Condee, 2008; Smith, 2006). Antinomies are statements about reality all of which are true in themselves but which cancel each other out when taken together. The insightfulness of the antinomial approach is vividly confirmed in matters of race: when Barack Obama was elected in 2008, he had the double-edged distinction not only of being the first black president of the United States, but also of being the first "post-black" president as well.

Obama's election was undeniably a historic event—a first—but it is impossible to generalize upon this to say racism has been finally overcome because Obama's victory does not cancel out the grim fact that the U.S. underclass continues to be mostly

14.4 Mitra Tabrizian, *City, London*, 2008. C-type photograph, 122 × 250 cm.
Courtesy of the artist.

African American. The two statements about race in America are both true, but they cannot be synthesized into a whole. Whereas dialectics holds out the hope of ultimate resolution, antinomies illuminate a society's generative contradictions without laying claim to a position of totality that gives a bird's-eye view of the whole. But is this not a case of déjà vu? With regard to conceptualizing postmodernity, Fredric Jameson has said, "It is ultimately always of the social totality itself that it is a question of representation, and never more so than in the present age of a multinational global corporate network."[8] However, the difficulty of finding such a representational space of totality was first registered in the 1920s by Walter Benjamin, who interpreted antinomies in baroque allegory as inscriptions of modernity in seventeenth-century mourning plays. Arguing against teleological models of progress, Benjamin (1998) drew on messianic conceptions of temporality so as to show how past, present, and future were felt to be increasingly disjunctive under the universally "fallen" conditions of modern secular life, where the ordering of time was beset with doubt and uncertainty.

Benjamin's philosophy of history is relevant on several counts. First, it reminds us that "modern" and "contemporary" relate less as chronological successors and more as quarrelsome siblings—Baudelaire's musings on the fugitive nature of modernity in the 1860s coincided with the publication in Britain of *Contemporary Review*.[9] In the twentieth century, Boston's Institute of Contemporary Art was renamed after 1945 because its previous name as the Institute of Modern Art was felt to be too politically charged. Hence, second, far from being interchangeable, the "modern" or "contemporary" distinction is critically decisive, and even more so when placed alongside the two terms "modernity" and "modernism." Whereas the former is taken by history and sociology to mean an overall mode of life uprooted from traditional certainties because of the mobility of people and things brought about by trade, travel, and market commerce, the latter term is mostly used to name art and culture's answering response to the experience of life as it is subjectively lived under these conditions. Loosening our attachment to linear models of time, such that the fractal patterns of cyclical time become apparent, Benjamin's heterogeneous temporality underscores a third issue: elements in an antinomial relation never exist on equal terms, but are always structured in dominance. Politics is precisely about the struggle to drive the contradictions of the conjuncture in one direction rather than another. Benjamin's vision of modernity as a landscape of ruins is thus ultimately optimistic, for if history bequeaths us only rubble, then the future is waiting to be rebuilt by awakening recombinant potential from the fragments that surround us.

The trouble with the "post" in postmodernism was its backward-looking stance.

In dismantling the monocultural narrative installed among art institutions circa 1930 to 1970, it helped clear the ground to reveal the agency of difference—modernism had been "multi" from the very beginning, but structures of disavowal installed by primitivist discourse meant it took us over eighty years to recognize it. But if postmodernism could never quite encompass the desire for differential futures, it is only now, in contemporaneity, that we have come face-to-face with what Okwui Enwezor—borrowing a term from historian Dipesh Chakrabarty—refers to as the "heterotemporalities" in which modernity has been worlded as a universal condition.[10] Including Annotating Art's Histories among recent scholarly and curatorial initiatives addressing the generative friction among constituent elements of the "multi," Enwezor suggests how the heterotemporal outlook acknowledges cross-cultural entanglements that have shaped experiences of modernity on a planetary scale. If we agree that the aesthetic specificity of the resultant artistic forms cannot be reduced to contextual determinations, then a heterotemporal understanding of multiple experiences of modernity challenges us to develop an account of the multiple modern*isms* that arose in the antinomial form of various artistic disputes and transcultural quarrels since the late nineteenth century.

Instead of a narrative sequence of beginnings, middles, and endings that aspires to have the last word, the cultural studies methods I use in my own work are predicated on a provisionality whereby it is accepted that mapping the conjuncture as a closed or total system is impossible, and yet thinking about what joins the parts into an articulated whole is indispensable. When curator Thelma Golden coined "post-black" for a 2001 survey exhibition of practices among African American artists, it was nuanced with double consciousness to name an "ongoing redefinition of blackness in contemporary culture" (2001, 15). But when it was taken up in a simplistic "before" and "after" manner to imply that blackness was now a thing of the past, her multiaccentual tone was squashed flat by either/or reductionism. In an art world that often can be as "mono" as it is "multi," where the ethos of inclusion does not cancel out hierarchies of cultural value, I worry that the linear sequencing that takes us through a unidirectional passage from modern, through postmodern, to contemporary, risks leveling out the intricate ties of cross-cultural entanglement that define the planetary networks through which the modern was universalized into a worldwide condition.

When Tate Liverpool held *Afro Modern* in 2010, a survey exhibition that was the first of its kind to use the diaspora concept as the basis for curating the twentieth century cross-culturally, it broke new ground by bringing African American, Latin American, Caribbean, and African modernists into a shared space with works by European and American artists of the classical canon. To say it was flawed by the drive to arrive

at "post-black" as the predestined end point of the curators' view that current practices "define new registers of cultural expression that supersede those of yesterday" (Barson and Gorschlüter, 2010, 8) is to hope that there will be many more opportunities to open up this aspect of cross-cultural modernity to further examination and debate, rather than assume that one exhibition bears the burden of saying everything there is to say on the entire subject. Considering the time gap between the Tate opening its doors to the public in 1897 and the twenty-first-century advent of *Afro Modern*, one might say the *longue durée* of such a deferral was worth the wait. If such patterns of delay feature often in the timelines of diaspora life, I am not only curious about visiting the future of art history, in terms of finding what else is asleep in the archive, but I also look forward to the slow journey getting there.

NOTES

This chapter was first published in *21st Century: Art of the First Decade*, edited by Miranda Wallace (Queensland: Queensland Art Museum, Gallery of Modern Art, 2010), and is reproduced with the kind permission of Queensland Art Gallery.

1. Hal Foster, "Questionnaire on 'The Contemporary,'" *October*, no. 130 (Fall 2009): 3.

2. Isabelle Graw, *High Price: Art between the Market and Celebrity Culture* (Berlin: Sternberg, 2010); Diedrich Diederichsen, *On (Surplus) Value in Art* (Berlin: Sternberg, 2008).

3. Julian Stallabrass, *Art Incorporated: The Story of Contemporary Art* (London: Oxford University Press, 2004).

4. Michael Hardt and Antonio Negri, *Empire* (Cambridge, MA: Harvard University Press, 2001); Michael Hardt and Antonio Negri, *Multitude: War and Democracy in an Age of Empire* (London: Penguin, 2004).

5. Alexander Alberro, response to questionnaire on "The Contemporary," *October*, no. 130 (Fall 2009): 55–60.

6. Dave Hickey, *The Invisible Dragon: Four Essays on Beauty* (1993; Chicago: University of Chicago Press, 2009).

7. See Kobena Mercer, "Guy Tillim: Avenue Patrice Lumumba," *Portfolio*, no. 51 (May 2010): 44–45.

8. Fredric Jameson, *The Geopolitical Aesthetic: Cinema and Space in the World System* (Bloomington: Indiana University Press, 1995), 4.

9. Charles Baudelaire, *The Painter of Modern Life* (1863) (London: Penguin, 2010). *Contemporary Review* was a quarterly founded in 1866 to encourage debate between religion and science; in the 1870s it published articles by John Ruskin, among others.

10. Okwui Enwezor, response to questionnaire on "The Contemporary," *October*, no. 130 (Fall 2009): 33–40; see also Dipesh Chakrabarty, *Provincializing Europe: Postcolonial Thought and Historical Difference* (Princeton, NJ: Princeton University Press, 2000).

PART V

Journeying

Each of the chapters in this part follows a recursive pattern of journeying in the archi-
val turn whereby a key feature among contemporary black diaspora art practices is the
quest to confront past trauma by bringing its violence into the field of representation
for the first time. Whereas earlier efforts to recover black history were confident that
representation could actually make present what had been absent, a critical awareness
of how trauma shatters relations that ordinarily distinguish the inner world from the
external realm of history led to strategies that encircle such conditions of unrepresent-
ability through acts of signifying indirection.

Following the protagonist of the film *Testament* (1988), an exile who makes a journey of return only to be thrown into a condition of transcendental homelessness, the montage strategies pursued by Black Audio Film Collective are investigated through the lens of John Akomfrah's notion of "black necrophilia," which complicates the psychoanalytic distinction between mourning and melancholia. Such aesthetics also confront psychoanalytic accounts of grief and loss with the allegorical realm of the baroque mourning play that for Walter Benjamin (1998) rehearsed modernity as a "fallen" state in which meaning itself is permanently at risk of crumbling into petrified decay. The in-between state of *dépaysement*, felt when one leaves home behind but has not yet arrived at a final destination, is the medium through which Renée Green revisits conceptual art strategies by way of mapping site specificity and visitor mobility onto Black Atlantic ruins that are witnessed in the course of her archival research, whether leading to modernist housing projects in Marseilles or to the port city of Lisbon as it is narrated in the diary of an African American *flâneuse*.

In the archival relations that Kerry James Marshall's epic paintings call forth between past and present, 1960s freedom dreams of the civil rights era are the subject not of irony or nostalgia but of critical contemplation. As poetic interferences on the picture plane invite the viewer to pause on the unfinished quest for social justice, the haunting beauty of jet-black figures that emit an uncanny aura of ghostliness come to embody past hopes that were never fully extinguished, but merely dormant, in the archive. Such figures turn to face us with the demand for a future in which past struggles can be belatedly fulfilled in the critical now of awakening. Cutting across time in chronotopes (Bakhtin, 1982) that connect current crises of sovereignty in an era of globalization that has made war a permanent shadow to the unending appetites of consumerism, Hew Locke's archival journey reveals what led a contemporary artist to the premodern forms of hybridity inscribed in the aesthetics of the baroque, the grotesque, and the gothic. These are aesthetic resources for a countermodern imagining of the possibilities to which the world's material resources might be put, that burst forth with an excess that counteracts the order and fixity of classical codes favored by the political authority of the state.

15

POSTCOLONIAL *TRAUERSPIEL*: BLACK AUDIO FILM COLLECTIVE

The very last scene in *Testament* (1988) consists of a shot/reverse-shot sequence in which Abena, the film's protagonist, is stopped in her tracks by the sight of an opened grave. The skull she sees within the broken crypt appears to look back at her, and we hear her catch her breath as the film fades to black. The encounter elicits an uncanny moment of delayed recognition, for Abena has been wandering the landscape throughout the eighty minutes of the film as if she were a ghost herself: she has been gripped and possessed by the force of enigmatic pressures that resist her conscious remembrance.

By virtue of its temporal placement at the film's ending, the uncanny effect of delayed recognition is not unlike the perceptual disturbance exerted by Hans Holbein's *The Ambassadors* (1533). It is only when leaving the geometral position of the painting's monocular viewing plane that the spectator can begin to "see" the peculiar squiggle of shapes and lines in the foreground as a readable mark of signification. "What is this strange, suspended, oblique object in the foreground in the front of these two figures?" asked Jacques Lacan. "Begin by walking out of the room in which no doubt it has long held your attention. It is then that, turning around as you leave—as the author of the *Anamorphoses* describes it—you apprehend in this form. . . . What? A skull."[1] John Akomfrah's mode of film direction brings the contemporary viewer into an encounter with something in the cinematic image that is equally inexplicable, for the final shot in *Testament* has a matter-of-fact quality that belies its narratological significance as the concluding moment that confers retroactive cohesion upon the storytelling process of the film.

Abena is a television reporter who has returned to Ghana after years of exile in Britain following the 1966 military coup that overthrew the country's first independent government led by Kwame Nkrumah. Ostensibly, she has traveled to Ghana to report a story about Werner Herzog, who is filming *Cobra Verde* (1989) on location. Attempts to obtain an interview break down, and in any case this plotline is something of a McGuf-

fin—a red herring of metacinematic referencing that nonetheless drives Abena's story forward. As she journeys through the country, she visits friends who were also fellow activists in the Convention Peoples Party that rose to power when Ghana became independent in 1957. However, no one wants to know: Danso refuses to speak to her, and Mr. Parkes talks in the esoteric idiom of lotto numbers. Rashid, who has converted to Islam, is the one former friend most sympathetic to Abena's musings as she is driven forward beyond this wall of silence by a quest for something she cannot quite name (fig. 15.1).

Crosscutting alternations between archival and diegetic segments deliver Abena into a "war zone of memories" (the film's subtitle): flashbacks reveal that she was forced to betray her friends when the Nkrumah Ideological Institute was shut down by the coup, while archive newsreels document the tumultuous rise and fall of Pan-African socialism. Torn apart at the crux of public history and private memory, the character of Abena inhabits the terrain of the "unknowable" that the films of Black Audio Film Collective (BAFC) address as a body of work that patiently explores *the slow time it takes to come to terms with postcolonial trauma. Handsworth Songs* (1986) paid witness to the conflicted relationship between past and present in postwar Britain by revealing an epic disphasure between the private memories of black life contained in family photographs, as documents that testify to diaspora experiences of immigration, and the official public records of the archive, as an institution of social memory to be found in yesterday's monumental statues and today's television reportage. "Something has gone terribly wrong," cried a voice on the soundtrack: rather than resolve the crisis of knowledge by appealing to a consensus among different points of view, BAFC's mode of inquiry opens a space of poetic reflection in which the limitations of all of cinema's available representational systems are put into question. Instead of a synthesis of memory and history, the collective's films underscore an irreconcilable agonism, for gaps, absences, distortions, fabrications, and contradictions arise on all sides: the forces of erasure, forgetting, and denial are as active in shaping family mythologies contained in snapshots and home movies as they are in shaping national mythologies that are based on the selective filtering of the collective past.

"We went to Ghana to try to make a film about Kwame Nkrumah, but also about a movement and a body of ideas that simply don't exist anymore," explains Akomfrah. "They'd been swept away not just by the force of historical events but also by attempts on the part of successive governments after Nkrumah to basically bury the man and all that he stood for. There is something metaphorically significant in that act because so much of diasporic history rests precisely in that gap between history and myth" (quoted in Harris, 1992, 10).

15.1 Black Audio Film Collective, *Testament*, film still, 1988. 16mm, color, sound, 80 min. Courtesy of Smoking Dogs Productions.

Where historical events are "buried" in the gaps and fissures of the state archive as a result of political repression, *Testament* reveals that individual memories are also irretrievable when normative patterns of psychical repression are reconfigured by colonial trauma. To the extent that history cannot be reconstructed as an object of positivist knowledge in situations where the colonial archive is structured by gaps, compactions, and distortions that are ordinarily covered over by myth and ideology, one might say that the subjectivity of formerly colonial peoples cannot be recovered or represented as a lost plenitude of former wholeness, for knowledge of the past is made equally unavailable to memory when events have been "buried" in the unconscious on account of their overwhelming pain. As "a film about the search for the emotional core that binds a person to place," *Testament* is about Abena's radical *un*binding, for the emotional ties that suture psyche and history are unraveled by what is repressed and unsaid in the colonial scene—as an exile who returns home only to be thrown into a condition of transcendental homelessness, she discovers "the effect of the lack of an archive on the diaspora persona" (quoted in Harris, 1992, 10). Abena's tale is not actually a "testament" at all, for what the film portrays is the impossibility of producing testimony in the historical context of the postcolonial realities that have irrevocably traumatized her inner world.

Like each of BAFC's films, *Testament* generates narrative out of a structural combinatory of five basic elements: original pro-filmic material, archive footage, sync sound, voice-over narration, and ambient sound design. To grasp the affective agency that the archival element exerts as the jewel in the crown of the Black Audio combinatory, close attention must be given to its role in the structuration of the montage. Far from playing an anchoring or fixative role, as it does in documentary realism, BAFC's aestheticized handling of the archive imparts a dynamic and liberating energy to these "unknowable" fragments. The multiple voice-over does not caption the image into denotative closure but teases out the connotative potential of anonymous visual data to maximize its polysemic qualities. Faced with unclassified scraps from public and private sources (accessed through the extensive research process that initiates each film), scriptwriter Edward George has crafted a lyric form of metonymic proliferation in which a surplus of aphorisms and little stories are coaxed out of the multiaccentual properties of the found image. Above all, sound designer and composer Trevor Mathison has engineered an ambient realm in which loops, drones, sirens, and sustained tonal notes encourage the viewer's attention to wander into a state of drift. Mathison's compositions play an important binding role in melding disparate visual materials, and in this sense his sound design acts as an acoustic mirror or semiotic chora that provides what D. W. Winnicott calls a "holding environment."[2] Black Audio arrangements in-

duce a becalmed space of critical reverie that allows the viewer to be touched by the strange emotions evoked by the archival material without being overwhelmed by their "unknowable" quality as orphaned images.

The collective was the first group of British film artists to address the uncertainties of the colonial archive as a starting point for a critical cinema of cross-cultural dialogue. African American documentarist Louis Massiah succinctly distilled the singularity of their achievement when he observed, "It makes sense that there is a fetishised use of archival material in a growing number of historical documentaries—celluloid or magnetic tape holds images of light reflected off the faces of our cultural, political and blood ancestors. One of the great gifts of the films made by Sankofa, Ceddo and Black Audio is to free such documents from the realm of mere images that support a narrative and to use them as objects with the potency of fetish: lovingly, respectfully, and, at times, fearfully, displayed."[3]

Film scholar Laura Marks concurs with this counterdefinition of fetishism, for she places BAFC at the leading edge of a global trend that created the new genre of "inter-cultural cinema." Where "inter-cultural cinema is not sanguine about finding the truth of a historical event so much as making history reveal what it has not been able to say,"[4] BAFC's poetic handling of the archival element performs a radical transvaluation of the ontology of the image. A diaspora's ancestors are always unknown, for diasporas are inaugurated by the primal catastrophe of involuntary separation, and an abiding attachment to the enigma of "origins" becomes a constitutive feature of their cultural formation. Ordinarily a fetish is a substitute for something that is not actually there—a lack. By bringing a range of formalist procedures (such as color tinting, differential film speeds, and reprinting) to the tender handling of orphaned "unknowns" from the archive, BAFC's bricolage-epistemology works through the chains of substitutions, condensations, and displacements that encircle the void of such a "lack" as the *objet petit a* of the postcolonial subject's desire to know.

Observing the iconography of the corpse as "a contemporary corollary to the bones of the ancestors," critic Kass Banning (1993, 28) identified a key marker of postcolonial consciousness, for the corpses found in tableau moments in *Seven Songs for Malcolm X* (1993) (fig. 15.2) also appear in the Sankofa productions *Dreaming Rivers* (1988) by Martina Attille and *Looking for Langston* (1989) by Isaac Julien. All of these films are imbued with a mournful structure of feeling, but the inexplicable trope of the "missing corpse" is an important marker of a struggle over the representation, retrieval, and preservation of collective memories in the black diaspora context: it implies both a responsibility toward the past and a promise made toward the future.

When Akomfrah says, "I think necrophilia is at the heart of black film-making," his phrase immediately arrests our attention: "It has to do with getting to the heart of something that is intangible, a memory of ourselves" (quoted in Banning, 1993, 33). Considering that *Testament* originated with "the question of whether you could make films about intangible things" (quoted in Harris, 1992, 11), how might the idea of black necrophilia illuminate the formal structure of the film? Adding that "I mean necrophilia not in a literal sense, but in a post-modern sense in which people are invoking figures, there is an act of feeding off the dead," Akomfrah's reference to *The Harlem Book of the Dead*—an album of mortuary portraits by the studio photographer James VanDerZee (which was an iconographic source for both *Seven Songs* and *Looking for Langston*)—touches on the protective aspects of fetishism in diaspora culture's abiding attachment to the enigma of unknown ancestors. "When you seize hold of these figures," he says, "they literally turn to masks and statues in your hand, but when you get over it . . . when you're comfortable with that mask, then the desire shifts from melancholia to necrophilia almost. You almost begin to desire these figures precisely because they are irretrievable, impossible to capture, therefore dead" (quoted in Banning, 1993, 33).

Read in light of Freud's 1917 distinction, the phenomenon of black necrophilia corrupts the clarity of the categories of mourning and melancholia. Both are responses to loss, but where "mourning is regularly the reaction to the loss of a loved person, or to the loss of some abstraction which has taken the place of one, such as one's country, liberty, an ideal and so on" (Freud, 1984, 252), melancholia, in contrast, defines an internal obstacle to the initiation of grief. Whereas mourning begins when the ego accepts its absolute separation from the lost loved one as a result of death, melancholia involves the ego's refusal to accept the reality of loss, such that the subject remains inwardly attached to the lost loved object and the initiation of grief work is delayed. Grieving is painful because cherished memories are called up into consciousness and hypercathected by the desire to hold on to what one has lost, while at the same time memories are decathected in light of the demands of reality testing, which counsels the necessity of letting go.

To understand Abena's journey is to accompany her through the eddies and rapids of this abyssal contraflow. Close attention to three factors—acting, intertextuality, and authorial voice—shows how the montage structure of *Testament* discloses a diagnostic understanding of the strange phenomenon Freud named *nachträglichkeit*, or deferred action, which lies at the heart of trauma. Akomfrah's thoughts on the fetish-like qualities of the masks and statues that feed off the dead revealingly prompted him to say,

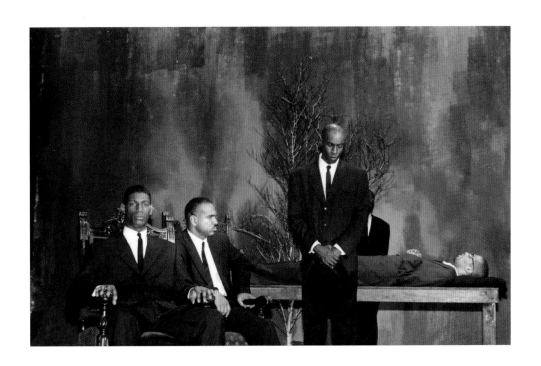

15.2 Black Audio Film Collective, *Seven Songs for Malcolm X*, film still, 1993. 16mm, color, sound, 53 min. Courtesy of Smoking Dogs Productions.

"The most powerful moments actually in *Testament*, for me, are the very end and the very beginning, both images really of death, a kind of stultification, atrophy, when she goes to the graveyard at the end and buries her father, or when the man walks in the very beginning of *Testament*, a wish-fulfillment of death, a drowning-wish going on there. There is a level of morbidity which I think people have to realize in the quest for identity. It is a morbid business" (quoted in Banning, 1993, 33).

Obeying the laws of narratology—that the ending should always reply to the beginning—*Testament* also disobeys by starting off with a prediegetic legend. Indicating that Nkrumah's Convention People's Party led the world's first experiment in African socialism, that red, black, and blue are Ga colors of mourning, and rivers are Ga gods of memory, a section of Zbigniew Herbert's poem "Report from the Besieged City"—"if we lose the ruins, nothing will be left"—establishes an elegiac tone. An echoing pulse heightens the first pro-filmic image: a fully clothed man, with pipe and straw hat, wades into the Volta River; he submerges, surfaces for air, his hat floats off, he sinks again. In all its sublime surreality, it works emblematically as an image that announces what the next eighty minutes are going to do—the film's montage will plunge viewers and characters alike into the turbulent rivers of memory, an unmasterable realm that offers the promise of renewal as well as the danger of drowning.

Testament's opening sections clearly signal a departure from the conventions of the classical realist text, and this principled refusal of "psychological depth" is directly related to the theme of memory-as-trauma, which has the potential to flood the narrative with excessive emotionality when encoded in realist or naturalist modes. To understand the formal structuration of the montage, two key factors must be taken into account. The first concerns official archives in a state of ruin and the "wall of silence" Akomfrah met in the preproduction process. He recalls: "When I realised that we couldn't do a straightforward historical account of what happened because of the lack of testimonies, or archives, it became clear to me that we needed a guide." Describing the improvised genesis of the script, and the construction of Abena's character as "a bystander, someone on the sidelines who got swept up by the force of history," he points out that "the bulk of support for the Convention People's Party were women." "Another reason I chose a woman character," he adds, "is because it fits my sense of connection with the country. There is a kind of over-identification with feminine figures in the ideas I come up with. If you ask me whether there's a degree of transference onto a feminine figure of what are basically the concerns of a black male film-maker—yes, that's clearly going on" (Akomfrah quoted in Harris, 1992, 11).

While an autobiographical voice neither explains the ultimate meaning of the

text nor guarantees a psychoanalytic reading, Akomfrah's following words illuminate a strategy of authorship that is all too keenly aware of the potentially uncontainable force of the psychical flows of transference and identification that circulate in the wake of traumatic remembrance:

> The film was very much improvised. I'd written out a sketchy scenario: Abena would arrive and try to get in touch with people, but people would not want to know her. She'd be confused, *and as a consequence, people watching the film would be confused.* As the film went on, it would become clear that she had left . . . because she had betrayed a number of friends. She was a squealer. And as a consequence of this her parents died. So Abena had to come back not just to do a report for television, but to see where her parents were buried. That crude schema more or less fit a number of dilemmas I wanted to deal with. (quoted in Harris, 1992, 11)

In reaching the cause of Abena's guilt—betraying her comrades—*Testament*'s diegetic schema redoubles it, for the consequences of her actions have caused her own bereavement. The subdiegetic flashback sequence revealing her humiliation at the hands of the sergeant who forced her to "squeal" functions as a screen memory, for "behind" that trauma lies the even greater pain of the death of her parents, which makes Abena not only an exile but also an orphan.

When we factor in the self-analytical (rather than autobiographical) impetus that Akomfrah reveals in the following passage, we begin to understand how BAFC has responded artistically *to the crisis of "unknowing" that results when mourning cannot be initiated as a consequence of postcolonial trauma*:

> A lot of what the film addresses is based on my family's history. . . . Both my parents were involved in politics at the time. They had both been studying in Britain and went back because of the independence movement. In a sense, it became their lives. When the coup happened in 1966—my father had died the year before—we basically had nothing. My mother had nothing. Politics was her life and so she decided that the best thing to do was to leave with her four sons. She knew that what usually follows these coups is a period of acrimony and revenge, in which people who were members of the outgoing government are made to pay for their involvement. She suspected that that would happen to her. (quoted in Harris, 1992, 11)

Trauma is not a memory but an overwhelming event that was never experienced during its occurrence because the force of the shock incapacitated ego consciousness. As Cathy Caruth suggests, the survivor's memory is compromised by the deferred

action that carries the psyche beyond the violence of the traumatic event. The survivor of a car crash cannot recall what actually happened because during the crash psychical mechanisms of withdrawal, numbing, or hypnotic immersion were mobilized to carry the subject through the force of the event as an ego-shattering "wound." In turn, because the event has not been recorded in memory's storage system, it roams the unconscious with no fixed abode—trauma literally takes possession of the psyche "against the will of the one it inhabits" (Caruth, 1995, 5).

Aware from the outset that Aristotelian rules of tragedy, mimesis, and catharsis were ill-equipped to deal with the twentieth century's traumatic modernities, BAFC examined the "crisis of unknowing" in *Mysteries of July* (1991), which investigated deaths in police custody to reveal the agony of blocked mourning among bereaved survivors when the factual cause of death is "buried" and repressed as a state secret. *Testament*, on the other hand, explores the psychic terrain of Abena's repressed grief by way of a purposely "blank" acting style that provides a necessary alternative to realism by thwarting the possibility of the viewer's overidentification with the protagonist. With her spaced-out demeanor and slouchy body language, Abena is not a very endearing character: in point of fact, she is not actually a character at all, for the affective disposition that actress Tania Rodgers communicates through her superb performance—head sinking while she speaks, arms folded on hips, hands clenched as she walks toward camera—subtly redistributes the potential overflow of emotions unleashed by the "river of memory." In channeling the viewer's thoughts and feelings away from the narcissistic stasis of overidentification, it gradually becomes clear that the acting is merely one more formal element in the overall montage-combinatory. The depopulated landscape acquires an increasingly dominant role in the film in proportion to the expressive depletion of Abena's character: rather than reflect or absorb her emotions, the landscape becomes just as much a "character" as she is. A cutaway sequence showing a man canoeing on the Volta River, as he recites a Ga parable, implies that "the river of memory" is an agent of narrative flow in its own right.

Discussing his chosen authorial influences—Ritwik Ghatak, Robert Bresson, Andrei Tarkovsky, and "English Brechtian cinema of the 70s"—Akomfrah has said, "It was very much a conception of cinema as a machinery of movement through which you could explore questions of rhythm, tempo, colour, and so on—very formal questions. . . . As a method, it is very rigorous and very anti-humanist in a way" (quoted in Harris, 1992, 11). Indeed, when Abena reports that negotiations to interview Herzog have broken down—on the steps of Elmina Castle—*Testament* reveals an unprecedented formal solution to the question of how the "intangible" realities of postcolonial

trauma might be brought into cinematic representation for the first time—by employing intertextuality as a holding environment for the river of memories (fig. 15.3).

As Abena sits down to talk to Danso in the opening scenes of the diegesis, the parched landscape evokes Antonioni's *Red Desert* (1967), even as the air of lassitude surrounding her flouncy skirt makes her a dead ringer for Dürer's *Melencolia* (1514). It is in the Elmina sequence, however, where we see Akomfrah directing Abena's television crew—in a Godardian moment of self-reflexivity that calls to mind the coastal setting of *Le Mepris* (1965)—that *Testament* discloses its architecture of intertextual quotation as an alternative to realism that also employs allegory as an alternative to symbolism. When the camera soars and glides above the spaces of the castle's fifteenth-century architecture, its apparent weightlessness inscribes a contrapuntal difference from the sheer gravitas of the historical site, which was built in the era of the Portuguese maritime baroque, initially as a way station in the quest for Prester John (who was believed to govern a Christian kingdom in Central Africa), before it was adapted for the Atlantic slave trade. Based on *The Viceroy of Ouida* (1980), Bruce Chatwin's novel about a Latin American slave trader in Dahomey, *Cobra Verde* is an object of critique here, for cutaways to Herzog's film set show mass-produced skulls serially arranged on a mud wall, as if to recycle primitivist myths of Europe's so-called other. The fake testimonies implied by these simulacra produce a striking contrast with the actual skull that disquiets Abena at the end, where, in Walter Benjamin's words, she has become a woman who has discovered that "everything about history, that from the beginning, has been untimely, sorrowful, unsuccessful, is expressed in a face—or rather in a death's head" (1998, 166).

The differentiation produced by the visual contrast between two sorts of skulls is crucial because it cuts between allegory and symbol as distinct registers of inscription. Lacan might say the skull that Abena encounters in the graveyard is neither imaginary nor symbolic but a piece of "the real" which shows the material remnants of subjectivity's traumatic core. For Benjamin, on the other hand, "whereas in the symbol destruction is idealised and the transfigured face of nature is fleetingly revealed in the light of redemption, in allegory the observer is confronted with the facies hippocratica of history as a petrified, primordial landscape" (1998, 166)—which accurately describes *Testament*'s opening scenes. The skull that inexplicably looks back at Abena at the end of the film "lacks all 'symbolic' freedom of expression, all classical proportion, all humanity—nevertheless, this . . . is at the heart of the allegorical way of seeing, of the baroque, secular explanation of history as the Passion of the world: its importance resides solely in the stations of its decline" (166).

Perhaps Abena's blankness is fitting for a ghost, that is to say, a survivor of post-colonial trauma who is both ghost *and* ghosted, agent *and* patient, whose subjectivity has been split between first and third person from the start. As the voice-over narrator (Sally Sagoe) introduces Abena through different pronouns—"twenty years ago I started running . . . Abena was a student at the Nkrumah Ideological Institute"—the fragments of her psyche, crucified by irreconcilable gaps between past and present, are cradled and "held" by the threnodic beauty of the compositions extracted from Arvo Pärt's *Fratres* (1977) and *Cantus in Memory of Benjamin Britten* (1977) and Krzysztof Penderecki's *Magnificat* (1973) that we hear on the soundtrack. Immersed in the rivers of memory, as newsreels tinted yellow and orange show the ebb and flow of political arrests and detentions "like the tide," the Jamestown Dirge Singers (who are professional mourners, as in Shakespearean Europe) form a semiotic chora to Abena's remorseful utterance, "In 1966 I believed two bodies could be one," which accompanies an inexplicable Super 8 image of conjoined twins on a surgeon's table.

Portrayed in traditional funeral attire on the prow of a boat, Abena reveals herself as a "quantum ghost," in the words of Wilson Harris.[5] Her journey crosses the "living cross-culturalities" of an aquatic realm in which Africa and Europe are not dichotomously opposed (as in Herzog's plastic clichés) but intermesh within an intertextual space of allegory that Christine Buci-Glucksmann refers to as "post-modern baroque."[6] *Testament*'s purposively desaturated rendition of the Ghanaian landscape alludes to Tarkovsky's *Nostalghia* (1983), in which variations in "color temperature" correspond to emotional motivation rather than realist logic, and in which elements such as fire and water are as much "characters" as the actors. Above all, where Tarkovsky explored the dilemma of a Russian translator exiled in Italy, *Testament*'s plotline also alludes to the "revolutionary nostalgia" of Andrzej Wajda's *Man of Marble* (1977), for Abena is twin-sister-in-reverse to Agnieszka, the chain-smoking film student protagonist who uncovers archival material of a 1950s propaganda hero and is pressured to revise her story by the communist state.

Although Wajda's hectic, verité style could not be more different, the baroque intertextual architecture that enriches *Testament*'s elliptical form produces a universalist understanding of traumatic modernity not by a frontal equivalence with the repressions wrought upon Central Europe by Soviet imperialism, but by making the "unspeakable" aspects of Africa's postcolonial condition tangible through a latticework of metonymic implication.

Where Abena's flashbacks form a silver thread in the diegetic binding, they reveal that "the phantom is . . . a metapsychological fact," for "what haunts are not the dead,

15.3 Black Audio Film Collective, *Testament*, film still, 1988. 16mm, color, sound, 80 min. Courtesy of Smoking Dogs Productions.

but the gaps left within us by the secrets of others."[7] Tinted by an indigo filter that converts day to night, this thread reveals the sergeant as Abena's "bad father"—like a screen memory, he is the phantom who blocks her recognition of the "lost parent" who lies behind the public shame she felt as a squealer. However, when Abena returns to the amber twilight of the densely wooded graveyard at the end—having recounted to Danso the childhood terror provoked by a hole in the grounds of her family home—*Testament* reveals the golden thread through which the film bares its soul as postcolonial *trauerspiel*, or sorrow song. This concluding image of the skull retroactively codifies her earlier graveyard visit as a hallucinatory wish fulfillment—where Abena "saw" her parents as two shadowy figures throwing rocks into a hole in the ground (in the film's sole utilization of point of view).

When Akomfrah says, "My father was buried in Ghana. I hadn't seen his grave but I wanted to" (quoted in Harris, 1992, 11), we must understand that the manifest filmstrip does not actually contain a scene in which "she goes to the graveyard and buries her father" (11) because all we actually see is Abena looking at a skull as she catches her breath at the end. Giving us the diegetic signified that is produced as a result of the *nachträglichkeit* of the montage's signifying work, but which is not otherwise shown or made visible, these words crystallize the dread power of BAFC's tender handling of metonymic indirection. Immersed in ego-shattering memories that must be simultaneously hypercathected and decathected, held onto and let go of, Abena survives the travails of the river of memory for almost eighty minutes, only to find that she must now initiate her grief and begin mourning *for the very first time*.

Once the tagline from *Handsworth Songs* is abbreviated slightly—"there are no stories … only the ghosts of other stories"—we find the hermeneutic key to the practice of intertextuality that informs the Black Audio montage principle as a whole. Just as the central "character" of *Who Needs a Heart* (1993)—the ill-fated 1960s black British activist Michael de Freitas, who renamed himself Michael X—is visually absent, and made present only through his effects on others, this latticework of metonymic indirection moves toward the "unrepresentable" by evoking the cyclical forms of the sorrow song that provides a holding environment in which unbearably painful stories can be made socially sharable for the very first time.

This chapter was first published in *The Ghosts of Songs: The Film Art of Black Audio Film Collective*, edited by Kodwo Eshun and Anjalika Sagar (Liverpool: Liverpool University Press, 2007), 43–59.

1. Jacques Lacan, *The Four Fundamental Concepts of Psychoanalysis* (1973), trans. Alan Sheridan (London: Penguin, 1977), 88.

2. D. W. Winnicott, *Holding and Interpretation: Fragment of an Analysis* (1972; New York: Grove, 1986).

3. Louis Massiah, "Using Archives," *Black Film Bulletin*, nos. 3/4 (Autumn/Winter 1993–94): 27.

4. Laura U. Marks, *The Skin of the Film: Intercultural Cinema, Embodiment, and the Senses* (Durham, NC: Duke University Press, 2000).

5. See Nathaniel Mackey, "Quantum Ghosts: An Interview with Wilson Harris," in Mercer, 2006, 206–221.

6. Christine Buci-Glucksmann, *Baroque Reason: The Aesthetics of Modernity* (1984), trans. Patrick Camiller (London: Sage, 1994).

7. Nicholas Abraham and Maria Torok, "Notes on the Phantom—A Complement to Freud's Metapsychology" (1975), in Abraham and Torok, *The Shell and the Kernel*, trans. Nicholas Rand (Chicago: University of Chicago Press, 1994), 171.

16

ARCHIVE AND *DÉPAYSEMENT*
IN THE ART OF RENÉE GREEN

Returning again and again to books and to places . . . to find something previously
missed. . . . Something that has a different meaning after different encounters,
different inhabitations, and different journeys over the passage of time.

—Renée Green, from the film COME CLOSER (2008)

The constituent elements of Renée Green's conceptual practice exist in a condition of
migrancy—constantly departing, arriving, and returning. Considering her work in
various mediums over the past twenty years—installations, films, sound pieces, web-
sites, and published writings—we begin to notice a distinctive pattern of circulatory
"returns." In the sense that site specificity is a characteristic of any given archive that
unifies a body of materials into *one* fixed place, there is always a dyadic relation be-
tween the singularity of the site and the journey required to get there. There is only one
place in the world where you can visit the Uffizi Gallery, for example, and if you are not
a Florentine resident then you must travel to see it. But the traveler's attitude is rarely
neutral or indifferent: driven by expectation, the art tourist embarks on a secular ver-
sion of a ritual pilgrimage—the goal is to experience a heightened state of conscious-
ness once the destination has been reached (enlightenment or fulfillment, for instance).
Even when the whole point is to get rid of a final destination, as in the bohemian roman-
ticism of aimless wandering, there is still a corollary between how you experience the
journey and what you hope to achieve when the traveling stops (ego loss or nirvana,
perhaps). Charting a course that takes us "elsewhere," Renée Green's work invites a
wholly different kind of journeying. It involves traveling toward the site-specific char-
acteristics of an archive through a circulatory pattern of directed mobility that results
in a condition of critical *dépaysement*. Connoting the estrangement that comes from
leaving home and abandoning one's familiar surroundings or habitus, this verb also

suggests the affective state of in-betweenness that is felt upon arriving in a foreign territory or a new situation for the first time.

Looking at the manner in which Green's installations activate ambivalent tensions between site specificity and visitor mobility, one might think of her practice as that of a third-generation conceptualist who has chosen to return to avant-garde methods of institutional critique associated with first-generation conceptual art of the late 1960s and early 1970s. To the extent that such a "return" is mediated, however, by a range of interests in identity and difference associated with the broader turn toward theory that took place with second-generation conceptualism during the 1980s, one might add that Green's artistic positioning is distinguished by an intergenerational contract, as it were, that engages the agency of return to bring out fresh possibilities that were not apparent to *either* of the preceding generations.

Based at the Whitney Independent Study program in 1989 and 1990, Green began her career in a moment of transition. The paradigm shifts initiated by feminism, cultural studies, postcolonial studies, and other interdisciplinary models of semiotics, psychoanalysis, and critical theory that had become academically institutionalized by this time precipitated a reaction on the part of the subsequent generation that was manifested as a revolt against the language of "theory." Acted out in the mocking irreverence of the abject art that arose as a reaction against identity politics, there was a drive to legitimate contemporary art as an absolute break with the image-text work of second-generation conceptualism of the 1980s by claiming a line of descent from avant-garde artists of an earlier era, such as Marcel Broodthaers, Robert Smithson, Bruce Nauman, or Gilbert and George. This version of returning to first-generation conceptualism paved the way for an attitude that heralded a neoconservative return to "beauty," but the alarm sounded by some second-generation actors was equally reactive. Following the 1994 *Bad Girls* exhibition at the New Museum in New York, the journal *October* asked whether the epistemological breakthroughs brought about by "theory" were being undermined by the naive appeal to performativity on the part of so-called postfeminist practitioners. Among the responses, art historian Lisa Tickner detected an underlying anxiety in the journal's all-or-nothing conception of intergenerational differences. Taking up her view that "the cultural field is a set of 'positions' that offers the artist a set of 'possibles.' *The avant-garde game is to change the field of the possibles*,"[1] one might say that what individuates Renée Green's mode of "return" are the ways in which her art *converts a potentiality into a possibility*. As Agamben puts it, possibilities are logically linked to the ontology of presence, whereas potentialities constitute a "not-yet-here" and a "not-yet-now" that calls something into being from the

future rather than pointing to something that is simply missing or lacking or absent as such.[2] Green's writings frequently reflect upon her own relationship to Broodthaers and Smithson, among many others. Establishing an intergenerational dialogue that translates site specificity toward contemporary ends, she neither "adds on" issues of race or gender or ethnicity that were absent in an earlier era nor merely "updates" an artistic procedure with present-day "content" such as globalization or diaspora or migration; rather, her work activates fresh possibilities out of hitherto dormant potentialities. Far from nostalgic hero worship, the agency of "return" exercised in her work reveals something about the resourcefulness of conceptual art itself, along the lines suggested by Hal Foster's (1996) account of the neo-avant-garde. Giving equal weight to the investigative voice that features in Renée Green's writings alongside the poetic voice that also features in her installations, we find that the experiential passage of such "returns" generates moments of dépaysement across multiple levels.

Green's contribution to Documenta 11, the *Standardized Octagonal Units for Imagined and Existing Systems (s.o.u.s)* (2002) (figs. 16.1 and 16.2), prompts a memory of such a moment that remains especially vivid for me. Feeling a bit exhausted from my itinerary around the sculpture park, I heard the sound of Alice Coltrane's music, which drew me toward one of the octagonal pavilion-like structures, where I took a seat. Facing a screen that sprouted out of the ground, I experienced the film *Elsewhere?* (2002) (fig. 16.3) as a multisensory data stream that induced a daydream state of mind. The words, sounds, and images demanded heightened concentration, yet the associative wandering they encouraged also led to a kind of ambient drift. Actuality images of the preparatory work of installing the *s.o.u.s* in the Staatspark Karlsaue called attention to the geography of the site, which could be viewed through the pavilion's panels, even as the film documented the coincidence whereby the first Documenta was held alongside the annual Bundesgartenschau (Federal Garden Show) that also took place Kassel in 1955. Bringing these two "facts" out of the archive and into imaginative contact, the film maximized the contemplative space of the installation. Offering me pause from my purposive activity of walking around the sculpture park, the *s.o.u.* altered the way I could inhabit, and therefore understand, the archival dimension of the site I was moving through by inviting me to reflect on my own passage through Documenta's public garden spaces.

Neither fully architectural nor sculptural as such, the installation acted as a time-travel machine. Stating that its octagonal shape "initially grew out of an interest in the hut . . . as a place of rest" in early European garden design, Green undertook research that tracked the commemorative and ritualistic uses of such geometry to Islamic gar-

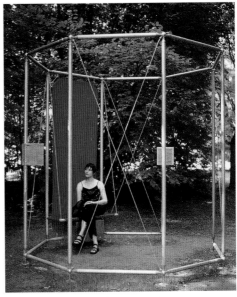

16.1 Renée Green, *Standardized Octagonal Units for Imagined and Existing Systems (S.O.U.s)*, 2002. Mixed-media installation: eight octagonal units, seven with sound (*Imaginary Places A to Z*), one with monitor and looped film with sound (*Elsewhere?*). Installation view, Documenta 11, Kassel, 2002. Photo: Werner Maschmann.

16.2 Renée Green, *Standardized Octagonal Units for Imagined and Existing Systems (S.O.U.s)*, 2002. Installation view, Documenta 11, Kassel, 2002. Photo: Werner Maschmann.

den settings.³ Noticing how it migrated through cross-cultural contexts (including the nineteenth-century fad for octagonal houses in America), she also retrieved from Documenta's more recent history some of the sculptures previously exhibited on the site that had taken a phenomenological interest in "the perceiver suspended in the act of perceiving."⁴ Folding each of these archival layers into her conception of the s.o.u. as a "place of rest amidst external stimuli," in which "perceivers can . . . sink into their own reveries more easily because the number of external distractions is reduced while the translucence and spaces between the panels allow a view of other units in the system," it is only in retrospect that I can understand how the strange sense of dépayse-ment I went through is perfectly explained by the artist's statement that "*part of what occurs is that the perceiver's attention is used as a medium.*"⁵

With their concern for embodied inhabitations of place, Green's early works also produce a similar quality of intimate unsettlement, although the formal ingenuity of such pieces as *Seen* (1990) often took second place, at the time, to the focus on mani-fest subject matter. Examining representations of black female bodies in Western art history—Saartje Bartmann or the so-called Hottentot Venus in the case of *Seen*, and Josephine Baker in *Revue* (1990)—this was one of several installations linked to Green's concurrent usage of museological conventions, such as the vitrines of *Terra Incognita* (1990), although the dyadic interface between site specificity and viewer mobility had already featured in *Sites of Genealogy* (1990).

Stepping up onto a wooden platform raised a few feet above the gallery floor, the viewer experiences *Seen* (figs. 16.4 and 16.5) as a stage or scaffold upon which one is compelled to bend or stoop in order to read inscriptions on the planks from which the structure is composed. In undertaking this action, one is immediately "seen" by an eye that appears on a video monitor placed beneath a hole at the center of the platform, which itself is placed in a corner of the exhibition space between a spotlight on one wall and a portable projection screen on the other. In the phenomenological aspect of walking up onto the platform and moving through the installation to get a view of what is hidden (the monitor) and what is shown (the text), the perceiver becomes the per-ceived. Being momentarily caught upon the platform as though one were a performer or an exhibit oneself, the viewer undergoes a passage from "looking" to "being looked at" in such a way that unsettles any clear-cut Kantian separation between object and subject of knowledge. Moreover, going through such an experience is hardly a purely intellectual event: there is bodily discomfort that one feels, and that one witnesses in others, during this momentary switch in subject-object positions—all of which pro-foundly alters the way one might understand Saartje Bartmann's "place" in the visually entangled archives of colonialism and modernity.

16.3 Renée Green, *Elsewhere?*, film still, 2002. Digital film, color, sound, 53 min. DVD.
Courtesy of the artist and Free Agent Media.

Whereas the viewer undergoes dépaysement in respect to *Seen*, in *Sites of Geneal-ogy* (fig. 16.6) the artist herself enacted such a process across three sites of the P.S. 1 building in New York—the boiler room, stairwell, and attic—over a ten-month dura-tion. Elaborating mnemonic associations from literary sources, Green visited the attic as the "loophole of retreat" described by Linda Brent, the narrator of Harriet Jacobs's *Incidents in the Life of a Slave Girl* (1861). In such a place of confinement the protago-nist of this slave narrative literally wrote her way to freedom—hiding in an attic over the period in which her text was shaped. Touching on intertextual references—from Emily Brontë and Virginia Woolf to Marcel Duchamp and Ralph Ellison—suggested by the site-specific conditions of her durational performance, Green described the dyadic process of repeatedly returning to the same place to perform a series of actions: "After returning to the attic several times a week to wrap the area which surrounds the desk, chair, lamp, typewriter and ladder . . . with string." In the diary in which she wrote on a daily basis, she added, "While traveling around and around in the attic (like the often mentioned 'madwoman' thereof) I will try to catch hold of my thoughts, which will begin my hour or more of writing to be done in the 'strung' space ('a room of one's own.'). . . . The traces of my movements . . . will accumulate in this space during the course of the year inside and outside the 'room.'"[6]

Extending her archival sites across slavery and colonialism, Green's early to mid-1990s work received attention on account of the representational forms of race and ethnicity laid out at the level of content, but her relationship to institutional critique was often overlooked. *VistaVision* (1991) explored the trophy hunt collection in the American Museum of Natural History, and her examination of the Indonesian materi-als gathered by Dutch collector A. C. van Bokhoven in *After the Ten Thousand Things* (1994) also lent itself to the artist-as-ethnographer paradigm which has played an in-fluential, and highly productive, role in our critical understanding of site specificity in contemporary art. But is Green's conceptualism really "ethnographic" as such? In what sense does her practice add to the "fieldwork" tradition in conceptual art, and to what extent does the diasporic dimension of her journeying open up a translative dépayse-ment of this artistic procedure?

Having included Green in his 1993 exhibition *What Happened to the Institutional Critique?*, art historian James Meyer offers a useful distinction between "lyrical" and "critical" nomadism to account for third-generation conceptualist practices that em-ploy strategies of travel to different ends. Describing the former as a "dramatization of the artist's peripatetic existence" in an age of globalization, often taking the transitory form of chance encounters thrown up by the hypermobility of the international bien-

16.4 Renée Green, *Seen*, 1990. Mixed-media installation: wooden platform, rubber-stamped ink, screen, motorized winking glasses, magnifying glass, spotlight, sound, 81.5 × 81.5 × 53.5 inches. Courtesy of the artist and Free Agent Media.
16.5 Renée Green, *Seen*, 1990. Installation detail.

nale circuit (Rikrit Taravanija is his example), Meyer's account of *Import/Export Funk Office* (1993) draws attention to Green's handling of the circulatory elements that are exchanged in cross-cultural traffic. Her quasi-museological display of African American music and literature in the collection of German critic Diedrich Diederichsen is directed by an understanding of the historical trajectories in which "the importation of a foreign culture requires a translation of the knowledge of the other" (Meyer, 2000, 22). One part of the installation calls attention to the journeys through which Angela Davis traveled to Germany to study with Theodor Adorno (prior to her defense of the Black Panthers in the late 1960s), thereby retracing the Atlantic crossing in which Adorno and other Frankfurt school members traveled to California as exiles in the 1940s. Themes of dépaysement arise here when Meyer notes that "each has left home to acquire a knowledge apparently only attainable elsewhere" (22). But far from being mutually exclusive, the critically "nomadic" drive precludes neither Green's phenomenological interests in the embodied experience of the journey that moves toward a site nor her interest in diaristic, autographic, and epistolary modes of writing that introduce a poetic or lyrical voice to her works. Indeed, the light touch of motility heard in Green's distinctive tone enhances the analytical impetus of her installations—instead of taking Diederichsen's library as an ethnographic "object," her starting point was to observe its similarities with her own collection at home.

Describing post-1980s practices in which art is "sited" in networks of discourse as much as in the sociological "fields" explored by first-generation conceptualists, Hal Foster registers his concern with a "vogue for pseudo-ethnographic reports in art" when he asks: "Who in the academy or the art world has not witnessed . . . these *flâneries* of the new nomadic artist?" (1996, 180). *World Tour* (1994) is given as a countervailing example where "Renée Green performs this nomadism of the artist reflexively" (278), although it may be observed that reflexivity tends to act as the sole criterion for genuinely critical knowledge of the self-and-other relationship in contrast to discourses in which otherness is merely romanced in Foster's account of "art and theory in the age of anthropological studies." Notwithstanding the sheer scope of references, from the ethnographic surrealism of Georges Bataille in the 1940s to the traveling theory conceptualized by James Clifford in the 1980s, it is worth noting that Green herself points to some limitations of the artist-as-ethnographer model in her 1997 essay "Slippages." Having diagnosed problems that arise whenever the "other" is subject to a leftist over-identification that only inverts the disidentification of neoconservatives (a situation read through Walter Benjamin's notion of the author-as-producer as a response to the dangers of "ideological patronage" in earlier times), Foster makes a distinction be-

16.6 Renée Green, *Sites of Genealogy*, 1991. Installation view, P.S. 1 Contemporary Arts Center, Long Island City. Photo: Tom Warren. Courtesy of the artist and Free Agent Media.

tween identity and identification that Green agrees with. But when it is applied to the wholesale critique of such a range of artistic and theoretical positions, she points out that "the term 'other' becomes very confusing here" because "what is left out of this formulation are the instances in which someone occupies multiple positions." Quite reasonably Green muses: "At this point I wondered how 'ethnography' was being used and what this designation was being asked to perform."[7]

If we took another Walter Benjamin as a starting point—the Benjamin of the city portraits found in *One-Way Street* or the memoirs of *A Berlin Childhood*, for instance— one could view the archival sites that Green travels through not as ethnographic fields so much as "contact zones" where new possibilities arise out of dyadic exchanges between visitor mobility and site specificity. Moreover, taking gender into account as a mediating variable, we might add that, far from being straightforwardly "nomadic," she practices a circular mode of journeying that encourages us to consider cultural historian Janet Wolff's observation that "like the *flaneur*, the stranger and the wanderer may be able to pass in anonymity; women, however, cannot go into unfamiliar places without drawing attention to themselves."[8] Is "the female stranger" isomorphic with "the modern stranger" in the epistemology of the ethnographic tradition, or is she closer to the exilic upheaval of displacement? Following George Simmel's account of "the stranger" who gains objectivity as a result of his borderline position vis-à-vis a given community, the dyadic tension of nearness and distance was understood as essential to the knowledge produced by observer-participant methods.[9] But by the same token, without opportunities to "return" to one's place of origin or departure—as occurs in the cases of both exile and diaspora—such tension dissipates. As one scholar notes, after Benjamin went into exile in 1933, his city portraits ceased because "with the loss of one's homeland the notion of distance also disappears. If everything is foreign, then that tension between distance and nearness from which the city portraits draw their life cannot exist."[10]

By maintaining a circulatory pattern of "returns," Green's journeys are distinct both from the unidirectional mobility of exiles and refugees who cannot go back home for reasons beyond their control *and* from the globe-trotting itineraries of nomads, tourists, and bohemians who are blasé or indifferent toward the places they visit. Taking up Wolff's suggestion that it is precisely "her very identity as woman which enables a radical re-vision of home and exile," such that feminine migrations may take "the form of 're-writing' the self," we might add that as well as the condition of dépaysement evoked in the view that "for the woman who leaves home . . . displacement (deterritorialization) can be quite strikingly productive,"[11] Wolff's emphasis on micrological

forms of writing, such as the diary or the memoir, also resonates with Green's work to a greater extent than the ethnographic.

Having begun life as part of *Tracing Lusitania* (1992), which was initiated in the quincentennial of Columbus's 1492 voyage to the Americas, *Walking in Lisbon* (1992) (figs. 16.7–16.9) is a video diary of an African American *flâneuse* ambling through shopping precincts and tourist sites, yet it is also a city portrait of a particular locale to which the artist has repeatedly returned as a result of encounters that arose during the course of research. Part of Green's initial project entailed traveling by boat to Ceuta—Portugal's first site of colonial conquest in Africa in 1415—but Lisbon also became a locus of exchange after Green met archivists and academics with whom she subsequently collaborated in later projects. The 1994 conference Green convened at the Drawing Center in New York, whose proceedings were published in a bilingual Portuguese-English edition as *Negotiations in the Contact Zone* (Green, 2003), documents transnational circuits of interdisciplinary cooperation that feature more prominently in her output than the genre of ethnographic reportage. Indeed, at a conference chaired by Homi Bhabha on the influence of Frantz Fanon upon the postcolonial and diaspora-based artists in *Mirage* (1995) at the Institute of Contemporary Arts in London, Green commented on the fault lines through which contemporary culture has compartmentalized the legacies of conceptual art by reproducing hierarchies between art and theory. Observing "a certain power dynamic that occurs in terms of how the artists are positioned in relation to the formulation of the theoretical ideas which disturbs me," she stated, "I would like to restructure this dynamic so that it doesn't feel like art is merely a decorative element—something that is tagged on to the 'heavier ideas'" (Green, 1996, 146). Writing reflexively about her own work as well as contributing to debates in art criticism and public culture at large—all of which places Renée Green in line with first-generation conceptual artists such as Adrian Piper and second-generation artist-theorists such as Victor Burgin or Mary Kelly—it is paradoxical that the use of fictional and novelistic voices in her films, writings, and installations has been somewhat ignored.

In the diary she kept of her participation in the 1993 Project Unité initiative in Firminy in France, where artists were invited to produce work in a mass housing estate designed by Le Corbusier, Green recorded her mixed feelings about the site, where, describing herself in the third person, "she pitched her tent inside what is now a modernist ruin."[12] Her frustrations fully confirm Meyer's point that far from being glamorous, migrancy today is also enforced by the demands of the global market, for "to be a working producer today is to be constantly on the move. Working conditions are hardly

optimum. The artist-traveller must work within the confines of often unfocussed cura-torial concepts" (Meyer, 2000, 23). By turns witty, episodic, but always insistently re-flexive, Green narrated her encounters with the building's tenants as if she were playing a part in a work of fiction: "The character is visibly a female with brown skin and dread-locks. She was born in the U.S. and thus speaks English. . . . She's been asked at vari-ous times and in various places whether she's from Martinique, Puerto Rico, Guyana, Jamaica, some island near Venezuela, Paris or New York."[13] While introducing a critical distance that sidesteps identitarian readings (by accepting the individuality and con-tingencies of her passage through the Firminy site), the autographic voice counteracts heavy-handed versions of institutional critique that aim to expose the ideological foun-dations of a given location in a programmatic or point-scoring manner.

Hence, when Green revisits Smithson's site-specific works that are now so much a part of the canon, it is striking to observe how her *Partially Buried in Three Parts* (1996–97) also involved the artist returning to her formative years in Cleveland. Above all, the very circularity of the "return" journey, which presupposes a place called home in a way that is not available to exiles as such, underlines the diasporicity of a mode of travel in which imaginary and symbolic mobility plays a privileged role precisely because of the awareness that literally going back to the point of origin is blocked as an impossibility. If there can be no return to the real place from which ex-African identities were driven out involuntarily, then Black Atlantic recrossings take possession of the sites and spaces that were historical locations of dispossession by practicing repetition as a kind of eter-nal return that alters the very experience of modernity, as Paul Gilroy (1993) argues. In *Endless Dreams and Water Between* (2009) (fig. 16.10), the film's transitions across a trio of dispersed sites—California, Manhattan, Majorca—are held together by an episto-lary exchange among four fictional (and all female) characters who think aloud about gathering together in one imaginary place called the September Institute. To the ex-tent that the film highlights the lyricism of Green's use of fictional elements to use the perceiver's attention as a medium, the ambient drift brought to bear upon the aquatic realm of the Mediterranean—George Sands's *A Winter in Majorca* (1855) is the shared text the four voices comment on while a Chopin remix plays on the audio track—is not unlike the daydream state of mind induced by the *Elsewhere?* film in the octagonal units of the Staatspark Karlsaue. Considering the film's journeying between the Algonquin site of New York City (an island where the artist resides) and meditations on Majorca as an island site of crossing between European and Islamic worlds, one notices that George Kubler's view—"historical knowledge consists of transmissions in which the sender, the signal, and the receiver all are variable elements affecting the stability of the

16.7–16.9 Renée Green, *Walking in Lisbon*, 1992. Video, color, sound, 53 min. Video stills sequence. Courtesy of the artist and Free Agent Media.

16.10 Renée Green, *Endless Dreams and Water Between*, film still, 2009. Color, sound, 74 min. DVD. Courtesy of the artist and Free Agent Media.

message" — (which Green cites in *Elsewhere?*) was a line of thought that Smithson repeatedly returned to himself.[14]

I have always found it intriguing that Green refers to the company she established in 1995, Free Agent Media, as a "dream production company."[15] The twist in the syntax suggests a production company capable of generating books and films that would fulfill one's dreams, but it also implies activity geared toward the production of dreams themselves. In the sense that what comes back from the avant-garde of the past is a potentiality that now has the chance to become a possibility, Renée Green's practice of "return" opens up imaginative contact zones between cultural, discursive, and institutional sites that were previously closed to one another by historical boundaries. Now, however, ancient and futural dream spaces once buried in the depths of the archive may possibly cross over into the sea of possibilities.

NOTES

This chapter was first published in *Renée Green: Ongoing Becomings, 1989–2009*, edited by Nichole Schweizer (Zurich: JRP Ringier, 2009), 21–26.

1. Lisa Tickner, "Questions of Feminism: 25 Responses," *October*, no. 71 (Winter 1995): 45.

2. Giorgio Agamben, *Potentialities* (Palo Alto, CA: Stanford University Press, 1999).

3. Renée Green, "Why Systems?" (2002), in "Other Planes of There," unpublished manuscript, consulted 2009, 236.

4. Green, "Why Systems?," 236.

5. Green, "Why Systems?," 235.

6. Renée Green, "Sites of Genealogy" (1990), in "Other Planes of There," 173.

7. Renée Green, "Slippages" (1997), in "Other Planes of There," 112.

8. Janet Wolff, "The Female Stranger: Marginality and Modes of Writing," in *Resident Alien: Feminist Cultural Criticism* (Cambridge: Polity, 1995), 8.

9. Georg Simmel, "The Stranger" (1908), in *Georg Simmel: On Individuality and Social Forms, Selected Writings*, ed. Donald N. Levine, trans. Kurt Wolff (Chicago: University of Chicago Press, 1971), 143–50.

10. Peter Szondi, "Walter Benjamin's City Portraits," in *Benjamin: Philosophy, History, Aesthetics*, ed. Gary Smith (Chicago: University of Chicago Press, 1989), 3, quoted in Wolff, "Female Stranger," 48.

11. Wolff, "Female Stranger," 8.

12. Renée Green, "Scenes from a Group Show: Project Unité," in *Site-Specificity: The Ethnographic Turn*, vol. 4 of *dis-, de-, ex-*, ed. Alex Coles (London: Black Dog, 2000), 115.

13. Green, "Scenes from a Group Show," 115.

14. George Kubler, *The Shape of Time: Remarks on the History of Things* (New Haven, CT: Yale University Press, 1962), 21.

15. Renée Green, "F.A.M.," in "Other Planes of There," 39–35.

17

KERRY JAMES MARSHALL:
THE PAINTER OF AFRO-MODERN LIFE

Kerry James Marshall addresses the unfinished history of post–civil rights America. His large-scale canvases place figurative groups among scenic backdrops that often evoke the utopian aspirations of the 1960s, yet his paintings are filled neither with nostalgia nor with irony but open onto an imaginative or even fictional space in which archival relationships between past and present become the subject for future possibilities.

His figures are composed in enigmatic groupings that suggest potential scenes of dramatic action, but any straightforward access to narrative content is intercepted by a rich ensemble of painterly effects in which various drips, dots, strokes, and scumbles are scattered throughout the mark-making procedures that are so distinctive to Marshall's paintings. To the extent that such painterly "noise" interferes with the figure/ground distinction as a foundational aspect of the practice of painting, it acts as the locus of conceptualization in Marshall's practice, marking the point at which alternative understandings of history are brought to the threshold of representation.

In the *Souvenir* (1997–98) series (fig. 17.1), the politics of the civil rights era are touched upon directly, in the form of a background tapestry that depicts Martin Luther King Jr. alongside John and Bobby Kennedy above a motto that reads, "We Mourn Our Loss." But more often than not, Marshall alludes to the 1960s indirectly, such that a more diffuse sense of pastness associated with childhood memories and the intimacy of family life takes precedence over the public realm in which the tumultuous events of the period took place. In the *Gardens* series, works such as *Better Homes Better Gardens* (1994) or *Untitled (Altgeld Gardens)* (1995) convey a precise feel for period specificity in the shape of the mass housing projects that were built as part of the Great Society program, yet even as the public/private distinction is literally blurred by splashes of paint that interfere with the spatial separation of figure and ground, there is an affective charge of unsettlement, disturbance, and violence conveyed by the way such painterly effects deface any illusion of pictorial depth. Far from summoning history

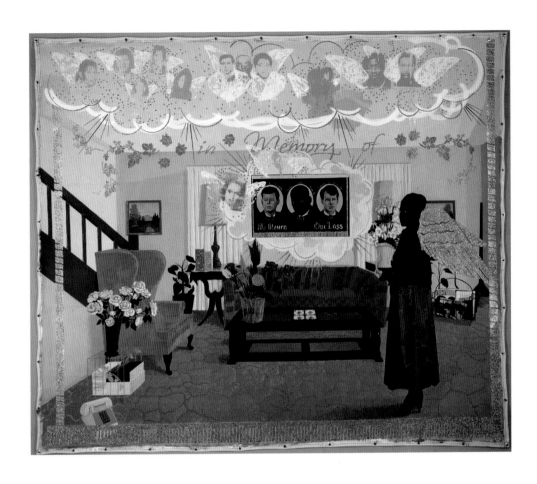

17.1 Kerry James Marshall, *Souvenir II*, 1997. Acrylic, paper, collage, glitter on unstretched canvas, 274 × 396 cm. Addison Gallery of American Art, Andover, Massachusetts. Courtesy of the artist and Jack Shainman Gallery, New York. © Kerry James Marshall.

as though it were a given body of knowledge passively waiting to be depicted or narrated, it is the opacity of the ongoing relation between past and present, which renders it enigmatic and resistant to transparency, that Marshall throws into the forefront of the viewer's attention. In this sense, the poetic interference activated by the disparate materials collaged onto the picture plane issues a break with the realist and naturalistic epistemology associated with the history-painting genre in the modern West. But if we could accurately describe Marshall as a modernist whose work operates from an alternate epistemology of collage, in which illumination is generated in a dialectical space where heterogeneous elements cut and mix, then we still face the question of how best to describe exactly what kind of modernist Kerry James Marshall might be.

There is something undeniably strange and haunting about the jet-black figures that have featured in almost all of Marshall's paintings since the early 1990s. At one level, it is their coloration that gives them an estranged and defamiliarized quality. Where African American skin tones might be rendered in a realist or a naturalistic setting with brown-blacks or red-blacks to convey warmth, Marshall's palette creates a striking effect by overlaying a colder tonal range of blue-blacks and gray-blacks as well. As if this was not enough of a denaturalizing gesture in its own right, Marshall's figures possess an equally uncanny quality at another level—at the level of line—whereby their bodies fully occupy the illusory depth of pictorial space, which they flesh out with ease, even as each figure boldly asserts its flatness as a mere shape that exists purely on the picture plane. By virtue of such signature moves, Marshall plays upon the multiaccentuality of blackness as an inherently ambivalent signifier, which may refer at one and the same time to the abstract phenomenon of color and to the concrete reality of historically constructed "racial" identities. Having denaturalized the visual inscription of race in this way, Marshall also plays on the tension between the figurative—a codified system of shapes and lines we automatically tend to read in terms of a likeness or verisimilitude to human bodies—and the figural, which is the random, inchoate mass of potentially signifying material as it exists prior to being given distinct form or bounded shape by cultural codes and conventions. In other words, while Marshall produces instantly recognizable (African American) figures, his painterly handling of blackness means the figurative is always brought to the edge of abstraction, which is what the concept of race often did in modern Western history by abstracting concrete humans into signs on which to hang someone else's idea of otherness.

The philosophical and political implications only grow in scope once we observe how Marshall's black figures are arranged into neoclassical ensembles that openly quote from the Western canon, such as the pastoral constellation of the figure group

in *Past Times* (1997) (fig. 17.2). In my eyes it is Andrea Mantegna who comes to mind when beholding the monumental scale that imparts grandeur and gravitas to these figures (and as Marshall's canvases are in the range of eight by twelve feet, his figures are literally larger than life). The artist acknowledges the wide range of citations he makes, from Raphael and Rembrandt to Picasso, as integral to the cross-cultural articulation of his practice, which also includes chalk *vévé* diagrams from Haitian vodun rituals as well as a series, the *African Powers* (1989) woodcuts, based on Yoruba divinities such as Shango and Eshu-Elegba. But when critics seek to capture the strangeness generated by these cross-cultural dynamics, the notion that Marshall simply "inserts" black figures into the pictorial grammar of Western painting, whether classical or modern, completely fails to grasp the agency of transculturation that modifies commonplace understandings of difference and identity across the board. Instead of merely adding black content to a neutral formal container, as though each retains its preexisting identity intact, there is a double-sided move at play that is best captured by Houston Baker's description of black modernism as a set of artistic tactics that enact the "deformation of mastery" while asserting the "mastery of form."[1]

Taking the latter part first, we can understand why Marshall disidentifies as postmodern. When he declares a "sense of obligation to advance the discipline" (Jafa, 2000, 74), there is an echo of Clement Greenberg's view that "the essence of Modernism lies . . . in the use of the characteristic methods of a discipline to criticise the discipline itself."[2] Born in 1955, Marshall is slightly older than the generation of neoconceptualists working in the medium of photo-text and installation, such as Renée Green or Lorna Simpson, who were associated with the paradigm shift around race and representation in the 1980s. And even though he is roughly of the same age as Fred Wilson or Carrie Mae Weems, it is his choice of painting as a medium that sets Marshall apart. After Marshall graduated from Otis Art Institute in Los Angeles in 1978, where he studied with African American artist Charles White, his formative choices were made during the decade when contemporary art, at the turn to postmodernism, had announced nothing less than the "death of painting." But while the issue of medium specificity in Greenberg's influential account of modernist painting meant the primary focus for postmodern debates on appropriation was photo-text, installation, and an interest in the found image or the found object, it is crucial to note that concepts of re-signification in postmodern criticism were equally applicable to Marshall's aims. When he says, "I don't think there's anything worse than having a good idea that is poorly realized," there is potential for misunderstanding, as if a dualism was set up between materials-based and ideas-based practices. But reading his statement in full, it is his quest to find a space

of complexity precisely at the level of conceptualization that led Marshall to say—"if you hope to break through to something meaningful . . . it's gotta come out of a more experimental approach to material. That way, you see the possibility in materials for constructing meaning. If you don't understand the capacity of materials to carry meaning. . . you're limited in your range to simple expressions rather than complex ideas" (Jafa, 2000, 29).

Picking up on his painterly interest in flatness, Helen Molesworth points out that instead of the outright rejection of formalist principles, on the part of the post-*Pictures* generation, for instance, and instead of the defensive retreat into endgame abstraction, Marshall responded to the "death of painting" by traveling an alternative path. By virtue of the combinatory principle whereby the picture plane acts *both* as a flatbed receptacle for collaging disparate elements together *and* as a pictorial window that supports illusory depth, Marshall's originality lies in the way his collage methods bridge a wide range of picture-making traditions, bringing them into a transcultural dialogue. In contrast to the Greenbergian doctrine of purity, we find not only that Marshall's combinatory principles bring into play elements of linguistic script and musical notation that consistently cut across the picture plane—in *Past Times*, the Temptations' tune "Just My Imagination" is sounding out from the radio—but also that as a result of such intermedia reciprocity the paintings activate a mood of contemplative reflection in terms of the structure of feeling they elicit from the viewer. In the *Gardens* series, which includes the individual work *Many Mansions* (fig. 17.3), Molesworth sees the paintings as meditations on the historical failure of the grand projects of modernism and modernization that gave rise, in the 1960s, to "American Type Painting," on the one hand, and to the late modernist architecture of the Great Society mass housing projects, on the other. Where such a meditative tone measures the distance between past and present, Molesworth discerns neither the pathos of nostalgia for a lost age nor the cool distanciation associated with the postmodern (where cool often covers over an angry or wounded sense of disappointment), but rather finds in Marshall's paintings a tender distanciation from the almost utopian political hopes of the era that is "born of having believed or having wanted to believe in the thing now treated ironically."[3]

Applying this insight to Marshall's portrayals of Boy Scouts and Girl Guides, or a patriotic scene in which a group of children pledge allegiance to the American flag in *Bang* (1994) (fig. 17.4), one might ask whether Marshall sees the civil rights movement as another historical "failure" of the 1960s. Considering that for many African Americans this moment was their point of entry into the American dream of suburbia and consumerism, my sense is that Marshall presents us with a perspective that could be

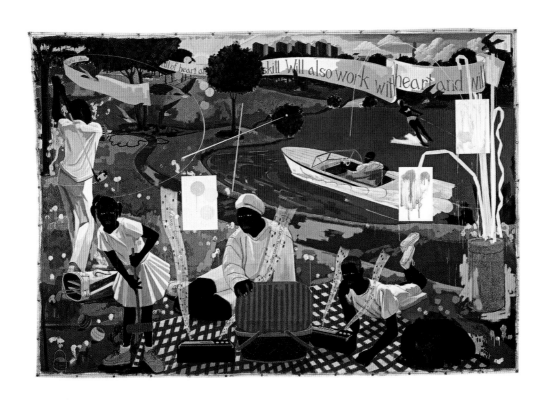

17.2 Kerry James Marshall, *Past Times*, 1997. Acrylic and collage on canvas, 274 × 396 cm. McCormick Place Convention Center, Chicago. Courtesy of the artist and Jack Shainman Gallery, New York. © Kerry James Marshall.

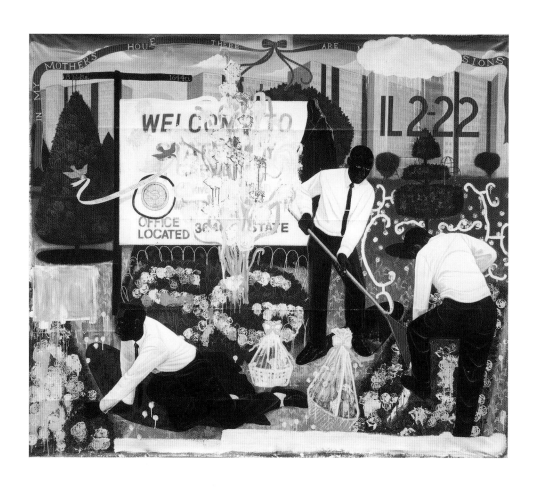

17.3 Kerry James Marshall, *Many Mansions*, 1994. Acrylic and collage on canvas, 114 × 135 inches. Courtesy of the artist and Jack Shainman Gallery, New York. © Kerry James Marshall.

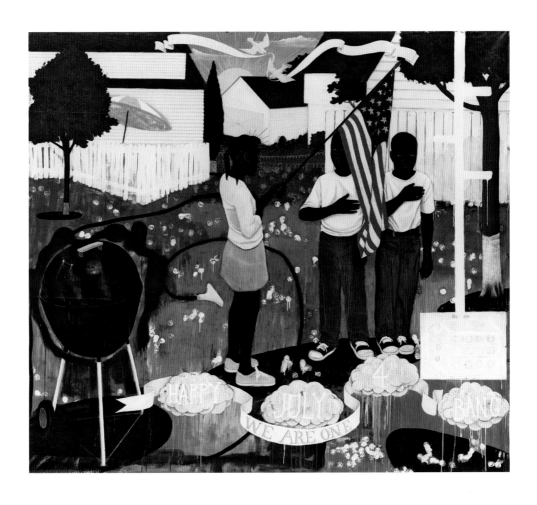

17.4 Kerry James Marshall, *Bang*, 1994. Acrylic and collage on canvas, 104 × 120 inches. Courtesy of the artist and Jack Shainman Gallery, New York. © Kerry James Marshall.

labeled *post*–civil rights not because he passes definitive judgment on political successes and failures but precisely because he opens up a novelistic or fictional space in which to reflect upon the thwarted aspirations and unresolved ambitions that, because they remain unfulfilled, continue to spill over from past to present. Far from being closed or completed, it is the archival relation whereby hopes that went unrequited and dreams that were lost or abandoned constantly leak over into the present that make Marshall's paintings not just historical but genealogical as well. The presence of the past in contemporary American politics also prompts one to observe that it was in the modernist architecture of Chicago's low-income housing projects, such as Altgeld Gardens, that Barack Obama began to address his political constituencies.

In any event, it is highly important not to lose sight of what Marshall has achieved by way of combining a formal interest in flatness with the referential dimension of the figurative. The "literary" quality that imparts a protonarrative drive to his works would be anathema for Greenbergian modernism, which saw literary references of any kind as an unwelcome legacy of eighteenth-century academic art, where aesthetic value was determined by iconographic programs at the level of content. So if Marshall's practice does not fit within received definitions of either high modernism or postmodernism, how else might we characterize "the combinatory" out of which he generates the differencing of his painterly practice? The most appropriate term, I would suggest, is the concept of Afro-modernism, especially when the idea is understood in light of the heuristic distinctions that Peter Wollen made in his notion of the "two avant-gardes."[4]

Understood as a distinctive variant in twentieth-century art that originated from a specifically African American source in the Harlem Renaissance, subsequently migrating through the Caribbean toward European contexts that include black British artists of the post-1945 period, Afro-modernism is an imaginative field of investigation driven by the impersonal rules of a code that makes use of the signifying differences thrown up in the space of cross-cultural encounters as a generative matrix for artistic decisions, choices, and procedures. In this sense, what differentiates Afro-modern practices as culturally "black" is not just the biographical origin of the artist or the social conditions of race and ethnicity under which work is produced, but rather the *critically dialogical relationship* that such Afro-modern practices engender in relation to the prevailing discourses of modernism in their outlying surroundings. On this view, there are two crucial strands of Marshall's work prior to his mid-1990s breakthrough that need to be taken into account in order to grasp how he arrived at his cross-cultural combinatory.

"I asked myself, What would happen to Analytical Cubism if you kept that frag-

mented structure but put back in all the stuff they took out?" (Jafa, 2000, 46). Discussing *At the End of the Wee Hours* (1986), a *papier collé* series he produced on a miniature scale, Marshall clearly aligned himself with the collage axis Wollen distinguishes from the axis of abstraction, which by definition involves a process of "taking things out" that was coded as a logic of extraction, subtraction, and purification for the Greenbergian formalist tradition in contrast to the combinatory logic of selection, mixing, and juxtaposition by which ready-made elements, such as found images or found objects, are "put back in," so to speak. The collage axis of the "two avant-gardes" include artists as diverse as Hannah Höch or Romare Bearden, but what differentiates Afro-modernism is the asymmetrical gradient whereby the collage episteme of selection, mixing, and combination acts as a counterweight to the exclusionary and absolutist consequences of the "purity" in abstraction that became a canonical value at midcentury. And there is more to this crosscutting hybridization Marshall practiced from the start: "at the end of the wee hours" is a quotation from Aimé Césaire's *Notebook of a Return to My Native Land* (1938–41), which shows that Marshall's papier collé exists in an intermedia condition of literary-cum-visual impurity.

Concurrently, Marshall quoted Ralph Ellison's novel *Invisible Man* (1952) in a series of paintings—including *Two Invisible Men Naked* (1985)—that enacted the "deformation of mastery" by summoning up the old racist canard that it is only by the whites of their eyes and teeth that blacks are visible in the dark. While their jokey aura meant they were mostly misread as a critique of stereotypical renditions of blackness, these paintings actually marked the point at which Marshall began to play with tonal ambiguities among warm blacks and cool blacks in such a way that made figure and ground virtually unreadable. Taking this latter process a step further, *Two Invisible Men* (1985) pushed the figurative through the figural to the point where mark-making gave way to monochrome (and the "blank" canvas can be seen as the ultimate form of abstraction).[5] In this diptych that pairs a white and a black canvas, Marshall seemed to play with notions of "racial" polarities, but where the work quietly quotes Robert Rauschenberg's *Erased de Kooning Drawing* (1953), it summons up a liminal condition of extremity in which the blank canvases put painting "under erasure" just as surely as the paintings suggest that the very idea of visible differences of race breaks down when the figure/ground distinction is no longer readable.

Far from being multiquotational for its own sake, this mid-1980s work explored two kinds of flatness. This enabled Marshall to arrive at the two principal coordinates of his history paintings—playing on the border between the figural and the figurative so as to denaturalize the signification of blackness, inscribed in the blue-black flatness

of his figure groups, on the one hand, while combining the illusory depth of spatial recession with a flatbed or collage approach to the picture plane as a receptacle for the heterogeneous stuff one strand of modernism wanted to "take out" but which another strand wanted to "put back."

To state it another way: Marshall is centrally preoccupied with beauty, and with the protean beauty of blackness as a multivoiced signifier that can never finally be fixed down or brought to closure. By virtue of the "discipline" that informs his painterly practice, his pursuit of beauty thus steps aside from the sentimental or the merely expressive, which is where blackness so often gets trapped in naturalism and realism. As he states, in characteristically trenchant style: "It's not about self-expression. If it were really just about self-expression, then that would require a receiver who is so sensitively attuned to your sensibility that they are capable of recognizing an intrinsic value—not in what it is you are doing, but who it is you are."[6] In the cleavage of this distinction between the ontological and the epistemological, the impassive monumentality of Marshall's figures bears witness to the violent histories of Afro-modernity, even as their shape-shifting figurality hints at the beauty of what blackness may yet become.

NOTES

This chapter was first published in *Afterall: A Journal of Art, Context and Enquiry*, no. 24 (Summer 2010): 80–88, and is reproduced with the kind permission of *Afterall*.

1. Houston Baker, *Modernism and the Harlem Renaissance* (Chicago: University of Chicago Press, 1989).

2. Clement Greenberg, "Modernist Painting" (1961), in *Art in Modern Culture: An Anthology of Critical Texts*, ed. Francis Frascina and Jonathan Harris (London: Open University, 1992), 308.

3. Helen Molesworth, "Project America," *frieze: contemporary art and culture*, no. 40 (May 1998): 56.

4. Peter Wollen, "The Two Avant-Gardes," *Studio International*, November/December 1975, 171–75.

5. See Angeline Morrison, "Autobiography of an Ex-Coloured Surface: Monochrome and Liminality," in Mercer, 2006, 134–53.

6. Kerry James Marshall in Wesley Miller, "On Museums," *Art21*, September 25, 2008, http://blog.art21.org/2008/09/25/kerry-james-marshall-on-museums/#.Uu_HOLSAq1c (accessed September 2009).

18

HEW LOCKE'S POSTCOLONIAL BAROQUE

Is it me, or is there something slightly overwhelming about the sheer wealth of visual information in Hew Locke's photographic series *How Do You Want Me?* (2007). Someone or something has been placed center stage within the pictorial space of representation—on that we might readily agree—but because the figure/ground distinction has been blurred by the all-over spread of eye-catching details, our ability to identify the subject of the scene is overpowered by the excess that brings every single item up to the very front of the picture plane. Standing before these larger-than-life-size prints (each measures some eight feet high by five feet wide), what one notices first of all is the frontal pose and hieratic posture of the solitary figure that eventually emerges out of the richly patterned mise-en-scène. Referring to the figure as a "fictional character," the artist describes his aims along the following lines: "The series takes the form of a portrait gallery of inherently sinister figures—corrupt Kings, Tyrants and Bandits. All carrying regalia of State, they may or may not be from the same dynasty. There is no narrative or order to the images. Originally conceived as a commentary on the State we are in, the central figure is a demonic Nemesis—a type of evil or threat to the state made flesh" (Locke, 2010).

One portrait's title, *Congo Man*, gives us enough orientation to suggest a postcolonial context, but we need to tread through this rogues' gallery with due care and attention to the cross-culturality that acts as the baseline for Locke's wide range of references: "The composition of a figure full-on in front of a backdrop not only references African studio photography but the video statements we have become familiar with from hostage-takers and terrorists/insurgents. The imagery also references nationalistic symbolism such as ideas of Albion or Arthurian legend. It is a complex mix . . . both colourful and violent" (Locke, 2010).

Indeed, far from being cross-cultural for its own sake, the accumulation of composite materials operates in such a way as to direct our attention toward the universality of the political subject matter at its heart. If the figure in *Congo Man* (fig. 18.1) is

camouflaged in ostentation, wielding an AK-47 as he emerges from the tropical foliage of the fabric backdrop, then his upright stature of phallic authority is all the more disturbing on account of the child's plastic toy being held in his hands—which is virtually the only point where we can see his skin. We could try to contain the queasy feelings induced by the excess by going for a literal approach. But even if we could pin the figure down as a signifier for an African state that has undergone three name changes in fifty years, the semantic presence of a sinister or corrupt tyrant such as a General Mobuto, or even an Emperor Bokassa, would still not be enough to stem the signifying excess or its unsettling flow of accumulating associations. Beneath the pearls that hide his face, like a Yoruba king shielding his subjects from his gaze, the figure in *Congo Man* is surrounded by a semicircular display of knives and swords that calls to mind the ethnographic holdings of primitive tools in the Pitt Rivers Museum in Oxford as much as news photos of illegal weapons seized by customs or captured by police.

Once we recognize how Locke's aesthetic strategy of visual excess undercuts questions of identity, delaying our ability to name its contents and thereby opening a space in which to reflect upon the polysemic agency of his materials, we arrive at the driving concerns that have informed his practice over the past ten years or so, namely, *the use of cross-cultural assemblage as a critical device for examining phantasies of power visually inscribed in the allegorical and emblematic forms of sovereignty.*

But is the figure in *Congo Man* just any old kind of sovereign? Floating enigmatically in the middle ground is a motto—almost indecipherable as merely one clamorous detail among others—and it is written in a foreign language: *Honi Soit Qui Mal Y Pense*. I shall come back to the origin of the phrase, which roughly translates as "Evil to Him Who Thinks Evil," but for now what matters is the weakening of identity-defining boundaries when sovereignty is in crisis. "The photos are messy and chaotic," says Locke. "We live in a whirlwind of change and insecurity. The figures are born out of this chaos, and they often have a feeling of decay and perversion. You can feel the power of the characters, at the same time feel their impotence—like many tyrants, they contain the seeds of their own destruction" (2010). Aware that one response to the terror that threatens the state is for the state itself to become a threat to its citizens, Locke is actually describing the political condition known as the state of emergency. Walter Benjamin was all too well aware of this condition almost a century ago, for he saw it as nothing less than a corollary of modernity. Bearing in mind his figurative use of the "prince" as a trope for the state, after the style of Gramsci and Machiavelli, if we were to interpret the plastic AK-47 as a substitute or double for the scepter that signifies in Benjamin's text, then we get a step closer to the Afro-modern originality of insight that

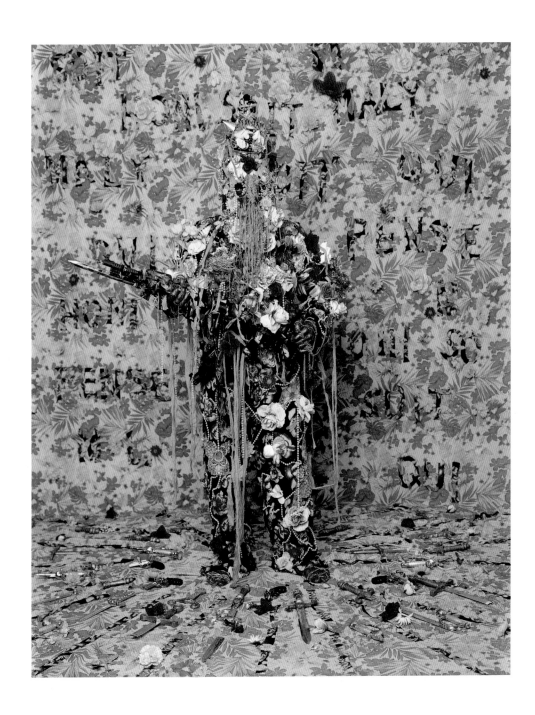

18.1 Hew Locke, *Congo Man*, from the series *How Do You Want Me?*, 2007.
C-type photograph, 244 × 152 cm. Hales Gallery, London. Courtesy of the
artist and Hales Gallery, London.

characterizes Hew Locke's trajectory as a postcolonial artist, for as Benjamin puts it: "The sovereign is the representative of history. He holds the course of history in his hand like a sceptre. This view is by no means peculiar to the dramatists. It is based on certain constitutional notions. . . . Whereas the modern concept of sovereignty amounts to a supreme executive power on the part of the prince, the baroque concept emerges from a discussion of the state of emergency, and makes it the most important function of the prince to avert this" (1998, 62, 65).

Customarily we tend to think of the baroque as a discrete period in European cultural history, from the late sixteenth century to the early eighteenth, whose visual art was dominated by excess and theatricality, a taste for the florid, the extravagant, and the ornamental. In this chapter I am going to borrow the term and translate it into the field of diaspora studies by using it metaphorically to designate the aesthetic force of the "too muchness" that characterizes Hew Locke's artistic methods individually, but also certain aspects of Black Atlantic visual culture more broadly.

Whereas the baroque was often disdained in art historical terms as a falling away from the classical ideals of harmony, proportion, and formal simplicity that held sway during the European Renaissance, in Benjamin's 1928 study of the mourning play, or *trauerspiel*, he not only stressed the secularization of history, in which the divine right of kings gave way to courtly power games among tyrants and intriguers, but also saw the sheer artificiality of stylistic excess in art as a kind of masking that covered over the profound loss of certainty brought about by secular modernity. In the philosophy of history he developed in the 1930s, the angel of history is propelled into the future by the catastrophe of "progress" that piles up the ruins of the past, but in his earlier view that "allegories are, in the realm of thoughts, what ruins are in the realm of things" (Benjamin, 1998, 178), Benjamin had already observed the empty sky left behind by an absent god who had abandoned humans to their creaturely life.

When we translate *trauerspiel* as "sorrow songs," in the African American vocabulary of W. E. B. Du Bois (1969), we understand not only that black diaspora traditions of masking and masquerade—from the carnival arts of Trinidad or New Orleans to the fake wigs and gold chains of the bling aesthetic—involve the construction of spectacular surfaces which charm, seduce, and beguile the eye, but that the artifice of such masking also hides and protects the inner world of diaspora subjectivity, acting as a hollow shell that allows the self a contemplative space of melancholy in which to count its losses and hence come to terms with them. Under the conditions of diaspora life, the catastrophe has always already happened for the violent act of separation brought about by forced migration—what George Lamming called "the commercial deporta-

tion of slavery"—means there is a constant reckoning with the constitutive losses out of which selfhood is socially shaped.[1] Whether we call it diaspora baroque or postcolonial baroque, what matters is the *double-sidedness of the mask* whereby the visuality of the exterior face serves to both solicit and deflect the gaze of others, while also containing and hence enabling the work of mourning that takes place on the side of the black interior.

Let me give a snapshot. Viewing another portrait in the series, *Lord of the Dance*, I would take the title as a cue for the Celtic mythology Michael Flatley has packaged for popular culture in *Riverdance*, revealing dance as a key site of cross-culturality, a locus of transatlantic entanglement among Irish and African American identities that Hazel Carby has vividly illuminated.[2] But Locke's sovereign, cast in full body armor such that he resembles a scarecrow, cannot be fixed by one point of reference alone. The extreme color saturation of the pink floral print—not just any pink, it is unmistakably Barbie pink—puts me in mind of the ocean bed of floral tributes to Princess Diana in 1997, even as the plastic doll's heads that garland the figure summon the biblical narrative of King Herod and the slaughter of the innocents. Standing in front of the photograph, beholden to its "too muchness," I am left with the feeling that these are indeed flowers in the ruins—they evoke bouquets wrapped in cellophane, purchased from gas stations and convenience stores, that today adorn the inner-city shrines to those who have died because of guns and knife crime. Often marking the loss of young life, such funeral sites, now increasingly commonplace in contemporary cities, also frequently include children's toys as a kind of memento mori. In the midst of abundance, then, *Lord of the Dance* contains unbearably painful traces of death. Without pathos, rage, or blame, there is a mournful place of contemplation hollowed out by Locke's artistic practice of allegorical indirection.

Masquerade or Baroque?

But why not just call it masquerade? What is specifically baroque about it? At this point I should clarify my approach by way of two key issues—around authorship and reception—that need to be addressed if we are to arrive at the most appropriate interpretative framework in which to appreciate Locke's body of work. Born in 1959 in Edinburgh, he grew up in Guyana from 1966 to 1980 before returning to study in the United Kingdom, where he graduated from Falmouth College of Art in 1986 and the Royal College of Art in 1994. He is of the same generation as the cohort of black British artists, including Keith Piper, Isaac Julien, and Sonia Boyce, who brought about a major para-

digm shift in the arts by way of a frontal or direct address to the politics of black representation, but Hew acknowledges the choices that distinguish his aims. In an interview with art historian Sarat Maharaj, he says, "I grew up with the Black Art thing of the Eighties. An inspiration but at the same time I felt it was not me. I tried to be that type of artist. But it did not really sit at all. I was about something much more idiosyncratic" (2005, 8). However, it should also be clear that Locke's practice does not reject politics per se so much as it pursues more oblique strategies of indirection. In contrast to figurative practices of depiction, in which the body, selfhood, and identity featured directly, Locke's conceptual approach—across photographs, drawings, or the wall-mounted assemblages that have become his signature medium, as in key works such as *Black Queen* (2004) (fig. 18.2)—is one in which figuration acts as scaffolding for an inquiry whose targets seem elusive, even if it is evident that his sovereign figures are implicated in cross-cultural translation. To put it another way, the collage methods used in the construction of his sculptural assemblages do not, first and foremost, suggest a personal statement about the British monarchy—whether in celebration or protest—but invite us to reflect instead on the underlying principles that have unified the many component parts that Locke assembles into a cohesive and iconic whole.

As his work has entered art world circulation, it has garnered much attention, and Locke enjoys a high degree of visibility. He was part of *Infinite Islands*, a survey exhibition of Caribbean artists held in New York in 2007, and in 2005 he held a major solo exhibition at the New Gallery in Walsall, United Kingdom, which acted as a mid-career review. But even though he has won public attention, can we say Locke's poetic strategies of indirection are widely understood? A review of the reception context reveals much coverage in the listings press but scant coverage in the art press. Even when one reviewer enthuses about his stylistic pairing of "pound-shop kitsch with classical iconography,"[3] we cannot help but notice that the conceptual and political gravitas of the artist's interest in the politics of sovereignty has been cut off from the dazzling surfaces that give so much visual pleasure. It is as if only one side of the masking process is acknowledged. There is a tendency to split off the two halves of the double-sidedness that gives the work its polyvocal dynamism. Its dialogic character, in Bakhtin's (1982) terms, has been univocalized so that its colorfulness is accepted but not the violence; its seductiveness is celebrated, but not the sickly suggestion of perversion and decay; its attractiveness is acknowledged, but anything repellent goes unseen. It also strikes me that another possible reason why Locke's work has not received a great deal of in-depth attention has to do with what the contemporary artist and writer David Batchelor calls "chromophobia"—that is, a feeling that excessive color choices are simply "too much" to be compatible with seriousness in art.[4]

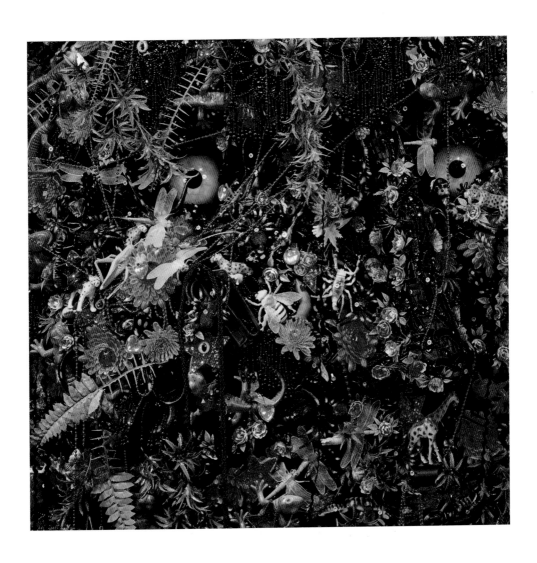

18.2 Hew Locke, *Black Queen* (detail), 2004. Wood base, screws, plastic, fabric, 290 × 160 × 60 cm. Cherrybrisk Collection, London. Courtesy of the artist and Hales Gallery, London.

Conversely, might it be the case that the underlying conceptual investigation into sovereignty has been purposively hidden? Bearing in mind the derivation of the term from the Portuguese *barocco*—meaning an imperfectly or irregularly shaped pearl—we should recall that the knowing superficiality of the European Baroque always hinted at an underlying complexity that is intentionally concealed, which is part of its beauty and charm, much like allegory, where the signifier does not come to rest in any single fixity of meaning but has an adaptable character that allows it to generate new meanings as it travels from one context to another. It is this underlying conceptual architecture of signifying indirection—which I think of as allegorical or emblematic—that is my primary focus here because it forms a consistent feature of Hew Locke's practice from the very beginning and yet has been more or less entirely overlooked.

Examining early works, such as the *Mercenaries* drawings (1997–98), there is a clear line of continuity with the recent photographic portraits—a solitary figure posed in the body language of self-asserting authority—and each figure has been built up out of microcomponents assembled from multiple sources. Carnival costuming is one such influence, as are the military uniforms and brocade coats of seventeenth-century Europe, even as their peculiar combination creates a visual cohesion in which these fictional characters have an uncanny familiarity. In his dialogue with Maharaj, the artist points to ceremonial Amerindian headdresses that he saw in Guyana as one among many of his stylistic sources, alongside the Macarena Madonna of Seville (also referred to as the Black Virgin Mary). But although Maharaj is finely attuned to the light touch of their signifying mobility, noting that "at every turn something seems to be cited and evoked without becoming the resting reference point or master key" (2005, 10), when he goes on to enumerate the multiple sources at play in Locke's assemblages— from Indian temple carvings and Islamic arabesques to Mexican sugar sculptures—it is as if the runaway logic of horizontal equivalence takes priority over the vertical axis that would seek to explain the underlying coherence into which all this heterogeneous "stuff" has been assembled. In addition to linguistic models of pidgins and creoles, Maharaj sheds light on the collage principles of selection and combination by citing two modernist precedents: the walk-through installations Kurt Schwitters constructed in his *Merzbau* project, which the German Dadaist rebuilt as an exile in England during the 1940s, and a poem by Ezra Pound in which "the kind of modern identity [Pound] sees emerging in the imperial hub of London" is compared "to the Sargasso Sea—the expanse of the Atlantic from the Azores to the Caribbean renowned as a depository of seaweed, flotsam, rare and rubbish drift. It is the zone of crossings, cargo and commerce," in which he identifies "a constantly deterritorialising self—made up of perishable, 'deciduous,' ever-renewing stuff" (Maharaj, 2005, 15).

Catching the drift, as it were, that situates Locke's practice in an Atlanticist space of circulatory flows, I nonetheless want to add the suggestion that a Black Atlantic conception of diaspora gives us a handle on the specificity of the elements in the mix, and that a conception of Afro-modernism as a distinctive variant in twentieth-century art, in which collage methods feature highly, offers us a vantage from which to grasp the relationship between past and present that allows us to describe Locke's work as post-colonial. We may have good grounds to hesitate before labeling Locke's art as masquerade or carnivalesque, for in view of his Caribbean as well as British background, there is the risk of falling into a biographical reductionism whereby black artists are conscripted into an ethnonational grid in which it is discursively predetermined that their art can only ever be about identity. As I and many others have argued, such pitfalls are mirrored in a converse tendency toward contextual reductionism whereby works of art are interpreted as if they were passive "reflections" of the social conditions of their production. Both tendencies work to minimize the aesthetic intelligence of the black art object as the primary focus of attention in its own right. Once we understand Afro-modernism as an imaginative field of inquiry that is driven by the impersonal rules of a code that makes use of the signifying differences thrown up in the cross-cultural encounter as a generative matrix for artistic decisions and procedures, then what makes such practices culturally "black" is not just the biographical origin of the artist or the social conditions under which the work is created but the critically dialogic relationship that such art produces in relation to the prevailing discourses of modernism that define its interpretive surroundings.

To prevent the ethnographic capture that would result when the conceptual principles of Locke's practice are simply bundled together with identity or context, we need to see that as well as the synchronic axis that assembles disparate elements into cohesive form, it is in the diachronic axis where the work critically engages various *pre*modern aesthetic categories that Locke's assemblage methods gain their diacritical bite as investigations into the ties the bind citizen and state into social phantasies of sovereignty. A Foucauldian would refer to this relation between premodern and postcolonial as "archival," and a Gramscian might refer to it as an "inventory of traces," whereas a Benjaminian iteration gives us a "constellation." To grasp how Locke constellates his insights by way of a critically dialogic relationship to the contemporary "afterlife" of premodern categories such as baroque, we need to pay close attention to the choices that have shaped the underlying conceptual architecture of his practice.

A Baroque Line of Flight through Afro-Modernism

Looking at another early drawing, *Immortal* (2001), which portrays the Queen Mother, three points need to be made. The first is the background influence of the Mexican graphic artist José Posada. In this regard I observe a connection between the 2001 exhibition *Ultra Baroque: Aspects of Post Latin American Art* and my own equally metaphorical usage of baroque as a designation for recombinant practices that repurpose elements which have atrophied under regionally differentiated conditions of modernism and modernity.[5] Where the Spanish Empire provided the literal means by which the European Baroque was exported along the trade routes of sixteenth- and seventeenth-century globalization, most notably in the architecture of Catholicism, the cross-cultural encounters that resulted in various forms of syncretism involved the colonial retention of premodern stylistic forms that, in the European world, were gradually eliminated or deselected by modernization and secularization. The European medieval "dance of death" became iconographically circumscribed as merely macabre, whereas festive rituals such as the Mexican Day of the Dead produced cross-cultural translations in which premodern survivals and retentions were semiotically transformed. We are accustomed to viewing the Caribbean as the New World contact zone par excellence, especially in light of Stuart Hall's (1990a, 2003) groundbreaking work on diaspora cultural identities, but it is worth asking whether art history has, up to now, adequately addressed the question of how visual signifiers actually "travel" across the language barriers of Anglophone, Francophone, and Spanish-speaking worlds, all of which come together in the distinct cultures of the Caribbean and its various diasporas. In view of this metaquestion, my third point is simply to observe that as the Queen Mum undergoes a process of visual creolization, there is not just Locke's suggestion that the royal house of Windsor is as vulnerable to decay as any imperial power, but that it is precisely through the global process of worlding that empires are brought up against their own inevitable decline. What I like about its cellular composition, encrusted with tiny skulls, is the dispassionate or even disinterested tone Locke adopts: this drawing is avowedly fictional, and yet it reads almost as a clinical diagram of what sovereignty does to the mortal bodies in which it is temporarily incarnated.

In turning to the work that established Locke as a major presence on the scene, *Hemmed in Two* (2000–2004) (fig. 18.3), we have a shift in medium, scale, and materials, although as an artistic proposition, this massive ship which has been made out of cardboard, is an equally fictional construct. If Keith Piper prefigured Paul Gilroy's concept of the Black Atlantic by a couple of years in his 1991 installation *A Ship Called Jesus*

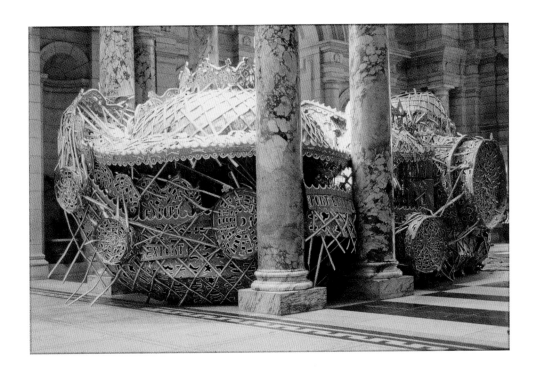

18.3 Hew Locke, *Hemmed in Two—V & A Version*, 2000. Cardboard, acrylic, marker pen, wood, found objects, 400 × 600 × 750 cm. Collection of Eileen Harris Norton and Peter Norton, Santa Monica. Courtesy of the artist and Hales Gallery, London.

then Locke has neither illustrated "theory" nor produced a mere representation of a preexisting idea, but he has instead extemporized a practice of visual thinking whose logic is best described in his own words. "Part boat, part package," he says, *Hemmed in Two* is a work that addresses "the global commodification of culture and its history, while the barcodes acknowledge that this piece is itself a commodity which can become cargo or freight as soon as it leaves the studio" (Locke, 2010). As it fills the architectural space in which it is displayed, *Hemmed in Two* has a site-specific aspect: it has been remade for various venues, and in its first version at the Victoria and Albert Museum, London, the barcodes that tumble from the ship's hull referred to the adjacent presence of seventeenth-century Meissen figurines that allegorically depict the four continents.

Standing before this work, which at ten feet high looms over the viewer as it heaves and bulges into its surroundings, I can see how it coheres conceptually—the iconography of the ship is a transatlantic trope that metonymically evokes the cross-cultural diffusion carried out by the triangular trade between Europe, Africa, and the Americas—but the key question for me is how exactly is it held together physically and literally? When we examine the installation's fine detail, we notice how the interlocking straps and perforations in the cardboard recall the cellular composition of Locke's drawings. By picking out every single edge with a white and black line—which gave rise to a lattice-like technique in subsequent portrayals of the Queen Mother and the British royal family—it is as if the excessive decorative patterning conceals the structural role that is played by the accumulation of multiple components. Inverting or perverting the base/superstructure hierarchy, which sees decoration as mere secondary dressing, the structuring principles of *Hemmed in Two* are brought to light by some of the architectural drawings seen in Locke's sketchbook (fig. 18.4).

In these finely observed renditions we see mosques and temples that have transposed Rajput motifs into the South Asian diaspora in Guyana alongside arches from Córdoba, Spain, which, as in the Alhambra, are engineered to support the roof even though the black and white pattern built into the arabesque appears to be purely ornamental. Pausing to reflect on what connects these sources—for each is a cross-cultural variant of Islamic architecture generated as a result of travel, whether moving west into Catholic Spain or east toward Hindu India—we realize how the artist is showing us the pivotal role of architecture, as compared to other mediums, in the process of transculturation whereby different cultural identities alter their own self-conception as a result of their mutual entanglement. Hence, as the bulky volume of the ship spills forth between the two Doric columns in the version incarnated at the v&a, it is clear that the juxtaposition between the two architectural styles is by no means arbitrary or acciden-

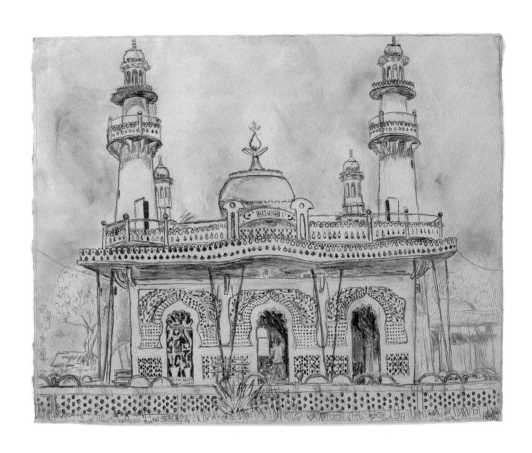

18.4 Hew Locke, *Mosque, West Bank, Demerara, Guyana*, 1992. Pencil on paper, 45 × 57 cm. Artist's collection. Courtesy of the artist and Hales Gallery, London.

tal. Slumped between the columns, *Hemmed in Two*, as its title implies, is reiterating the contrast between the two very distinct aesthetic registers that Heinrich Wölfflin addressed in his canonical art historical study, *Renaissance and Baroque* (1961).

In a series of contrastive distinctions, such as the linear and the painterly, Wölfflin gives greatest emphasis to the two qualities of *massiveness* and *movement* as key aspects of baroque style. Now, whereas the standard reading of Wölfflin's analysis accepts the horizontal or chronological axis of the differentiation between the two period styles as a given, I would add that in his quest to explain the causes of historical change in art, Wölfflin was theorizing art's historicity by way of a paradigmatic or vertical contrast that can be analytically detached from the European corpus it primarily refers to and thus "translated" into other visual traditions. After all, if we readily accept our Harlem Renaissance, then is it not time for us to embrace our Diaspora Baroque?

What Hew Locke brings to our attention, in the installation's front view, is not a face-off between two opposing aesthetic registers but the mutually symbiotic relationship of interdependence that produces baroque as "other" to the historically dominant paradigm of Greco-Roman classicism that was central to the European Renaissance. As a sculptural volume that heaves and slumps downward, along the lines in which Wölfflin's corporeal analogy led him to describe the "bulging muscles and swirling draperies" of baroque bodies as a dissolution of the symmetry and perfection of classicism's bodily ideal,[6] we should also notice that what the artist has staged on the rear side of the V&A iteration of *Hemmed in Two* is a scene of entropy in which the very boundary between outside and inside is dissolved.

"Part boat, part city, part animal, part infestation," in the artist's words, "it is made out of a material that is very useful [yet it is also] a perishable material" (Locke, 2010). At one level, the cardboard signifies indexically, as a protective layering around goods in transit, and quietly implies that sixteenth-century merchants took greater care of inanimate objects than they did with the human cargo that was also shipped across these routes. Locke also indirectly suggests that the very genesis of baroque style in early European modernity was materially dependent on the wealth created by the trade in slavery. But at another level, the conceptual architecture of the ship hollows out a shell-like interior in which to think through the complexity of the cross-cultural entanglements brought about by the global conditions of modernity. The ship is at once a container for exported and imported identities and a diffuser in which all identities are exposed to an otherness in which new transcultural mixtures burst forth as an uncontainable signifying excess.

When Wölfflin says, "The baroque required broad, heavy, massive forms. Elegant

proportions disappeared and buildings tended to become weightier until sometimes the forms were almost crushed by the pressure,"[7] we might be tempted to metaphorically connect the stylistic quality of massiveness with the symbolic weight of crushing pressures that overburden blackness with contradictory meanings in the West. Similarly, the agitated quality of movement Wöfflin identifies when he says "emotion breaks out with violence in certain organs, while the rest of the body remains subject only to gravity,"[8] suggests a correspondence with the sheer restlessness of diaspora life as a product of involuntary migrations. But rather than a one-to-one equivalence, the key link for me lies in the protean and shape-shifting character of the baroque ethos of movement, for it is here that Wöfflin joins company with Benjamin.

In the sense that symbol is to allegory as classicism is to baroque, Benjamin saw allegory as a demystifying alternative to the classicist symbol which, in his view, falsifies human life as stable, timeless, perfectible, and transcendent. Whereas the symbol seeks to incarnate absolute values of truth and beauty for once and all time, allegory begins from the premise that the process of becoming can never ultimately be incarnated: and, hence, where such transience reveals itself in a condition of all-too-earthly fallenness, so historicity itself is understood as "a process not of eternal life but of irresistible decay" (Benjamin, 1998, 178). In place of the conventional view, which interprets the upward flight of heavenly bodies on baroque chapel ceilings as a literal ascension, it is the constant struggle between rising and falling that preoccupied Benjamin, who saw a restless and agitated quality of "petrified unrest" in the trauerspiel's allegories of mourning for a fragmented and broken world.

We started by asking what holds this assemblage together. And if we regard it as a kind of flat-pack assembly that has taken root in the curved space of a baroque fold, rather than the Euclidean space of clear-cut geometric separations, then we could transpose the artist's vocabulary to see how Locke arrived at the highly specific allegorical form of heraldry, coats of arms, and other emblems as the gateway for his postcolonial investigations into sovereignty. If *Hemmed in Two* is an allegorical work of genesis and entropy—becoming boat, becoming city, becoming animal, becoming infestation— then it is this last choice of words that is most telling. As we follow the sinewy and serpentine line that crosses his *Sovereign* (2005) series of drawings and the *Natives and Colonials* (2005) series, in which photographs of monumental public statues of Churchill and Cromwell, among others, are overpainted in the garish and gaudy colors that give Hew's line a kind of voodooesque quality, we can see that he has reactivated the "contagion" model of cross-cultural diffusion.[9] If the organicist basis of the hybridity concept rendered it unusable for some critics and scholars who were anxious about

the risks of biological reductionism, it is important to bear in mind that corporeal imagery almost always accompanies the way in which the processes of transculturation are conceptualized. This not only applies to the distinction made in the sociology of embodiment, between baroque bodies and the more predominant forms of Protestant embodiment under capitalist modernity, but also touches upon the psychoanalytical dimension that Christine Buci-Glucksmann points to in her innovative philosophical account *Baroque Reason: The Aesthetics of Modernity*.[10]

Moving through two other major works, we can see how Locke has pursued an idea of cross-culturality as beautiful contamination. In the conceptual architecture of his practice, any notion of a fixed separation among self and other has given way to a folded space of becoming in which transcultural entanglements are housed within the "afterlife" of premodern aesthetic categories. Historically subordinated to the classicist tradition of the symbol, recombinant allegorical fragments thus become the site of re-generative possibility under the globally interconnected conditions of postcoloniality.

In *Cardboard Palace* (2002) (fig. 18.5), Locke used his interlocking method of modular assemblage to create a walk-though installation in London's Chisenhale Gallery that did indeed acknowledge Schwitters's *Merzbau* as a model. Adding pavilion architecture and Victorian fun fair stalls into the mix of Rajput motifs, the imagery cut into the cardboard included members of the British royal family in the form of stencils that cast a web of shadows across the entire space as a result of the theatrical lighting. When I reviewed the piece, my first impression was that I felt I had been swallowed up into it like Jonah in the belly of the whale, although it was not until after I had completed my passage through it that I realized I had been walking through a grotto.[11] In the act of naming that derived *grotteschi* from grotto, following the excavation in 1480 of Emperor Nero's pleasure house, next to the Coliseum in Rome, the decorative art that showed flora and fauna all mixed and entangled together was not just disdained and disparaged as a stylistic register that was "too much" for the rational order of classicism, but also gave the grotesque the potent suggestion of an underground realm of darkness and death, of fertility and regeneration, that made this stylistic code a constant shadow-side presence throughout the history of art, as Frances Connelly reveals in her edited collection *Modern Art and the Grotesque*.[12]

Limiting myself to two key points, I would argue that even if we cannot merge baroque and grotesque as equally "other" to the dominant Western classical order, we should at least take note of the generative ambivalence highlighted by two of our most eminent guides to the complex structures of feeling inscribed within them. Bakhtin's (1984) distinction between grotesque realism and the classical ideal—the former being

18.5 Hew Locke, *Cardboard Palace* (detail)—*Chisenhale Version*, 2002. Cardboard, acrylic, marker pen, wood, mixed media, 400 × 1,100 × 1,970 cm. Commissioned by Chisenhale Gallery, London. Courtesy of the artist and Hales Gallery, London.

open, unfinished, pendulous, and exaggerated, the latter being perfect, complete, uni-
fied, and closed—is part of his larger account of how the carnivalesque was pushed
down into the debased sphere of low culture, where as merely comic or burlesque it was
split off from the overall cosmology that it expressed and thus came to be demonized
as ugly or diabolical. For his part, John Ruskin gave much attention to what he called
the "noble grotesque," in contrast to the merely "sportive grotesque," because he too
was fascinated by a highly imagistic form of signification that seemed to be universally
understood but which always eluded the rational and logical order of linguistic com-
munication.[13]

Hew Locke is incredibly knowledgeable about these apparently arcane aspects of
premodern art history, but he wears his learning with a light touch that allows him to
set up a contract with his audiences in which his insights are imparted intuitively. If we
come away with the understanding that classicism achieves dominance by working to
simplify, to reduce, to eliminate, and hence to purify art from the otherness of all the
heterogeneous "stuff" that surrounds it, then the alternate and subordinate traditions
that include the grotesque, the arabesque, the carnivalesque, and the baroque are all
part of a counterculture of modernity that in twentieth-century art manifested itself in
the cut-and-mix logic of collage and montage. Hew's methods of composite assemblage
find their deep historical precedent in works by Giuseppe Archimboldo, but where
these paintings from the 1580s were pushed out of the official Western canon and dis-
missed for hundreds of years as comic entertainment before being rediscovered by the
Surrealists, we can also see that they are predicated on a fiercely materialist and anti-
transcendentalist conception of human identity. To suggest that our mortal identities
are not cut from whole cloth but are made up of lots and lots of composite parts is to
suggest not only that identity is a practice and not an essence, but that the fragile and
precarious composition of selves that are in a state of constant becoming is both what
makes them perishable and deciduous *and also* what makes them open to growth and
transformation. For Benjamin, this philosophical contrast has another consequence,
which is inescapably political: where sovereign power aspires to be timeless and un-
changeable, the human existence that lives and dies in a constant state of flux is pre-
cisely that realm of lived experience that constitutes our creaturely life.

Sovereignty and Creaturely Life

As we come up to date with Hew's work on emblems, most strikingly present as the
third major strand of his oeuvre so far, *King Creole* (2004) may give us a feeling of
déjà vu. The assemblage combines skull and crossbones with the stylized design of a

portcullis created by Augustus Pugin, the nineteenth-century architect who built the British houses of Parliament in neo-Gothic revival. In this particular installation, the Doric columns supporting *King Creole* are those of Tate Britain. While connotations spill out in multiple directions — the artist cites ornate funeral wreaths in movies portraying Mafioso gangsters, and the commission for this piece happened to coincide with the demise of Saddam Hussein — the one aspect that I want to zero in on concerns the status of the emblematic as an intrinsically hybrid mode of signification that always combines visual and linguistic elements into highly imagistic, and instantly recognizable, forms.

Emblazoned on the British passport — a material artifact that Salman Rushdie once called the most valuable book in his library — the queen's coat of arms is actually a composite accumulation of elements that do not represent or depict so much as they perform an act that confers identity upon the bearer. An icon may be grasped in animistic terms as a sign behind which lies an invisible or spiritual force, yet an emblem not only has the legal authority to bestow the rights and duties of citizenship but also has the power to give a subject an identity or to take it away. As a document, my passport does not actually belong to me but to the state — when it expires, it should either be handed in or officially defaced so it cannot be copied. Modernity encouraged us to think of our identities in terms of autonomy, but a work such as Locke's *Veni, Vidi, Vici (The Queen's Coat of Arms)* (2004) (fig. 18.6) reveals the binds of heteronomy whereby part of my selfhood belongs not to me but to the state to which I am subject.

Replacing the central shield or blazon with a death's head, Locke has inserted a plastic baby doll's head just below the crown. One suggestion is that, as subjects of the state, we are born and we die amid emblems that are so taken for granted as to be overlooked. But even when we scrutinize the queen's coat of arms in detail, how confident are we about actually deciphering that enigmatic phrase, *Honi Soit Qui Mal Y Pense*, placed above the more familiar motto "God and My Right"? In relation to the installation *Evil to Him Who Thinks Evil* (2005), I want to take two lines of approach. In *States of Fantasy*, Jacqueline Rose points out that the noun is always double sided: the state is the bureaucratic, rational, and impersonal apparatus of modern governance, but in a subjective sense, to be in a "state" is to be emotionally unsettled and all over the place, as in the phrase — "he was in a right state" — in which case, moreover, the rational or governing part of the ego has been usurped by the mess and chaos of unconscious fantasy. To take up Rose's view that the state relies on an element of fantasy for its authority is to suggest that the obedience of its subjects rests, in part, on the inner meaning given to enigmatic signifiers such as the emblems that form part of the state's representational apparatus of legitimacy.[14]

Derived from the Most Noble Order of the Garter, a medieval chivalric order of knights limited to twenty-four members, the *Honi Soit Qui Mal Y Pense* phrase is said to have originated when King Edward III, in 1348, picked up a garter that fell from the leg of the Countess of Salisbury while dancing at Eltham Palace. "Shame upon him who thinks evil of it," or in another translation, "Evil to him who evil thinks." It is thus a declaration of royal honor, and yet it is couched in the most extreme kind of allegorical indirection imaginable. Immigrants to Britain today are obliged to undertake a citizenship test, but do any of us really know the origin of the emblems that feature among all modern nation-states?

Where Rose suggests that unconscious fantasy acts as an emotive binding among social groups, she points out that the emotional ties of identification that bind subject and state are always experienced as though they were invisible: these identificatory bonds only become visible in times of crisis and upheaval. Or, to take up the issue in another vocabulary, this emotional "state" is most deeply felt during the traumatic "state" of exception. As Giorgio Agamben shows, the sovereign decision that declares a state of emergency results in the banishment of those who have been identified as a threat to the state. But where the sovereign decision suspends the law in order to preserve the rule of law, what is revealed is the potential for lawlessness at the very heart of the state. Furthermore, those who are banned are not simply placed outside the law, but, as Agamben writes, they are "rather abandoned by it, that is, exposed and threatened on the threshold in which life and law, outside and inside become indistinguishable."[15]

Far from being random, the messy jumble of the excessive "stuff" Hew Locke uses in his assemblages is, I want to conclude, guided by an intuitive grasp of this zone of indistinction. Sovereign is to creature as self is to other? No, not quite, because where ancient theology asked the question—how absolute is the boundary separating creature from creator?—this conundrum was taken up in seventeenth-century political theory, wrestling with secular modernity, to reveal the paradox of sovereignty. While a creature has a heteronomous existence, being dependent upon its creator, under whose command or law it undergoes continual transformation, is there not, they asked, an element of the divine in every living part of creation? Transposed into secular politics, the question then became: if sovereignty resides in the king's body alone, then state and subject are clearly separated, but if sovereignty is exercised by all the people, that is, by demos, then how is power brought to bear upon the state's subjects when they themselves form a commonwealth?

In the sense that we are rendered creaturely by being vulnerable to the threat of violence, the implications of Locke's artistic propositions are actually quite horrifying.

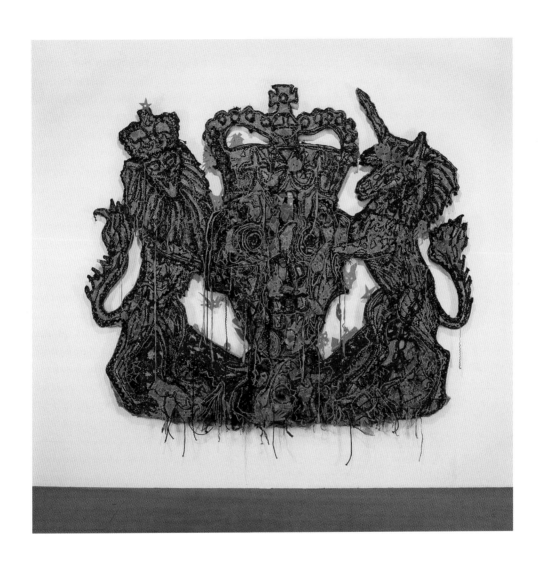

18.6 Hew Locke, *Veni, Vidi, Vici (The Queen's Coat of Arms)*, 2004. Textile, plastic stapled on wood, 240 × 244 cm. Commissioned by The Drawing Room, London. Courtesy of the artist and Hales Gallery, London.

Coming back to *How Do You Want Me?*, the collapse of identitarian boundaries in the zone of indistinction comes through when the artist says, "I am literally putting myself inside sculptures . . . there is an aspect of acknowledging the potential for violence within each of us as individuals" (Locke, 2010). And there is a gendered dimension as well. *Serpent of the Nile* shows how the zone of indistinction might assume hermaphrodite form, but it is masculinity that is specifically at issue when Hew says, "'How Do You Want Me?' is the question many people ask when having their portrait taken at a high street photographer — how should they pose in order to be acceptable? I am saying — OK — if this is how you see black men, then I can play up to that image if you want" (Locke, 2010).

The beads and chains from which *Evil to Him Who Thinks Evil* assembles its emblematic form, with a death's head at its center, certainly evoke the fetishistic self-fashioning of gangsta chic and the bling aesthetic where such jewelry, real or fake, is displayed as a sign of wealth and power. But the routine view of the gangsta's glamorized lawlessness as the result of a pathological aberration or a breakdown in the rule of law is completely upended in Locke's critical suggestion that gangsta fantasies of having absolute power of life and death over others merely betray the constituent antinomies of sovereignty under the political conditions of secular modernity. And there is more. As well as his allegorical indirection over issues of guns and knife crime in the metropolitan West, Locke also evokes the contemporary figure of the child soldier, in Africa and elsewhere. The pose adopted by a youth in a reportage photograph of Liberia's civil war, as he brandishes his AK-47 and swivels on his hips, is both reminiscent of the *Congo Man* portrait and a startling confirmation that truth is always stranger than fiction. Hence, in these terms I would qualify Locke's practice as postcolonial baroque in contrast to, while overlapping with, the distinct strand of diaspora baroque we can see at play in paintings by the African American artist Kehinde Wiley.

Similarly focused on the way power is conveyed through bodily pose, posture, and display — Wiley's sitters choose a style to pose in that is based on sixteenth- and seventeenth-century paintings, as in *St. John the Baptist* (2005) — the critical superficiality being performed here underlines the importance of masking in the visual cultures of the black diaspora that I mentioned earlier. But even if it is understood that the macho pose is a kind of shield designed to protect the vulnerable side that some young black men want to hide from others (although the masks' exaggerated qualities always betray what is concealed), and even though Locke and Wiley share a mutual source of inspiration in the fabric backdrops of African studio photography in work by Seydou Keïta — as shown by Locke's *Tyger Tyger* on the one hand, and Wiley's *Rubin Singleton* (2008) (fig. 18.7) on the other — I suggest that what differentiates these two trajecto-

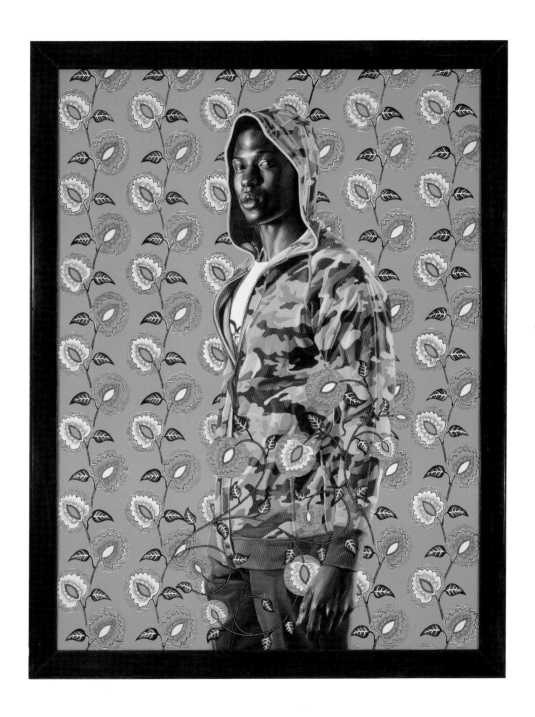

18.7 Kehinde Wiley, *Rubin Singleton*, 2008. Oil on canvas, 96 × 72 inches.
Courtesy of the artist.

ries through the field of Afro-modernism is that where Locke addresses the political emblematics of sovereignty, Wiley's paintings tend to mobilize black male beauty as a defense against the horror of violence, lawlessness, and death. And I would add that Jean-Michel Basquiat mediates this contrast, for if works such as *Head* (1981) disclosed Basquiat's deep interest in the sovereign as a figure suspended between life and death, then we should also recall that Basquiat had fully grasped the scripto-visual hybridity at work in picture-puzzle modes of signification such as the emblematic.

The last word goes to Walter Benjamin, who regarded allegory as signifying in a place beyond beauty. Etymologically based on *allos* (that is, otherness) with *agorenin*, which shares a root with *agora* (the marketplace, the forum, the public space where citizens are called to assembly) the word led Benjamin to observe the agitated rhythm of petrified unrest whereby allegory lifts mundane objects out of the ordinary as potential signs of revelation even as it plunges them down into a state of ruin where they are drained of life and emptied of meaning. The allegory in Dürer's engraving *Melencolia* slumps down in a desert where her instruments of knowledge have become useless, and the scene bears witness to the loss of meaning brought about under the violently unsettling conditions of modernity, yet Benjamin was mostly preoccupied with her brooding attitude. As well as the trauerspiel, he was fascinated by seventeenth-century emblem books in which picture puzzles encouraged readers to ponder multiple interpretations. Far from being defeatist or fatalistic, such brooding is necessary if art is to sift through the ruins of the past so as to select the fragments from which a new future can be rebuilt.

Hew Locke arranges cheap, trashy, plastic toys that have a use-value of weeks or months before they end up in landfills for years: but in the dialectic of scatteredness and connectedness by which multiple meanings are called to assembly under the sign of otherness, his allegories and emblems understand that the subjective correlative to the state of emergency lies in the painful work of mourning. We come to knowledge of the emotional ties that play a foundational role in our lives only in the moment of letting go, when life gives way to death. What makes it "postcolonial," then, is Locke's grasp of the insight Benjamin communicates when he writes that "significance is a function of mortality—because it is death that marks the passage from corruptibility to meaningfulness" (1998, 166).

NOTES

This chapter was first published in *Small Axe: A Caribbean Journal of Criticism*, no. 34 (March 2011): 1–25.

1. George Lamming, *The Pleasures of Exile* (London: Allison & Busby, 1961), 160.

2. Hazel V. Carby, "What Is This 'Black' in Irish Popular Culture?," *European Journal of Cultural Studies* 4, no. 3 (2001): 325–49.

3. Helen Kane, "Major New Hew Locke Art Installation Opens at Rivington Place," *culture24*, http://www.culture24.org.uk/art/art60429 (accessed January 2010).

4. David Batchelor, *Chromophobia* (London: Reaktion, 2000).

5. Victor Zamudio-Taylor and Elizabeth Armstrong, eds., *Ultra Baroque: Aspects of Post Latin American Art*, exhibition catalogue (San Diego: Museum of Contemporary Art, 2000). See also Lois Parkinson Zamora and Monika Kaup, eds., *Baroque New Worlds: Representation, Transculturation, Counterconquest* (Durham, NC: Duke University Press, 2010).

6. Heinrich Wöfflin, *Renaissance and Baroque* (1961), trans. Kathrin Simon (Ithaca, NY: Cornell University Press, 1964), 80.

7. Wöfflin, *Renaissance and Baroque*, 44.

8. Wöfflin, *Renaissance and Baroque*, 81.

9. On the "contagion" model of cross-culturality, see Barbara Browning, *Infectious Rhythm: Metaphors of Contagion and the Spread of African Culture* (New York: Routledge, 1998).

10. Christine Buci-Glucksman, *Baroque Reason: The Aesthetics of Modernity* (1984), trans. Patrick Camiller (London: Sage, 1994). See also Phillip A. Mellor and Chris Shilling, *Re-forming the Body: Religion, Community and Modernity* (London: Sage, 1997).

11. Kobena Mercer, *frieze*, no. 70 (October 2002): 95.

12. Frances Connelly, *Modern Art and the Grotesque* (Cambridge: Cambridge University Press, 2003). See also Robert Storr, *Disparities and Deformations: Our Grotesque*, exhibition catalogue (Santa Fe, NM: SITE Santa Fe, 2004); and Kobena Mercer, "Postcolonial Grotesque: Jane Alexander's Poetic Monsters," in *Jane Alexander: Surveys (from the Cape of Good Hope)*, ed. Pep Subiros, exhibition catalogue (New York: Museum for African Art, 2011), 26–35.

13. John Ruskin, *Modern Painters*, vol. 3, pt. 4 (London: Smith, Elder and Co., 1865), 100.

14. Jacqueline Rose, "Introduction," in *States of Fantasy* (Princeton, NJ: Princeton University Press, 1997), 8.

15. Giorgio Agamben, *Homo Sacer: Sovereign Power and Bare Life*, trans. Daniel Heller-Roazen (Palo Alto, CA: Stanford University Press, 1998).

Bibliography

Adams, Brooks, and Norman Rosenthal, eds. 1997. *Sensation: Young British Artists from the Saatchi Collection*. Exhibition catalogue. London: Royal Academy of Art.

Anzaldúa, Gloria. 1987. *Borderlands / La Frontera: The New Mestiza*. San Francisco: Aunt Lute.

Appadurai, Arjun. 1996. "Disjuncture and Difference in the Global Economy" (1990). In *Modernity at Large: Cultural Dimensions of Globalization*, 24–47. Minneapolis: Public Worlds.

Appiah, Kwame Anthony. 1992. "The Postcolonial and the Postmodern." In *In My Father's House: Africa in the Philosophy of Culture*, 137–57. New York: Oxford University Press.

Araeen, Rasheed, ed. 1989. *The Other Story: Afro-Asian Artists in Post-war Britain*. Exhibition catalogue. London: Hayward Gallery.

Bailey, David A., Ian Baucom, and Sonia Boyce, eds. 2005. *Shades of Black: Assembling Black Arts in 1980s Britain*. Durham, NC: Duke University Press.

Bailey, David A., and Stuart Hall, eds. 1992. "Critical Decade: Black British Photography in the 80s." Special issue, *Ten.8* 2 (3).

Bailey, David A., and Gilane Tawadros, eds. 1998. *Veil: Veiling, Representation and Contemporary Art*. London: Institute of International Visual Art.

Baker, Houston, Manthia Diawara, and Ruth Lindeborg, eds. 1996. *Black British Cultural Studies: A Reader*. Chicago: University of Chicago Press.

Bakhtin, Mikhail. 1982. "Discourse in the Novel" (1935). In *The Dialogical Imagination: Four Essays by M. M. Bakhtin*, translated by Caryl Emerson and Michael Holquist, 259–422. Austin: University of Texas Press.

———. 1984. *Rabelais and His World* (1968). Translated by Helene Iswolsky. Bloomington: Indiana University Press.

———. 1986. "Towards a Methodology for the Human Sciences." In *Speech Genres and Other Late Essays*, translated by Vern W. McGhee, 159–72. Austin: University of Texas Press.

Banning, Kass. 1993. "Feeding Off the Dead: Necrophilia and the Black Imaginary, An Interview with John Akomfrah." *Borderlines*, nos. 29/30 : 28–38.

Barson, Tanya, and Peter Gorschlüter, eds. 2010. *Afro-Modern: Journeys through the Black Atlantic*. Exhibition catalogue. Liverpool: Tate Publishing.

Barthes, Roland. 1981. *Camera Lucida: Reflections on Photography*. Translated by

Richard Howard. New York: Hill and Wang.

Beauchamp-Byrd, Moira, ed. 1996. *Transforming the Crown: African, Caribbean and Asian Artists in Britain, 1966–1996*. Exhibition catalogue. New York: Caribbean Cultural Center.

Bell, Clare, Okwui Enwezor, Danielle Tilkin, and Octavio Zaya, eds. 1996. *In/sight: African Photographers, 1940 to the Present*. Exhibition catalogue. New York: Guggenheim Museum.

Benjamin, Walter. 1973. "Theses on the Philosophy of History" (1950). In *Illuminations*, translated by Harry Zohn, 255–69. London: Fontana.

———. 1998. *The Origin of German Tragic Drama* (1928). Translated by John Osborne. London: Verso.

———. 2008. "The Work of Art in the Age of Its Technological Reproducibility: Second Version" (1936). Translated by Edmund F. N. Jephcott. In *The Work of Art in the Age of Its Technological Reproducibility and Other Writings on Media*, edited by Michael W. Jennings, Brigid Doherty, and Thomas Y. Levin, 19–55. Cambridge, MA: Belknap Press of Harvard University Press.

Bhabha, Homi. 1983. "The Other Question—The Stereotype and Colonial Discourse." *Screen* 25 (4): 18–36.

———. 1992. "Postmodern Authority and Postcolonial Guilt." In Grossberg, Nelson, and Treichler, *Cultural Studies*, 56–68.

———. 1993. "Beyond the Pale: Art in the Age of Multicultural Translation." In *1993 Biennial Exhibition*, edited by Elisabeth Sussman, Thelma Golden, John G. Handhardt, and Lisa Phillips, 62–73. Exhibition catalogue. New York: Whitney Museum of American Art.

———. 1994. *The Location of Culture*. London: Routledge.

Bhimji, Zarina. 1991. *I Will Always Be Here*.

Exhibition catalogue. Birmingham: Ikon Gallery.

Bindman, David, and Henry Louis Gates Jr., eds. 2010–14. *The Image of the Black in Western Art*. 2nd ed. 5 vols. Cambridge, MA: Harvard University Press.

Boime, Albert. 1989. *The Art of Exclusion: Representing Blacks in the Nineteenth Century*. London: Thames and Hudson.

Boyce, Sonia, and Manthia Diawara. 1992. "The Art of Identity" (interview). *Transition*, no. 55: 192–201.

Bracewell, Michael. 1997. *England Is Mine: Pop Life in Albion from Wilde to Goldie*. London: HarperCollins.

Braziel, Jana Evans, and Anita Mannur, eds. 2003. *Theorizing Diaspora: A Reader*. Malden, MA: Blackwell.

Bundy, Andrew, ed. 1999. *Selected Essays of Wilson Harris: The Unfinished Genesis of the Imagination*. London: Routledge.

Caruth, Cathy, ed. 1995. *Trauma: Explorations in Memory*. Baltimore: Johns Hopkins University Press.

Cheah, Pheng, and Bruce Robbins, eds. 1998. *Cosmopolitics: Thinking and Feeling beyond the Nation*. Minneapolis: University of Minnesota Press.

Cliff, Michelle. 1987. "From Object to Subject: Some Thoughts on the Work of Black Women Artists." In *Visibly Female*, edited by Hilary Robinson, 140–57. London: Camden Press.

Clifford, James. 1988. "On Collecting Art and Culture." In *The Predicament of Culture: Twentieth-Century Ethnography, Literature and Art*, 215–51. Cambridge, MA: Harvard University Press.

———. 1997. "Traveling Cultures" (1990). In *Routes: Travel and Translation in the Late 20th Century*, 17–46. Cambridge, MA: Harvard University Press.

———. 1998. "Mixed Feelings." In Cheah and Robbins, *Cosmopolitics*, 362–70.

Cohen, Robin. 1997. *Global Diasporas*. London: University College London.

Corrin, Lisa, ed. 1993. *Mining the Museum: An Installation by Fred Wilson*. Exhibition catalogue. New York: New Press, 1993.

Crenshaw, Kimberlé. 1989. "Demarginalizing the Intersection of Race and Sex: A Black Feminist Critique of Antidiscrimination Doctrine, Feminist Theory, and Antiracist Politics." *University of Chicago Legal Forum*, no. 140: 139–67.

Crimp, Douglas. 1993. *On the Museum's Ruins*. Cambridge, MA: MIT Press.

Dent, Gina, ed. 1992. *Black Popular Culture: A Project by Michele Wallace*. Seattle: Bay Press and Dia Center for the Arts.

Diawara, Manthia. 1992. "Afro-Kitsch." In Dent, *Black Popular Culture*, 285–91.

——. 1998. "Talk of the Town." *Artforum International* 36 (6): 64–72.

Dollimore, Jonathan. 1991. *Sexual Dissidence: Augustine to Wilde, Freud to Foucault*. New York: Oxford University Press.

Du Bois, W. E. B. 1969. *The Souls of Black Folk* (1903). New York: Signet Classics.

Elkins, James, ed. 2007. *Is Art History Global?* New York: Routledge.

Ellison, Ralph. 1964. *Shadow and Act*. New York: Vintage.

English, Darby. 2007. *How to See a Work of Art in Total Darkness*. Cambridge, MA: MIT Press.

Enwezor, Okwui, ed. 1997. *Trade Routes: History and Geography. 2nd Johannesburg Biennale*. Exhibition catalogue. Johannesburg: Johannesburg Municipal Council and Prince Claus Fund.

——. 2002. "The Black Box." In *Documenta 11_Platform 5: Exhibition Catalogue*, edited by Gerti Fietzek, 42–55. Ostfildern: Hatje Cantz.

Enwezor, Okwui, and Octavio Zaya. 1996. "Colonial Imaginary, Tropes of Disruption:

History, Culture and Representation in the Works of African Photographers." In Bell, Enwezor, Tilkin, and Zaya, *In/sight*, 17–47.

Enwezor, Okwui, and Chika Okeke-Agulu. 2009. *Contemporary African Art since 1980*. Bologna: Damiani.

Eshun, Kodwo, and Anjalika Sagar, eds. 2007. *The Ghosts of Songs: The Film Art of Black Audio Film Collective*. Liverpool: Liverpool University Press.

Fani-Kayode, Rotimi. 1988. "Traces of Ecstacy." *Ten.8* 1 (28): 36–43.

Fani-Kayode, Rotimi, and Alex Hirst. 1990. "Metaphysick: Every Moment Counts." In *Ecstatic Antibodies: Resisting the AIDS Mythology*, edited by Tessa Boffin and Sunil Gupta, 78–84. London: Rivers Oram Press.

Fanon, Frantz. 1967a. *Black Skin, White Masks* (1952). Translated by Charles Lam Markham. New York: Grove Press.

——. 1967b. *The Wretched of the Earth* (1961). Translated by Constance Farrington. London: Penguin.

Farquarhson, Alex, and T. J. Demos, eds. 2010. *Uneven Geographies: Art and Globalisation*. Exhibition catalogue. Nottingham: Nottingham Contemporary.

Farrell, Laurie Ann, ed. 2003. *Looking Both Ways: Art of the Contemporary Black Diaspora*. Exhibition catalogue. New York: Museum for African Art.

Featherstone, Mike, Scott Lash, and Brian Robertson, eds. 1995. *Global Modernities*. London: Sage.

Fisher, Jean, ed. 1994. *Global Visions: Towards a New Internationalism in the Visual Arts*. London: Kala.

——. 1996. "The Syncretic Turn: Cross-Cultural Practices in the Age of Multiculturalism." In *New Histories*, edited by Lia Gangitano and Steven Nelson, 32–38. Exhibition catalogue. Boston: Institute of Contemporary Art.

——, ed. 2000. *Reverberations: Tactics of*

Resistance, Forms of Agency in Trans/cultural Practices. Maastricht: Jan Van Eyck Akademie.

———. 2003. "The Work Between Us." In *Vampire in the Text: Narratives of Contemporary Art*, 266–69. London: Institute of International Visual Arts.

———. 2008. "Diaspora, Trauma, and the Poetics of Remembrance." In Mercer, *Exiles, Diasporas and Strangers*, 7–27.

Ford, Simon. 1998. "The Myth of the Young British Artist." In *Occupational Hazard: Critical Writing on Recent British Art*, edited by Duncan McCorquodale, Naomi Siderfin, and Julian Stallabrass, 130–41. London: Black Dog.

Foster, Hal. 1985. "The Primitive Unconscious of Modern Art, or White Skins, Black Mask." In *Recodings: Art, Spectacle, Cultural Politics*, 181–208. Seattle: Bay Press.

———. 1996. "The Artist as Ethnographer." In *The Return of the Real*, 171–203. Cambridge, MA: MIT Press.

———. 2002. "This Funeral Is for the Wrong Corpse." In *Design and Crime: And Other Diatribes*, 123–43. London: Verso.

Foucault, Michel. 1977. "Nietzsche, Genealogy, History" (1971). In *Language, Counter-memory, Practice*, edited by Donald Bouchard, 139–64. Ithaca, NY: Cornell University Press.

Freiman, Lisa D., ed. 2007. *Everything Is Separated by Water: The Art of María Magdalena Campos-Pons*. Exhibition catalogue. Indianapolis: Indianapolis Museum of Art.

Freud, Sigmund. 1974. *Beyond the Pleasure Principle* (1920). Translated by Ernest Jones. London: Hogarth Institute Press.

———. 1984. "Mourning and Melancholia" (1917). In *On Metapsychology*. Translated by Joan Riviere, 245–68. Pelican Freud Library 11. London: Penguin.

Fusco, Coco. 1999. "Captain Shit and Other Allegories of Black Stardom: The Work of Chris Ofili." *Nka: Journal of Contemporary African Art*, no. 10 : 40–45.

Fusco, Coco, and Brian Wallis, eds. 2003. *Only Skin Deep: Changing Visions of the American Self*. Exhibition catalogue. New York: International Center of Photography.

Gates, Henry Louis, Jr. 1988a. *The Signifying Monkey: A Theory of Afro-American Literary Criticism*. New York: Oxford University Press.

———. 1988b. "The Trope of a New Negro and the Reconstruction of the Image of the Black." *Representations*, no. 24: 129–55.

———. 1992. "Critical Fanonism." *Critical Inquiry* 19 (1): 457–70.

———. 1997. "Black London: The Rise of Afro-Saxon Culture." *New Yorker*, April 28–May 5, 194–205.

———. 2010. "Fade to Black: From Cultural Studies to Cultural Politics." In *Tradition and the Black Atlantic: Critical Theory in the African Diaspora*, 33–82. New York: Civitas Basic Books.

Gilman, Sander L. 1985. *Difference and Pathology: Stereotypes of Sexuality, Race, and Madness*. Ithaca, NY: Cornell University Press.

Gilroy, Paul. 1987. *There Ain't No Black in the Union Jack: The Cultural Politics of "Race" and Nation*. London: Hutchinson.

———. 1993. *The Black Atlantic: Modernity and Double Consciousness*. Cambridge, MA: Harvard University Press.

———. 1994. *Small Acts: Thoughts on the Politics of Black Cultures*. London: Serpents Tail.

———. 1997. "Diaspora and the Detours of Identity." In *Identity and Difference*, edited by Kathryn Woodward, 299–346. London: Sage.

Glissant, Édouard. 1989. *Caribbean Discourse: Selected Essays* (1981). Translated by Michael Dash. Charlottesville: University of Virginia Press.

———. 1997. *Poetics of Relation*. Translated by Betsy Wing. Ann Arbor: University of Michigan Press.

Golden, Thelma, ed. 1994. *Black Male: Representations of Masculinity in Contemporary American Art*. Exhibition catalogue. New York: Whitney Museum of American Art.

———. 2001. "Introduction." In *Freestyle*, edited by Christine Y. Kim and Franklin Sirmans, 14–15. Exhibition catalogue. New York: Studio Museum in Harlem.

Gonzalez, Jennifer. 2008. *Subject to Display: Reframing Race in Contemporary Installation Art*. Cambridge, MA: MIT Press.

Gramsci, Antonio. 1971. *Selections from the Prison Notebooks*. Edited by Quentin Hoare and Geoffrey Nowell-Smith. London: Lawrence and Wishart.

Gray, Herman. 1995. *Watching "Race": Television and the Struggle for Blackness*. Minneapolis: University of Minnesota Press.

Green, Renée. 1993. *World Tour*. Exhibition catalogue. Los Angeles: Los Angeles Museum of Contemporary Art.

———. 1996. "Artist's Dialogue." In Read, *The Fact of Blackness*, 144–65.

———. 2002. "Survival: Ruminations on Archival Lacunae." In *Archival Practices and Sites in the Contemporary Art Field*, edited by Beatrice von Bismarck, 147–52. Cologne: König.

———, ed. 2003. *Negotiations in the Contact Zone*. Lisbon: Assirio and Alvim.

Grossberg, Lawrence, Cary Nelson, and Paula Treichler, eds. 1992. *Cultural Studies*. New York: Routledge.

Hall, Stuart. 1978. "Pluralism, Race, and Class in Caribbean Society." In *Race and Class in Post-colonial Society*, 150–82. Paris: UNESCO.

———. 1984. "Reconstruction Work." In "Black Image / Staying On," special issue, *Ten.8* 1 (16): 2–9.

———. 1986. "Gramsci's Relevance for the Study of Race and Ethnicity." *Journal of Communication Inquiry* 10 (2): 5–43.

———. 1987. "Minimal Selves." In *Identity: The Real Me*, edited by Lisa Appignanesi, 44–46. ICA Documents no. 6. London: Institute of Contemporary Arts.

———. 1988a. "Gramsci and Us." In *The Hard Road to Renewal*, 161–73. London: Verso.

———. 1988b. "New Ethnicities." In *Black Film / British Cinema*, edited by Kobena Mercer, 27–30. ICA Documents no. 7. London: Institute of Contemporary Arts.

———. 1990a. "Cultural Identity and Diaspora." In *Identity: Community, Culture, Difference*, edited by Jonathan Rutherford, 222–37. London: Lawrence and Wishart.

———. 1990b. *Rotimi Fani-Kayode (1955–1989): A Retrospective*. Edited by Friends of Rotimi Fani-Kayode, n.p. Exhibition brochure. London: 198 Gallery.

———. 1991. "The Local and the Global Part 1: Globalization and Ethnicity." In *Culture, Globalization and the World-System*, edited by Anthony King, 19–40. Binghamton: State University of New York.

———. 1992. "The Question of Cultural Identity." In *Modernity and Its Futures*, edited by Stuart Hall, David Held, and Anthony G. McGrew, 273–316. Cambridge: Polity.

———. 1996a. "'When Was the Post-colonial?' Thinking at the Limit." In *The Post-colonial Question: Common Skies, Divided Horizons*, edited by Lidia Curti and Iain Chambers, 242–60. London: Routledge.

———. 1996b. "Who Needs Identity?" In *Questions of Cultural Identity*, edited by Stuart Hall and Paul du Gay, 1–17. London: Sage.

———, ed. 1997. *Representation: Cultural Representation and Signifying Practices*. London: Sage.

———. 2001a. "Conclusion: The Multicultural Question." In *Unsettled Multiculturalisms:*

Diasporas, Entanglement, Transruptions, edited by Barnor Hesse, 209–41. London: Zed Books.

———. 2001b. "Museums of Modern Art and the End of History." In Stuart Hall and Sarat Maharaj, *Modernity and Difference*, edited by Sarah Campbell and Gilane Tawadros, 8–23. INIVA Annotations, no. 6. London: Institute of International Visual Arts.

———. 2003. "Creolisation, Diaspora and Hybridity in the Context of Globalisation." In *Créolité and Creolisation*, edited by Okuwi Enwezor, Carlos Basualdo, Ute Meta Bauer, Susanne Ghez, Sarat Maharaj, Mark Nash, and Octavio Zaya, 27–41. Ostfildern-Ruit: Hatje Cantz.

———. 2007. "Through the Prism of an Intellectual Life." In *Caribbean Reasonings: Culture, Politics, Race and Diaspora—The Thought of Stuart Hall*, edited by Brian Meeks, 269–91. Kingston: Ian Randle.

Hall, Stuart, and Sarat Maharaj. 2001. "Modernity and Difference: A Conversation between Stuart Hall and Sarat Maharaj." In Stuart Hall and Sarat Maharaj, *Modernity and Difference*, edited by Sarah Campbell and Gilane Tawadros, 36–56. INIVA Annotations, no. 6. London: Institute of International Visual Arts.

Hannerz, Ulf. 1996. *Transnational Connections: Culture, People, Places*. London: Routledge.

Harris, Thomas Allen. 1992. "Searching the Diaspora: An Interview with John Akomfrah." *Afterimage*, April, 10–13.

Hassan, Salah M. 2008. "Flow: Diaspora and Afro-Cosmopolitanism." In *Flow*, edited by Christine Y. Kim, 27–31. Exhibition catalogue. New York: Studio Museum in Harlem.

Hirst, Alex. 1990. "Unacceptable Behaviour: A Memoir." In *Rotimi Fani-Kayode, Photographer (1955–1989): A Retrospective*, n.p. London: 198 Gallery.

———. 1992. *The Last Supper: A Creative Farewell to Rotimi Fani-Kayode*. Exhibition catalogue.

Wolverhampton: Light House Media Centre.

Jafa, Arthur. 2000. "Fragments from a Conversation, June–July 1999." In *Kerry James Marshall*, edited by Eve Sinaiko. New York: Abrams.

Jameson, Fredric. 1984. "Postmodernism, or the Cultural Logic of Late Capitalism." *New Left Review*, no. 146: 59–92.

Jantjes, Gavin. 1993. "The Long March from 'Ethnic Arts' to 'New Internationalism.'" In *Cultural Diversity in the Arts*, edited by Ria Lavrijsen, 59–66. Amsterdam: Royal Tropical Institute.

Jones, Kellie. 2011. "In Their Own Image" (1990). In *Eyeminded: Living and Writing Contemporary Art*, 329–40. Durham, NC: Duke University Press.

Julien, Isaac. 1988. "Aesthetics and Politics. Panel with Martina Attille, Reece Auguiste, Peter Gidal, Isaac Julien, and Mandy Merck." *Undercut*, no. 17: 32–39.

———. 1992. "Black Is . . . Black Ain't: Notes on De-essentialising Black Identities." In Dent, *Black Popular Culture*, 255–63.

Kapur, Geeta. 2000. *When Was Modernism: Essays on Contemporary Cultural Practice in India*. New Delhi: Black Tulip.

King, Anthony D., ed. 2011. *Culture, Globalization and the World-System: Contemporary Conditions for the Representation of Identity* (1991). Minneapolis: University of Minnesota Press.

Locke, Hew. 2010. "How Do You Want Me?" www.hewlocke.net. Accessed January.

Magiciens de la Terre. 1989. Exhibition catalogue. Paris: Musée national d'art modern.

Maharaj, Sarat. 1994. "'Perfidious Fidelity': The Untranslatability of the Other." In Fisher, *Global Visions*, 28–35.

———. 2005. "A Sargasso-Sea Hoard of Deciduous Things: Hew Locke and Sarat Maharaj in Conversation." In *Hew Locke*,

edited by Deborah Robinson and Emily Marsden, 8–16. Exhibition catalogue. Walsall: New Art Gallery.

Marcuse, Herbert. 1977. *The Aesthetic Dimension: Toward a Critique of Marxist Aesthetics*. Boston: Beacon.

Mercer, Kobena. 1994. *Welcome to the Jungle: New Positions in Black Cultural Studies*. London: Routledge.

——. 1996. "Decolonization and Disappointment: Fanon's Sexual Politics." In Read, *The Fact of Blackness*, 114–31.

——. 1997a. "Inter-culturality Is Ordinary." In *Inter-cultural Arts Education and Municipal Policy*, edited by Ria Lavrijsen, 34–44. Amsterdam: Royal Tropical Institute.

——. 1997b. "Witness at the Crossroads: An Artist's Journey in Postcolonial Space." In *Keith Piper: Relocating the Remains*, 12–85. London: Institute of International Visual Arts.

——. 1998. "Intermezzo Worlds." *Art Journal* 57 (4): 43–45.

——. 2002. "Romare Bearden: African American Modernism at Mid-century." In *Art History, Aesthetics, Visual Studies*, edited by Michael Ann Holly and Keith Moxey, 29–46. New Haven, CT: Yale University Press.

——. 2003. "Frank Bowling's Map Paintings." In *Fault Lines: Contemporary African Art and Shifting Landscapes*, edited by Gilane Tawadros and Sarah Campbell, 139–49. Venice: Africa in Venice.

——, ed. 2005a. *Cosmopolitan Modernisms*. Cambridge, MA: MIT Press.

——. 2005b. "Iconography after Identity." In Bailey, Baucom, and Boyce, *Shades of Black*, 49–58.

——, ed. 2006. *Discrepant Abstraction*. Cambridge, MA: MIT Press.

——. 2007a. "'Diaspora Didn't Happen in a Day': Reflections on Aesthetics and Time." In *Black British Aesthetics Today*, edited

by R. Victoria Arana, 66–78. Newcastle: Cambridge Scholars Press.

——, ed. 2007b. *Pop Art and Vernacular Cultures*. Cambridge, MA: MIT Press.

——. 2007c. "Tropes of the Grotesque in the Black Avant-Garde." In Mercer, *Pop Art and Vernacular Cultures*, 136–59.

——, ed. 2008. *Exiles, Diasporas and Strangers*. Cambridge, MA: MIT Press.

——. 2010a. "Art History after Globalization: Formations of the Colonial Modern." In *Colonial Modern: Aesthetics of the Past, Rebellions for the Future*, edited by Tom Avermaete, Serhat Karakayali, and Marion von Osten, 232–42. London: Black Dog.

——. 2010b. "Cosmopolitan Contact Zones." In Barson and Gorschlüter, *Afro-Modern*, 40–47.

Meyer, James. 2000. "Nomads: Figures in Travel in Contemporary Art." In *Site-Specificity: The Ethnographic Turn*, vol. 4 of *dis-, de-, ex-*, edited by Alex Coles, 10–26. London: Black Dog.

Mirzoeff, Nicholas. 1999. *Diaspora and Visual Culture: Representing Africans and Jews*. New York: Routledge.

Mishra, Sudesh. 2007. *Diaspora Criticism*. Edinburgh: University of Edinburgh Press.

Morley, David, and Kuan Hsing-Chen, eds. 1995. *Stuart Hall: Critical Dialogues in Cultural Studies*. London: Routledge.

Muhammad, Erika. 2000. "Reel Stories: Isaac Julien." *Index*, June/July, 90–94.

Nesbitt, Judith, ed. 2010. *Chris Ofili*. London: Tate Publishing.

Noble, Alex. 1989. "The Blues: An Interview with Mitra Tabrizian." *Ten.8* 1 (25): 30–35.

Obrist, Hans-Ulrich, ed. 1998. *Kara Walker: Safety Curtain*. Exhibition catalogue. Vienna: Weiner Staatsoper.

Ofili, Chris, and Thelma Golden. 2003. "A Conversation." In *Chris Ofili: Within Reach. British Pavilion, 50th Venice Biennale*,

n.p. Exhibition catalogue. London: Victoria Miro Gallery.

O'Grady, Lorraine. 2010. "Olympia's Maid: Reclaiming Black Female Subjectivity" (1992). In *The Feminism and Visual Culture Reader*, edited by Amelia Jones, 174–85. New York: Routledge.

Oguibe, Olu. 1996. "Photography and the Substance of the Image." In Bell, Enwezor, Tilkin, and Zaya, *In/sight*, 231–50.

Oguibe, Olu, and Okwui Enwezor, eds. 1995. *Reading the Contemporary: African Art from Theory to the Marketplace*. Cambridge MA: MIT Press.

Owens, Craig. 1992a. "The Discourse of Others: Feminists and Postmodernism" (1985). In *Beyond Recognition: Representation, Power and Culture*, edited by Scott Stewart Bryson, Barbra Kruger, Lynne Tillman, and Jane Weinstock, 166–90. Berkeley: University of California Press.

——. 1992b. "Representation, Appropriation, and Power" (1982). In Bryson et al., *Beyond Recognition*, 88–113.

Oyedeji, Koye. 2007. "In Search of . . . (Adequate Representations of Our Post Black Condition)." In *"Black" British Aesthetics Today*, edited by R. Victoria Arana, 119–34. Newcastle: Cambridge Scholars Publishing.

Papastergiadis, Nikos. 1994. *The Complicities of Culture: Hybridity and "New Internationalism."* Cornerhouse Communique, no. 4. Manchester: Cornerhouse Gallery.

——. 2000. *The Turbulence of Migration: Globalization, Deterritorialization and Hybridity*. Cambridge: Polity.

Patton, Sharon F. 1999. *African-American Art*. New York: Oxford University Press.

Paul, Annie. 2008. "Visualizing Art in the Caribbean." In *Infinite Island: Contemporary Caribbean Art*, edited by Tumelo Mosaka, Annie Paul, and Nicollette Ramierez, 21–34.

Exhibition catalogue. Brooklyn: Brooklyn Museum.

Pieterse, Jan Nederveen. 1995. "Globalisation as Hybridisation." In Featherstone, Lash, and Robertson, *Global Modernities*, 45–68.

——. 2004. "Hybridity, So What? The Anti-hybridity Backlash and the Riddles of Recognition." In *Globalization and Culture: Global Mélange*, 85–111. Lanham, MD: Rowman and Littlefield.

Piper, Keith. 1991. *A Ship Called Jesus*. Exhibition catalogue. Birmingham: Ikon Gallery.

Pollock, Griselda. 1999. *Differencing the Canon: Feminist Desire and the Writing of Art's Histories*. London: Routledge.

Powell, Richard J. 1997. *Black Art and Culture in the 20th Century*. New York: Thames and Hudson.

——. 2001. *Black Art and Cultural History*. New York: Thames and Hudson.

Read, Alan, ed. 1995. *The Fact of Blackness: Frantz Fanon and Visual Representation*. London: Institute of Contemporary Arts.

Rubin, William Stanley, ed. 1984. *"Primitivism" in 20th Century Art: Affinity of the Tribal and the Modern*. 2 vols. Exhibition catalogue. New York: Museum of Modern Art.

Saint Léon, Pascale Martine, and N'Gone Fall, eds. 1999. *Anthology of African and Indian Ocean Photography*. Paris: Editions Revue Noire.

Scott, David. 1997. "'An Obscure Miracle of Connection': Discursive Tradition and Black Diaspora Criticism." *Small Axe: A Caribbean Journal of Criticism* 1 (1): 19–38.

——. 2005. "The Ethics of Stuart Hall." *Small Axe: A Caribbean Journal of Criticism* 9 (1): 1–16.

Sealy, Mark. 1996. "A Note from Outside." In *Communion: Rotimi Fani-Kayode, 1955–1989*. Exhibition catalogue, n.p. London: Autograph.

Shonibare, Yinka. 1996. "Fabric and the Irony

of Authenticity." In *Mixed Belongings and Unspecified Destinations*, edited by Nikos Papastergiadis, 38–41. INIVA Annotations, no. 1. London: Institute of International Visual Arts.

Smith, Terry. 2006. "Contemporary Art and Contemporaneity." *Critical Inquiry* 32 (4): 681–707.

——. 2010. *What Is Contemporary Art?* Chicago: University of Chicago Press.

Smith, Terry, Okwui Enwezor, and Nancy Condee, eds. 2008. *Antinomies of Art and Culture: Modernity, Postmodernity, and Contemporaneity.* Durham, NC: Duke University Press.

Sussman, Elisabeth, Thelma Golden, John G. Handhardt, and Lisa Phillips. 1993. *1993 Biennial Exhibition.* Exhibition catalogue. New York: Whitney Museum of American Art.

Tate, Greg. 1992. *Flyboy in the Buttermilk: Essays on Contemporary America.* New York: Simon and Schuster.

Tawadros, Gilane. 1996. "Beyond a Boundary: The Work of Three Black Women Artists" (1989). In Baker, Diawara, and Lindeborg, *Black British Cultural Studies*, 240–77.

——, ed. 2000. *Changing States: Contemporary Art and Ideas in an Era of Globalisation.* London: Institute of International Visual Arts.

Thompson, Robert Farris. 1983. "Black Saints Go Marching In: Yoruba Art and Culture in the Americas." In *Flash of the Spirit: African and Afro-American Art and Philosophy*, 1–96. New York: Vintage.

——. 1991. "Afro-Modernism." *Artforum International*, September, 91–94.

——. 2011. *Aesthetic of the Cool: Afro-Atlantic Art and Music.* New York: Periscope.

Vergne, Philippe, ed. 2007. *Kara Walker: My Complement, My Enemy, My Oppressor, My Love.* Exhibition catalogue. Minneapolis: Walker Art Center.

Vogel, Susan, ed. 1991. *Africa Explores: Twentieth Century African Art.* Exhibition catalogue. New York: Center for African Art.

Volosinov, V. N. 1973. *Marxism and the Philosophy of Language* (1929). Translated by Ladislav Matejka and I. R. Titunik. Cambridge, MA: Harvard University Press.

Wallace, Michele. 1990. "Modernism, Postmodernism and the Problem of the Visual in Afro- American Culture." In *Out There: Marginalization and Contemporary Culture*, edited by Russell Ferguson, Martha Gever, Trin T. Min-ha, and Cornel West, 39–50. Cambridge, MA: MIT Press.

Wallis, Brian, Marianne Weems, and Philip Yenawine, eds. 1999. *Art Matters: How the Culture Wars Changed America.* New York: New York University Press.

Walmsley, Ann. 1992. *The Caribbean Artists Movement, 1966–1972: A Literary and Cultural History.* London: New Beacon.

Werbner, Pnina, and Tariq Modood, eds. 1997. *Debating Cultural Hybridity: Multi-cultural Identities and the Politics of Anti-racism.* London: Zed Books.

Willis, Deborah. 2000. *Reflections in Black: A History of Black Photographers, 1840 to the Present.* New York: Norton.

——, ed. 2010. *Black Venus 2010: They Called Her "Hottentot."* Philadelphia: Temple University Press.

Young, Louis, ed. 1990. *The Decade Show: Frameworks of Identity in 1980s Art.* Exhibition catalogue. New York: Museum of Contemporary Hispanic Art.

Young, Robert J. C. 1995. *Colonial Desire: Hybridity in Theory, Culture, and Race.* London: Routledge.

Žižek, Slavoj. 1997. "Multiculturalism, or the Cultural Logic of Multinational Capitalism." *New Left Review*, no. 225: 28–51.

Index

Institute of International Visual Arts (INIVA), 28, 190, 192–93, 203–4

interraciality: in Black Atlantic art, 136, 138–45; hybridity and, 77–82; in Julien's films, 129–30, 134, 139; in twentieth-century film, 139, 142–43

intersectionality, 66–67

intertextuality, diaspora art and, 10, 284–92, 300–309

In the Desert of Modernity exhibition, 251

invisibility trope in black cultural criticism, 7, 194–202, 223, 227–28, 239–47

Islands in the Sun (film), 77, 139

Jaar, Alfredo, 212

Jacir, Emily, 272

Jackson, Janet, 184

Jackson, Michael, 55

Jacobs, Harriet, 300

Jagede, Taiwo, 100

Jameson, Fredric, 26

Jarman, Derek, 143

Jarrell, Wadsworth, 238

Johns, Jasper, 239

Johnson, Malvin, 109

Jones, Kellie, 28, 66

Jones, Lois Mailou, 109

Jordan, Neil, 60, 142

Julien, Isaac, 2, 5; *The Attendant* (video), 130, 132, 134; black diaspora and, 32, 34, 87–88, 325; films of, 71, 77, 105, 211, 218, 283; iconography in work of, 129–45, 270; *Looking for Langston*, 139–45; politics of difference and, 54, 67

Jungle Fever (film), 77, 142

Kafka, Franz, 20

Kandinsky, Wassily, 254

Karenga, Ron, 238

Kaur, Permindar, 190, 204

Keïta, Seydou, 6, 157–60, *162–63*, 164, 170, 172, 175, 176, 184, 342

Kelly, Mary, 305

Kelly, Mike, 186

Kempadoo, Roshinii, 66, 102

kente cloth, 150, 232

Kentridge, William, 266, 270

Khan, Keith, 54, 81

King, Anthony, 252

King, Martin Luther, Jr., 310

King, Rodney, 5, 54–55

Kingelez, Bodys Isek, 210

King Kong (film), 60

Klee, Paul, 254

Koons, Jeff, 268, 270

Kubler, George, 306, 309

Kumalo, Alf, 182

Lacan, Jacques, 80, 279, 289

L'Afrique par Elle-même exhibition, 170

Lam, Wifredo, 224

Lamming, George, 324–25

Landers, Sean, 186

La Rose, John, 204, 225

Latamie, Marc, 54

Lataque, Oscar, 158, 179

Latin American art, baroque aesthetics in, 330

Lawrence, Jacob, 29

Lawrence, Stephen, 195

Lawrence, T. E., 130

Lee, Spike, 24, 54–55, 77–78, 142, 246

Le Mepris (film), 289

Lewis, Norman, 238

Lewis, Samella, 257

Ligon, Glenn, 4, 54, 64–66, 80, 212

Lisk-Carew brothers, 179

Live/Life exhibition, 188